SURVIVAL
OF THE
BEAUTIFUL

ART, SCIENCE, AND EVOLUTION

David Rothenberg

BLOOMSBURY

LONDON · NEW DELHI · NEW YORK · SYDNEY

First published in Great Britain 2011
This paperback edition published 2013

Copyright © 2012 by David Rothenberg

The author has asserted his moral rights

Bloomsbury Publishing Plc
50 Bedford Square
London WC1B 3DP

www.bloomsbury.com

Bloomsbury Publishing, London, New York, New Delhi and Sydney

A CIP catalogue record for this book is available from the British Library

ISBN 978 1 4088 3056 7

10 9 8 7 6 5 4 3 2 1

Designed by Sara Stemen
Typeset by Westchester Book Group
Printed and bound in Great Britain by CPI (UK) Ltd, Croydon CR0 4YY

For my mother,
a great artist and teacher

Contents

CHAPTER 1

Come Up and See My Bower

BUSHWHACKING through the Australian rainforest back when I was hunting down exotic bird songs, I thought I had stumbled on the remains of a picnic—a pile of blue plastic spoons. "Who would leave their trash in the middle of this pristine forest?" I asked my guide, ornithologist Syd Curtis.

"Rubbish?" he laughed. "What are you talking about? That's a profound thing you're looking at right there. The oldest artwork in the world."

"How do you mean?"

"Look right behind the spoons. You'll see what's left of a structure made of dried grasses."

I squinted. He was right, there were two walls built there, with a bit of a walkway in between. Like a country road guarded by two short parallel hedges. "Who built this?" I wondered.

"A male satin bowerbird." Syd smiled. "This creation is called his bower. It's not a nest, but an artwork he builds with the hopes he can attract a female to visit it, observe his performance in and around the bower, and if he's lucky . . . mating just might occur!"

I still didn't get it. "What about the spoons?"

"Ah . . . I almost forgot," said Syd. "It's not enough for our boy to build a bower. He has to decorate it with something blue. Blue flowers, blue shells, the blue feathers of rollers and parakeets. Sometimes they paint the things with blue pigment that they grind up from fruit pulp with their beaks. Nowadays they raid picnic tables up to ten miles away

if they see readymade blue decorations. The latest thing! Of course they haven't always had plastic to work with. You see, bowerbirds have been building bowers for fifty million years. They have adapted to the times."

What I thought was litter turned out to be my first discovery of the origins of art, the material of a creative process millions of years older than the ancient cave paintings of Lascaux. The satin bowerbird has known that blue is the color, the most beautiful, best, and right color, for eons longer than human beings have been around on this planet to invent utensils designed to be used only once.

Bowerbirds, say biologists, are unique. There is perhaps no other species besides human beings that is known to create things so beautiful beyond their function, structures that we have a hard time calling anything else but art, the arrangement of objects that please us. Bowers are built to attract females, but they are far from the simplest solution to such a problem. Yet a male won't get a female without one. And somehow, evolution has led them to build them in exact and precise ways.

It is no surprise we humans consider ourselves special. We transform our environment, live in complex societies, speak complex languages, reflect on our place in the universe. We express how wonderful it is to be alive by making art, the pure expression of possibility, just because we can. No other species is like us, and it's easy to spend a human life thinking only about other humans, by humans, for humans.

And yet we don't. We are obsessed with animals, plants, life of all kinds. Long before the theory of evolution we have all felt a kinship with living things as much as we have been told how different from every other creature we are. We are different, and we are part of the whole. Art and science together reveal the vicissitudes of nature. Just as no other species is able to step back and reflect on its own position in the scheme of things, no other species is supposed to make art.

Human art has been called frivolous, essential, the best any culture can produce, and (less often) necessary. It seems the product of a certain amount of comfort and leisure time, when life is no longer the harsh battle for survival that evolution makes it look like. But for art to

be necessary and inevitable, we want to be able to find it in nature, that world without doubt, which marches along without its inhabitants stopping to wonder or seeking to jump ship.

There are plenty of species that sing songs and do dances far beyond what basic biological needs might seem to require. Gibbons sing stylized duets to one another, cranes do a fabulous mating dance, birds of paradise eloquently flaunt their wares. But so far there is only one animal we know of who makes physical, constructed works of art, building structures whose complexity and elaboration seem to suggest art for art's sake. Sexual selection may explain the process away, but it says little about why such aesthetic ability appeared in these particular species. This reasonable explanation says nothing about the levels of intricacy and excess that mark this activity, which amazes most humans who see it, and gives justification for the idea that art in a pure form can be made by creatures far away from humanity on the gnarled evolutionary tree.

Evolution has produced one species who has the need to take a look around and wonder where it came from. Fellow humans, how did we get here? Charles Darwin compiled mountains of evidence to demonstrate how all living creatures are connected, how each species ends up with unique defining features that distinguish each from every other, and through the process of selection, this wonderful precision and diversity emerges with no one in charge of the design. Chance mutation, competition, and evaluation, the fittest possibilities surviving— this is what makes for a multifarious and infinite living world. The genius of the idea of evolution is that so simple a process can explain so much.

From the moment he thought of it, much like any twelve-year-old kid who first learns it, Darwin realized that the idea of evolution seemed so powerful it could explain almost anything—the mobility of bacteria, the tails of cats, the aerodynamics of pelicans, the seaworthiness of a shark. Look around you, and you can easily see in nature evidence of brilliant designs, efficiency in animals and plants as if they were machines. Evolution through trial and error, over millions of years, produces ingenious solutions to the problem of adaptation to a habitat,

a challenge, or a situation. This is the heart of Darwin's idea, introduced in *On the Origin of Species*, of evolution by natural selection, where those traits prevail that are best adapted to the situation. This is the idea that gets popularly understood, or oversimplified, into "survival of the fittest."

If the fittest really did survive, we would have the best of all possible creatures, the most perfectly evolved, the most ingenious solutions. Of course, evolution doesn't really work that way. Instead, we have "pretty good" beasties that manage to endure, the result of accident and test in the real world of millions of years of chance experiment. If there were a designer to it all, we might have ended up with a far more organized, more perfect, but probably less diverse world.

People tend to accept the "survival of the fittest" simplification of evolution and leave it at that. It makes most of us both proud and uncomfortable at the same time. We are honored to be part of this great march of life, which creates us as much as it does the slime mold and the fruit fly. At the same time it humbles us, since we know humans have certainly never been perfect, but are instead some kind of improbably happy accident, one strange strategy for survival that has some very strange ideas about how to make the environment adapt to our needs. Looking at the rest of life, who could have predicted that a strategy as outlandish as that of humanity would ever get off the ground? We need to clothe ourselves to survive in our chosen environments, which we totally manipulate to our needs. We need all kinds of tools, social organizations, languages, cultures, customs that are anything but efficient. No, if evolution were exact and planned out, we never would have appeared within it.

As thrilled as he was by the vast range of phenomena his theory of natural selection could explain, Darwin was by no means satisfied with it. One thing he had a hard time explaining was the excessive beauty so prevalent in nature—plants and animals brimming over with unnecessary frills and flourish. "The sight of a feather in the peacock's tail," he wrote, "whenever I gaze at it, makes me sick!"

How could a part of nature so beautiful make the great scientist feel ill? This huge fanned tail is anything but fit. The great feathered

display of the male peacock is just the most famous example of nature's exuberance. The natural world is far from a functionalist utopia. Instead, we are treated to case after case of wild, untrammeled craziness: narwhals with a single unicorn-like tooth, flycatchers with tails five times longer than their bodies, ancient moose with antlers so big they could barely move. It was usually only the males of the species that possessed these extreme attributes. Darwin had a hunch that these sorts of qualities must have evolved some other way.

That's how he came up with the idea of sexual selection, introduced to the world in his next major book, *The Descent of Man*. Sexual selection is what happens when females of the species evolve to prefer certain traits of the males, for no good reason whatsoever. In sexual selection, there need be absolutely no reason for the peacock to have that crazy tail beyond the fact that females have evolved to like that kind of tail. Indeed, the liking of that particular tail, a tail more outlandish than any other avian tail, is something completely arbitrary, with no significance except that the females happen to like it. Nowadays biology tends to treat sexual selection as a subset of natural selection, but that's not the way Darwin saw it. For him sexual selection was a slap in the face of natural selection, a challenge, a contrasting and conflicting force working its own wily ways against the doctrine of efficiency and adaptation.

So the females, in most examples of sexual selection, call all the shots. With this theory, they immediately have a whole lot of power and gain in biological status. This idea was not popular in the Victorian age, and indeed, one view of the history of biology has it that sexual selection was basically ignored for more than a century because it gave women far too much say in the scheme of things. Many in the nineteenth century found this theory far more controversial than natural selection, since it offered a rather frivolous view of the most beautiful aspects of life on Earth, and biology wasn't going to take such features and traits seriously until it could find some good reasons for them.

Society may have been too prudish to give sex such power as the guiding force behind all that natural beauty. Should Darwin instead have named this process *aesthetic* selection? Could we simplify it as

"survival of the beautiful"? Life is far more interesting than it needs to be, because the forces that guide it are not merely practical.

Evolution cannot be accurately encapsulated in that one phrase "survival of the fittest." If we are going to reduce Darwin's two-part thinking on the matter to a sound bite, then let's go as follows. Evolution consists of two overlapping strands: survival of the fittest, and survival of the interesting. Together they produce the vast cornucopia of delights we call life, that tangled bank, those endless forms. No single plan lurks behind this great march of time and exploration. We can only search for details in the record of all the beauty that has happened. Shall we then be satisfied by saying all evolved beauty is the result of arbitrary accidents?

There is no better group of species to wonder about this question with than the bowerbirds and their unusual propensity to make art. Charles Darwin knew well the amazing artistic will of these feathered creatives. He knew that each species had evolved to make radically different works.

The differences between the constructions of each bowerbird species can be compared to the distinct styles of individual human artists or schools of art. The satin bowerbird, most common and easy to observe, builds a simple avenue, but then strangely decorates it with blue. Vogelkop's bowerbird builds a tepee-like mound around a pole and surrounds it with a series of small piles of flowers, seeds, and feathers from birds of paradise. In some areas they build a wide hut around the base of the bower. MacGregor's bowerbird makes the most elaborate structure, something like an exploding Christmas tree or a frozen firework, decorated with hanging ornaments of moss and lichen.

How do we connect this diversity in bower styles to the march of evolution? A chart of genetic family relationships shows that related species of bowers construct related kinds of bowers. The green catbird, the most ancient member of this group of species, already has the strange behavior of constructing a basic display ground marked by a circle of upside-down leaves. When they dry out, the male catbird replaces them. Why would catbirds possibly need to do this? It's their

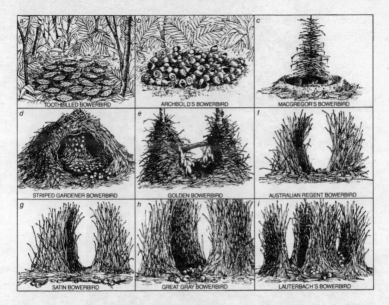

Fig. 1. Each species of bowerbird has its own bower design.

evolved aesthetic sense. The more recent species of bowerbirds have carried this to the next extreme.

The satin bowerbird is the most studied of these avian artists, because it is happy to live close to human habitation, at the edge of backyards or in sunny forest clearings throughout the wooded parts of Australia. The rather minimalist avenue design, with one thatched construction on either side of a protected display way, is simple and iconic.

Building the bower is a rigorous process. The male satin bowerbird first plucks away all the leaves on bushes and low branches that keep the sun away from his chosen site. Then he clears a one-square-meter patch of all debris. Next he brings in his own debris: hundreds of little twigs and sticks, which he tramples into the dirt to create a woodsy platform upon which the walls of the bower will be erected.

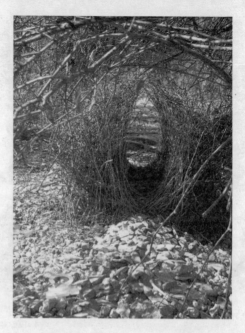

Fig. 2. A satin bowerbird's bower.

The platform, once matted, is as strong as a nest, and has even been carried away by scientists in one piece.

The next phase, the real construction of the bower, is unique enough that biologists have a hard time figuring out from what previous bird behavior it could have evolved. The male satin now collects very long twigs, around a foot in length, and places hundreds of these in two vertical rows, with space for himself in the middle, usually oriented with the largest opening toward the north so it gets the most sun. When he is done, each wall is about as thick as the bird himself, about the same size as a hefty crow.

Once the basic structure is finished, the customization begins. Some birds line the display floor with fine grasses. Others paint the inner wall of the bower with crushed berries, some even brushing on the berry juice with soft pieces of bark.

No other animal does anything like this, with such determination, and with such individual variations. Forget the joke book *Why Cats Paint*. Bowerbirds really do paint, and they have done so for millions of years.

Next, the male satin decorates the sunny, northern-exposed open side of the bower with anything blue he can find. Blue blossoms and parrot feathers are traditional, but the blue color, always rare in the Aussie eucalyptus environment, can be especially hard to find today. Hence the satin bowerbird's love for blue plastic.

These bowers are built solely to attract females, and hopefully convince them to be impressed enough to mate with the artist. Male satin bowerbirds are in tough competition for female attention, and building a sturdy, symmetrical bower and adding a flourish of picnic spoons might not be enough. They must trounce the competition, and what better way than to raid neighboring bowers, grab some of the prized blue ornaments, and carry them back to your own studio? And while on the attack, why not pull a few twigs out of your rival's wall, just to deface his work a bit? The male who is most aggressive on the attack and ends up with the most decorations impresses the females most.

After the battles, the males wait patiently in their bowers for the females to approach, at which point they begin a song and dance display in front and inside the bower to impress her. Usually she just flies away. They seem to be most impressed by the most complete and best-decorated bower, usually the creation of the older, more experienced males (or so say the older, more experienced scientists, at least). In one territory, the five most assertive out of thirty-three males managed 56 percent of the matings.

The female satin bowerbirds *do* choose their mate after what they see in the bower and what they take in from the song and the dance. But are they really evaluating the quality of their mate? Modern sexual selection theory says what they are looking for is good genes, while Darwin's original sexual selection theory focused only on what the females like. Look what he has created—an artwork with style and substance, something no animal besides humans is known to do. Are we to

brush all this effort off as a sign or a code for something more mundane and hidden? What if bowerbirds attract, mate, and procreate for the propagation of bowers, not offspring? Look at the process as an example of *aesthetic* selection, and you can find the roots of the history of art beginning millions of years before humanity with these remarkable birds.

The other clade of bowerbirds builds not hedge-like avenues but, instead, something akin to a maypole. MacGregor's bowerbird begins with a small sapling, about four feet in height. Then he plucks all the leaves and branches off it, clears a circular area around the tree of all detritus, and covers the cleared spot with a solid layer of moss. Next he carefully arrays twigs from a few inches to a foot in length all around the branchless tree, interlocking them to create something stable. Friction and the overlapping weave hold it all together. As the bird works upward, longer sticks are inserted around the shorter ones, giving the whole artwork its mad inverted Christmas tree appearance. He adds ornaments as well: small mushrooms, strands of spider silk, beetles, butterfly wings, stringy lichen. It takes him about a month to construct the maypole bower, and for the remaining several months of mating season he continues to decorate and redecorate its fronds: ornaments appear, disappear, return again. Are they stolen by rival males, as with the blue tchotchkes of the satin bowerbird? We do not really know.

Australia's golden bowerbird, smallest of the family, builds the largest bowers, a unique, two-tower design, sometimes up to ten feet in height. The twin towers are usually built around two small trees linked by a fallen branch, or perhaps connected halfway up like Kuala Lumpur's Petronas towers, among the world's tallest buildings. In those cases the bird begins high up in the air and works his way down to the ground. Should we be surprised that it is based on an ancient design form used by bowerbirds millions of years ago? The tree bridge connecting the twin bowers is decorated in the case of this species with hanging lichens and two kinds of flowers: fresh olive-green ones and dried cream-colored blossoms, the latter only if shiny black seeds are attached.

If you raise a male bowerbird in isolation, he will not be able to

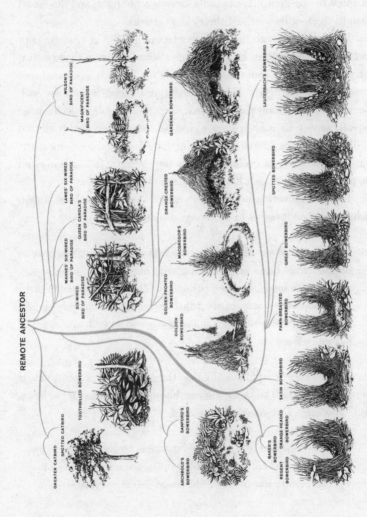

REMOTE ANCESTOR

GREATER CATBIRD
SPOTTED CATBIRD
TOOTHBILLED BOWERBIRD

ARCHBOLD'S BOWERBIRD
SANFORD'S BOWERBIRD

BAKER'S BOWERBIRD
REGENT BOWERBIRD
ORANGE-HEADED BOWERBIRD

SATIN BOWERBIRD

GOLDEN BOWERBIRD
GOLDEN-FRONTED BOWERBIRD

MACGREGOR'S BOWERBIRD

FAWN-BREASTED BOWERBIRD

GREAT BOWERBIRD

SIX-WIRED BIRD OF PARADISE
WAHNES' SIX-WIRED BIRD OF PARADISE
QUEEN CAROLA'S BIRD OF PARADISE
LAWES' SIX-WIRED BIRD OF PARADISE

ORANGE CRESTED BOWERBIRD
GARDENER BOWERBIRD

WILSON'S BIRD OF PARADISE
MAGNIFICENT BIRD OF PARADISE

SPOTTED BOWERBIRD

LAUTERBACH'S BOWERBIRD

Fig. 3. The family tree of bower types.

build a substantial bower. Males have to see other bowers being built, since their artistic ability, though rooted in genetic inheritance, requires learning as well. There is a distinct and varying aesthetic that is accepted by the group. These birds know what is right, and they must learn to create it by watching their elders at work.

Does the bird with the most decorations get the most mating opportunities? Quantity is, by definition, easier to measure than quality, but we can't always count the ways evolution has produced such nuanced animal aesthetics. There are right and wrong bowers for each species, and if we really paid attention, we might be able to decide what the *best* bower for each species would be. Sexual selection trades on quality, not quantity, by definition something much harder to measure. Our understanding of evolution is only improved by taking beauty all the more seriously than it has been until now.

Darwin knew that his contemporaries were wrong about human exclusivity when it comes to an appreciation for beauty:

> This sense has been declared to be peculiar to man. . . . When we behold a male bird elaborately displaying his graceful plumes or splendid colours before the female . . . it is impossible to doubt that she admires the beauty of her male partner. As women everywhere deck themselves with these plumes, the beauty of such ornaments cannot be disputed.

Finely inherited plumage is one thing, but artistic creativity is even better proof. "The best evidence, however, of a taste for the beautiful," continues Darwin, quoting Gould,

> is afforded by the three genera of Australian bower-birds. . . . "these highly decorated halls of assembly must be regarded as the most wonderful instances of bird-architecture yet discovered."

Not structures to live in, but for the females to admire. They are built to be one thing—beautiful.

Why has evolution led an animal to spend weeks, even months in

the same vulnerable location carefully perfecting a complex artwork with no obvious function? Is this not a complete waste of the bird's time? The complexity of what could be called frivolous if not downright risky behavior on the part of the animal made Darwin pause. Sure, he gave countless examples of how animals evolve to be most adapted to their surroundings. But they do not do so in the most efficient, engineered sort of way. They do so with magnificent diversity, the range of which astonishes all of us who try to make sense of the vast plethora of life on Earth.

The simplest and most efficient solution is not the course that evolution follows. Generations of female whim guarantee that some of the most tantalizing possibilities survive. Unwieldy peacock tails, hourlong bird songs, and (in a few species of bowerbirds and in humans) the need to construct creations of beauty—all of it has been justified by appeal to females of the species, with one arbitrary direction in evolution selected for generation after generation until something really excessive evolves. The male bowerbird evolved into an artist for the simple function of attracting a female to take a look at his beautiful creation.

This mechanism of evolution may well be true, but in a way it totally misses the point. Why these *particular* patterns on the peacock's tail? Why *this* color, *this* crest on the back of the lizard? And, toughest of all to explain, why should bowerbirds have evolved the ability to make art? No other animal so blatantly makes artworks that have no clear function. Might there be a clue to the evolution of human arts in the lifeworld of the bowerbird?

As Darwin notes, a Mr. F. Strange wrote the following letter to ornithologist John Gould, explaining how satin bowerbirds behaved in captivity, perhaps a tad differently than in the wild:

> My aviary is now tenanted by a pair of satin birds, which for the last two months have been constantly engaged in constructing bowers. Both sexes assist in their erection, but the male is the principal workman. At times the male will chase the female all over the aviary, then go to the bower, pick up a gay feather or a large leaf,

utter a curious kind of note, set all his feathers erect, run round the bower, and become so excited that his eyes appear ready to start from his head, and he continues opening first one wing and then another, uttering a low whistling note, and, like the domestic cock, seems to be picking up something from the ground, until at last the female goes gently towards him, when after two turns round her, he suddenly makes a dash, and the scene ends.

Darwin noted that if "this case stood alone it would constitute ample evidence that some animals possess emotions of the beautiful."

In Darwin's grand scheme, the art making of bowerbirds had to be the result of sexual selection. Yet if nature has the ability to evolve art among animals in the wild, then why is it so rare? Extremes, it is often said, make bad examples, though their existence proves that the outlandish is possible and the improbable can sometimes push through. This suggests that even a crazy species such as *Homo sapiens* can occasionally make its mark on an evolving planet, but also that the tendency toward art is there in the very roots of evolutionary yearning, in the want to please, the drive to express.

Biology in the twentieth century privileged function over fashion, natural selection over sexual selection. Perhaps it seems less frivolous, more serious, and more objective. Gerald Borgia at the University of Maryland is certainly the greatest bowerbird expert in the United States, and the one scientist who has been most preoccupied with why they do what they do. Already in the late 1970s he was critiquing previous hypotheses for the existence of this strange aesthetic ability in just this one family of birds.

One early twentieth-century hypothesis was that bowers were some kind of proto-nest that was necessary to stimulate females to get them ready for mating. Problems with this hypothesis: none of the three basic types of bower—avenue, maypole, or matted cave—looks anything like an actual bowerbird nest. And Borgia didn't like that this hypothesis "portrays females as principally constrained by physiological problems associated with the control of the timing of mating." The more we have learned about the behavior of all kinds of animal

females in relation to sexual selection, the more we know they are capable of quite sophisticated behavior in mate selection. This resembling-a-bird's-nest game won't fool them.

Bowerbirds nest in trees, like most birds, to avoid predators and keep eggs and vulnerable nest-warming parents out of view. Bowers, on the other hand, are out in open clearings, easily visible to all. The avenue and cave structures, though, do offer some shelter for the male performer and the female audience, so predators, if there are any, won't notice what they are up to.

Borgia is most impressed by the fact that male bowerbirds steal decorations from one another, and hypothesizes that the top male will be the one who can keep his court well decorated and perform his song and dance there without interruption. Figure 4 shows a male spotted bowerbird, another Australian avenue builder, with an impressive collection of baubles lining his work. Although the spotted bowerbird builds a similar-shaped bower to the satin, the range of his decorations is much greater.

If you read Joah Madden's 2002 report on spotted bower decorations, even this impressive array of knickknacks is a small sample of what you might find. Here is a partial list of what his exhaustive research revealed of the media utilized by the spotted bowerbird: avocado berry, prickly berry, wilga berry, solanum berry, capped-spiny berry, lime berry, eucalyptus nut, brigalow pod, mother of millions leaf, carissa sprig, pigweed stem, bottletree leaf, emu eggshell, itchy grub case, insect exoskeleton, mushroom, green slime, reptile skin, snail shell, spider egg case, crystal quartz, pink quartz, black stone, brown stone, gray stone, green glass, aluminum foil, ash, red plastic, white plastic, wire, bone, dung.

It should be noted that for spotted bowerbirds, snail shells are at least ten times more popular than anything else. Why? That is the kind of question that interests me. I believe the answer is aesthetic rather than practical. Not surprisingly, different researchers who study bowerbird preferences come up with very different results. Madden found that mating success could be most reliably correlated with the presence of solanum berries, which are glossy and green. But Borgia found

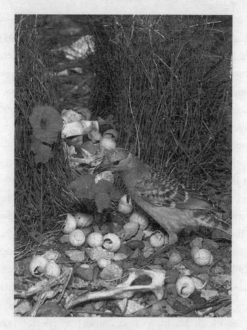

Fig. 4. Spotted bowerbird and his artwork.

that in a different population hundreds of miles away, the greatest mating success was with piles of reddish pink glass and a measure of "total fruit," which he claimed explained 96 percent of mating success. At Madden's site, red glass was among the *least* popular decorations. And no one has enough data to be sure of anything, as it's quite difficult to observe enough bowers in enough locations. Bowerbird preferences may be cultural, like the taste in songs of their relatives, the lyrebirds. In different populations of the same species, different decorations are preferred.

Why do the spotted bowerbirds have oh so many ornaments in their artworks? Borgia points out that they have a particularly elaborate display, with long, angular cries and a wild dance called a body shudder that includes the tossing of snail shells high into the air. The show is so boisterous that the females are often afraid of getting too

close to it. Luckily, the walls of the spotted's bower are quite thin, so the females (and the scientists) can well observe the song and dance from outside the bower at a fairly safe distance, though hard shells occasionally do crash down on their heads. The females may be fascinated by all the rowdiness as well, and want to get as close as they can to be sure what they see can be believed. The males, at the same time, do not want to threaten potential mates, but they also know that the females are more excited by an aggressive display than a lukewarm, halfhearted one. So maybe they protect their audience by doing it behind a very thin see-through bower wall.

Why toss the shells so vigorously up in the air? Maybe if they held a shell firmly in their mouths it would look too much like a threat instead of a game. Borgia has always tried hard to find a rational adaptive explanation for his birds' behaviors. It is not the beauty of the bower that matters to him, but how the whole sculpture and its associated performance art serve to mark the male artists' aggressive and competitive abilities. In the end, bowerbird art is just another way for boys to show off their acumen and strength.

At least that's what he said in the 1980s. By the twenty-first century, bowerbird studies have gotten a bit more technologically advanced. A recent study by Borgia's student Gail Patricelli did confirm that females prefer to mate with the males who perform the "most intense" displays. However, these gripping performers tended not to be so intense all the time. They gave their best shot only once in a while.

Why such a cool approach? The scientists were now able to examine this male behavior with the most up-to-date technology: robot female bowerbirds (see figure 5.)

This simple automaton can be programmed to mimic the "startling" behavior of female bowerbirds when presented with a performance that is too suddenly passionate for their liking. Figure 6 depicts the artificial female ensconced inside the artwork of a possible mate.

If the fembot bowerbird jumps with surprise, then the male immediately backs off and displays much more calmly for a while. He seems to know that the girls do prefer the full whiz-bang performance, but not all the time. (Or at least he figures out what the fake bird likes!)

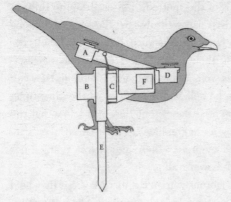

Fig. 5. Blueprint for a robot bowerbird.

Know when to be at fever pitch and when to lay back; be intense but reassure your audience that they are perfectly safe. Good performance practice here. Pretty sensible advice to all artists, I reckon.

Bowerbirds are exemplary and perplexing, but what to do with their radical story? It's hard enough to study the more normal cases of simpler creatures who seem remarkably adapted to their surroundings; finches with specialized beaks to obtain different kinds of food turned out in the Galapagos to be the perfect example for the practical side of Darwin's theory. Yet some of the most interesting animals that have survived do anomalous things that are very hard to explain. Why are honeybees the only animals we know of that have a symbolic communication system in the form of dance? Why do squid change color and shape as they communicate with each other? Why do bowerbirds build bowers that are so time-consuming and ornate? Biology tends to note with amazement such discoveries, then quickly moves on after saying that *most* creatures do nothing so outlandish; most animals are simply trying to maximize the survival potential of every challenge or encounter.

Contemporary biologists try their best to demystify the art of bowerbirds. Borgia has a very clear story:

The ancestor to the lineage that led to modern species that build bowers probably displayed on a decorated ground court. Females

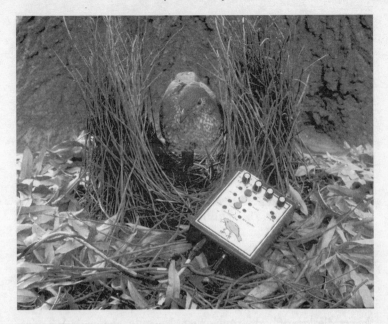

Fig. 6. The fembot bowerbird in action.

favored courts with a natural barrier, such as a sapling, that separated them from males during courtship because it allowed them to approach the male and closely observe his display and decorations while still retaining the ability to leave if not stimulated by the display. Males who enhanced this barrier, e.g., placed sticks around the sapling and enlarged its diameter, offered females a safer vantage point for observing display. Males could gain from this elaboration by exploiting the female preference for mating in a protected environment. Increased female visitation and lessened threat during courtship contributed to an overall increase in matings over what might be achieved by forced copulations. Gains for females from the avoidance of forced copulations might include eschewal of genetically inferior males and reduction of direct physical costs (e.g., parasite transmission and time lost in remating). Remating of females which have been forced to copulate with other

males would lower the value of forced copulations to court owners and may have caused males to shift efforts toward attraction of females.

Borgia is trying hard to fit these strange, beautiful creations into the rubric of purposeful sexual selection that is supposed to reveal the quality of the males who are performing these behaviors. Like most biologists today, he is trying to subsume sexual selection under natural selection. Might this be beside Darwin's point? Are not these spectacular creations beautiful works of art in themselves? Is it only wishful human thinking that gives every evolved trait in an animal a perfectly rational explanation? The statistical evidence for such hypotheses is always mixed at best.

Evolution is the greatest idea we have to make sense of the moving march of life, but often it is misunderstood. We imagine that it explains much more than it does. As Ofer Tchernichovski, professor of neuroscience at the City University of New York and a pioneer in the study of the complexities of bird learning, describes it, "Evolution doesn't really explain much. It's more a way of describing the context of history. There is an unlimited potential for generating little machines in nature, they are built on each other's shoulders, but they are not really evolving in a way that makes much sense." Why do we have the beauty and the forms that we do? He believes such questions are beyond our logical propensity: "All we can do is admire. We cannot understand things all the way through. We have to live in peace with that; we can only go so far."

I believe attention to aesthetics and the evolution of beauty *will* help us go further. I will not claim that the best in human art can be explained by simple, evolutionary rules or principles. But I will investigate how the existence of art and beauty in the animal world brings up questions that our current theories have not adequately explained. I do not believe evolution as we know it can explain art, but a deeper consideration of art can enhance our understanding of evolution.

Humans, of course, are another extreme species in the tangled

thicket of life, yet we derive plenty of comfort by recognizing that we still are animals. Evolution by natural and sexual selection links us to all living creatures past, present, and future. Animals endlessly fascinate us as we strive to figure out how we are like them and how we are nowhere near the same.

Some people say sex explains all human artistic activities. There is some truth in that angle, but such a view tells us very little about the art or about beauty itself, just what it might get you if you do it well. There has to be more to the story than an overarching adaptive version of sexual selection. Even animals don't have one-track minds.

So if we decide that at least one group of animals, the bowerbirds, are making art, does that make us more or less comfortable about our own artistic behavior? The presence of the bowerbird and his need for the bower makes art itself just a little bit more necessary to evolution than if humans were the only species to do it. And maybe it is just an extreme development of nature's penchant to evolve beauty, a beauty that I don't think is better understood if its arbitrariness is emphasized more than its specific and immediate blast on our and the female creatures' senses. Each species has its own aesthetic, which defines what colors, sounds, and shapes its members desire.

When I propose this line of thinking to contemporary biologists, many are surprised to hear about it. By and large biology has ignored this angle of inquiry and stuck with sexual selection, which is much easier to believe in, while sidestepping the greatest mysteries and toughest questions about why life has turned into the complex and wonderful pantheon that it is.

Sexual selection may explain *why* animals desire at all, but it says little about *what* they desire. That is its great incompleteness, and that is why the evolution of beauty has not been taken as seriously as it ought. Our present conception of sexual and natural selection sidesteps the importance of the aesthetic: either art indicates some other kind of general fitness or else it is the by-product of more serious, adaptive forces. These two explanations avoid taking the secret of beauty seriously. Art is important to nature, and we get no closer to grasping why by explaining it away.

We should wonder why a sped-up humpback whale song sounds just like a nightingale. Very different routes of evolution have led to similar aesthetic preference. Mere accident? Don't tell a bowerbird all the hours he spends building a bower according to exact aesthetic rules is arbitrary. For the artist immersed in the style, it is the most necessary act in the world. These birds cannot live and thrive without art, and most humans probably feel the same way.

The unique constructions of bowerbirds have been known to the West for more than two centuries, but there is one reason we ought to take them more seriously today. The aesthetics of human art have evolved tremendously in the twentieth century, as images, music, and literature have embraced the abstract, trying to cast away the rules and styles that evolve over the centuries. One consequence of this that is rarely talked about is that the love of abstraction makes so much more of the beauty of nature appear as art: the black-and-white contrast of tree shadows on snow, the crazy textures of metamorphic rocks, the dizzying complexities of winter wrens' songs. The more human conventions we explore, the more art we find in the natural world.

In the nineteenth century, the bizarre sculptures of bowerbirds looked less serious than they do to us now, since today we have the celebrated land art of Andy Goldsworthy, who is known for his delicate circular arrangements of colored leaves on a forest floor, or beautiful arrangements of twigs and stone, often in simple patterns that have a universal appeal. Did he get the idea from bowerbirds? The BBC's David Attenborough asked him this, and Goldsworthy said:

> I am not a bird and I do not mimic the things I see that birds and animals make. However, there are parallels to be made.
>
> The sculptures are a response to place, light, atmosphere, the daytime. But it starts with the material. That's the beginning, and if there are a lot of branches that have curves in them, then that takes me in a certain direction. It allows me to work with the material in particular ways that I cannot with a straight branch.

Bowerbirds clearly choose curved stalks for similar reasons, and though their aesthetics seem to be species- or population-determined, subtle individual variations may lead to the greatest success with their work.

With today's growing appreciation for art made out of natural environmental materials, we see art in the wild, where previously we might have seen only tendencies toward art, or "primitive" artworks. With the whole ritual of bowerbirds painting and decorating their bowers, dancing and strutting in the presence of females, we have a multifaceted example of nature's own performance artist, combining a range of talents in some weird mixture that is not just visual art, dance, or theater, but some whole new medium encompassing all three, yet with its own standards of appreciation.

Goldsworthy is by no means alone. The American artist Patrick Dougherty makes sculptures that look like mad, extreme bowers of some imaginary superbird. (See figure 7.)

Dougherty learned from nature that he could create intricate structures out of twigs and branches. "I was drawn to sticks as a plentiful and renewable resource. I watched animals work and realized that saplings have an inherent method of jointing, that is, sticks entangle easily. This snagging property is the key to working this material into a variety of large forms." He first learned about bowerbirds as a child, and has wondered for years if he and the birds might share some similar working processes.

"I feel that materials have rules, they tend to have sets of possibilities. Some sticks flex and can be lodged in a matrix and when they are released, compress against other sticks. Sticks snag and entangle easily . . . so they have an inherent method of joining to one another. If you flex a stick too much it breaks. For me sticks are not only the material of my structures, but are lines with which to draw. I use the same drawing conventions that someone with a pencil might use. One crossover with a mark made by a pencil, and the line of a stick, is that they are both tapered and that gives the line a potential of implied motion. That is, if you mass a lot of sticks with all the points going one way, the

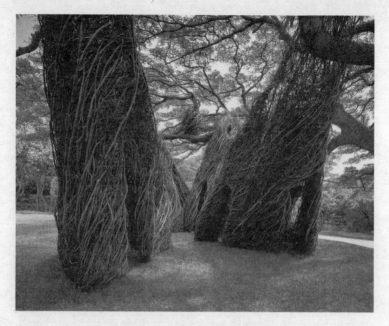

Fig. 7. Patrick Dougherty, "Na Hale 'o waiawi" (2003).

surface looks more alive. I don't know if birds are attuned to this fact, but I seem to remember that bowerbirds are attuned to the big and small ends of sticks and set some of the sticks with the butt down on purpose . . . which adds to the illusion of uplift."

Dougherty works a bit like a human bowerbird. He calls his work "drawing in space," and it is nearly always temporary. When the construction is done, he moves on to a new assignment and is ready to build again. None of his works lasts more than a few years, by which time the materials gently wither away.

Dougherty specifically tries to create works that look like they have evolved out of their sites, as if nature had put them there with a kind of "effortless effort." He seems to be searching for the rightness or certainty that every bowerbird artist knows—that his work is guided by the march of nature. Here is how he suggests the details of his aesthetic: "As to beauty, I often say that a graceful curve is the bend

Fig. 8. Patrick Dougherty, "Holy Rope" (1992).

achieved just before the stick breaks. For metaphorical effect, I find myself sequencing my material—hardening the exterior with bold lines and softening the interior with finer branches. This seems to have a harmonious effect on the viewer. Then there is the natural 'beauty' or 'rhythm' that comes from the repetitive act. If you act with a material consistently, the outcome is always more pleasing. I think I share this with bird workers."

As we come to take human art of this kind more seriously, we are obliged to take nature's own art more seriously as well. Human culture has evolved to be able to appreciate the depth of bowerbird activity beyond the wish of biology to fit it into the basics of reason and behavior. Nature is far more remarkable than that. Extreme examples, such as bowerbirds and humans, push the aesthetics of life ever closer to the forefront as we realize that beauty all around us, in appearance, in action, cannot be brushed away as mere accident.

You cannot completely explain the elaborate beauty of the bower-bird's building by simply saying it is all necessary to impress potential mates. Or even that bowerbird art is a matter of holding the sculpture together—that the one who keeps the best decorations on his bower long enough is the guy who wins all the girls. What impresses people about bowers is that they seem wonderfully sumptuous, a precise example of how nature often gives us more than seems necessary, in marvelous and surprising ways.

What Iris Murdoch wrote about human art applies equally here: "The pointlessness of art is not the pointlessness of a game; it is the pointlessness of human life itself, and form in art is properly the simulation of the self-contained aimlessness of the universe." The best art, she believes, melds "the minute and absolutely random detail of the world" together with "a sense of unity and form."

Dame Iris is on to something. Evolution may be aimless, but it produces wonderfully coherent creatures with odd but essential behaviors. Unity and form appear after millions of years of the twin pulls of adaptive and aesthetic selection. Does the practical move in opposition to the beautiful? Do both processes need to always be present? Can we find aesthetic principles in nature that inform even the said-to-be-arbitrary aesthetics of different human cultures and styles? More important, I believe our understanding of nature increases if we spend more time wondering about all this useless beauty.

In the next chapter we will look at the idea of beauty coming out of form, how it is sexually selected in nature, but how it is also built out of basic laws of physics and chemistry that nature is made up of. What forms are possible are those all nature is composed of, so by their necessity, if not their familiarity, we find them beautiful. Aesthetics is easily beyond the province of humanity if females have evolved a discriminating sense of taste to choose among colors and patterns that appear, even if those patterns are based on inevitable mathematics deep in the fundament of nature. These are appearances that evolve, beauty created by an unstoppable process with no one in charge. That could be the most amazing thing about it at all.

CHAPTER 2

Only the Most Fascinating Survive

F OR many years now I have believed art can be considered as a tool to find greater meaning in nature. Though the qualities we find in natural forms do not always make adaptive sense, I have not been happy with the idea that every living thing evolves as the result of random mutation and the play of adaptation and aesthetic/sexual selection. The latter is Darwin's fine attempt to explain what doesn't seem to be immediately useful. Though it celebrates chance, fashion, and whim, it still wants to explain all this diversity away as quantity, not quality. Why is the cardinal red? Sexual selection. Why does the nightingale sing tirelessly through the darkness instead of relaxing in sleep? Sexual selection. Why do butterflies come in so many dizzying colors? Sexual selection. Are there any specific qualities of beauty that hold all these traits together? Sexual selection has no comment about that.

The visual beauty of nature is the most chronicled, but I come to this quest after years spent listening to the sexually selected sounds of creatures we understand little about. In my book *Why Birds Sing* I compared what science, poetry, and music have to say about bird song, and in the end I was most satisfied joining in with the songs of laughing thrushes and lyrebirds with my own clarinet, making an interspecies music whose beauty and logic, like that of any music, are hard to quantify but still somehow make sense. In *Thousand Mile Song* I tried the same approach with the songs of an animal much less familiar than birds—the whale, and in particular the humpback whale, an animal

27

who sings the longest song of all, a solo aria that can go on for up to twenty-three hours at a time.

You may peruse those two books for all the details, but in the case of birds, there is plenty of evidence that it is usually only the males who sing, and that sexual selection is the mechanism that has evolved these mellifluous songs. Some readers of my books have protested that I deny all the scientific evidence that supports sexual selection, but perhaps I was not clear enough in my precise objections, which is that sexual selection is not enough to explain the *specific* complexity of what precisely is sung. It may tell us why birds sing, but not *what* birds sing, which is often so remarkable and lovely. It is simply not true that the bird with the longest song, the most complex song, the most notes, or the loudest voice gets the most opportunities to mate. In a few species it works like that, but more likely, the females of each species have an ability to decide what is the *best* possible song a male bird can sing. We humans, though, have usually not figured out what exactly it is that makes a song best, especially in the case of birds with very complex, variable, evolving songs, like mockingbirds and nightingales. Evolution for some reason has produced extreme beauty and profusion in the songs of these species, and most humans are still more amazed by this beauty than we are content with any explanation for it. Beauty is like that, as elucidation takes no magic away.

In the case of humpback whales, we have a song that very few humans knew about until the end of the 1960s, so we have only a half century of attempts to make sense of what it might mean. Once again, only the males do the singing. Their half-hour-long songs are sung mostly during mating season, so sex probably has something to do with it. But unlike in songbirds, we have zero evidence that female whales care—we have never seen them show a whit of interest in the males' amazing singing. So either the sexual selection of whale song is far more subtle than we have been able to see, or something else may be at work.

We know but a little about nature, or we know a lot, depending on what your standards are. But we are so much better coming up with reasons or functions than we are analyzing the content. For here's the

thing: humpback whales and nightingales are far apart on the tree of evolution, and yet there is something quite similar about their songs. Why should this be so?

Both of these creatures are outliers, because the sounds they make are particularly intricate, extended, and beautiful. Nightingales sing from twilight long into the dark hours—if you haven't yet heard one, you may be surprised that their songs are not immediately melodious, but rhythmic, strange, like a secret pulsed code emitting from an alien star. There is indeed something otherworldly about their clear whistles and ratchety rhythms heard across a forest lake in the middle of the night. From our current listening vantage they sound a bit like a DJ scratching records or some Euro techno artist; perhaps to Shakespeare or John Clare they sounded like something else entirely. Their songs, though, are full of energy, sung all night long while the birds sit motionless on a high branch, easy for a predator to pick off. We do not know where the females are as this happens, but the males do compete with each other for attention with the songs, a fact observable in the wild and in the laboratories of Berlin, where Dietmar Todt and his students have shown how the male birds specifically compete with each other to jam rival signals, and through song establish a hierarchy of musical dominance that plays out on the mating field.

Rhythms at different frequencies, interspersed with long, clear whistle tones, a few whoops and bleeps—definitely organized, with a structure not yet much analyzed by human scientists or human musicians. But a music is there, an always alien music. Is it beautiful? To the female nightingales, it is supposed to be. To other males? A challenge.

Take the nightingale song and slow it down, stretch it out, and take the pitch down a couple of octaves. It used to be with tape recorders that when you slowed the speed down the sound got slower and the pitch went down, but if you do this digitally the two factors are independent. We slow down a song like this so that our differently tuned human ears can make better sense of it, think about the patterns, hear their relationship with time to track it.

Ask a person what a slowed-down nightingale song sounds like and he or she might say, "It sounds a lot like a humpback whale!" Those

whoops, blats, chirps, and grumbling rhythms happen at a whole different metabolic scale, in a different medium, the tough-to-see-through tropic underwater world, slow enough that humans again have a hard time paying attention to the whole way it moves. But again, there are clear patterns, rhythms, tones, a definite structure. Speed it up, raise the pitch, and it strangely resembles the nightingale's song in terms of kind of different elements, spacing of the silences between sounds, and relative complexity of structure. Figure 9 shows a small sampling of each, with scale of time and pitch adjusted to see the similarity, ten seconds of bird compared to one minute of whale.

This is the convergence that led me to write this book. Why should these very different animals have songs with similar attributes? If they are supposed to be the result of sexual selection, a process of evolution that favors extended preference of random qualities, or at least arbitrary qualities, why should the songs of these very different animals be so alike instead of wildly divergent?

The occurrence of similar patterns of sound and song throughout the animal kingdom has hardly been studied at all. But visually, patterns in living creatures have received some attention, especially more than a hundred years ago, when the beauty of nature was celebrated more seriously by aesthetically inclined scientists including Ernst Haeckel and D'Arcy Thompson. They were both interested in fundamental patterns at the heart of life, and advanced their own differing theories on how the form of nature is anything but arbitrary; rather, it is governed by certain laws of mathematics that guide chemistry and physics.

Is it not strange that biology appears to favor randomness while these other sciences have more agreement on the rules governing form? Do these rules define beauty as well? The physical laws of nature determine what form the natural world takes. Because we are of this world, and we are the species who has evolved to step back and take stock of nature in all its myriad forms, this is what we will find beautiful. Is this where our aesthetics comes from? Is there a kind of beauty that all species appreciate, in their own ways?

Sexual selection implies that the specifics of a bird or whale song

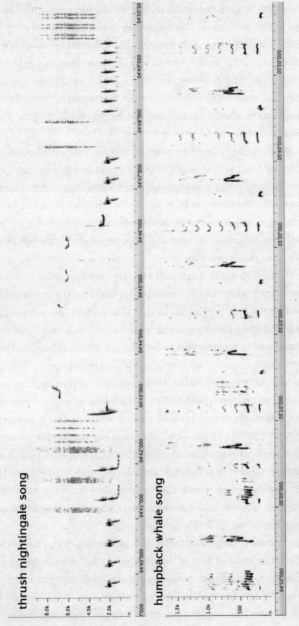

Fig. 9. *Nightingale and humpback whale songs compared.*

are so essential to each species that they will be more beautiful in their contexts, to the females who are listening, than they could ever be to us. But the parallels in what is preferred at different levels of life, like the similarities in the songs of birds and of whales, suggest that nature may favor certain kinds of patterns over others. Visually, the symmetrical; colorwise, the contrasting and gaudy; displaywise, the gallant and extreme. Soundwise, the strong contrast between low note and high, between fast rhythm and the long clear tone. Many traits, when examined closely, appear to be the result of *both* natural and sexual selection. That is, they can be practical and also excessive, like the famous narwhal's tusk, which is a unicorn-like protrusion that's quite odd to be found sprouting asymmetrically from the mouth of a whale, but recently has been found to be a sophisticated sense organ, able to sense the salinity and temperature of the water. Of course, why only the males need this ability, we really don't know.

Plenty of patterns that appear in nature may be considered beautiful but are not chosen just by sexual selection, like the mysterious inscriptions on the backs of seashells that almost look like alien writing, or the live pulsating patterns on the bodies of octopus and squid, which can be used partly for camouflage but also for strange inexplicable animal performance—to entice females, but also to hypnotize their prey. Humans see such things and find them astonishingly beautiful, and are we wrong to see nature thus? Nature both bores us and inspires us, as we know it is more necessary and eternal than anything our rapidly changing civilization can produce, but it also doesn't want to change for millions of years. It is greater than our edifices and epic tales, but it has no self-consciousness or self-awareness. We are nothing compared to it, but we are still possessed with the endless need to create and admire. Can we create our way into better understanding of and acceptance by the huge natural world? I believe that we can.

One thread through this book will be the argument that science can make better sense of beauty if it takes sexual selection more seriously as the development of taste among animals, evolution producing real preference for aesthetic traits, not practical ones. Another will be a quest for greater admiration of nature's beauty, believing that a more

open-ended understanding of art will enable us to find more beauty out in our surrounding world. This is in marked contrast to most recent books on art and nature, which expect science to explain too much. *The Art Instinct*, by the late Denis Dutton, wants to argue that art is an adaptive aspect of human evolution, with the strongest examples coming from fiction and storytelling; to succeed, our species needed to be able to tell well-structured tales about ourselves and the world. Dutton also suggests that the traditional values of art echo the biological needs humans have had since evolving on the open savannah, with its wide-open sense of landscape and space. Such arguments contain a hidden conservatism: modern and contemporary art that veers toward the shocking and outlandish, says Dutton, is an example of how humanity has lost its way from some original, honest evolutionary path.

It is easy to make modern art a target if you follow the argument that the most important twentieth-century works of art are pieces such as Duchamp's urinal tilted on its side and Andy Warhol's facsimile of a Brillo box, works that call into question what should or should not be considered art instead of works that genuinely try to make sense of nature, with a free play of color, shape, form, and line that may be less shocking but is unabashedly aesthetic. Klee, Kandinsky, Pollock, and Rothko all played with pure forms, lines, and colors. I'm most interested in how accepting such works might make the pattern, color, and symmetry of things we find in nature to be all the more aesthetic when we encounter them from within a culture that has come to accept the contributions of abstract art, art that doesn't simply represent things we already know in the world, be they scenes of savannah-like landscape, readymade pisspots, or finely designed soap boxes. Our world becomes steeped far more deeply in beauty when we can look all around us and see colors and forms that make us swoon and smile.

But wait, you say, isn't the aesthetic selection produced by millions of years of sex based on the appeal of ornament, excess, frills, and flourish? Where is any Bauhaus aesthetic of purity and clarity in wild and woolly nature? The answer may lie in the forms beneath the appearances, the rules and order of nature that make all the multifariousness of beauty possible. Will we go with random mutation that allows

any possible trait to be desired and extended to absurdity over the generations? Or will basic forms underlying the workings of nature be the qualities that guide us?

Humans do desire beauty, but not in the way other species have evolved to do so. Every other species knows its own aesthetic so well, while we endlessly debate what is desirable or not, changing our preferences over the centuries while often believing there is also some absolute we want to understand, always just a little bit beyond our reach. The human striving toward progress, toward improvement, may be hard to explain by biology alone, though it might mean that our particular strategy for surviving in the world is one that will never be quite satisfied with itself.

Is there actual progress in aesthetics, a betterment of art? That was the early modernist dream: the most perfect music would explode all of tonal history, the most perfect art would blow apart all need for representation, and the best literature would discard the need to tell any story at all. In the twenty-first century we are not supposed to believe such revolutions anymore. Today we have so much of history available instantly at our fingertips that we mine and love it at will, rather than plotting a timeline where what is newer is always better.

I believe the most beautiful art is that which makes the world appear richer, deeper, and more meaningful, making nature seem ever more intricate, interesting, and deserving of our attention and love. There is meaning in nature far beyond use; there is form and beauty far beyond function. The mechanism that evolves life has taught us this, and Darwin understood it. Today we strive to see how much of the evolution of beauty is based on random possibility and how much is based on the very shape and form underlying nature itself.

How does the mechanism of randomness jibe with the order of the universe? A vast question, but science writer Philip Ball puts it clearly in his excellent book *Flow*: "For neo-Darwinists, randomness is the order of the day, pruned by the struggle to survive. Anything else smells to some biologists of creationism by stealth—which is to say, that loathed pseudoscience 'intelligent design.'" But physics and chemistry need not admit any sort of designer in order to concur with Gali-

leo and say that the book of nature is at least in part written in the language of mathematics. The behavior of physical reality is governed by many rules; some of these rules may lead to specific kinds of pattern, patterns that many species evolve to admire. Thus these laws may have something to do with universal ideas of beauty. Nature may evolve in myriad directions but still be guided by certain principles of symmetry, gravity, and form. All "arbitrary" preferences may still be bound by such principles, yet this is something that biology seems to deemphasize.

The English master of natural shape and development, D'Arcy Wentworth Thompson, was not impressed by biologists' tendency to argue that every aspect of an organism's growth and unfolding was guided by eventual usefulness once the creature or plant was full-grown. Does each of those butterfly patterns and radiolarian shapes really descry a different function? Attempting to explain the beautiful patterning of various animals more resembled a Rudyard Kipling just-so story than it did honest empirical observation: "What with standing half in the shade and half out of it, and what with the slippery-slidy shadows of the trees falling on them, the Giraffe grew blotchy, and the Zebra grew stripy, and the Eland and the Koodoo grew darker."

The idea that every coloration of every animal might be a form of camouflage was quite popular as a challenge to Darwin's idea that color might instead be the result of generations of sexual whim. In 1907, painter Abbott Thayer, together with his son Gerald, wrote a magnificent book on the subject, illustrated by his amazing natural camouflage paintings, the most famous of which is of a peacock masterfully hidden in a leafy green forest, with each part of his feathered body perfect for hiding himself in the thickets. Peacocks don't even live in such green habitats in the wild! Wishful painting, indeed. Pink flamingoes, Thayer also argued, were perfectly hidden at their most vulnerable times of the day, dawn and dusk, as the bloodred sun rises and falls on a tropic shore. So even the most outlandish colors found on an animal make perfect sense according to the laws of camouflage.

These rules of camouflage, which we will consider in greater detail in a later chapter, attack the indeterminacy of Darwinian sexual

selection from another side. Thompson and Haeckel suggest the intricate forms of nature derive from basic properties of the world itself, axioms of form that underlie all the possible directions arbitrary mutation can take. The Thayers, father and son, suggest that no trait, however extreme or outlandish, evolves without good reason, and that it is irresponsible for science not to seek these reasons. All well and good, but will the search for reason overstep the importance of accepting that beauty might matter for its own sake? Is it an affront to science to say that evolution as it unfolds is a process, engaging female preference upon principles and boundaries offered by nature, a process that defines beauty as it progresses?

Darwin had challenges to his vision of sexual selection from both sides. I've already mentioned how many in the Victorian science community were not ready to admit that female intuition or taste had so much power to guide how the forms and types of creatures played out over the millennia—no way could all that beauty be the result of arbitrary preferences of fashion. Arbitrary, though, is not random. Sexual selection serves to define the nascent qualities of the species. Once the species distinguishes itself enough to be unable to breed with its ancestors, it has become its own creature with its own aesthetic. Peacocks will only beget peacocks—what is this rush to explain them? Evolution is like a lens upon which to view the world. As when any pupil first gets hold of the idea, he looks about the world and wants to use it to explain everything. The simpler the idea, the more powerful: why throw a monkey wrench in it by mixing aesthetics with adaptation? The idea that any feature in life has a purpose even though there is no master plan explains all and nothing at once.

So the fans of camouflage and practicality, devotees of Alfred Russel Wallace, that lesser-known co-discoverer of the theory of natural selection, had no place for Darwin's love of beauty, caprice, and feminine whim. Does this mean that lovers of art found solace in Darwin because he made beauty matter so much to the changing march of life? On the contrary—he was attacked even more vociferously from this other side.

In the nineteenth century much aesthetic attention was devoted to careful definition of exactly how and why nature was beautiful, with the most famous critic and theorist of the day, John Ruskin, writing copious volumes on the precise magnificence of the bucolic landscape. In addition to volumes of art criticism he wrote a four-hundred-page book on the beauty of roadside flowers, entitled *Proserpina*. You could think of Ruskin as an early ecologist in the cultural sense: for nature to be worthy of our valuation, it had to be as lovely as our greatest human artworks. "The flower," he writes, "exists for its own sake. . . . It is because of its beauty that its continuance is worth Heaven's while." To truly appreciate it, you must immerse yourself in its symmetry, order, and form, as if you were gazing at a portrait painted by a Dutch master. Form, shape, symmetry, structure—I find myself endlessly repeating these words and wonder how Ruskin could get up four hundred pages of contemplation of the beauty of blossoms and leaves! Answer: careful observation and love.

He too would not take the flower-as-thing as the main object of connoisseurship. Like Darwin, he also wanted to tell the story of where it came from and where it was going. But he was suspicious of Darwin's explanations. How would *you* like it, he writes, if your reactions to beauty were turned into something merely materialistic? "I observe, among the speculations of modern science, several, lately, not uningenious, and highly industrious, on the subject of the relation of colour in flowers, to insects—to selective development, etc. etc. There *are* such relations, of course. So also, the blush of a girl, when she first perceives the faltering in her lover's step as he draws near, is related essentially to the existing state of her stomach; and to the state of it through all the years of her previous existence. Nevertheless, neither love, chastity, nor blushing are merely exponents of digestion."

No one who feels emotion or admiration in the face of beauty really wants it to be explained away by science. The testing and statistical analysis that characterize modern scientific reason can easily want to tear beauty up into its tiniest components. Ruskin was an aesthete, a student of the beautiful in art and in nature, but he was no murky

sentimentalist. He believed in rigorous analysis, something that comes
from deep attentiveness to the subject, trying to inhabit it as directly as
possible. He lambastes Darwin for being "incapable of so much as see-
ing, much less thinking about, colour." Ruskin chides the scientist for
analyzing the ornate feathers of the Argus pheasant as if the bird is
"imitative of a ball and socket." And if Darwin "imagined the gradation
of the cloudings in [peacock] feathers to represent successive generation,
it never occurred to him to look at the much finer cloudy gradations in
the clouds of dawn themselves; and explain the modes of sexual prefer-
ence and selective development which had brought *them* to their scarlet
glory, before the cock could crow thrice."

If so much beauty in nature arrives without any kind of sexual se-
lection, why should we strive to explain the beauty of life so easily?
Ruskin's own answer is far from convincing. "Wherever men are noble,
they love bright colour; and wherever they can live healthily, bright
colour is given them." A nice idea, if a bit human-centered: the world
appears to offer us the greatest beauty we are able to accept, if we live
the proper way and take it as seriously as we can. To Ruskin, the sad
theory of evolution is trying to write this seriousness away.

Darwin saw himself as a copious collector of real evidence for his
ideas, carefully observing and recounting others' observations of the
way animals appear and behave, in that nineteenth-century style of
amassing piles of disconnected information, perhaps a method that
the Internet has brought back to us. But Ruskin says Darwin is not con-
nected to the tales of life he recounts, because he does not draw what
he sees. "If I had him here in Oxford for a week," lectures Ruskin, "and
could force him to try to copy a feather by Bewick, or to draw for him-
self a boy's thumbed marble, his notions of feathers, and balls, would
be changed for the rest of his life."

The relationship between Darwin and imagery is a complex one,
and although he commissioned beautiful engravings for *The Descent of
Man* and other works, his tale of evolution is primarily narrative, not
visual. In page after page full of exquisite detail, he gives copious ex-
amples of how differences in feature and behavior between the sexes of

different creatures leads to beauty and diversity. It is the fact of this profusion all over the natural map that most impresses him, not any sense of universal aesthetic or basic features of form and order observed throughout nature.

But did his audience get lost in all the detail? Darwin was determined to convince the world of science that females and males of a species could have evolved a specific relation to beauty, which they manifest in opposite but intertwined ways. In speaking of the flamboyant Argus pheasant, he says:

> He who thinks that the male was created as he now exists must admit that the great plumes, which prevent the wings from being used for flight, and which are displayed during courtship and at no other time in a manner quite peculiar to this one species, were given to him as an ornament. If so, he must likewise admit that the female was created and endowed with the capacity of appreciating such ornaments. I differ only in the conviction that the male Argus pheasant acquired his beauty gradually, through the preference of the females during many generations for the more highly ornamented males; the aesthetic capacity of the females having been advanced through exercise or habit, just as our own taste is gradually improved.

Was it hard to give females such an important role in the evolution of beauty even though their own appearance was rather drab? This was difficult for many in the Victorian age, but not for Darwin.

> Everyone who admits the principle of evolution, and yet feels great difficulty in admitting that female mammals, birds, reptiles, and fish, could have acquired the high taste implied by the beauty of the males, and which generally coincides with our own standard, should reflect that the nerve-cells of the brain in the highest as well as in the lowest members of the Vertebrate series, are derived from those of the common progenitor of this great Kingdom. For we can thus

see how it has come to pass that certain mental faculties, in various and widely distinct groups of animals, have been developed in nearly the same manner and to nearly the same degree.

The Descent of Man offers pages and pages of examples of aesthetics in the animal world. For Darwin it was all somewhat akin to legal evidence, piles of precedent and empirical data, in the form of animal life histories, to back up a general theory of how random features can be preferred and selected for even if they seem of little specific use. It wasn't this that got the general public most excited about sexual selection. The profusion of life is all the more impressive when one sees it, not when one thinks about it.

Ruskin was right to point out that Darwin's methods were not deeply visual. Darwin most needed to convince the scientific establishment, and he was less concerned with the general public. What made evolutionary ideas widely popular were, first, the exaggerated claims of their relevance for human society, as popularized as "survival of the fittest" by Herbert Spencer, and, second, the artistic approach, brought on by the German polymathic apostle of Darwin's theories, Ernst Haeckel.

Haeckel was a descendent of the great Teutonic Romantic scientists such as Goethe and Alexander von Humboldt, who championed a tradition of God equaling Nature, the sense of science as a grand spiritual quest to reveal the meaning and form of the divine world around us. You may think this old-fashioned, but this idea still beats in the hearts of all investigators, whatever their field, who find the results of their discoveries beautiful, mysterious, evocative of the grand sense of wonder that led many to choose science as a profession in the first place. The startling possibilities of a world engendered by random mutation is one thing, but the formal qualities of the creatures that have emerged must mean something if the world we discover and reveal through science is not a manifestation of the divine but the divine itself. Thus the art in nature is as important as the facts of nature.

Among the millions of possible species to study, scientists choose those that can express their research interests. Haeckel chose the mi-

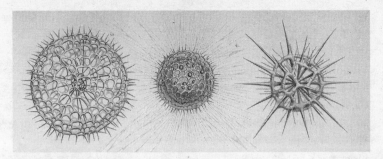

Fig. 10. Haeckel's radiolarians.

croscopic overlooked sea creatures called radiolarians to be the subject of his great obsession. He drew and painted hundreds of pages of beautiful illustrations of these tiny sea organisms that no one previously had ever taken seriously. Why? Because they are so spectacularly patterned and symmetrical, like myriad snowflakes of the sea. Haeckel's genius was to realize that beauty was a fit subject for natural history. No creatures better exhibit the amazing evolved order of nature than the humble radiolarians, elevated by Haeckel to poster beasts for the crystalline exactness of nature's evolutionary process.

In 1864 he mailed Charles Darwin a copy of two of these spectacular folios, and Darwin responded in a letter, writing that they "were the most magnificent works which I have ever seen. . . . You are one of the few who clearly understands Natural Selection." Yet gaze upon page after page of these beautiful, crazy creatures, and you may have a hard time believing random processes could produce such intricate delight. But it is this amazing fact that so inspired Haeckel to become Darwin's greatest champion in Continental Europe. Because of his great ability as a draftsman and artist, he produced scientific works that were also beautiful to look at, making him one of the first figures to straddle the difficult place between art and science.

By choosing to focus on the radiolarians, Haeckel came upon a gold mine of evolutionary aesthetics, creatures whose diverse and symmetrical appearances supported the idea that change in nature promoted a plethora of intense and possible forms, beautiful in their vast

variety but all somehow based on basic laws of symmetry and development. In his greatest work, *General Morphology* of 1866, Haeckel strove to combine the principles of Darwinian natural selection with laws of form that describe the shape and beauty of the myriad plants and animals that exist, from single-celled organisms all the way up to the human being.

In his popular book *The Wonders of Life*, several decades later, Haeckel reveals why radiolarians so captivated him at the beginning of his career:

> The interest which we take in natural and artistic forms . . . depends for the most part on their beauty, that is to say, on the feeling of pleasure we experience in looking at them. . . . Actinal beauty (the subject of radial aesthetics); the pleasure is excited by the orderly arrangement of three or more homogeneous simple forms about a common centre, from which they radiate; for instance, . . . the four paramera in the body of the medusa, the five radial-pieces in the star-fish. The familiar experience of the kaleidoscope shows how amply the simple radial constellation of three or more simple figures may delight our aesthetic sense.

With his great skill as an artist and lover of symmetry, Haeckel sought out those creatures in the pantheon of evolution that were the most symmetrical, the most beautiful in an abstract, formal way. He found this beauty everywhere in nature, and he painted it and celebrated it. Though his scientific principles may have later been proven naïve, the beauty of his images still lures students into the wonders of biology, and turns out to have profound implications for an aesthetic combining art and science.

Haeckel is often misunderstood as being primarily a popular writer, as evidenced by his bestselling books of popular science, starting with *The Natural History of Creation* in 1868 and on to *The Riddle of the Universe* in 1899, its sequel *The Wonders of Life* in 1904, and the most well-known, the original natural science coffee table book, *Art Forms in Nature*, from the same year, which made evolutionary theory

clear, beautiful, comprehensible, and meaningful to millions of readers all over the world. *Riddle of the Universe* sold more copies in the first year of its publication than *On the Origin of Species* sold in forty years in England! It later came out in twenty-four languages. The young Mohandas Gandhi even wrote to Haeckel to arrange for its publication in Gujarati.

It is this kind of story that makes Haeckel suspect to the world of science. He is dismissed as a popularizer, and a careless one at that. In *Natural History of Creation* there is one engraving comparing incipient embryos in human, pig, sheep, and chicken. At their earliest stages, they appear identical, and only with time do their unique differences develop. Thus there is evidence for the biogenetic law that "ontogeny recapitulates phylogeny," meaning simply that in the development of one organism from embryo to full-fledged form, the whole path of evolution is repeated, a wonderful and amazing fact.

Of course it's not really true, though it sure would be nice if it were. Then we could see most clearly the evolution of an organism from prior ancestors as it singularly develops. Though ontogeny resembles phylogeny, it doesn't duplicate it as closely as Haeckel would have liked. And his critics pointed out that he massaged his illustrations so that they bolster his point. Scientific fraud, they cried, and challenged his reputation. In subsequent editions of this book the offending illustration was changed, but the damage was already done.

Later readers have been shocked by Haeckel's idea that *Homo sapiens* should be divided into twelve human "species," with all the white races—he mentioned Berbers, Jews, and Northern Europeans—at the same level of highest human evolution, placing other races lower on his imaginary categorization. (Of course, he was not alone in making such a claim; this kind of nonsense was quite popular in the late nineteenth century.) This belief in racial hierarchy made Haeckel a darling of the Nazis and is yet another gaffe that tarnished his reputation.

But even more significant scientifically is his notion that evolution represented a kind of teleology, that all this biological change was going somewhere, toward some monistic goal of ultimate unity, some

ineffable place where matter and spirit would merge into one. Nowadays we know this is an illusion, that the remarkable thing about evolution is that so much wonderful change happens with no particular end in sight. But in the late nineteenth and early twentieth centuries, science was a new beacon of hope. Who wouldn't want science to prove its own kind of secular religion, and bring a clear goal to life itself? We try not to be so innocent today.

Haeckel, more than being a firm believer in natural selection, was the man who made the concept not only known but loved all over Europe. His visual works were immensely popular and were found in the most cultured houses. The most compact and best-known of these volumes, *Art Forms in Nature*, is still popular today, especially with artists and architects. In his most popular book, *Riddle of the Universe*, he coined the word "ecology," which itself has evolved to mean the scientific study of the interrelationship between organisms and their environment, as well as becoming a catchphrase for the science and movement of saving the earth from our human selves, a moral code finally becoming mainstream in the twenty-first century.

The paradox here is that Haeckel's influence on science decreased the more popular he became. Like many thinkers who loved evolutionary theory, he imagined the theory was going somewhere, that it had some great goal of constant improvement and understanding, explaining not only how nature could change so but also where it was going. Born out of randomness, the theory reveals the deep structure of the universe by unfolding all possibilities. This grand sort of language lures us readers in. Leafing through Haeckel's glowing printed pages, we see the cornucopia of a nature symmetrical and grand, elaborately designed without any sort of designer. It *must* be going somewhere. When we find out where, we will have solved the conundrum of the universe itself.

What an age it was when we could take such thinking seriously and not laugh it off as a tale out of *The Hitchhiker's Guide to the Galaxy*. Perhaps today we know too much to think we will ever understand where time is taking us. The great power of evolution, through natural

and sexual selection alike, is that so much order can be created without the process needing to go anywhere at all. This is why it explains so much and so little at once—and why at the end it really is not all that satisfying, because it says little about the precise nature of the beauty that surrounds us. Perhaps the most important things are those about which the least can be said. Was science never meant to capture wonder?

Haeckel thought it was. His paintings of jellyfish inspired chandeliers and World's Fair pavilions of the Jugendstil, and the organicism of his line inspires a new generation of architects in the present day. Because he made evolution come alive with pictures, he made the greatness of Darwin's theory accessible to the world.

Haeckel may have been Continental Europe's greatest popularizer of natural selection, but his own disciple, the novelist Wilhelm Bölsche, became an even greater popularizer of sexual selection. While all these previous investigators of the wild diversity of life have emphasized its sober scientific origins, the story goes that the majority of Victorians were afraid of the possibility that sex might be so important in the creation of all this craziness. This underlying force that seems so base and complex at once—of course it matters more than anything, the root of pleasure and procreation, the one thing we know is necessary and must be pursued. It is almost impossible to write well about it, and I'm not sure how good a writer Bölsche really was, but he was certainly a popular one, with several million copies of his book *Love-Life in Nature* in print in the years leading up to World War I, requiring three volumes in German and two in English, nearly a thousand pages to tell the lush tale of procreation and purpose from bacteria to the melding of human bodies joined in passion.

> If we are to speak of love, it must be a different speech in these different days. Follow that beautiful butterfly yonder; how majestically it sinks down to the thyme. Out of animals lower than this hovering butterfly, you, man, have come into being, you the man of modern knowledge. Your race came up from primordial beings

much more incomplete even than this mute motionless thyme bathing in the burning sun. *You* were grotesque creatures without a trace of your form. They crawled on the shore of the sea when this shore was still soft ooze, which to-day forms those adamantine ridges of rock, on which the blue waves break in foam. And what connects you with all these creatures that were *you* and yet not you, aeons ago, is the mighty cosmic force of love, of procreation, of the eternal process of birth and coming into being.

Florid writing from the sublime depths of history, dreaming of the great spiritual love conquest, the end of all transformation.

Spiritual language has always been alluring, no more so than when it builds upon the power of sex:

> Think of the vast region of the finer spiritualized feelings of our erotic life, which lead us so very softly, step by step. . . . Think how these lovers keep on soaring onward and upward again, quite loosely joined, just hand in hand, even more than that, just eye to eye, thought beside thought, over great distances and into a totally different, ethereal blue sphere above those wild red flames, whose heat is to melt their individualities bodily together. . . . Love as a spiritual value of the very highest kind ever anew strives upward on proud eagle's pinions high into this same blue above the dark chemical mysteries of the sexual act, [into an] infinite golden wave that floods everything which . . . love has even touched.

With page after page of human and animal erotic acts and mad displays energetically described, Bölsche reads like an X-rated version of a David Attenborough BBC program.

> Now take the case of an amorous male frog; and you must say to yourself that here the outwardly visible energy of stimulation as well as . . . the inward intensity of sensual pleasure have already reached a peak which can hardly be surpassed. The male frog flings itself

upon any female frog like an insane creature, actually like a maniac of the one deep, droning key. . . . It seizes the female about the body with such force that the latter not infrequently dies as the result. If no genuine frog female of its own kind happens to be on hand, it grabs hold of some other animal that happens to be available and excites itself on this to attain its object. A carp is ridden till the scales fly and its eyes are not infrequently scratched out.

Bölsche even knew what we all saw years later in the Australian cult nature film *Cane Toads*:

A dead female frog is embraced exactly as wildly as a living female; in fact, a single piece of a dead female's skin unleashes the full fury of the male. A couple that is already united in love is in turn mounted by bachelor males, till a whole disgusting lump of tangled life results. Even lifeless wood is seized and used for the sexual act. A mad game. No wonder that in view of this state of affairs man came too late everywhere in this field.

No wonder people loved his words more than those of Haeckel and Darwin combined—Bölsche put the sex back into sexual selection! And while scientists chortled in amazement at how grand an edifice could be evolved by random mutation with no one in charge, a march of change rambling on through the eons going nowhere in particular. *Love-Life in Nature*, like the best texts that satisfy readers' need for closure, presented a world that was going somewhere, to the great goal of total love subsuming sex into the grand end of life itself: total perfection and oneness with the Creator.

No surprise that of all the generation intoxicated with the implications of Darwin, it was Wilhelm Bölsche who dared to take on the example of the bowerbird. *Love-Life in Nature* contains a substantial chapter titled "In the Nuptial Bower of the Birds of Paradise," showing him totally entranced by the story of this spectacle, a wonder of nature that he saw only in the glass cabinets of the Dresden museum, an "aesthetic work, having absolutely nothing to do with commonplace utility." Bölsche is

even more touched by the fact that these bowerbirds decorate their sculptures with blue feathers, even those from birds of paradise if they are sharing a habitat with such avian beauties.

The two species, bowerbirds and birds of paradise, are related; they are in the same family. One is spectacularly adorned, the other spectacularly creates. Can we not even identify more with the relatively drab bowerbird because it too loves the bright and the colorful? "Our brain feels the blue bird of paradise to be beautiful; but here is a bird [the bowerbird], which itself is already very closely related to the birds of paradise, and at sight of the bird of paradise feathers, the direct feeling of the beautiful likewise results in this bird's little brain." Darwin offers a mechanism to get to this point, but he does not dwell deeply enough on the sexual part of this selection to realize with Bölsche that these mad creative birds are drunk on love:

> An animal is as if bewitched during loving-time. In all its feelings it belongs to another dimension . . . for a more or less brief period of intoxication it is a citizen of another world sky-high above the ordinary cares of life. Something in the animal reaches out beyond the individual: that something is the life of the species, which wanders over generations, over millenniums. . . . The time of love's feelings becomes . . . a time of liberated aesthetic inner life, a time of beauty.

The ecstatic desire to create bewitches the bowerbirds into the inadvertent evolution of the need for art. They go farther than any animal has gone before with raw creativity and the need to build beautifully in order to impress. These bowers are thus beauty incarnate, and each species has a distinct aesthetic clear enough for even us humans to be able to judge which of them is going to be the best.

Such a rhapsodic picture of the bowerbird's will to create did not gain popularity among scientists. Bölsche's book may have been loved by millions, but it brims too far over the top to have satisfied meticulous empirical minds. No, instead it circumscribed just those aspects of sexual selection that science was more inclined to ignore than investigate.

It's no surprise science ignored sexual selection for nearly a hundred years if this is where taking it seriously led to. Why don't we all want to believe in evolution even though we know all the evidence says it's true? Not because it conflicts with any religious obligations, but because the explanations of natural and sexual selection don't give satisfactory answers to life's greatest mysteries. We still can't answer that gravest question, "Well, how did I get here?" Could we have reached the same place by any other path?

Bölsche's writing may be over the top, but it does get people excited in how nature works—we are already excited if we realize the true nature of the subject matter. History may have brushed him off the table as irrelevant, but Bölsche does explain in rapturous detail what sexual selection has got to explain if people are going to learn to love it as a theory. For Bölsche, there is a pulsing allure to the tangled bank:

> Think of the rhythm in an artistically articulated and arranged piece of music, or the harmonious rhythm of motion in dancing. Rhythm, however is the basis of all ornamentation. . . . Rhythm determines the magic of certain combinations of colours. Rhythm dominates the columns of our temples as well as our verses, the formal side of a painting as well as the technical structure of a tragedy; it embraces the whole tremendous extent from a Beethoven symphony to the carving on the back of a chair. . . . There is invariably an absolutely mathematical trait in the innermost nature of the rhythmic element. It is the extreme opposite to all arbitrariness, to all chance confusion of parts.

Speaking of rhythm like this turns math into a sexy, dancing sway. It's all in motion and flux, with an evolving groove—it keeps me dancing just thinking about it. Yet this language is in direct opposition to the precise way scientists want to talk about the traits produced by sexual selection. They are not random, meaning any which way but designed. No, they are *arbitrary*, meaning that the precise nature of the trait doesn't matter. What females choose and evolve over generations could be almost anything.

Bölsche has a countervision, where what is alive is something that's got soul:

> You clearly have occurrences with a rhythmic ring to them in the reproductive sequence of living beings, in heredity, in metabolism, in division of labour among the cells of the higher organism, in short, in most of the results of evolution which we have discussed. In this sense, all life on earth is a kind of grand rhythm.

This was but a few years before Henri Bergson won the Nobel Prize in Literature for his evocative, purple-prose philosophy on the march of consciousness toward a dimly visible grand finale of union with all creation. Nowadays these kind of ideas have plenty of followers too, but they are usually called "New Age" and segregated from the increasingly precise and specialized inquiries of science. People still yearn for a science that would make the world intensely marvelous; we crave information that makes us ever more amazed by the nature in which we evolved.

Biology has, since Darwin, developed an ever greater ability to justify how all creatures managed to evolve the way we did, but it has always had difficulty expressing the value of all that has come to pass. Conservation biologists such as E. O. Wilson urge us to save as much biodiversity as we can, based upon the axiom that nature as it has come to be is an ultimate good—an idea that harks back to those German Romantic biologists who found God here on Earth. But it has never been their task to explain *why* this nature is better than any other possible nature—it's just the only one we've got.

If you want to explain what is so great about this nature, you must have a hold on why it is beautiful, and search for common rhythms, common values that underlie the world and all the parallel levels of organization. But the notion of such commonality challenges the notion of sexually preferred beautiful traits flying off in wild, arbitrary directions.

Not all celebrations of natural rhythm are wild and dance-like. The most famous of the sober accounts from a hundred-odd years back is the meticulous *On Growth and Form* by D'Arcy Wentworth Thompson. Thompson's beautifully written book is a challenge to the idea that

sexual selection allows the evolution of life to produce wild patterns and designs far removed from the mundane structure of inorganic life. If classical physics teaches us that the laws of nature are simple, elegant, and geometric, then the forms of nature should appear thus. Life, in contrast, is supposed to be messy, based on random mutation, infinitely pliable and disheveled, so that's why living creatures take such crazy shapes and forms.

Why is it, then, instead of being so distinct from one another, that the forms of life often take the same forms of the natural world beyond the limits of the living? Spirals, lattices, tessellations, undulations, waves, and crystalline forms are all found in living cells, both creatures and plants, but also in clouds, sand dunes, storms, rocks, even the arrangement of planets and stars. Certain forms and patterns are determined by the rules of chemistry and physics, not necessarily by natural or sexual selection. Why do male bighorn sheep have curved horns? Because the females like this kind of horn the best?

That's part of the story. But what if the process of horn growing tends toward certain shapes? If a horn grows at the same rate all over, then it becomes straight, but if there is a bit of imbalance in the growth, a curve will result. No other shapes are physically possible. Thus physical and chemical forces underlying nature can determine the shapes and other qualities nature turns out to possess. The range of possible choices for form is thus from the outset determined by simple mathematics applied to growth of molecular form. Among spiral horn forms there is a nuance of possibilities. (See figure 11.)

One reason we care about these shapes is because so many of them appear to us to be beautiful. And if we trust the idea of sexual selection, they are also beautiful to the animals who appraise the shapes and come to prefer them as well. Aesthetics, according to Thompson, becomes a blend of what is possible with what is preferred, over generations of evolution. The rhythmic laws of nature, and the mathematics that determines them, have something beautiful right at the source. This is not a beauty veiled in mystery, but a system of symmetry that mathematics can help to make clear.

Even suggesting such things starts to tear at the Romantic belief

I. Highland Ram. (Homonymous curves.)
II. Mouflon. (Homonymous *perversion*.)
III. Markhor. (Heteronymous twisted curves.)

Fig. 11. The three basic types of animal horns.

that nature is wild and unruly, borne forth by sex and passion: "To treat the living body as a mechanism was repugnant, and seemed even ludicrous, to Pascal," writes Thompson.

> Goethe, lover of nature as he was, ruled mathematics out of place in natural history. Even now the zoologist has scarce begun to dream of defining in mathematical language even the simplest organic forms. When he meets with a simple geometrical construction, for instance in the honeycomb, he would fain refer it to psychical instinct, or to skill and ingenuity, rather than to the operation of physical forces or mathematical laws.

This is not the lush, sticky prose of Bölsche, but it is another plea to take the veracity of natural form seriously and not be content with arbitrary movement as the guiding force of evolution. While Darwin admired the honeybee for its perfect honeycomb, which "perfectly economizes labor and wax," the result of eons of adaptive honing to the best possible form, Thompson points out that the very physics of surface tension leads to the hexagonal form—this is simply what form physics predicts the material will take. This doesn't mean selection didn't lead the bee to find this solution, but it is an inevitable solution

based upon the laws of matter. For this we should admire it even more, not less.

When it comes to Haeckel's beloved radiolarians, Thompson emphasizes that the lesson to be learned from them is that they reveal basic principles of symmetry and order in the mathematical chemistry of nature. The forms they take come from the laws of surface tension operating in three dimensions, where hexagons will not work, only pentagons, squares, or triangles, together with the basic forms of Platonic solids: tetrahedron, cube, octahedron, dodecahedron, icosahedron. Basic laws of form explain all their skeletal structures, and most likely there are fewer species than Haeckel claims there are. "We seem to know less and less of these things on the biological side, the more we come to understand their physical and mathematical characters. I have lost faith in Haeckel's four thousand 'species' of Radiolaria."

Consider the difference in the way these two scientists organized their investigations of form in nature. Haeckel celebrates beauty, diversity, the vast profusion of nature, while Thompson strives to enumerate the simple principles that guide all natural form. Haeckel offers us lush symmetry in scores of crystalline color plates, while Thompson offers simple black and white etched diagrams.

But it would be most wrong to say that Thompson is trying to explain away all nature's beauty. On the contrary, he wants us to love mathematics because of the universal wonders it predicts:

> The harmony of the world is made manifest in Form and Number, and the heart and soul and all the poetry of Natural Philosophy are embodied in the concept of mathematical beauty. . . . The living and the dead, things animate and inanimate, we dwellers in the world and this world wherein we dwell . . . are bound alike by physical and mathematical law.

The *poetry* of natural philosophy—I like that, this notion that the richest understanding we can have of nature is not only science but also philosophy, the delving into larger questions of why. The answers remain lines in a kind of free-verse poem, still more lovely than it will

ever be exact. A longing for this poetry got me going on this whole project, all the while wondering why the whale's and the bird's songs should be so alike in their distant complexity, even though far removed from each other on the myriad tracks of evolution.

How did these ideas of form, passion, and rule influence art, that part of human activity that is expressly concerned with the investigation of beauty? I believe certain tendencies in the twentieth century led us to turn art itself into something better equipped for the appreciation of these very forces at the root of nature, because at last, art no longer needs to represent the world as it appears, but directly, visually goes after the patterns and shapes at the root of things, the pure forms not really abstract, but of nature itself.

In the twentieth century arts of all kinds were in the midst of a vast upheaval. Tonality in music was being stretched to its chromatic limits, in literature story was being expanded into nonlinear expressive ways, poetry was being released from the confines of rhyme, and in visual art, painting and sculpture were being opened up beyond the need to clearly depict what is immediately visible in the surrounding world. From within the world of the arts, it was an incredibly exciting time, when everything seemed possible and a new world of expressiveness was changing all around. From the audience's perspective, much of the work seemed initially strange and hard to comprehend, but a hundred years later we're all quite used to this, and the play of color, form, and shape—without needing to "look like" anything in the material world—is accepted by all of us today, who now have so many fluid technologies to manipulate sounds, images, and stories, even on ever-smaller devices that we carry with us all the time.

It might seen this century has freed us from interest in any kind of constricting form or function in art, but I want to test out a different theory: that abstraction in the arts has made us find more possible beauty in the natural world, either physical, based on the formal properties of matter, or organic, based on the melding of sexual selection with the same formal limits. As art exalts pure form and shape, the laws of symmetry and chaos found in mathematics and science seem ever more directly inspirational. Aesthetically, we become more prepared to

see beauty where before we only saw the clues of beauty, its glimmers or possibilities. Whereas Aristotle said human art finishes what nature begins, today we are able to appreciate more: we see beauty in nature complete in itself, beautiful because our minds are more attentive to an abstract kind of beauty that we can discover but do not necessarily build or create.

To some commentators on the relation of human art to evolution, this is a sign that we have lost our way. Denis Dutton and Roger Scruton, philosophers both, have this tendency to identify conservative values in art as signs of work closer in line with what is "necessary" by virtue of human evolution. They worry about the twentieth century's tendency to get to the point where anything can be called art, where the calling of attention to the object, putting it on display, and saying to the audience, "Look at this" are as important as any inherent qualities of the work itself. It's true, that is one of the things that has happened in twentieth-century art, music, dance, literature, all of it. But it is certainly not the most interesting thing to talk about. The most interesting aspect of the arts to me is how they change the way we see and experience things, and this should never be through too simple an argument. Rather than argue whether something is or isn't art, it's more interesting to discuss how artistic expression changes how we think in ways only art can accomplish.

The science of evolution changes art by putting forth an incredibly provocative theory that begs for illustration and creative questioning. Then the opening up of artistic expression to consider pure line, shape, and form leads artists to take the scientific investigation of these things much more seriously. So we had Klee, Kandinsky, Albers, and Itten teaching at the Bauhaus school about the pure beauties of form beyond the excesses of ornament—it's Haeckel versus Thompson, and they're neck and neck. Klee wanted visual art to be harmonically grounded upon rule and rigor, as classical music used to be, but instead everything blew apart into wild expression and pure choice. How does such freedom encourage us to see? If more shapes and appearances are considered beautiful, we will find greater beauty everywhere. Look back at nature, and it is more magnificent than ever before. The philosophizing

brought forth by art should enhance our interest in the world, not push us toward greater irony, disinterest, lack of humor and a sense that everything's all been done and we can only laugh at it or waste away.

If contemporary art has blasted our aesthetic sense wide open, can we now find beauty in anything, with no need of ugliness or repulsion to set in contrast with it? Would we find any planet beautiful, any universe? Or is there something more *right* about this one, which we and our ancestors have evolved in over millions of years, cascading up to today's single insignificant moment? These questions are enough to swirl around in our heads to a flurry of confusion, like the splatter drips of a Jackson Pollock painting, the icon of abstract art's mad excess. Yet Pollock, in fact, learned closely from the social realist painter Thomas Hart Benton, who learned closely from basic ideas of form that he set out in a guide for art students in the 1930s, which in a looser way parallels what was happening in the rigorous course of the Bauhaus on the other side of the Atlantic. From his World War I experience, Benton knew quite a bit about the aesthetic behind military camouflage, a field that intricately tests the usefulness of evolutionary science and abstract art. What seems formless in Pollock has its secret codes of form. And these in turn have a basis in the patterns and shapes Haeckel and Thompson were deriving from the deep investigation of the myriad possibilities of life.

With all we now know and can instantly call to view today, we should get a greater ability to see. Otherwise none of the experimentation will have been worth it. So if you are to believe in modern art, it must make life richer, more expansive, with the world as we see and hear it coming in ever clearer and more detailed. Some of us believe it, others don't, but by and large the abstract language of modern visual art has seeped into our world through graphic and architectural design, so the shocking plainness of minimalism and geometric formalism are all around us now, without much surprise. Not everyone loves it, but it's there. There are even some who believe that the prominence of functionalism and structuralism in design and art thinking are the ideas that kept sexual selection out of biology for a hundred years!

I want to believe, though, that not only does science inspire art (and that there are countless examples) but art can inspire science. In this age of fast-moving visual thinking, we identify patterns and order and interest where previously we saw only chaos. Our attention has been honed by the rush of visual stimulation and possibility, and if decoding nature is about finding pattern and reason through analysis where previously there was only confusion, then we should be better equipped to see further and make better hypotheses.

The songs of birds and whales sounded only like glimmers of music in the days of Darwin. Today, with our sense of what can be music far expanded, they are well within the boundaries of our musical aesthetic, as I have explored in my recordings *Why Birds Sing* and *Whale Music*. Still, the science of song does not take seriously the notion that each species might have a precisely evolved aesthetic that we could learn to understand by believing there can be a best song, not only a longest or loudest song; that there can be a best peacock tail, not just the biggest or heaviest. Trusting that there can be an art to nature, or an aesthetic to the wild, will lead us to take the specific beauty of nature more seriously, and not turn sexual selection into a generic mechanism to explain how nonadaptive features emerge. It provides a method for such evolution, but not a reason. Arbitrariness—or random mutation, if you prefer—is a mechanism, not a reason. It shies away from the search for the specifics of beauty. The splendor of nature may come from the basic forms or patterns at the root of all life, or it may evolve through the long evolution of specific aesthetics. We can learn those aesthetics, and with what art has become today we will see wider possibilities of pattern where previously all was noise.

I am most impressed by art that changes the way we see the world. Nature has always seemed to be this grand mystery that contains us all, which will still be greater than any of our interpretations of it, be they scientific conclusions or artistic responses. With all of our tools operating together, we can make the largest sense of this immense world, that by its greatness will always elude us. The human quest is to keep going, to continually work to understand the beauty and wonder of the world with deeper intensity, so that we may understand it better and then

bend its workings to our needs. Nature will remain greater than those needs, and we shouldn't imagine we can change very much of it. But there are so many different ways we look around ourselves and call what we find knowledge.

How do these methods work together? Art evokes, comments, eludes analysis, takes a stab, stuns us with its surprising tack. The rules that tell us how to make it are *meant* to be assimilated and then ignored; they are challenges for the next generation to jump ship from the old. The goal is to change the way we see the world through astonishment and delight. Science, on the other hand, wants to reveal the world by carefully building on the knowledge gained before, to cite it, to study it, with a rigorous method to assess whether each claim is worthy of being added to the pantheon of its conclusions, or whether a statement should be rejected because it doesn't have firm enough ground to stand on. Art doesn't work that way; it is less clear when a piece of it makes any truly stunning difference. But that doesn't matter. Some need art to give their lives meaning, while others just need to keep making it because it seems there's nothing else to do.

Usually these two forms of knowledge, art and science, are kept separate, like reason and faith, in order that we may use both to make sense of the world. Their goals are different, and their methods are different. Since art is easily inspired by everything we know, science has always influenced it immensely. But I will fight for the value of the other direction, with art truly able to influence science if its images and certainty are solidly valued. Why do neuroscientists such as Semir Zeki want to gaze at what colors light up in the brain when human observers look at different kinds of paintings? These brains are encountering not symbols, patterns, or ciphers, but real works of deep cultural meaning? Can we map something special in the brain that lights up then? Why did Richard Taylor use fractal mathematics to try to prove the authenticity of a Pollock drip painting? And why did George Birkhoff come up with a single ratio to indicate the perfect beauty of an aesthetic measure? Such calculations may sound laughingly primitive to those who believe the mystery of art trumps any attempt to explain it, but even asking such questions is the start of a radical leap.

Natural history has always wondered what it is that separates humans from other species. We know that many animals have language, use tools, and organize complex societies. At least we're the only ones who make art for its own sake, aren't we? But we can't forget those bowerbirds. The sculptures they make are not nests. They are works of art, built by the male birds to attract the females, and an enormous amount of effort, design, and care go into them. We believe evolution has produced this behavior, but *why*? And does the human aesthetic of modern art help us make sense of it?

Dave Hickey is one of a small number of contemporary art critics who think beauty needs to be taken more seriously. "Whenever I get the chance," he writes,

> I look at art and ask myself: how long will I remember this and how precisely? Then, more critically, how long will other people remember it? . . . Is this work better than works that are similarly priced? Is it better than the blank white wall upon which it hangs? Is it better than everything and, if so, how long will I love it? How much do I think about it? How much would I miss it? How often does it surprise me? How many words can I write about it? How much would I pay for it? How much would I sell it for? What would I trade it for? How many people agree with me? Who are they? How complex is the constellation of objects in which it resides? How deep is its historical resonance? How much does it mean, and how much does that matter? These are not difficult questions unless you're too busy to think about them.

Taking stock of art with such spiraling inquiries is not a popular activity these days. We are taught that art should just be made, to express whatever lies buried inside us that needs to be expressed. We all know beauty is in the eye, ear, or touch of the beholder. We like what we like; it's all supposed to be personal opinion.

How can the contemplation of art in nature help us understand human art? The bowerbird is not supposed to ask these kinds of questions as he carefully constructs, refines, rebuilds, and redecorates his

bower. But I do wonder what is going through his mind as he works. The male bird is willed to create, because his art is absolutely necessary for his species' survival. The aesthetics of each bower type, from avenue to maypole to cave, are what distinguishes one species of bowerbird from every other. The specifics are something he must learn, as he grows up, in order to become one of his kind. The older he is, the better he gets, until he starts to tire too easily and can no longer compete.

From our perspective, from the outside, the choices of color and decoration may appear arbitrary, frivolous, another example of weird and curious behavior in the animal world. In fact, arbitrariness colors our whole understanding of the mechanism of evolution. Wonderful random mutations in genes and behavior appear and just happen to be preferred by the females who are doing the choosing. That's how the grand diversity of life appears: blue here, green there, red, maybe yellow, a white petal, a strand of moss, and in a few thousand years we have some very remarkable species of birds.

If a satin bowerbird raised in captivity is unable to find something blue to decorate his bower, he will get extremely agitated and flustered. His eyes will dart all over the aviary glancing, needing, hoping to see the color of his dreams. If his eyes happen to spy any small blue bird, such as a motmot or a bunting, he will go for it and attack for this tint of blue. The normally peaceful and vegetarian bowerbird will kill the first blue bird he finds. If he has to, the satin bowerbird will murder in quest of his chosen hue. It is a need for blueness that can drive him to such a crime, never a direct fight for a mate or to prevent a rival from filching a decoration from his bower.

Could we ever say that from this driven bird's perspective, his need for blue could be considered the arbitrary result of sexual selection? When do humans ever need art this much?

So far I have found only one biologist who is interested in considering such questions . . .

It Could Be Anything

Male and Female Animals in Their Art Worlds

RICHARD Prum remembers the first time he saw a bowerbird. "The first time I saw a golden was in Queensland, up near Cairns. Mostly brown with bright yellow in the back of the head; they make a double maypole. I kept my eye out for the bower. I had previously seen satin bowerbird avenues, and they are a foot or so tall, so I was walking carefully, making sure I wouldn't step on it. Then I rounded a bend and came across one and it was like three and a half feet high and four and a half feet wide! You're not gonna step on this thing! What was amazing about it was that one side was ornamented with these beautiful forsythia-colored flowers, just this pure banana-ish orange-yellow. Like its own head. The other side was threads of this electric-green lichen. There was not a single piece that was out of place. One half exactly symmetrical to the other, yellow versus lime green."

His mood is one of pure aesthetic amazement, just what the female bowerbird is meant to feel. Pure delight. An artwork made exactly for her, just the way she has evolved to like it. The sense of taste is absolutely there. Arbitrary? Not for the female bowerbird. Essential, necessary, certain in a way human art worlds can never be.

Prum is professor of ecology at Yale University and curator of birds at the Peabody Museum. He is one of a few top-level scientists who believe that beauty has gotten short shrift in our study of evolution. (I hope that after you finish reading this book, there will be a few more.) He stresses that the artworks of male bowerbirds must first and

foremost be beautiful for female bowerbirds. "We humans might not always like what we see. The work of some bowerbirds is more outlandish than beautiful to us. Archibald's bowerbird in New Guinea builds his bower on top of sharp ridges. The whole thing drops off steeply on two sides. They get all these little red and blue fruits, and in this case it is a maypole bower, with a sapling and then all these other horizontal twigs stuck in. Looks like a Christmas tree with some way crazy ornaments. Hanging on all these horizontal twigs are little pieces of brown caterpillar shit! What's so beautiful about caterpillar shit? He likes it because he knows she will."

What have other scientists said about these birds' wonderful creations? Gerald Borgia writes that the collection of seashells and berries suggests a bountiful cornucopia, a wide-ranging healthy diet. Others suggest they are all anti-rape structures, allowing the females to give adequate consent before mating is going to happen. Prum is not at all convinced. He believes the vast diversity of life is there simply because it was possible to evolve. Evolution has tried out the most interesting possibilities and look what it has come up with! We shouldn't be afraid if nobody can explain it.

Richard Prum once had some of the finest ears in ornithology. He traveled the world cataloging birds solely by their sound. "I used to be able to go to South America, listen my way through an avifauna of three hundred species, find the bird I'm looking for, and describe its behavior. I was an expert in listening."

Then in Senegal he picked up an unnamed tropical virus. Hearing in his right ear started to go. "My hearing became monaural. The challenge at first was that I could hear all the birds that everybody else could hear; I just couldn't *find* them. It was like living in a flat world. I could still hear—oh, that is a warbler—but where the hell is it? In the early to mid-nineties I started having problems in the opposite ear. I had no idea that my right ear was going to be the *good* one.

"Nineteen ninety-eight was the last time I went to Madagascar to study the velvet asity. By the time I got there, I had three or four field assistants, we were on the trail in Madagascar and we got up to the site and our bird was still hanging out in the same territory. A little bigger

than a warbler, smaller than a thrush, iridescent black, short tail, and he kicks backs his head, opens his mouth, and I couldn't hear a damn thing. That was totally painful. Here was this high, squeaky song that I was the first to describe. We published a sonogram, we recorded it—now I couldn't even hear it. Terrible, devastating. This, I thought, was the end of my career."

Modern hearing aid technology has restored Prum's hearing in one ear to the extent that he can speak and carry on a damn good conversation even in fairly noisy circumstances, but he still can't get those high, crisp bird notes essential for bird song work. "I'm glad I can still hear functionally, but the effect on my work was catastrophic. I felt like shit. Here I was in midcareer, having to totally switch gears. That's how I got interested in the color of birds and how feathers really work. There have been people who said, 'Oh, it is so fortunate for you—if this hadn't happened you wouldn't have gotten into feathers and that is what brought you to Yale.' That is totally bogus. It sucks."

Through advances in genetics Prum has been able to make amazing strides in understanding how the DNA in a single bird cell contains all the information necessary for feathers to properly grow and to present the creatures' distinct colors, appearance, and layout with astonishing detail. The technique is so good that recently Prum and his team became the first to accurately discover what color a dinosaur really was, bringing him newfound fame on the stage of truly amazing scientific advances. For his work on understanding the genetics and systematics behind how feathers form, Prum was awarded a MacArthur Fellowship in 2009.

"An award like this is either a blessing or a curse, because it recognizes quirkiness, not usually mainstream acceptance," Prum notes. He does see himself as a maverick, a scientist out on a limb in his field, not because of his genetic discoveries but because he takes seriously something most evolutionary biologists do not: beauty.

AFTER Charles Darwin wrote *On the Origin of Species*, explaining how evolution marches on by making possible species that are uniquely

adapted to their environments, he realized there was a real hole in his argument. He still couldn't explain the peacock's tail. How could such a flamboyant display of feathers of such great complexity be a trait that has evolved as an adaptation to any challenge of environment or fitness?

In his next major book, *The Descent of Man*, Darwin emphasizes the idea of sexual selection, whereby females of the species evolve a sense of taste and discrimination that favors certain beautiful features in the males. These features are selected for generation after generation simply because the females like them, because their aesthetic evolves over the millennia to define the salient qualities of the species. For Darwin it is important that those features chosen to be beautiful may in fact be *arbitrary*—that is, they have no distinct function apart from the fact that females have evolved to like them. Once they have been selected for over time, the fact of the peacock's magnificent tail is no longer arbitrary in defining the species. It has come to be that bird's defining characteristic, but only because females have evolved to appreciate it.

Sexual selection, says Prum, is really a matter of the evolution of aesthetics in nature. The evolution of all these beautiful bird songs, these ostentatious patterns of bird feathers, and the fabulous performances in bird displays are all for the delight of the female. In sexual selection according to Darwin, aesthetics is central. Today biologists tend to understand sexual selection as an indicator of "general male quality," an even more nebulous idea whereby anything beautiful—a tail, a song—is supposed to show that a male is stronger, more fit, and better at things such as mating, parenting (if that's part of the species requirement), and genetic viability.

To Prum, this misses the point. We are trying to explain away aesthetics by refusing to consider aesthetics, instead jumping immediately to what it is supposed to indicate. By sticking more closely to Darwin's original views, Prum is encouraging scientists to admit that particular aesthetic traits are arbitrary—as the selection process began millennia ago, it could have been anything! The species gets defined by the increasing preference for the trait over many generations, and then you

have the coevolution of the art of the male animal and the aesthetic appreciation of the female. The work evolves together with its public, and Prum finds he can learn more from the art world theory of philosopher and art critic Arthur Danto than he can from biologists who try to deny that sexual selection is actually separate from natural selection. "They're stuck with Darwin book one, denying the importance of Darwin book two. I want to recognize the importance of both books, and celebrate the delight and taste found in nature as depicted in the second." So the key to understanding sexual selection is not to subsume it into natural selection but to keep it separate, recognizing that it is a key understanding that nature is actually beautiful, because the traits we find there have evolved together with something much harder to see but just as real, a sense of aesthetic appreciation.

"When Darwin came up with sexual selection, he came up with two modes, male/male and male/female, and what happened immediately was that the armaments that evolved by male/male competition immediately became accepted, the idea that big macho males could compete with each other for sexual success. People loved this, since it fit right into cultural Darwinism with a sexual twist, what could be better than that?" But the idea that females select males on the basis of traits that they arbitrarily consider to be beautiful was taken much less seriously for more than a century. It seemed frivolous, inappropriate for a domain as serious and carefully evolved as nature and the whole realm of life. Male/female sexual selection went into popular culture, into the writings of Wilhelm Bölsche and his ilk. We had to wait nearly a hundred years before new developments in science brought it back to biology, in ways that Prum considers to be totally misguided.

"What happened was there were several pieces of theory that suddenly made female preference relevant. My perspective is that the vast majority of the literature since 1983 has made a horrible turn in the wrong direction," comments Prum. Amotz Zahavi, the Israeli biologist, put forth a theory that tries to turn sexual selection into natural selection, by suggesting that ornaments previously considered to be outlandish are coded indicators of general male quality and viability. Says Prum, "Zahavi claimed in a backwards sort of way that there really

must be a *reason* for the peacock's tail. Ornamentation evolves as a consequence of natural selection on female preference to prefer those variations in trait that actually give her either direct benefits, such as I'm going to be a good dad and feed the young, or indirect ones: I've got good genes. But the genetics are tricky, they only work if the cost of the tail is greater than the benefits."

So Zahavi is imagining that the peacock's tail tacitly says, *Look how strong and solid I am. I can carry around this huge useless tail and still get around okay and avoid being snapped up by predators. I'm the guy for you.* Darwin did not see it this way. He said that ornamental traits *delight the mind* of the female. As Prum puts it, "It's about charm; it's about beauty." By contrast, Zahavi uses Darwin's first major work to argue against his second: *Origin of Species* trumps *Descent of Man.* He makes Darwin's mechanism even more Darwinian by putting sexual selection *under* natural selection. Female choice is now seen as being part of an adaptive strategy, suggesting that there should be a real difference in quality between the males that the females choose.

Zahavi's view has convinced most biologists today, and this is what they probably taught you in your college biology class. "They prefer to obfuscate the whole thing by arguing that females are constrained by a *need* to select for fitness, instead of according to the whims of fashion," remarks Prum. "In a cultural sense, this is very creepy. Darwin said that when females are in charge, beauty evolves." The Victorian era was threatened by this, and biology may still be threatened by the idea that the cumulative effect of female choice might guide the development of beautiful, fanciful traits in nature for no rhyme or reason whatsoever.

Prum is worried that in trying to go back to the original sense of what Darwin meant by sexual selection, he stands alone among biologists. "What happens when female preferences are *not* under natural selection? What if all males are basically equivalent? All the birds I work on are lek species, which means that the males do displays on an open ground where the females are supposed to assess their ornaments and their performances. To explain those ornaments, ornithologists have to say one male is *actually* better than the other. I just don't buy

it." In a few cases biologists can find examples where a male with one particular trait turns out to be more genetically viable. But not in most cases. What do scientists do? They ignore all the many cases that don't fit their theory, and focus only on the few that do.

"People are so convinced by this adaptationist view that they comb through nature and find just *one* species that fits their model, and ignore all the others. It's the worst kind of science," Prum says. They ignore what is actually created by the male birds: the actual bower, the actual song, with their interesting, largely unstudied, and, according to Prum, arbitrary qualities that could be anything as long as generations of females have evolved to prefer it. Since the questions of form and beauty seem far from useful things such as questions of sperm quality, these biologists fail to even ask the most interesting questions anymore, such as why birds sing the songs they sing, or why bowerbirds have evolved to make artworks that seem so far from the practical and the useful. Says Prum, "In order to avoid an actual description of the mysterious arbitrariness of nature, we have to ignore almost everything interesting."

This is something I had long noticed in bird song science, but I had never met a scientist who would agree with me as simply and plainly as Prum. For example, in England, it has been noted that in the case of the sedge warbler, a male who sings a longer and more complex song has greater mating success than all the other males. Does this prove the song indicates greater male quality? Not necessarily, but it does show that the females do like length and complexity in their music. That's their preferred aesthetic. But consider a closely related bird, the European marsh warbler. This one sings the most complex of all European bird songs, an amalgamation of all kinds of fragments of African bird songs that it learns during its winter migration. No other bird we know of does anything like this. But in this species, there is no clear correlation between singing ability and anything else. So no students have been encouraged to study it, because it doesn't fit the simplistic model. In *Why Birds Sing* I presented a somewhat romantic idea that science will never be able to explain such wonders. Prum is trying to convince me instead that science might well be able to elucidate

them someday, but it must ask better questions. Perhaps, more beautiful questions.

Biologists are afraid of sexual selection because it always claims a certain amount of arbitrariness. If we demonstrate that it does work, what are we able to prove or predict about nature? Only that nature works in mysterious and beautiful ways. The world is less machine and more art. Prum is not afraid of this, and he believes that evolved traits are arbitrary until proven adaptive. This is where we should start, instead of the other way round.

He wants to bring back to the fore the work of R. A. Fisher, who proposed very briefly in the 1920s how sexual selection might practically work. He was the originator of the "runaway model" of sexual selection, where evolved traits could get totally out of hand through generations of one-sided sexual selection. "In order to tell the story better, you have to get into some genetics, get under the hood, and see how it works," continues Prum. "Fisher's two-page verbal model was turned into useful math by Lande and Kirkpatrick in the early 1980s. That provides the bones for all of Zahavi's models." The runaway is one extreme consequence, but the original model is far deeper.

"Let's imagine that we just start with genetic variation for trait and preference. Every individual has genes for both, but they only express whichever one is associated with their sex. Any individual could be plotted based on what would be the product of its preference or trait genes. Let's start out with a null distribution, a blob in the center.

"What's going to happen as a consequence of mating? Females who like long tails will mate with males who have long tails. Females that like short tails will mate with these here. But there will be very few matings where preference and trait do not match. You end up with a genetic correlation between trait and preference. What that means is certain types of evolution come easily. At the heart of the Fisher runaway process is the correlation between genes for preference and genes for traits.

"Now let's look at population space, with average preference and average trait. It was recognized by Fisher, and later by Lande, that the trait to have is what most females prefer. Males should match the pref-

erence of the population. The best way to be sexually successful is to be popular, to be what females want. Done! Nothing complicated here. The more complicated question is Freud's: 'What do females want?' The conundrum is, it's easy to observe the traits, but it's impossible to know what's going on inside the minds of tropical bird females. How female preferences evolve is what is most opaque.

"What's cool about the Fisher hypothesis is that it says any trait can evolve. What males end up evolving is totally arbitrary; it can take *any* form. What's amazing is that they take a form that is determined by female preference—the function of that plumage or display in the mind of a history of females who have observed it." The feathers and the song function not in the external world but in the mind of an appreciating individual female. They possess meaning only in an aesthetic world.

But the vast majority of biologists say that female preference is *under* natural selection. Take a male bird who is bright red—say, a house finch. The red pigment in the house finch is assumed to come from carotenoids in what the bird eats. Carotenoid-containing foods are rare in the finch diet, so a bird that has a lot of it is supposed to have succeeded where most others have failed. By putting the red in his plumage, he is supposedly telling females how great his diet is and how fit he would be as a potential mate. But the house finch mainly eats seeds, the part of plants with the *least* amount of carotenoids, so although he is most definitely red, it is not because of what he eats. "The fact is that most evolutionary biologists have a very narrow comfort zone. They think that their job is to explain the world by natural selection. But it doesn't explain everything," says Prum.

What is Prum's alternative? He says to start by considering the specific nature of sexually selected traits to be arbitrary. "In this case 'arbitrary' is defined as a feature that provides no additional information about the male, it merely corresponds to female preference." It indicates nothing more than what females have evolved to prefer. Instead of ending with Fisher, we start with Fisher. Fisher's runaway model is the null hypothesis, the place where our understanding should begin.

Prum mentions the courtship displays of a family of manakin species in South America. In most of these species the male flies down on a log, jumps up, turns around in midair, and lands with his head down and tail up. But one species lands in a totally opposite way, with head up and tail down. "Most of my colleagues would say there must be some kind of reason for this. I would argue that it must be totally arbitrary. They tell me you can't say it's arbitrary until you've tested every other adaptive hypothesis. What else other than natural selection can shape preference? Is the ability for preference to evolve structured by the nature of the brain? I would answer hell yes! In birdsong we can identify many relationships that are present in human music; those convergent intelligences have structured the same preferences." In bird display there are elements parallel in human dance, and in bowerbird sculpture one finds certain principles that artists know quite well.

Why do the females prefer one trait and not something else? I ask Prum if science might be able to answer questions of aesthetics like this one. He is optimistic: "There is a science that will. We just aren't asking the right questions yet. If you go to books on sexual selection, you will find there is not a single example of a completely arbitrary trait that the literature will accept! They only publish on the things that support their adaptive paradigm! How are you going to get a job unless you are firmly connected to the prevailing view? The rebels to the norm have not yet arisen."

I ask if there are other biologists who agree with him. "I'm almost totally alone on this," he laughs. "They all drank the Zahavi Kool-Aid."

Many biologists think of sexual selection as the explanation of last resort. I remember when I was speaking with Martin Nweeia about his research into the tusk of the narwhal, the longest tooth in the animal world. Long considered a purely sexual ornament because only the males have it, Nweeia concluded that it is actually a sophisticated sense organ that can give the whales precise information on the temperature and salinity of the water they navigate through. "People choose sexual selection as the explanation when they have no idea what an animal's feature is for," he told me. That's the other view on the story, that sexual selection is sort of a cop-out, an avoidance of serious attention to

natural mystery. But how much do we need to find a reason for beauty? No adaptive explanation, no matter how ingenious, can erase the sheer magnificence of what nature has managed to evolve. The progress of science must find a way to acknowledge such an insight.

"To me, the expansively arbitrary diversity predicted by the null [Fisher hypothesis] looks a lot like the overwhelming, multidimensional diversity of secondary sexual display traits in nature. Is this account anywhere near accurate? Currently, intersexual selection research is structured to prevent us from being able to find out. Adopting the [Fisher process] as the null model in intersexual selection will permit us to do so for the first time," writes Prum in his first essay on the topic, proclaiming the Fisher process the null model in sexual selection, which basically means that most of the time, what females prefer is totally arbitrary, and we must delve deeply into this arbitrariness. Let's assume Fisher is right, and consider adaptive explanations in sexual selection only when we have real evidence of them. Don't let a prejudice against random beauty get in the way of our experience of it! This incessant quest for function is missing the point.

Then how can we better understand natural beauty? Prum says we should consider the whole thing as a form of art. This is an area where we have thousands of years of appreciation of the presence of beauty and the ability to articulate that, revealing how human perceptions of it have changed and culturally evolved.

RICHARD Prum may be the only biologist to have been seriously influenced by the aesthetic views of philosopher Arthur Danto. Danto, professor of philosophy and longtime art critic for the *Nation* magazine, has become unusually influential for a theorist among artists and art lovers today, because he is one of few writers to celebrate the fact that *anything* can be considered art today, no matter how mundane, spectacular, beautiful, ugly, or downright repellant. It need not matter what the object is; what's important is just the fact that the work is put forth for our aesthetic contemplation. If something is in front of us in a gallery, museum, or sculpture park, it is offered up as art. If it is

performed in a concert hall or theater, it is performed as art. If it is published in a certain way on the page, it is poetry, not prose. If it is on display, in one of the contexts for aesthetic imbibing, it is and can be and must be accepted as art, even if we might not see the skill involved, the technique, the expertise, or any claims to mirror or reflect reality in the thing itself.

In 1917 Marcel Duchamp tipped a urinal on its side, signed and dated the pisspot "R. Mutt, 1917," named the work "Fountain," and submitted it to the New York Armory Show, which stated that all work would be accepted. It was never actually displayed during the exhibit, and at the time no one knew the noted Duchamp was behind this stunt. Shortly afterward the original was lost. Some artists even today consider this to be the most significant artwork of the twentieth century, presumably because of its incredibly liberating suggestion: that anything can be art if we say it is.

I always thought that the main thing here is that Duchamp tipped the urinal *down* to make its lovely form more easy to see, offering us something rather modern, clean, pure, and beautiful to contemplate, smile at, and laugh at—a full-blown aesthetic experience, as satisfying as a long piss, full of all kinds of references and layers. But at the same time I wouldn't want to dwell on it or defend it too readily. As in the case of John Cage and his famous musical piece of pure silence, this is an artist who made many other more interesting works. The extremes of these guys and this period make for good propaganda, but dwelling on them is more useful for denouncing art than defending it.

Arthur Danto and his many followers think otherwise. They consider Duchamp's "Fountain" to be one of the greatest works of the twentieth century because it paves the way for the work of art to matter less than the act of setting up a situation where meaning can be discussed. The conversations that follow from the aesthetic experience will now matter more than the experience itself. Art, at last, will have become philosophy. This harks back to the ancient thinkers who wanted almost every practical problem turned into philosophy. Whatever leads to greater careful thinking and reflection is of the greatest value.

So what is good art? That question doesn't matter. How to respond

and care about art? This is what matters to Danto. He first articulated this view in an essay called "The Artworld," which appeared in 1964, when a lot of people seemed very perplexed by the work of a young upstart artist, Andy Warhol. How dare he paint replicas of Brillo soap-pad boxes out of wood and stack them in a gallery for our contemplation and our purchase?

> And why need Warhol *make* these things anyway? Why not just scrawl his signature across one? . . . Is this man a kind of Midas, turning whatever he touches into the gold of pure art? And the whole world consisting of latent artworks waiting, like the bread and wine of reality, to be transfigured, through some dark mystery, into the indiscernible flesh and blood of the sacrament? Never mind that the Brillo box may not be good, much less great art. The impressive thing is that it is art at all.

For Danto, though, it's only art if you know enough about how art got to this point:

> In order to see it as part of the Artworld, one must have mastered a good deal of artistic theory as well as a considerable amount of the history of recent New York painting. It could not have been art fifty years ago. But then there could not have been, everything being equal, flight insurance in the Middle Ages, or Etruscan typewriter erasers. The world has to be ready for certain things, the Artworld no less than the real one.

Danto is trying to explain, using philosophical terms, how Andy Warhol can get away with mimicking Brillo boxes in his artwork, and what makes a Warhol Brillo box command a much higher price than the real thing. It's all about context.

Since Duchamp, an artist can put anything forward in the situation of an art world and no one will bat an eyelid. This is only because the gallery and museum have evolved to accommodate anything, ever since Walter Arensburg said no work would be refused from the infamous

Armory Show. Duchamp took him at his word, and fifty years later Warhol went one step further, putting the products of Madison Avenue forward as the most worthy of artistic acceptance. The art world, so redefined, had no choice but to accept.

For Danto this is proof that what makes something art is not its intrinsic qualities but how it is situated and valued by the appreciators of art. Patting himself on the back, he says that this is exactly why artists need theories of art—not just critics who like and dislike, but thinkers who explain why something matters:

> It is the role of artistic theories, these days as always, to make the artworld, and art, possible. It would, I should think, never have occurred to the painters of Lascaux that they were producing *art* on those walls. Not unless there were neolithic aestheticians. . . . Brillo boxes may reveal us to ourselves as well as anything might: as a mirror held up to nature, they might serve to catch the conscience of our kings.

So the artwork itself need not be sophisticated, or unsophisticated. What matters is what sophisticated thinking might arise from our encounter with the artwork.

This is what Prum gleans from Danto's take on Duchamp and Warhol: the nature of the work itself matters little. It really can be *anything*, as long as a coherent story has arisen about why the work should be appreciated, and a community of tastemakers and art lovers evolves to celebrate the work (or style) and promotes it strongly enough so that it will endure in society long enough to make a difference.

Thus the evolving art world has an interesting parallel with the aesthetic features of life as evolved by sexual selection. Prum adapts Danto's idea into a definition of art that just might work both for human culture and for biological evolution. Prum proposes that "art is a communication that evolves by coevolution between the observed and the observer, a performance and an audience, through sensory evaluation. Basically there are an extreme number of biotic art worlds that we are observing from the outside: a nightingale art world, a bowerbird art

world, a mockingbird art world. For humans we've got cubism, social realism, abstract expressionism, minimalism." Coevolution theory thus provides a framework for understanding art, in terms of how the trait to appreciate evolves with the making of the works. What are aesthetic values? "We gotta get over ourselves. We are not the center of life or the universe. Our culture is not the center of culture. There is a seamless interaction between coevolutionary theory and aesthetics."

From Arthur Danto's recent book *The Abuse of Beauty* Prum gleaned that philosophically, the end of art history means a liberation for artists to do whatever they want, which restores beauty to its rightful place. Now art is "what we like, what delights us."

And this is how human art worlds work as well: art is coevolution for evaluation. So what happens when *we* look at bird plumage or listen to bird song? Our human sensibilities have evolved with certain interactions: we've heard Mozart, we've seen Ansel Adams. We evolve human aesthetic ideas. When we enjoy a bird song, it's an *inter*–art world experience, like listening to Noh theater and not knowing the Japanese language—there's going to be some understanding, but the more culture is involved, the more likely there is to be *mis*understanding. "Ask people all over the world," suggests Prum, "What's more beautiful, a nightingale song or a nightingale begging call? Or compare Pollock and Peking opera. They're going to have an easier time agreeing about the bird song than about human art. The only way to satisfactorily define art is as a communication that is the result of a particular kind of evolutionary process. We're talking about the flower and the bee; we're talking about the brilliant colors of poisonous coral snakes. There's something about the aesthetic value that can be arbitrary: we see beauty, they see fear. Same with glistening poison dart frogs. It's art that leads birds and other potential predators to flee in fear."

What do we gain by calling these things art? "You gain because you've picked a definition of art that isn't centered on people." If birds have intention, then the natural world has meaning. If birds have culture, they create artifacts, and we have more levels of understanding to share with them. We may treat them with more respect; we might be much more likely to want to get to know them better.

How important is the arbitrariness of natural aesthetics for Prum's coevolutionary idea? Danto was trying to come up with some philosophical justification for why it had become possible in the twentieth century to put forth even a tipped pisspot as art and have a century of artists and art lovers take it seriously. The object, he tells us, has been sidelined. The act of display matters more. We lived through a time when all dogmas have been questioned—the century cannot hold. Question everything! Danto applauds this. It turns art into philosophy.

I never quite trusted this conclusion, for, as a philosopher, I would rather turn philosophy into art. Make it more beautiful, evocative, wandering in beauty. Less logic, more poetry. Less argument, more dance. If the book you're reading is to work, it's got to have some of that danger, risk, and delight. So in a way I'm prejudiced against Danto: he writes too much about famous but somewhat bogus art. Duchamp is an easy target, and Denis Dutton leaped to the challenge. His recent book *The Art Instinct* is the result of spending many decades thinking about how the evolution of art is intrinsic to the evolution of the human species. Dutton argued that art is necessary for our place in this natural world, and that the right, best human art fits into our place in the environment as a species.

He too wants art to be beautiful and aesthetic, but he also wants it to be adaptive, useful, good for humans, because it is instinctually part of our makeup. But only *our* makeup. Not in animals, not in plants, not in the order of crystals or the sublime abyss of the heavens. Certain things about Duchamp's "Fountain" trouble Dutton, because they are missing from our experience of this work. First, it takes little skill or virtuosity to create the thing, as all Duchamp did was put it forward as a readymade, on a pedestal and tilted just so for the viewer's contemplation. Then there is little direct pleasure in viewing the object. The pleasure is more ironic, like a joke or a shaggy-dog story. It is not a thing saturated with emotion, something that encourages us to study it more deeply or spend time with it. It is nothing that encourages a profound imaginative experience. In other words, there just ain't much there. It trivializes Duchamp to overemphasize this work in his oeuvre, just as it trivializes John Cage to think of him only as the composer

who wrote a piece that was 100 percent silence. It trivializes twentieth-century art to take this one work too seriously, as many artists I know do. When Duchamp himself was asked later in life about this famous work, he replied, "Please note that I didn't want to make a work of art out of it." Dutton asks, "Isn't it high time to take Duchamp at his word?"

Richard Prum is not convinced. To him, Dutton is a man who has definitely drunk the Zahavi Kool-Aid. "Come on—Dutton doesn't recognize any culture in birds, or even in people! If we really think about what we know about bird song, we would eliminate any definition of art as a human enterprise alone." This is because it is the temptation for all who want to connect art to evolution to find evolutionary justification for why we humans seem to be wasting so much precious time on the creation and appreciation of things that seem, to some, biologically useless. How can this be? We value art so highly that it must be important to our very human essence, which means our biological makeup and the unique and unusual way human beings have adapted to our environment using our unique strategy of culture and technology to find our place in the biosphere.

Dutton applauds the relevance of sexual selection to explain why there is so much beauty in human life, but he is expressly uninterested in the aesthetic creations of animals such as bowerbirds, calling them unartistic because they occur with no sense of self-reflection or learned culture. They may look impressive to us because they are unusual in the realm of animals, but since birds don't think about what they are doing, why bother calling them artists? It is rather curious that someone so interested in the evolutionary origins of art would employ such a philosophical sleight of hand to separate us from the rest of nature because we are able to analyze what it is we are doing.

But we have demonstrated that birds do possess intention before singing or display, says Prum. "Erich Jarvis has shown that birds have that—they *know* whom they're singing to, they have intention, we have absolute mechanistic support that the bird is intending to sing, it is not a mechanical music box. How about meaning? I've argued against the importance of meaning in the peacock's tail. But the red plumage of

the house finch *may* mean *I'm better, I come from a better egg.* But just in the house finch, not in the cardinal."

Could it also mean *I'm beautiful*?

When Dutton moves to apply biology to behavior, be it of animals or humans, he begins to explain away the self-criticism and creativity that is supposed to be so uniquely human. Following Zahavi, creating works of art should show that whoever is making them has the kind of serious resources that makes them a good potential mate.

"Total rubbish," says Prum. "Just thinking about Dutton is enough to ruin your day." It's bad enough if scientists swallow Zahavi's unproven, limiting theories, but now we have theorists of art glomming on to them too. And yet what is Prum offering as an alternative? Arbitrariness. Art as evolved through sexual selection is coevolution of the created and the appreciated, but anything at all could be selected for.

Look to animals, says Prum, for an understanding of what good and bad art could be. Each animal species has evolved its unique situation of performance/appearance by the males and appreciation/taste of the females. They know what's good, what's right, what's necessary. They do not need to reflect on it or be self-aware of the situation, because they are inherently situated in the artistic midst. What ends up being selected for does start out arbitrary, but once it's evolved, it's as certain as if your descendants depended on it. And they do.

ONCE the extremely beautiful features of a species are established, aren't they somehow fixed? Peacock tails don't get bigger and bigger until the male birds can no longer move. Species aesthetics seem to become fixed somewhere along the way, and the males develop those traits the females appreciate—in appearance, in performance, and in those rare cases, in the artworks they build. But in many cases there is also learned behavior that is different in different groups, so animals are said to have culture (at least by those who don't get overly protective of the term). How much of a reason do we need to find for this variation? Does it vary because it can, because evolution makes it possible, or because it is somehow necessary?

What about those peacocks? Are all the tails the same? While
Darwin said the peacock's tail made him pale with confusion, for Prum
his field's tales of its meaning make him really angry: "I was looking at
the peacock's tail and saying that I think it's arbitrary, and everyone
else is thinking it's not. And I say, there are all these biological reasons,
like there's no male perennial care, there's no opportunity of direct ben-
efits beyond avoiding some disease, and there are too many dimensions
of ornamentation for the tail to be explained. Because what these Za-
havi models say is that every single handicap has to have an indepen-
dent production of viability costs, corresponding dimensions of quality
information. There just aren't that many."

Look at how little we know about human biology after decoding
our own genome. Sure, it's a tremendous achievement, but it is no Ro-
setta Stone for everything. "If we can only explain 8 percent of the heart
attacks with 100 percent of the genomic information, then how is the
female peahen going to do better than that by just looking at her guy's
tail? She's not. So to me that's what I describe as *merely* beautiful.
Then people come to me and say, 'But Rick, that's nihilism. You're tell-
ing me shit doesn't matter.' And I'm going, 'Why do I see this as intrinsi-
cally meaningful, a fantastic scientific insight, and they see it as the end
of their job? Why do I find so much enjoyment and meaning in my re-
search, and they find my approach to be sterile?' I needed a new way to
put it. That's when I started to think about beauty. What this means is
that the peacock's tail is clearly beautiful, and beauty should be of in-
terest to everybody, even if we are freakin' scientists.

"Then I started getting into the literature of beauty, and found
that the literature of aesthetics provided no solace to my problem.
And as I read I thought perhaps I have a solution to some of their prob-
lems. Art can be described as the coevolution of evaluation and its
signal. So when you have feedback of either a cultural or genetic mech-
anism between the preferences for a stimulus and the stimulus itself,
you create the same dynamics that the peacock's tail is one singular
example of. Some others are fruit advertisement, floral advertisement,
and sexual advertisement. This implies that aesthetics and biology
of communication are potentially the same field. With humans, the

culture component is turned way up and the genetic component is turned down. We are not alone in this: bowerbirds are like that too."

Aesthetics and biology one and the same? I thought the latter was where we came from and the former was supposed to be all in the eyes of the beholder, at least at the species level. Is beauty there or is it a mirage? Coevolution makes it real, necessary, there. But *still* arbitrary? I ask Prum if there is bad art in the natural world.

"Most of those peacocks," he says, "don't ever get to mate."

"Is that really true? What about that study that shows all the tails are basically the same size?"

"Ah," he says with a smile. "Those were in captivity. The females took whoever was available. But in the wild, yes, in the *wild*, with peacocks, birds of paradise, manikins, there is strong competition among females for the best and the brightest males." For almost all the males the females are out of their league. The female aesthetic is so clear that they *know* who the best boys are. So much for everyone getting his girl in the end. Maybe we really are better off being human.

"So most of those beautiful birds of paradise don't look so spectacular, only a few?"

"Not spectacular enough. And that is where ideas of the good and the bad come from. Masterpieces can evolve because you have a process where the end result is very high achievement. This is intrinsic to certain art worlds—highly evolved forms of human artistic achievement, and extremely evolved birds." For Prum these superbirds are artworks in themselves, rare and special, and can be compared to highly refined human genres of art—as opposed, he says, to country and western music, "where matching the preferred aesthetic is not that hard. There is an extraordinarily low standard of rejection."

"Really?" I wonder. "And it is some of the most popular music in America. From the personal sexual selection standpoint, this is a fine kind of music that just might get you laid."

"Connoisseurship is hard," Prum says, and grins. "If you don't really get into wine, you'll be happy drinking Bud." Animals don't have this choice. Each species has evolved its own level of refinement. You are what you are. If we take this wild art/evolution analogy seriously,

humans do have an unusual level of choice, that's why we will always have so many kinds of art.

"I try to establish how aesthetic process occurs," Prum goes on. "I try to say that the population of individuals that are producing and evaluating is the critical group in which this process occurs, with gene flow and subdivision by geography. Then I say, basically, inherently this process has a lot of randomness, but then there is the curious fact that bird songs sound beautiful to us—anyone can appreciate a wood thrush. We can't say what is beautiful outside of a specific art world, where we know how what works is transmitted from generation to generation as long as that art world is intact, as long as a species endures.

"Sometimes these art worlds converge. But that has to do with the properties of mind, which is a huge mystery. What the framework does is to compartmentalize those issues in a way that talks about things in a predictive way, how those kinds of generalizations are going to emerge from aesthetic process to give rise to things that are either beautiful or arcanely weird. I think there is an area where so far there is no science. The scientific questions here lie in trying to understand the structure of these minds. The interesting prospect, this is somewhat spooky: if there are other intelligences on other planets, might they converge in the same way that bees and humans have on olfactory agreement on some aspects of beauty?"

I nod in agreement. I am entranced by this same mystery, of some common aesthetic different species may appreciate, somewhere defined by the fluid rules and tendencies of nature that make it all possible. It's too easy to say nature is the guide, nature is the key, nature is the one, the right, the pure, the ultimate. It's an old, vague idea everyone knows to be part true. But nature is also everything else that we don't like, that wears us down, kills us, destroys us. It's all those pure principles we will never completely know. But the parallels, the patterns, the excitement, the joy! Why these forms and not others? Laws of physics, chemistry, and mathematics may underlie it all, but life tests them out with the play of arbitrariness.

Arbitrary, accidental, nothing but chance . . . sexual selection can work upon anything, and both plain and ornate art worlds can be

evolved. Is this not too easy? Does this end up taking no stand on aesthetic value whatsoever? Is it then wrong to call a Wilson's bird of paradise beautiful, with its dramatic curlicue tail and its single blue crest feather? Is a gray catbird not also beautiful, with its understated lines and color? Nature has both sublime minimalists and gaudy decorativists, but whatever species you're inside of, you haven't got all that much choice of what you're going to do or what you're going to like. In those animals with cultural variations in song dialect, plumage, or performance, you've got some, but usually individual expression is not rewarded. When you're inside the art world, it feels anything but arbitrary. The beauty of nature might mean no individual has to strive to be so different as to push the envelope of the species.

But somewhere that must happen sometime, else no species would ever become another. This is difficult, though, to see, unless you wait around and watch for a million years.

I decide to bring my friend and colleague Ofer Tchernichovski to visit Richard Prum at the Peabody Museum at Yale. Tchernichovski is one of my favorite bird song neuroscientists, described in *Why Birds Sing*, because instead of killing his zebra finches right after they sing to examine exactly what is lighting up inside their brains, he recorded every single sound the baby finches made while learning to sing, during their three-month sensitive learning period. This way he has an amazing record of how the birds learn the very specific patterns that are meaningful to them: How they learn a piece of the song, how they forget a bit. How they fall asleep right after they get a new sound. How the whole song crystallizes. Which patterns matter most. Tchernichovski is also not a strict adaptationist. He doesn't believe everything evolves for the greatest optimization of something. He studied in Israel and remembers Zahavi well.

"Zahavi, he is a very convincing guy for an undergraduate. One of the things I remember very well, we were studying stalking behavior in the gazelle. When they see you they turn their butts towards you, wiggle their tail, jump up and down a few times, then run away. Take

just pure logic. Say you are a deer and you have very strong abilities, strong muscles, in good shape, you have seen the predator. The issue is telling the predator, 'Here I am, here I am!' which is what they do, basically—then it makes a lot of sense. You can describe the round muscles—the color pattern emphasizes that—and he is jumping up and down. You can immediately get the idea that you can't catch that guy. But if you jump badly, then the most stupid thing you can do is tell the lion, 'Here I am, here I am.' Everything is supposed to be designed in a way that will immediately expose your weakness, which is why this communication evolved to begin with! From the beginning the predator can derive meaningful information—it's only because of the handicap. So the logic is perfect! But there's one problem . . . Zahavi is all theory." He has no data at all for this whole just-so story.

This is a side of science that seems much more like faith: there must be a practical reason for all biological phenomena that seem striking, curious, or beautiful. Our explanation should not be *no* explanation. Tchernichovski says to me, "I am actually on your side, as I do believe that perhaps 90 percent or more of what we see is not adaptive, not functional, not anything."

"I'm not saying the emperor wears no clothes," Prum answers cryptically. "I am saying that the emperor is wearing a loincloth. And my prediction is that the naughty bits under the loincloth constitute about the proportion of total intersexual signals that are covered by the adaptive signaling hypothesis. And the vast majority of the details are actually undescribed. Because people have a faith that their mission is to confirm their own personal feelings of meaning in nature by discovering the single explanation by natural selection. What I think happened is that whole generation had this unbelievable buzz—like, 'Wow, the power of natural selection'—that reinforced the adaptationist argument." The adaptationist framework led to sociobiology. Ethology, the study of animal behavior, was pushed to the sidelines, because with the handicap hypothesis we had such an elegant example of the power of natural selection to incorporate things that were currently outside of explanation into natural selection. "Zahavi was on the outside, raving in the wilderness, until people started to take female choice seriously

when this math was invented. Then they suddenly realized that can work, but what to do with arbitrariness? Zahavi saves us from doubt; he folds all this diversity back into meaning. And I think there is a deep-seated need among certain intellectual types for the world to be meaningful."

Tchernichovski doesn't like this. "We are beating a dead horse in a sense. Zahavi operates *totally without data*. What else have you got? So all these natural features are arbitrary, so what?"

Prum laughs. "Why is arbitrary interesting? I think that it is fundamentally interesting that genetic variation itself has incredible consequences. I think the consequences in particular have to do when genetic variation becomes correlated with genetic evaluation. And that in and of itself is intrinsic to the feedback between preference and trait, creating a dynamic process that gives rise to what I describe as art and beauty in nature. The feedback between male and female that evolves through sexual, not natural, selection, gives life this quality."

Isn't some of what appears characteristic of the forms in nature made possible by math and physics, challenging the arbitrary with some sense of absolute, those patterns of order revealed by Ernst Haeckel and D'Arcy Thompson?

Tchernichovski says: "I completely agree. And one thing this reminds me of, in my own history, is when I went to Ilan Golani's lab—he was my mentor in Tel Aviv—he thought about all these ideas maybe twenty-five or thirty years ago and developed them quite a bit beyond the level of what you talk about now. He was working on movement. He was using rats, how they moved around a maze. We were working under the assumption that everything is like 90 percent arbitrary, but that's not the point. The point is the beauty of the behavior, studying from basic principles. And we were hoping that physics would give us this. Actually your work on feathers sort of touched a nerve in me, because you were implementing such ideas when you looked at how feathers form and the specific ways they produce color."

Prum: "What's fascinating and a special case of sexual selection and art in general is that in the case of the feather, in the case of the body plan, in the case of development, the substrate that determines

function is the physical world; the feather either functions or it doesn't. They evolved that way, they were unconstrained in that way. But what is unique about sexual selection is that the function substrate of the communication is *in the brain of another individual*. Female choice is what decides—that is an unconstrained place that gives rise to new dynamics where the functional target is not just crawling, walking, running. The functional target, as Darwin said, is delight. *Delight!*"

The world is beautiful, and it is loved.

Tchernichovski is a bit skeptical: "What you are doing is saying our brain is designed and the world is designed, so life is guided by constraints. And some of those constraints might be universal. This can only become science when you have the ability to say those are the actual constraints in the brain's interactions with the real world. Can you tell me why bird songs sound beautiful to us, and answer using the methods of science?"

"In music and sound it is almost trivial, because the physics of harmony is so overt and so obvious," says Prum.

"So is a bird going to hear an octave as an octave?" I asked. I never did get a straight answer to this question in all my research into it.

"Absolutely." Prum, at least, is sure. "The fact that they even hear octaves or thirds or other sorts of harmonic steps and that those are statistically distributed in songs that have pure tone components is an unbelievable confirmation of the aesthetic hypothesis. We have marvelous support for the aesthetic hypothesis that is staring right at us. Yet we see this as trivial. I have already defined aesthetics as the process of coevolution of the work with its evaluation that occurs in an art world. You're asking for the biases that go into actually determining what the content of that is. Plenty of bird songs are ugly. The Henslow sparrow has a repertoire of one song: it goes *slick slick slick*. What's unusual is that its ancestors had a much more complicated repertoire and complicated acoustic content, but over evolutionary time it has become simplified. It is a precise product of aesthetic process, demonstrating the arbitrariness of the sexually selected direction. This song got simpler, while others get more complex. It could go any which way . . . that's how aesthetics works."

Tchernichovski gets agitated. "You can't do this! You can't! It is completely religious, what you are doing, no better than Dawkins and Dutton drunk on adaptive explanations for everything! All you have is faith in your approach."

"Not faith, but philosophy," Prum says, defending himself. "I'm thinking through how to demonstrate that art can evolve right out there in nature."

Tchernichovski finds Prum's direction circular to the point of proving nothing, and he only gets angrier, shouting, "This argument that song is complex in order not to be boring, to me this *argument* is boring. Who gives a shit about arbitrariness if it gets you nowhere?"

The problem with Prum, Tchernichovski later confides to me, is that he is just proposing theories, thinking like a philosopher, which approaches Zahavi in one dangerous direction, toward "operating totally without data." Is that what philosophers do? All of us concerned with such topics are caught in paradoxes. I believe art makes us more attentive to the world around us, that it really helps us conceive of a world with more purpose and definite meaning. This is a hunch, but I can document it through history. I can demonstrate the value of an aesthetic view, and others have done so before. It has been hard to find scientists who are sympathetic to his view, but now we've got two in the same room.

Do they disagree? As a biologist, Prum believes that through his idea of coevolution he can revolutionize aesthetics, a field that most of philosophy, and most of art, tends to shy away from. No creative person seems happy distinguishing the good from the bad from the ugly. We do not want rules or pronouncements. Looking to biology for the rules for beauty seems inherently conservative, the opposite of Duchamp and Danto, who prove that anything can be put forward as art if a sufficient number of people are game enough to talk about it. But these are extremes, and they may make bad examples. I am more interested in how art leads us to see more in the natural world around us, how it is one more part of human experience that makes the world we have evolved in seem ever more meaningful and important.

How do we find out which is good art and which is bad? Good art

is certainly not the art that the greatest number of people like, which would be the obvious choice for some devotees of the sexual selection theory of art. I wonder if Prum's model will really hold up to statistical scrutiny. So I ask him, "How far can you carry this sexually selected coevolution model to explain human art? The most advanced human art worlds are not the ones with the widest audience. Following a co-evolution model, wouldn't the biggest pop stars be the best musicians, because a larger part of the population is impressed by them?"

He laughs. "That is like saying that just because I can memorize 'There once was a whore from Nantucket,' somehow limericks are better than sonnets or blank verse, because they worm their way into your brain. In fact, the most popular art worlds are usually art worlds where the aesthetic requirements of participation are really low—in birds with a low amount of sexual selection, where every male gets a mate and raises young, the songs are not that complicated compared to, say, a lyrebird, where there is large polygamy. And bowerbirds have more complicated plumage than thrushes because their sexual selection is stronger. In advanced art worlds, most art is going to *fail*. It is no accident that most peacocks don't get to mate. They are different enough for females to prefer one to the other. In other words, the fact that most opera sucks is an indication of how hard it is to do it well. But when you fulfill those aesthetic criteria for success, you have the potential for a true masterpiece, something that endures for centuries. Whereas a country and western song or a rap song, the aesthetic level for success is much lower."

"But wait a minute, some of these songs endure for centuries. Many of them."

"Well we haven't centuries enough—"

"To forget the Beatles? People have been singing 'Amazing Grace' and 'Yankee Doodle' for quite a while. When asked to sing the oldest song they knew, the pygmies in the Ituri Forest sang 'Clementine.' These songs are not going away. Meme or earworm, we're stuck with them."

Prum goes on: "I am saying there are explicit variations between art worlds—in the likelihood of success, the strength of preference, and

selection—that have predictive consequences for aesthetic success. Most poetry sucks, because poetry is hard! That means something very powerful about the poetic art world survives its coevolution with critical scrutiny. That stringing together of random words or obsequious little terms that rhyme at the end is not enough. In country and western music the aesthetic criteria for success are a lot easier. This is something that distinguishes low art from high art. I would use *low* and *high* purposefully and with an ability to define them. Because if you have something that has an incredibly specific aesthetic criterion for success, it is going to become a high art, even if it is something like graffiti."

So are some animals higher artists by their very nature?

"Some birds are objectively higher artists than others. There are going to be a lot more aesthetic papers on mockingbird song than on the Henslow sparrow's *cheep*." Of course, there are hardly any written on either, because biology doesn't value aesthetics highly enough. There are only papers on zebra finches and canaries, because those are the model species whose genomes have been sequenced. There are very few papers on the most aesthetic of birds, even bowerbirds, which are such amazing artists, and birds of paradise, whose bodies themselves are feathery sculptures of color and light. Scientists seem to not know what to say in the face of such beauty, or even what questions to ask. Yet until science changes its tune, we will miss much of what is important about nature's ways.

Some people have tried to say that only human art is intended to mean something. But what does that fugue by Bach mean? It means the same way a bird song means. Bird song, bird sculpture, and even bird plumage is thus an art with its own criterion for success. You can't easily translate it into anything else. It is only better or worse inside the context of female appreciation for the trait, which has evolved together with the trait in a logic that makes sense only within the species-specific, closed art world.

But is Prum really comfortable taking the beauty of the artwork and focusing on the gesture and whether or not the audience will be taken in by it? Damien Hirst can put a shark in formaldehyde in a big

tank, and someone has paid $12 million for this. After that, all these fisherman are saying, "Look, I got a shark here! Do you want to preserve my shark? It will cost you a lot less," and no one is interested. It's not the beauty or possible sublimity of the pickled shark that matters; it matters who has done it and what his acts of outrageousness are worth. For the small number of people able to afford a Damien Hirst, the very fact of its expense is what matters. The collector who bought it is saying, "Pssh! Merely $12 million! That's nothing to me—I could buy twelve more." Art with an uncertain long-term value and possibly highly inflated current price is meant for those who have so much money that the investment value of the purchase matters less than its outrageousness. Are they the birds of paradise of the art scene?

"I would defend the purchase of a stuffed shark for $12 million, or the urinal in the armory, because at various points these works were making strong intellectual and creative points," says Prum. "But the difference between these two cases is that Duchamp was making a point about an exhibition that pledged to accept *all* entries; they couldn't refuse his urinal, and so the history of art was changed. The stuffed shark is made in a different period, where art by a few star artists is now superexpensive, going for much more than anyone thinks the work will be worth in the long term. It's important for the buyer of this work to prove he has so much money that it doesn't matter to him whether it's a good investment or not. It kind of plays into Zahavi or Dutton: my ungainly stuffed shark that fills the living room is no major handicap, because I've got ten houses all over the world waiting to be filled with shocking cutting-edge art. Doesn't matter if you think it's ridiculous, because *you* can't afford it."

IT is while watching Prum thumb through the field guide to South American birds that I finally understand why he is so drawn to aesthetics.

"Look at these toucans!" He points excitedly. "There is one clade of yelping toucans, and there's another clade of croaking toucans. It turns out there are independent radiations. These guys are the yelpers

Fig. 12. Richard Prum explaining the birds.

and these guys are the croakers; these are the models and these are the mimics. My hypothesis is that the smaller species is evolving to converge on the larger species, to take advantage of its social behavior. Imagine there's enough ecological similarity between the species that the big one has a reason to repel the smaller one. For the larger species, there is some ecological cost to the presence of a smaller species; they are also gamed by the smaller species when the smaller is not repelled.

"If we encounter each other at two feet in the hallway, you know exactly how big you are relatively. In a nasty bar, if you're on the way to the bathroom and bump into somebody face-to-face, you know exactly how big the other guy is. But if you encounter somebody at twenty or fifty meters away, you are much less likely to be so sure. Just like the seventh grader walking home from middle school will try to look tough so that he is mistaken at a block's distance for a high schooler—so that he doesn't get his ass beat.

"We see the same thing in this North American field guide. You know, the downy woodpecker and the hairy woodpecker look similar,

only one is bigger. What's interesting is that they're not so closely re-
lated as species. The downy woodpecker has evolved to converge upon
the dominant larger species, so that the larger species at certain dis-
tances will mistake it for itself and thereby overestimate the cost of
aggression." It's game theory at work in evolutionary challenges, but it
plays itself out in aesthetics, one species evolving to disguise itself for
another at certain moments in its life encounters.

These kind of game theory explanations sound like adaptationist
thinking to me. What happened to arbitrariness? What is arbitrary is
that these particular odd solutions didn't *have* to happen. They existed
among the many possible evolutionary strategies. A blend of necessity
and random invention made them come to pass. Aesthetics is not in
the service of practicality; rather, it's one aspect of evolving diversity
that might end up helpful or might end up ridiculous. But a strange
trait still might survive against all odds even if it seems totally frivolous
and nonengineered.

Prum flips further through the bird book's pages, finding all kinds
of relationships that the average reader might easily miss. "Look at this
ornate hawk eagle, a big boss—he's an orangey guy. Here is a smaller
accipiter, the South American goshawk. That's the juvenile, absolutely
convergent with the ornate hawk eagle, and this is clearly going on for
some kind of aesthetic reason—sexual pairing, looking cool so they can
mate with each other. This is a guy who is gaming the system. Just like
a real stable forgery should be rare. All these things about authenticity
and rarity and forgery have been going on in all of these art systems
forever."

"Wouldn't you say there are certain principles behind how the
plumage is all arranged? It's *not* true that anything could happen."

"When you knit a sweater, knit one and purl two is easy. Cables,
that is really easy. But paisley, forget it—it's really hard. In the same
way, feathers have things that are easy to do at the level of the feather;
at the level of the plumage, there are things that are very accessible
variations, and there are variations that are very difficult to access."

"What is the most difficult feather?" I ask.

"Well, there are impossible feathers. And there are ones that still

defy our explanations, such as Darwin's favorite, the Argus pheasant. We can't explain him. For the peacock we have an explanation at multiple levels. We have a loose hypothesis that needs testing. We've simulated them with easy math, and we can get a circle or a concentric set of circles like the peacock."

Over the years since he lost the acuteness of his hearing, Richard Prum has not turned away from a love for the beauty of birds and a belief that this beauty can be figured out. Are the feathers on birds the result of arbitrary preference over generations of coevolved aesthetic chances and preferences? Actually, it is not completely arbitrary by any means. Prum tells me he is one of few scientists who is "actively engaged in D'Arcy Thompson's research program." What he means is he is trying to quantify the morphology of an aspect of nature using rigorous mathematical means. How do feather patterns happen? The growth and color of feathers are extremely complex, even at the level of a single feather, not to mention the complex of feathers that colors the entire bird. At the level of the single feather, there is a vast range of possibilities, but could their appearance really be almost anything? Figure 13 illustrates a sampling of the basic pattern forms nature makes possible.

It is not hard to look at these and realize there are certain kinds of patterns that appear, and many possibilities one could imagine that never appear. Using reaction-diffusion equations first modeled by the great mathematician Alan Turing in the 1950s, Prum and his colleague Scott Williamson were able to model mathematically six variables of feather growth, and then come up with nine basic kinds of feather patterns producable by activator and inhibitor chemicals.

This is the same mathematical approach proposed by Turing in 1952 to explain convincingly why animals with patterned pelts usually have versions of lines or stripes, based on the number of nodes in the chemical system that turn pigmentation on and off in the cells that make up the molecular structure of the animal as it develops from its most incipient form. He called this a reaction-diffusion system. Subsequent development of Turing's idea using more precise genetics led mathematical biologist Hans Meinhardt to convincingly explain in 1972 why it is that animal skins tend to have patterns that are either lines, circles,

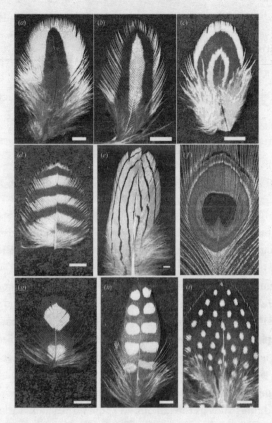

Fig. 13. Richard Prum's basic feather types.

or spots. The mechanism was now clarified as an "activator-inhibitor scheme."

Using equations "that I don't even understand completely," says Prum (making me feel a little more at ease), he and Williamson were able to tweak a series of six variables to produce a series of possible feathers that model quite effectively the range of what is out there. They also came up with two possible feathers that don't seem to exist in nature. Are there feathers not accounted for by their model? "We still haven't figured out Darwin's beloved Argus pheasant," he admits.

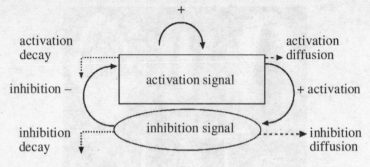

Fig. 14. Richard Prum's activation/inhibition model, based on Turing.

This magnificent feat of genetic analysis and mathematical modeling has profound aesthetic implications. These are the possible patterns; so are they then the beautiful patterns? If these are the forms that nature makes possible, then should we consider that something is more beautiful about these results than those that are impossible?

The simplest pigment pattern in a feather is a central patch of color, easily simulatable with differential rates of diffusion in activating and inhibiting protein signals. Different diffusion rates and scales can simulate a series of concentric central patches, and then barred feather patterns, simply by adjusting the numbers of the mathematical variables. More complex patterns require simultaneous differentiation over both space and time, such as the famous eyespot in a peacock feather. There are other patterns the team first found mathematically and only then noticed in the real world—for example, a double spot pattern that their equations predicted, but which they only later realized appeared in the feathers of the greater flameback woodpecker of Indonesia, a most impressive bird.

So can one produce a model like this and still say the appearance of sexually selected traits is arbitrary? Prum would qualify and say that within this realm of mathematical possibilities, the arbitrariness sets in. To me this suggests that there are absolute senses of aesthetics, located right here in this mathematics. It is the legacy of Haeckel and D'Arcy Thompson melding with the advances of a century of genetics.

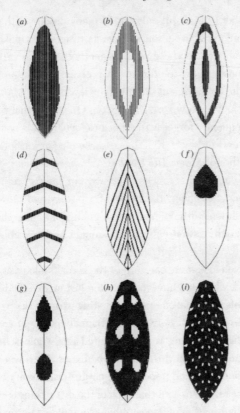

Fig. 15. A diagram of Richard Prum's basic feather types.

We are learning ever more about how specific genetic information in single cells makes possible the whole development of feather patterns in birds and coloration and form in other living things. Of course, there is more focus on how form develops than on why certain forms exist and not others, because predictive power is much stronger for mechanisms than for aesthetic choice. But those choices are made somewhere in the system. Is it not a cop-out to say it is all arbitrary? Pushing arbitrariness too much denies the relevance of all this feather modeling to the whole aesthetics story.

Remember, this is still only one of many processes that evolution uses. You can look at evolution and see its results as a makeshift, haphazard assembly of all these possible methods, which rarely use the simplest or most elegant solution to any problem of an organism finding its place in the environment. That is the view of Gary Marcus, professor of psychology at New York University: "One thing that people, even scientists, frequently forget is that because evolution is not planned in advance, its end products aren't necessarily elegant or optimal." Marcus is the author of *Kluge: The Haphazard Construction of the Human Mind*, which argues that much of the way our brains are put together is, as Prum might concur, the result of arbitrary and messy developments in evolution, with no easy system holding it all together. He concludes that much of what nature has wrought has the same makeshift quality:

"When you look more carefully at the actual biology, at what genes are expressed, when and how, nature often just misses the boat. A good example of this is the dozen or so alternating 'stripes' that you see early in fruit fly development. For years, mathematicians and computer scientists had been showing you could build the whole schmear using Turing's elegant reaction-diffusion mathematics. But even though the computer models seemed impeccable, nature just doesn't build the fly that way; instead, it turns out that each of the fly's stripes is coded for by a different combination of genes. What seemed elegant on the outside is actually hard-coded internally a really clumsy way. Natural selection is a *meliorizer*, a process that makes things better, not an *optimizer*, which makes things as good as they could conceivably be."

So even natural selection, not only sexual selection, owes a lot to random mutation and arbitrary directions to set up the evolution of solutions. We must blend elegance with happenstance.

Still, I am sympathetic with Prum's desire to liberate aesthetics from adaptive explanations. If sexual selection can go any which way, from plain brown to riotous color, dependent on the course each species has taken, then one could say there are no rules. But when it comes to feathers, it is clear there are certain constraints, certain ways nature has turned out to be because of the mathematics that guides our world.

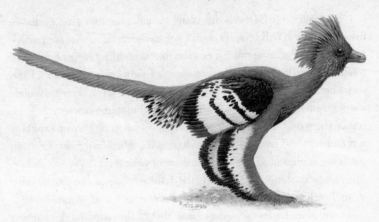

Fig. 16. Anchiornis huxleyi, *the first dinosaur whose real colors we have discovered.*

Using the same understanding of how pattern, expressed in feather color and shape, develops cellular genetic information, Prum has done what many would consider impossible: accurately demonstrate what color feathers a fossil dinosaur had, ending more than a century of speculative reconstruction of dinosaur color based on wishful thinking and humanly impressive aesthetics. With the genetic techniques he has pioneered, in 2010 Prum and a team of researchers was able, for the first time, to accurately depict the color of one very interesting-looking prehistoric beast, *Anchiornis huxleyi,* who lived more than 150 million years ago.

So at last we can answer the question that has gripped us for so long: which came first, the feather or the bird?

Being able to reconstruct plumage and pattern of a creature whose feathers have been decayed into dust for millions of years before humans ever appeared to marvel at them is truly an amazing development. With such impressive recent successes in science, perhaps his radical views on sexual selection might gain some wider acceptance.

"Is science going to appreciate your sidetrack into aesthetics?" I ask.

He smiles. "No, I think it's going to make me look like a lunatic. Except I think it will broadly contribute to the structuralist alternative to the extreme adaptationist direction that is building across evo-devo, genetics, and the biological component of pattern formation and the social behavior of signaling. One of my goals is to try and create a non-adaptationist interconnection between evolutionary biology and the rest of the world, in particular academia. We skip right over Dawkins and Dennett and we create our own channel, where our field is no longer being represented by merely one set of voices.

"Darwin showed a breadth that I think none of the Darwinians around today show. He took the limitations of his explanations seriously and then invented a whole new theory that explained what was happening outside of natural selection, unconstrained by natural selection. And he was right on, and that led straight up to the connection between aesthetics and sexual selection. So when people say 'Darwinian' today, especially in regard to sexual signaling, they really mean Wallacian, which is, 'Oh, yeah, sexual selection is happening, but it's constrained entirely and will give dynamics that are totally identical to natural selection because it's totally determined by natural selection.'

"If we can get the humanities to understand that evolutionary biology is not about form and function exclusively, but about historicity, development, and structure, these are exactly the kinds of concerns that somebody who studies Dickens should have. What was Dickens like as a boy and how did that affect his work? Basically about the same thing. Not about, 'Oh, Dickens wrote this book so he could have more money so he could attract hotter chicks and have more fitness.' That is a nonexplanation of his output. It's ridiculous for literature, and it's as ridiculous for life itself!"

Prum is so enthused about how artistic the world of evolution can seem that he wonders if he might go even further, to ponder whether sex itself could be considered art. "Because I am trying to basically get people to think, 'Okay, sexual selection is like art, it has the same process.' But that doesn't mean that all of art is about sex, since that doesn't lead to the actual engagement with the content of art and its

evolution. So do beautiful people have greater sexual pleasure than ugly people? To me the answer is no. Now, one may lust after whomever, but the very fact that a larger audience of people would think that the people involved in the sex act are actually lovely or attractive to a greater number of people does not speak to the quality of the sexual experience of those people. All the broken marriages in Hollywood support the view that a lot of beautiful people have really shitty experiences—it is kind of related to this aesthetic question. We are constrained by our biology, in terms of sex, *but also in terms of art.* Until the ear actually evolves, we have a certain standard set of potential harmonic capacities to appreciate sound. My ear is the same as the caveman's ear, at least until I got my viruses."

If different bird species have different art worlds of various complexity, they also have different sexworlds, none more elaborate than the convoluted shapes of the Pekin duck penis and its intended Pekin duck vagina. You might think we are way off topic here, but consider this experiment of Prum and his colleagues Patricia Brennan and Christopher Clark to demonstrate how the female's genitalia has evolved to make copulation especially difficult, not easy, for the corkscrew-like penis to make its way in. I couldn't describe it better than their own abstract:

The functional morphology of the waterfowl penis and the mechanics of copulation in waterfowl . . . are poorly understood. We used high-speed video of phallus eversion and histology to describe for the first time the functional morphology of the avian penis. Eversion of the 20 centimeter muscovy duck penis is explosive, taking an average of 0.36 s[econds], and achieving a maximum velocity of 1.6 [meters per second]. . . . To test the hypothesis that female genital novelties make intromission difficult during forced copulations, we investigated penile eversion into glass tubes that presented different mechanical challenges to eversion. Eversion occurred successfully in a straight tube and a counterclockwise spiral tube that matched the chirality of the waterfowl penis, but eversion was significantly less

Fig. 17. Duck genitalia and mechanical barriers. (a) Male and female genitalia in a Pekin duck (Anas sp.). The phallus (right) spirals in a counterclockwise direction and the oviduct (left) spirals in a clockwise direction. The vagina has blind pouches (b.p.) proximal to the cloacal entrance, followed by a series of spirals (sp.). s.s, sulcus spermaticus; a. ph., tip of the penis; cl., cloaca. Scale bar, 2 cm. (b) Diameter glass tubes (10mm) of different shapes used to test penis eversion; from left to right, straight, counterclockwise (male-like), clockwise, and 135° bend (female-like).

successful into glass tubes with a clockwise spiral or a 135° bend, which mimicked female vaginal geometry. Our results support the hypothesis that duck vaginal complexity functions to exclude the penis during forced copulations, and has coevolved with the water-fowl penis via antagonistic sexual conflict.

So coevolution of male and female is more than taste and appreciation—we shouldn't forget convolution and struggle! I can only imagine how Duchamp would have smiled to see the tools of Prum's investigation this time.

Let's see which juried exhibit of contemporary art would accept this project. (Plenty of them!) I even sense a strand where Prum has learned from the world of art in enjoying the surrealistically absurd aspect of this grand investigation. Here is a man dedicated to revealing the obscure, the shocking, the surprising, the beautiful, all as some-

thing that we just might one day explain and have something rational to say about. The surrealism of science as it revels in the delight in just how magnificently weird nature can be—he out-Duchamps Duchamp! And yet behind it all there is a mission, a critique, and anger at all those in his field who are trying to imagine nature as too practical, too adaptively designed, too methodically *boring*, really, and forgetting beauty, forgetting delight. He wants to get to the bottom of all this, and believes science can truly progress at helping to explain the how and why of the art and wonder that the plethora of life truly is.

Can there ever be such progress in aesthetics itself?

"Well, I am hoping to make some," says Prum. "Let's put it this way. You play the clarinet, right? Think of Adolph Sax's 1869 adjustment of the shape and position of the E-flat key—that was progress, no? Same with the paintbrush—now there are new materials that help us paint in certain ways. And the invention of photography created a whole new art." Yes, yes, certainly there is progress in technology, and in the tools used to make art. But in our sense of what is good and bad, better or worse, have we advanced? One would hope that as we amass ever more information on the patterns and beauty possible in nature, and those chosen by evolution in nature, we may increase in our ability to appreciate all of what we discover, to organize it, to make sense of it, to hold it all in our heads.

Does the history of human art in the twentieth century hold up to Prum's analysis as "coevolution of the work and its appreciation"? Does this analysis shed any light on art's recent development? Even art that appears to be abstract has much to do with nature, and if such art succeeds, it will change the way nature appears, and even our view of evolution itself.

CHAPTER 4

Pollock in the Forest

Abstraction as Measure of the Real

IN 2000, Yuan Chai and Jian Jun Xi walked into the Tate Modern Museum in London, dropped their pants, and attempted to pee on Marcel Duchamp's "Fountain." Unfortunately for them, it was protected behind a plastic case, since this wasn't the first time such a stunt had been tried. Onlookers applauded, certain they were witnessing a performance piece sanctioned by the museum. In a few minutes security guards whisked the Chinese duo away and barred them from the premises. Yuan and Jian defended their actions, claiming they were adding to Duchamp's work in the same spirit of its conception, where Duchamp took a urinal and presented it as art. "The urinal is there—it's an invitation," said Yuan. "As Duchamp said himself, it's the artist's choice. He chooses what is art. We just added to it."

It's art if the artist says it's art, right? It's good art if enough people decide they like it or it teaches them something. The art of animal behavior, expression, and appearance that evolves through sexual selection is good if it lasts for generation after generation, as Prum says the appreciation of females develops together with the expression of males. Does this view of evolution's whims and wonders have anything to do with where human art went in the twentieth century? Clearly Duchamp's "Fountain" can't be the last word in what has happened to art in our time. No one who loves beauty can be content with examples that just turn conventions upside down. Even a tilted pisspot can still be pissed on.

In what way might abstract art, with all its powers of raw expres-

sion, refer to the details of nature in such a way that it may help us better understand nature? A closer look at abstraction challenges Prum's contentment with the idea that aesthetic preference is the result of generations of coevolution around an arbitrary glitch in the system. Behind all of selection's myriad results still lie the principles of nature. Many possibilities, sure, but not impossibilities. Nature will let only some things happen, because it is a world that evolved purely arbitrarily, but according to rules.

Haeckel's illustrations made the formal beauty of nature known to millions, casting belief in evolution as something spiritual and reverent. Bölsche made even more people care by rendering the same story at once sensual, physical, and spiritual. Thompson, finding shape and pattern at the very root of nature, made the book of nature's mathematics all the more present, ever more real. Evolutionary biology was not too interested in these cultural developments, shying away from beauty and sexual selection until just a few decades ago, when we finally got the genetic tools necessary to do anything with these tendencies, this as yet unexplained wonder out of nature.

But people loved all these ideas because they were so beautiful. And because the ideas were found right in nature, they made the world that surrounds us all the more valuable. What inspiration did they give to the artists of the early twentieth century, and what of artists today? Abstract art enables us to see more in nature, because our aesthetic senses have been opened up, expanded, enabling us to see and hear ever more than before. This, I know, is an extremely optimistic view about modern art, one that is not always shared by artists or the public. I also realize that modern art is considered by some to already be a relic of a previous age when optimistic expansion of creative possibility was everywhere (and since reined in by the rough realities of the twentieth century); the rush to experimentation might just be the mood of one particular time. We still believe there is consistent progress in technology, but not necessarily in art. Are not the great creative achievements of the past far more clearly valuable than the frivolous excesses of raw sounds remixed all over the place, or washes of colors and shapes fighting each other all over the canvas? No one debates the greatness of

Rembrandt, but those solid blue Kleins or soggy Dalí clocks? Many people remain unsure about them.

I don't consider abstract art to be a misguided turn away from the true and necessary qualities of art. In the end I want to show that it really helps us see the world as a more beautiful place. It will help us understand bird songs and bird bowers. It will make even the formal or chaotic beauty of inanimate things all the more rich and important. It will challenge Prum's idea of pure arbitrariness by revealing rules of form that exist in nature even before biology. Abstract art began to take hold toward the end of the nineteenth century. Did it learn much from the beautiful images of formal natural history?

The mainstream of art history does not say much about Haeckel and Thompson; if anything, they are more acknowledged for their influence on architecture and design. We know that the florid ornamentation of the Jugendstil, with frilly neo-Corinthian columns and snake- and jellyfish-like tendrils oozing out of concrete gateways and spires, comes directly from Haeckel's illustrations of radiolarians and his book *Art Forms in Nature*. René Binet specifically designed a custom gate to the Paris Exposition of 1900 based on one particular radiolarian in Haeckel's report on the specimens from the *Challenger* expedition. Binet and his associates also produced a catalog of popular chandeliers and other lighting solutions based on these oozy octopus-like forms. The stated influence was clear.

What aesthetic theories were in vogue in the early twentieth century? The enormous possibilities of modernism were already there. The opening up of dissonances in music, the cubist machinations in painting, and even the "merde" of Alfred Jarry had shown that in the arts, perhaps anything could go. How did the philosophers try to make sense of all this experiment? Haven't they always been somewhat conservative in defending the old, great art against the dangerously appealing wild alternatives at the moment the latter are composed?

Willard Huntington Wright tried to assess all the arts upon common formal principles in *The Creative Will*, a book that attempted to justify how artists might take liberties with the world as most people tended to see it. Many art students pored carefully through its pages

Fig. 18. René Binet's gate to the Paris Exposition of 1900.

looking for guidance on how art might truly become modern. "The art-ist," he writes, "sacrifices the minor scientific truths to his creative in-ventiveness, because he is ever after a profounder truth than that of the accuracy of detail." Form is the basis of beauty, and artists in all media should attend to the rhythms of nature in a creative way somehow more precise than what our instruments can measure. "Even in the most abstract of the great painters the form is concrete," Wright wrote in 1916. Beauty is the heart of art, but it is completely different from beauty in life, which is sexual, pleasing, or desirable. Beauty in art is created by assembling forms that produce an emotionally charged aes-thetic response, something that can transcend the repugnance or fear of a scene or story that might repel us were we to confront it in the real world.

Art evolves as humans evolve. The greater intensity of modern life has led to greater arts: more knowledge, more technology, more sounds for composers to use, more possible harmonies and rhythms, better colors for painters to use—Wright is a grand optimist. Reading him will console the searching or lost artist even today, nearly a hundred

years later. The artist is an explorer or inventor who "has posed problems which mere collections of data cannot solve." Great art permeates every fiber of its spectators' being. Beauty is necessary for the advancement of man, but do not denigrate it by calling it useful. Utility implies praxis; beauty is an outlook or point of view, one that does not lead us to nature the way science does but rather leads us "via nature to knowledge."

What kind of knowledge? Don't stop with the "primitive demand for symmetry." I suspect Wright was thinking of Thompson and Haeckel when he called this one of our most basic aesthetic senses, something that could have come right out of evolution. When we see something uneven, our "internal and involuntary demand for balance" means that we become uneasy. It's the same kind of thing psychologists test people and animals for today. Wright acknowledges harmony, counterpoint, melody—analogies for form that can cross between all the arts. But he wants to turn these common concepts into something greater yet more nebulous, some grand aesthetic rhythm, which has nothing to do with rhythm in the ordinary sense of tempo or beats or swaying lines but is a profounder pattern, the result of an ideal assembly of all the qualities of art. "It is a complete cycle of poised movement presented as a simultaneous vision . . . in three dimensions." The deeper we get into aesthetic appreciation, the more we will see these common pulses and silences, thrums and gaps, at the heart of all artistic response to the world around us, the celebration of the world through images and sounds depicted in works of beauty.

It sounds good, but it gets awfully woolly as all the arts are stewed together. Can such rules lead anyone to make truly great art, or does it all serve to explain only what has been? Despite his high and mighty ideas, Willard Huntington Wright used a pseudonym, S. S. Van Dine, when writing detective fiction. His hero, named Philo Vance, became quite the rage in the 1920s in books, radio, and even film, making Wright yet another philosopher who found his creative expression in something more straightforward than the most noble ideals he preached. Wright certainly did have a grand system, but it is in aphorisms that his disconnected paragraphs touch us the most. It requires a more visual genius

such as Paul Klee, as we shall see below, to turn rhythmic thinking into something truly artistic.

One standard story of why modern art got more abstract and less concerned with representing a real-looking world says that as photography improved and became more accessible, accurate representation of the world as it really appears no longer was painting's primary task. Plus, the great achievement of Renaissance painting had clearly been reached: we knew how to perfectly present light, shadow, faces, events. Art became free to try new things.

Realism moved into impressionism, with a fuzzy, woozy, pointillistic, or blurrist world view, then cubism, where the fundamental shapes of real objects were divided up into their raw forms and presented as half abstract and half real. Then came the more radical abstractors, with pure form as their guide. Constructivists in Russia and Futurists in Italy demanded a new art in step with the newly rational, forward-looking times: squares, circles, pure angles, exact shapes of color.

How did this relate to the inspiration nature might provide? We're talking about art here, so precise explanations must step aside for raw, insightful uniqueness. But schools arose to teach abstract art to the next generation. And in these schools there were classes, exercises, rules to learn and to break. Nowhere was the nature of abstraction more carefully plotted out than in the famous Bauhaus school of art and design. And nowhere is the difference between the study of form and the making of art more clearly explained than in the notebooks of artist and teacher Paul Klee, published many years later in two volumes, *The Thinking Eye* and *The Nature of Nature*. I want to examine some passages in these two books to show how art can learn from the formal conclusions offered by science, but how it is looking for a somewhat different purpose than simple explanation.

The Bauhaus wanted to make the teaching of art and design into a science. Form must follow function, in human architecture as well as in nature, the way adaptation drives evolution. What of the ornate frills and excess of Haeckel's radiolarians? I think the Bauhaus leaders Gropius, Albers, and Itten would have frowned upon it. They looked

instead to the basic shapes—the circle, the square. They probably preferred Thompson over Haeckel, adaptation over ornamentation. Such functionalist ideas influenced the appearance and form of the modern world—either soulless, geometric cities and houses, or the cool beauty of pure empty forms, take your pick. Biologist Geoffrey Miller even says it is the influence of such functionalism in our society that turned science away from the excess exuberance of sexual selection for a hundred years. We were taught for so many years to look at form and see only function.

If form follows function, then you have to follow it to somewhere new and surprising. In reducing art and design to the simplest elements, there is the easy danger of oversimplifying the world. Build that world in brown and gray concrete and you'll get a lot of depressed people. That is why I think the strongest ideas from the Bauhaus come from Paul Klee, who combined a yearning to grasp the meaning of form with a real appreciation for the messiness of nature. I get a sense he was influenced by both Haeckel and Thompson, but I suspect he appreciated the wild weirdness of Bölsche as well. Klee's notebooks are essential reading for anyone who wants to make visual sense of the energetic messiness of the natural world.

Klee thought the most abstract art was music: the play and mix of sounds obsessed only with itself, not needing to represent anything literally in the surrounding world. An accomplished violinist, Klee had studied the intricate rules of harmony and counterpoint that make the precise beauty of baroque music possible. Bach works so well because he follows all these exact rules to make near-perfect music; why couldn't visual art work this way, to be based on a precise grammar of lines, points, angles, shapes, and rhythm? Klee did his best to forge such a grammar all the while realizing it was a bit naïve and confining. His note-drawings are playful and speculative and will make you smile. He was playing with fire, dreaming the original rules at the heart of the beautiful.

The basic possibilities of structural formation are uniformity, alternation, and progressive change (from the inside out or from the outside

Fig. 19. Two of Paul Klee's rhythms.

in)—not even shapes, but the movement toward shapes. See the two ways he articulates rhythm in figure 19.

Four-part simple time has a gently curved rhythm when visualized. Or see many beats in four-part time swirling into rhythmic connections. This is starting to look like a wild Haeckel creature, but it is based on the rule-type thinking of Thompson. You need art to bring these disparate approaches together.

What would a grammar of visual forms be? Think of music, which has notes, organized into scales, and rhythms, organized into beats and measures. They have been combined for centuries without reference to anything in the external world. Different cultures have different rules and scales, yet all of Western music has been able to make do with basically the same organized material and the same solid principles that musicians learn, whether studying classical, folk, jazz, or rock. The same basic rules produce a myriad of possible interpretations, whole different styles built upon a solid core.

Can visual art work the same way? Not really. It has something to do with the way we see being different from how we hear. Music evolves over time, and even at its most complex it is still clearly built on these basic elements listed above. Visually we take in so much more. And images have a history. Even before our oversaturation with them today, by the early twentieth century humans had already been bombarded by centuries of paintings, photographs, illustrations, and prints. Klee was

no doubt motivated by the same sense of overkill that many of us feel today—there is too much to see and hear, and our minds are full of images, more than we ever thought possible. Today with the aid of technology we are all wrapped up in the idea of categorizing, formalizing, figuring out how images are put together. Klee wanted to rationalize creativity down to its bare bones.

I stood mesmerized by one Paul Klee painting at the Museum of Modern Art's recent Bauhaus show, staring at it while all else around it, the vast detritus of this important movement, faded away. It was soft, colorful, a bit purple, full of playful nests of geometrical images. His work is always more than the rules behind it, like great Bach inventions written exactly upon those regulations that can seem so stifling to most of us who try to emulate him. Klee had the genius that leaps beyond the rigors of the system. Of course, modern art, heralding individuality, is supposed to have that. Does such a thought make any sense for science? Haeckel, Thompson, and Bölsche had it too, in their own mad ways. They may be more artists than scientists.

Klee doesn't really end up with any testable grammar of visual form, but instead he offers clues, even arguments to explain why abstract art isn't really abstract. It is about the interlocking meshings of the real world. Imagine any plant, he postulates, as an overlapping series of not only biological but also visual systems. We have the stem and shape, the flower, the seeds; even insects pollinating it are part of the system. Klee is almost a budding ecologist: "With the function of the flower begins the sexual episode which serves for reproduction." Visually growth expands from the fertile center. "In questions of movement we thus distinguish two sexes. There is an absolute means of representing directed movement: with the help of major-minor; and a relative means based on the sex, or gender, of the movement. If you judge not from part to part but as a whole, the question of movement and the inclination to choose a definite movement appear in another light. Then the form stands before our eyes as an undivided whole." Concentric feminine movements versus aggressive linear stabs. Sexual selection of circle versus line? Perhaps, but really an attempt to unify

the widest social meaning of the simplest mathematical forms, staying honest, admitting they are both fuzzy and precise.

"Monday, March 13, 1922. I. Pasture of a grazing animal, functions of this part. II. Hunting ground of a beast of prey, functions of this part." Movements seen in nature, the work of creatures, abstracted from here into projected shape, a map of dynamic happenings. Flowers helical or spiral, the artist wending his way through the possible models of form. Klee's drawings are like secret commands, hidden military codes, Brian Eno's *Oblique Strategies* cards to get an observer primed on how to use all the exact inspiration mathematics and formal illustrations provide. In Klee's time there were many wars, not just the ones decimating Europe and all of Western civilization, but wars of aesthetics, battles between representation and pure idea. We might not have such battles anymore, since we are too sorry for ourselves and what we've done to the planet. So all of it, Haeckel, Thompson, Bölsche, looks like possible art in an age where history no longer demands destiny. It's all up for grabs, but we still need to dance lightly through what we find.

"Infinite natural history" is what Klee names his project. He barely has the data for what he has to say, but he senses the full grammar of forms pulling at any point, the ways lines may emerge, the way ripples can form on a pond or currents can carry us far downstream. Science too seeks shape and order out of what it may see. But the equation hunters who seek pattern are rarely as imaginative as Klee. He sees a full range of all the tendencies toward pattern that are actually out there, far beyond the simple rules that we often wish we would find.

Klee grasped this essential truth: nature is messy, art is messy. They are both only *based* on pure patterns and forms. These are tendencies you can see out there; it is simply not true that the Platonic exact form is the most real form. Circles and spirals may be pure ideas at the root of all things, but they are not what nature produces. The inexactness is what rules. Life is only *striving* toward the exact; this is why we crave the exact. Things are never so perfect as we wish they would be.

Other pioneers of abstraction favored hard-edged, geometric lines, while still after some expression wilder than the grid. The art of Piet Mondrian, famously geometric lines and rectangles of color, enraged people in its day as looking cold and calculated. Yet as he wrote about his work in the book *Natural Reality and Abstract Reality*, his words are lush and alluring, with a mix of humility and the pull of the grand quest: "Nature is perfect, but man doesn't need to represent perfect nature in art . . . precisely because nature is already so perfect. What he does need to represent is the *inward*. We have to transform natural appearance, precisely in order to see nature more perfectly." (Emphasis mine.) Art must turn away from nature because it is a sin of pride to imagine we can represent it better than it is. Inside human thought lie line, shape, and pure form. When we have got that all figured out, though, we will be able to see nature all the better. So don't paint what you see, but paint whatever tools you need to see the world as precisely as you can.

This understanding of art suggests why abstraction was supposed to matter so much—it would change the way we see the world. And this is the function, much more so than the idea that it socially could change the world, that is most helpful to my vision of showing how the arts and sciences aid and promote each other. Mondrian's ideas, expressed in this strange and Galileo-like three-part conversation first published in Dutch in 1919, seem very much about purely visual issues, not claiming too much for what the picture can do for us. Even Mondrian's most famous work of geometric grids, "Broadway Boogie-Woogie," is always put forth as an example of how an abstract grid is actually an image of an exciting New Yorkish world of jazz and swing, traffic lights, noise, and sweat—the exciting color splash of modernity in a man-made mechanical city standing for a whole new world.

It is tempting to use art as a sign of its times. But if you try to strip away all you think you know about a piece and just look at it, the value of seeing might truly come clear. Geometry is not art, math is not the formalization of the beautiful. Having found his images to be all too clear and square, I am surprised by the way Mondrian writes:

Everything that appears geometrically in nature shares plastically in the inwardness that is proper to the geometric. Yet the geometric can manifest itself as either straight or curved. The straight represents the greatest tensing of the curved, which has more of the "natural." Many curved lines are discernable in this starry sky— making it still "natural" and, therefore, demanding intensification to straightness in order to annihilate its naturalness and plastically bring forth its innermost power. Whether in art or simply in conscious contemplation we must reduce the *curved to the straight*.

We need help to have all these pure forms in our heads; they are not always already there, as Plato once wished long ago.

Mondrian does want to make the world more human and less natural, pushing us further into the grid that seems so alien to the rest of the evolved world. His approach has made an impact, as the forms he so eloquently painted and suggested to us are now the stuff of architecture, graphic, and electronic design. We are so used to them we easily forget how one man pushed them to their limits, going beyond his simple notion that straight is better than curved and making real art about these ideas by using form, composition, color, the classic techniques of visual design. Still, it is worth noting that Mondrian thought abstract art was the most "concrete" art that could be. What did he mean by this sleight of words? "The new man will learn to see plastically, and bend the curved to the straight. The external will be an image of the internal." Diagrams of the workings of the mind? Today's more complete consciousness demands a different representation, but we are indebted to Mondrian's rectilinear dreams and his efforts to describe them.

And the bare bones of line and color can still stand for so much! Amédée Ozenfant, he of so woolly yet poetic a name, established with Le Corbusier an artistic movement called purism that tried to move away from the decorative ornamental quality latent in cubism and return to more basic forms at the heart of nature. For he was an artist

deeply touched by the resonant possibilities of D'Arcy Thompson's writings, which he found joyful and beautiful in a nearly reverential way.

> Bees construct their cells to an obvious geometry: solutions crystallize out in constant forms: waves are propagated according to curves that can be formulated and reduced to equations: capitals curl on themselves like Ionic shells. Joy for the senses and the mind. . . .
> Is the world geometric? Is geometry the thread that man has seized which links all things? Or is it that the laws which guide the brain are geometric, and so it is able to perceive only what fits into its warp and woof?

The forms of mathematics are also, wisely notes Ozenfant, the rudimentary language of all the arts. Out of the chaotic melee of nature we find entities based on shape, angle, line, and curve, and we can make art because we know what structure is. Does a bee, asks Ozenfant, know what structure is? It makes structure, it has to, it has no choice, but *we* are the species who takes it in, categorizes it, and admires it. We find the forms of nature through observation and science, which amasses a huge amount of data but does not always know how to synthesize it in a clear and beautiful way.

Pages of rhapsodic language implore us to create, to turn all the rules of beauty we discover into magnificent art. Faded black and white images in my well-worn copy of Ozenfant's manifesto, *Foundations of Modern Art*, make modernism wonderful because modernism alone can make sense of the many layers of order found in the universe: a sensuous photograph by Blossfeldt of an unfolding fern, a perfect diatom à la Haeckel, the Milky Way, concentric waves tracing on film, the inside wood slats of a dirigible, the round craters of something as far away as the moon. The Eiffel Tower grazes the clouds. It is the beginning of the age of endless photographic imagery. Art that admits the grand veracity of pure forms is the only way to make sense of all the onslaught, and this is already the overload of the 1920s; what would he have thought of image searching on the Internet? Perhaps there has always been information overload. Pure art is a "maximum efficiency, intensity, and

quality issuing from the utmost economy of means. . . . Nothing is more lyrical than a rocket, nothing more exact. In art, therefore, such inevitability must also be present. Everything in a work of creation must be and appear to be the pure resolution of these problems. An immense difficulty! . . . Art is the very apex of human effort."

The conclusion to Ozenfant's soaring, thrumming opus is a paean not to art but to science, which alone has the greatest capacity for synthesis, the ability to make us drop our mouths open in wonder. We must dare to dream big, to comprehend the universe and man. We will be modern only by creating an art and a science that will elevate man in his quest to grasp the deepest of questions, upon the most basic of forms; their harmony, their wild race of possibilities.

I read lines like these and just want to create, create, create, make more, dream bigger, go further. This dream seems necessary but at times obsolete, because the horrors of the mid-twentieth century and the push up against the limits of morality and freedom revealed that pure expression could not save us. There is something naïve about the belief that art can cure our deepest ills. Nowadays the dreamers among us imagine we will either sift ourselves into some hypothetical digital future of raw information or else turn back from the coldness of all this formal thinking and return to a simpler, more harmonious way to live with the Earth. There is a tendency to temper everything now that the wild concordance of imagery is so easy to tap into. I suspect, though, that we are at the verge of an effort once more to categorize, to order, to make sense of all we can see upon basic laws of form, shape, and composition. We want to sift through images online in an organized way, to identify them, to code them. We long for aesthetics, some way to make sense of the endless imagery, sound, and video that comes so quickly: pictures of ourselves, of the natural world, in resolution so crisp and high that we don't quite think it is real. Of course those who watched the first fuzzy silent films felt the same. We're bound by what we're used to, the history that came before.

Aesthetics has always been full of generalizations that seem too easy, too general, too firm in their certainty, full of themselves, with surety about how all art fits together upon simple rules, rules that you

are supposed to study or just feel but which will never guarantee you will make anything great. We are trusted to elude these rules, or at least elide them.

How mathematical and exact can artistic expression become? The Swiss artist Max Bill interacted with the Bauhaus group but then went his own way, inspired heavily by Mondrian to develop an aesthetics of what he called "concrete art," not just built on the rectangular grid but on pure circles, angles, and colors. He did think there was something ultimate and spiritual in such pure forms, which in their purity represented something not ultimately natural but ultimately human. So such concrete art "should have the sharpness, the clarity and the perfection that must be expected from the human spirit." It sounds a lot like Ozenfant's purism, but whereas Oz was gesticular, intense, excited, full of all the great imagery that modernity could produce, Bill made similar great claims for the truly simple and precise. His most famous works are pure arrangements of circle, color, and line; one series called "Fifteen Variations on a Single Theme," made in the mid-1930s, traces the evolution of a single equilateral triangle into an octagon.

It's not as minimal as Josef Albers's nested squares, designed to teach color theory, but it is far more diagrammatic and pure than the abstract expressionist minimalism that came a few decades later. Bill's work lures the viewer into the beauty of these forms—they kind of hook you in—but they still look more like mathematical diagrams than fine art. They are not forms in nature but forms in form, the kind of image one might abstract from one of Haeckel's über-symmetrical radiolarian illustrations. There is much more interplay of mathematical ratios here. These images would not be out of place illustrating a geometry book. Yet there is something purely beautiful about them; perhaps they prove or maybe illustrate nothing.

To present these interplays of chromatic rhythm and ratio is to argue that the pure beauty of mathematics is also a form of art. The math used by Bill is not so complicated, but it is more precise than what Mondrian or Klee was talking about. In 1949 Bill made his boldest claims for the possibility of a new kind of art based on mathematics:

In the search for new formal idioms expressive of the technical sensibilities of our age these borderline exemplars had much the same order of importance as the "discovery" of native West African sculptures by the Cubists; though they were equally inapt for direct assimilation into modern European art. The first result of their influence was the phase known as Constructivism. This, together with the use of new materials such as engineering blueprints, aerial photographs, and the like, furnished the necessary incentive for further developments along mathematical lines. At about the same time mathematics itself had arrived at a stage of evolution on which the proof of many apparently logical deductions ceased to be demonstrable and theorems were presented that the imagination proved incapable of grasping. Though mankind's power of reasoning had not reached the end of its tether, it was clearly beginning to require the assistance of some visualizing agency. Aids of this kind can often be provided by the intervention of art.

Mathematics needed new imagery too, something beyond the simple forms that had graced centuries of geometry books. Art could now have the new role of visualizing the full range of form and pattern at the very edge of representation. Bill doesn't want to put art in the service of illustrating the new form-twisting branches of non-Euclidean or uncertainty mathematics. No, his new kind of art will be "the building up of significant patterns from the everchanging relations, rhythms and proportions of abstract forms, each one of which, having its own causality, is tantamount to a law in itself." The simple senses of form and symmetry that entranced Haeckel and Thompson are not enough. He wants to make art out of Möbius strips with only one side, Klein bottles where the inside is the outside, worlds where there are no parallel lines.

Thus Euclidian geometry no longer possesses more than a limited validity in modern science, and it has an equally restricted utility in modern art. . . . Things having no apparent connection with

mankind's daily needs—the mystery enveloping all mathematical problems; the inexplicability of space. . . . Though these evocations might seem only the phantasmagorical figments of the artist's inward vision they are, notwithstanding, the projections of latent forces; forces that may be active or inert, in part revealed, inchoate or still un-fathomed, which we are unconsciously at grips with every day of our lives; in fact that music of the spheres which underlies each man-made system and every law of nature it is [in] our power to discern.

He calls for form to be named as beauty, but new forms that lie beyond the simple shapes of the evolution of life. He worries that his critics might object that he is turning art into philosophy, but a few de-cades later that is exactly what Danto would try to do. Art should visu-alize natural rules and forces that only the mind can see. Bill's picture of art is something conjuring up inside the human mind, not the raw vision of what we might see in nature. He is stepping into the pictures of ideas themselves.

Later in life Bill mellowed a bit, saying art must use a logical method, not a strictly mathematical method, to remain truly concrete. Is this just sly wordplay, since what he was talking about was squares and planes of color, shiny metal programmed curves, and other forms that many viewers might call abstract art? Bill did argue that one must set constraints upon oneself in order to make art in so complex an age as ours, the same argument that Stravinsky used in music, though for the latter setting constraints meant wild emotional expression, not pure minimal forms. Bill believed that after Mondrian there has been a "radi-cal attempt to dispense with all individual stylistic expression." He wrote that in 1960, and certainly that was not the only trend happening in art by then, but the rejection of the past did seem to indicate some cleansing, purifying meditative act: "No reduction can be extreme enough. . . . The aesthetic quality is beginning to withdraw into the most extreme reductions, into the most extreme objectivity, culminat-ing ultimately in the negation of newness."

He did not endorse others' all-black paintings, or the elimination of all aesthetics in favor of pure shock value. "Art can originate only

when and because individual expression and personal invention subsume themselves under the principle of order of the structure." Bill remained a structuralist to the end of his days, turning his formal principles into beautiful work, while Klee and Stravinsky were more polemicists in their writings, talking about structure and rule but tricking us by making work that was wild, crazy and free. Bill kept his cool and visually had something crisp and definite to say.

How much can we expect mathematics to do for aesthetics? In the 1920s George Birkhoff wanted to reduce aesthetics to a single equation, which he named "aesthetic measure." The equation is simple, almost iconic: $M = O/C$, or aesthetic measure equals order divided by complexity. It might seem a trivial attempt to quantify the usual aesthetic demand for unity in diversity, balance in confusion, asymmetry in symmetry, or François Hemsterhuis's eighteenth-century definition of the beautiful as "the greatest number of ideas in the shortest space of time." But Birkhoff really wants to measure this, to put it to the test.

Aesthetic feeling begins with the directing of attention. His model of the brain is current with what science thought in the 1930s:

> Look to that complementary part of the nerve current which, impinging on the auditory and visual centers, gives rise to sensations derived from the object, and, spreading from thence, calls various associated ideas with their attendant feelings into play. These sensations, together with the associated ideas and their attendant feelings, constitute the full perception of the object.

In these associations the determining aesthetic factor will be found.

He begins by evaluating shapes with straight lines bounding them, the polygons, which Birkhoff finds the easiest to define. A polygon can have vertical symmetry, rotational symmetry, equilibrium, the possibility of being used as a tile, the possibility of being gauged against its complexity, and then its possibly "unsatisfactory" form (too small distances from point to point, angles too near 0° or 180°, too many niches, too many directions, "unsupported reentrant sides"). Complexity is also

simple: just the raw number of sides. The square comes out ahead, then rectangles, then triangles. Stars are lower, irregular trapezoids lower still. He tested out his list of ninety polygons on students at Columbia and Harvard, and they seemed to concur. But did they concur over mathematical beauty or aesthetic beauty? The single-number approach seems too easy, but one can also see its appeal. Wouldn't it be nice if the meaning of life really was, as Douglas Adams suggested, forty-two? A satire of science in the singular whole.

Birkhoff goes on to music. Major chords are higher on the list than minor, higher than sharp-4 Lydian chords. Music psychologists and melodic expectancy theorists push these same universal arguments today even as musical-cultural diversity seems to suggest that different cultures prefer different kinds of scales, but they defend themselves by saying these are different ways of dealing with the universal common appeal or disdain for certain balances of order against chaos. Birkhoff goes all the way to consider the complexity of artworks with his simple equations. Of course one number will not explain genius or ultimate artistic beauty. But it gives a clue to the root ratios supposedly acting on the brain, that simplified brain that in 1933 we thought worked that way. "The 'complexity' of paintings is usually so considerable that they are analogous to ornamental patterns whose constituent ornaments must be appreciated one by one." Maybe, maybe. But he's right—a sense of form can usually be extracted by those who want to explain why their attention resonates with one particular artwork rather than another. He cautions against directly applying aesthetic theories into the making of art, lest the artist end up producing what he calls "puzzle-art," like M. C. Escher, where the theory is more prominent than any aesthetic delight. The most wonderful thing about the ratio, the number, the countable secret explanation for a shape, form, or even evolved natural design is that you cannot see it and you cannot use it; you can only abstract to it from the initial aesthetic experience.

No rule will ever tell you exactly how to create, and this may explain why there was an opposite trend in modern art, the movement toward wild expressivity and the seeming rejection of formal principles.

In the popular eye, if Andy Warhol is the poster child of Danto's "art as philosophy" argument, then Jackson Pollock is the icon of the "I can do that" school of modern art. Splattered paint—is it not all just an uneducated mess? Generations of art critics have tried to explain to the skeptical public why Pollock matters, and those who take the time to look at the paintings are often eventually taken in. However, only recently has it become known that even Pollock was tremendously influenced by early twentieth-century ideas of form in painting.

Art was stretched to its visual limits in the twentieth century, and we need to examine whether our openness to such directions has led us to perceive the actual world in any different ways. Jackson Pollock exemplifies the maximalist sense of abstract painting in its extreme form, the race of mess and splatter that perplexes many but lures in many more. Pollock's paintings are icons of wild energy, crazy abstractions, a rough-and-tumble pour of paint on floored canvas. With such cacophony, what can they say about the forms of nature?

Surprisingly, Pollock fits neatly into our story. He studied with Thomas Hart Benton, whose own works are known for their blocky realism, severe colors, and weighty human figures. Benton hung out in Paris with philosopher of aesthetics Willard Wright, debating principles and reading manifestos of movements such as synchromism and purism. They were both impressed by bright color, form, and rhythm—how to make sense of it all? Wright made grand, unifying artistic pronouncements on how all should fit together upon rhythm, pattern, and balance. Benton used such principles more specifically in his teaching at the Art Students League. In the 1930s Jackson Pollock was his student and became a close friend.

Benton, as a practicing artist, knew theory could only go so far. Most of what he wrote in the serialized five-part article "Mechanics of Form Organization in Painting," in a sequence of issues of *Arts* from 1926 to 1927, is, he said, "intuitively if not reflectively known to all intelligent practitioners of art." So it might often appear with the broad aesthetic pronouncements we have been considering in this chapter—they almost seem obvious, but writers and artists still feel the need to

articulate them, as there is a recurring desire for systems to help dis-
criminate the good from the bad. Aesthetics is frustrating, unpopular,
sometimes cold, but we still want to believe that such principles exist.

Benton took Wright's principles of aesthetic rhythm and drew
them out explicitly. The parts of a painting must be in a visual state of
balance, a kind of equilibrium. If a work is too static, we won't want to
linger with it. The successful piece of art should encourage interested
contemplation, movement or exploration with the eyes. Lines may seem
like static elements, but for them to work in an image they must encour-
age movement, revealing just the right amount of order. "Dynamic bal-
ance is asymmetrical. Equilibrium is held by a series of shifts and
counter-shifts which approach but never reach a perfect oppositional
alignment of proportions." Ah, so the better artwork is *not* exactly
symmetrical. Is this a nod to the idea that more symmetrical art—say,
the designs of Binet so specifically influenced by Haeckel—are better
considered as *decorative* rather than fine art?

Twentieth-century art had an ambivalent relationship with sym-
metry. Even the most mathematically inspired art is rarely perfectly
symmetrical. If it's art, it should not just be a design. Benton's diagrams
in the first part of his article clearly suggest this, that at least one axis
of unevenness is necessary for a structure to be a good basis for artistic
form. Does this mean nature, with its love of symmetry, is not beauti-
ful in a higher sense, but merely decorative? Certainly the results of
sexual selection are often spoken of as ornament. But another way of
looking at the natural world is to admit that everything you find there
is always a little uneven—pure symmetry is most clear in the abstrac-
tions of the human mind, trying to purify nature within rules simpler
than the brash reality of what's actually out there.

Benton's diagrams were meant to show the forms and rhythms at
the root of more realistic paintings, not necessarily as guides for pure
abstractions. The interplay of his visual chartings looks like ancient
dance notation, or experimental music, or doodles trying to aim for a
pleasing balance of the exact and the free, avoiding the formulaic but
still having designs at their core. This is so the viewer won't rest quickly
with a painting, decide she has figured it out, and move right on. The

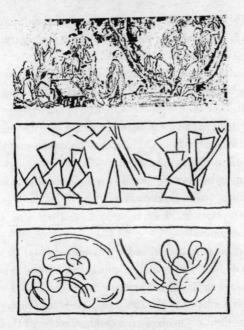

Fig. 20. Thomas Hart Benton teaches abstraction.

eyes of the audience must be delighted and surprised. Art should not be overly easy to visually figure out.

As his article continues, Benton wants to explain how the use of color and the abstraction of three-dimensional forms can make a painting seem to stand out and proffer greater life, becoming something that sounds a bit cosmic for a social realist: "deep space painting." He wonders if this goal is like the stream of consciousness of then-fashionable William James, "an affair of groping nebulosity where sensuous, mystic, and sentimental leanings, inhibited in other fields, may play without bumping into anything hard." When learning these principles, Benton continues, don't copy the contours of the great art you see. Delve down for the form, discover the underlying rhythmic structures. "We should be able to get at the logic of those fundamental combinations of line, mass and volume which are beneath the total aspect." You cannot just describe these features; you have to diagram them out in order to grasp

them visually, which is necessary to understand their role in composition. Here Benton, whether he realized it or not, was preparing his students for the world of the abstract.

Did Pollock's wild splatters really benefit from such diagrammatic study? Henry Adams's recent book *Tom and Jack* tries to make a case for this, even showing how many of Pollock's greatest works are specifically organized over a wide horizontal canvas and based on a series of poles, with rhythmic elements overlaid upon them. When Benton heard of the sale of Pollock's "Blue Poles: Number 11" to the National Gallery of Australia, he told a friend, "I taught Jack that!" Even though Benton's style would seem to many to be the opposite of Pollock's, after his student's death he mused, "Jack never made a painting that wasn't beautiful."

Many geometrically inclined artists valued Pollock's art long before the public did. It was Piet Mondrian who urged Peggy Guggenheim to support it. "That's not painting, is it?" she asked him. "There is absolutely no discipline at all. This young man has serious problems."

"I'm not so sure," answered the great geometer. "I think this is the most interesting work I've seen so far in America. . . . You must watch this man."

"You can't be serious," exclaimed the founding patron of American modernism. "You can't compare this and the way you paint."

"The way I paint and the way I think are two different things," Mondrian said. He must have seen that Pollock too was after some universal quality underlying all things. The fact that to the uninitiated it looked like chaos might confirm that he had learned to see something others could not yet grasp.

Is the essential thing about abstract painting that it does not refer to the external world and is only about these shapes, patterns, and forms that have been bandied about by all these pontificators mentioned above? "I'm very representational some of the time, and a little all of the time," Pollock once said.

In 1959 Hans Namuth filmed Pollock creating some of his most important works. In almost every work, Pollock's first layer of dripping involved recogonizable subjects, including human heads, shoulders,

Fig. 21. A. I. Yarbus reveals how the eye looks at a painting.

fingers, legs, perhaps a dog lying underneath a table. Did his later drips serve to "veil" the initial figurative image, the guiding lines derived from Benton's diagrammatic approach? Benton analyzed existing works; Pollock applied his process in reverse, perhaps to show how far such structural principles could be carried. Look at Pollock's "Blue Poles" and see how it immerses you in its world. Henry Adams and Julian Schnabel have both noted that looking at it is like standing in a forest watching the complex patterns of branches and leaves shadow over you in the dappling sunlight.

In the 1950s Russian psychologist A. I. Yarbus put tracking contact lenses on human subjects' eyes as they looked upon a series of pictures, including I. I. Shiskin's dark, mysterious painting "In the Forest." The resulting image of how the eyes move all over the frame resembles a Pollock splatter upon a realistic northern woodland scene, with glimmers of the sense of visual form evident in Benton's diagrams. How do our eyes actually look at a painting of a forest? Figure 21 shows what Yarbus found out.

The moving eye keeps subjects interested. There are focal points in the eye-tracking reports, but also darting exploration, like a visual dance of attention. Here they are scientific tools, but the achievements of Pollock upon the rules of Benton help us see such images as having the potential to be art.

The eye's movements take one back into the shimmering miasma of the natural world. Perhaps this ultimate abstraction is a map of exactly

what it looks like to intelligently *see* the actual, natural living world, which, after Pollock, reveals a brand-new kind of visible order. As Julian Schnabel realizes, "The concreteness of a painting can't help but allude to a world of associations that may have a completely other face than that of the image you are looking at. The concept of Formalism imposes false limits on painting under the guise of esthetic purity." So art always refers to the world when used by those who spend the rest of their lives looking at the world. We cannot doubt that Jackson Pollock has changed the way we see.

So Mondrian observes in Pollock's early work glimmers of the workings of his own mind, and Pollock knew the value of disguising realistic starting points in a glare of creative disruption, painting that in its splattering seems so much more about paint than about anything else. To gaze at it may take you into a world where disruption turns into vision, where art starts to see what without it cannot be seen.

Such paintings may have began with a few identifiable, realistically sketched objects, but is that really the point? In abstraction and explosion is where Pollock transforms our sense of what we might visualize and what we might like. Does it need to stand for anything outside itself? The cover of Ornette Coleman's 1961 album *Free Jazz* is a die-cut hollow rectangle over a full-bleed Pollock image beneath. It's a record of almost all spontaneous invention, simultaneous playing by *two* jazz quartets—that means two drums and two basses in addition to everything else. Could the modern mind of forty years ago really make sense of all that spontaneous cacophony? The fact that we could see Pollock's work as beautiful was used to make a visual argument that we could hear order and pattern within as well. Our modern taste had evolved to enjoy the cacophonous, the wild, the overly intense and filled-in overlaps of sound, rhythm, and tone. The painting expressed, for Coleman at least, what it might be like to see what he was hearing and playing.

Did Pollock's work suggest anything useful for those who were trying rigorously and methodically to make sense of the increasingly chaotically understood modern world? Like Wright the aesthetician, Pollock famously used modernity to justify his imagery and technique:

"It seems to me that the modern painter cannot express this age, the airplane, the atomic bomb, the radio, in the old forms of the Renaissance or of any other past culture," he said in an interview. It is an easy and valuable argument to make. But never mind the artists—what does the acceptance of such imagery do to those of us living through this era? How can we see differently today? How might the visual understanding of cacophony change our ability to make sense of the intricate, detailed information world?

How does the viewer grasp the organization of the swirls and drips in a Pollock painting? Is there really something natural about them? Do they reveal some new kind of order in nature? The mathematician Richard Taylor, in 1999, felt strongly that there ought to be a way to *prove* that Pollock's work reveals something fundamental in nature. By the end of the twentieth century, Pollock's paintings easily appeared brilliant, important, but also somehow real to many who saw them. To Taylor this meant there was something specific about the way they approached an aesthetic of nature. Was there a way to mathematically prove this? Taylor and his colleagues were able to demonstrate through mathematical analysis that the form of Pollock's layers of lines on the canvas was akin to nature's own patterns of snow on the forest floor, trees in a forest seen from the air, or lichen growing on rocks: unplanned but not random, ordered and designed according to a mathematics of chaos derived from the fractal equations of the famous Mandelbrot set, revealing levels of order in what initially appears confusing, showing a plan within nature far more multifarious than anything Haeckel tried to draw.

It is fractal mathematics that allows computer games to spew out convincing mountain ranges and landscapes with fairly simple equations, showing how order can be found in what at first seems random. Break down a broccoli head into smaller florets—they all have the same basic shapes. Take a river and stare down at it from the sky, or gaze at the rivulets that stream down a tiny muddy bank—they all have the same kind of branching structure, never exactly symmetrical, but looking similar at vastly different nested levels of scale.

Physicists have dripped paint from swinging pendulums that

oscillate in several dimensions, and they soon approximate the kind of drip-stroke that Pollock made as he swung his arms back and forth over the canvas on the floor. In the end, Taylor believes he has proven that Pollock mimics, either implicitly or explicitly, the way nature works. This is why when you gaze long enough at a Pollock painting, until you feel like you are inside it, you get the feeling of running fast through a thick forest or tangled wood.

The artist grasped the importance of fractal geometry before it was even discovered. Instead of representing nature, he intuitively adopted its own undiscovered language to make abstract works infinitely more real than anything before him. A fragment of the painting inside a frame has as much happening as the whole thing, as Coleman discovered when he chose a piece of a Pollock for his album cover. It's like a complex bird song that only becomes more complex the more it's slowed down and stretched out, with layers of intricacy like an infinite coastline.

Fractal geometry is endlessly appealing as a metaphor for the hope of finding order in a world that often seems a messy maze. If we can map chaos according to mathematical rules, then maybe the rush of this confusing world will not serve to overwhelm us. Danish mathematician Henrik Jensen went further than Taylor in a way, arguing that Pollock's work is *better* than that of earlier artists who explicitly based their work on geometrical forms, such as Kandinsky and Klee, and by association Max Bill, who were too obsessed with more abstract, simplistic mathematical forms. Their kind of mathematics was out of touch with the rich, rough, real dynamism of nature, which only the recently discovered chaotic fractal math can reveal. So painting might make more use of geometry without even realizing it, as a more rough-hewn expressive approach succeeds because it intuitively approaches beauties that only the mathematics of the future can hope to explain.

So is this a case where art has inspired math and science? Not exactly. In each of these cases the mathematicians seem to want to make their own pursuits seem more creative, more cool and exciting, not boring and mundane. While stopping short of calling mathematics an art, Jensen says people usually don't get it: "The quantitative and exact

nature of mathematics tends to make people think of it as a useful technical device rather than a soul enriching exercise," he frets. But at its best math too aims for a conceptually satisfying goal, "something not at all alien to an artist's struggle to reflect reality." In the nexus of science and art many artists want to show how hip they are by using science, and many scientists want to reveal their deeply creative natures. But how do they really aid each other?

This attempt to reveal Pollock's hidden geometrical genius might have remained just another art/science footnote had not Alex Matter found a stash of thirty-two abstract drip paintings in his parents' house in Long Island, near where Pollock and his wife, Lee Krasner, once lived. Matter's parents, Herbert and Mercedes, were good friends of the Pollocks and a note on the package indicated that they were Pollocks purchased by the Matters between 1946 and 1949. Or did they paint the works themselves? In the first case the works would be worth millions; in the second, little or nothing at all.

Could mathematics be of any help? Richard Taylor weighed in on the situation. His analysis showed that these thirty-two mysterious paintings had none of the rich fractal qualities of the Pollock originals. Thus they must be fakes. Physicist Katherine Jones-Smith presented a counterargument, showing that very simple doodles that she drew presented the same fractal characteristics Taylor claimed could be found only in the true Pollocks. The whole debate became moot a few years later when it was found that some of Matter's paintings contained pigments that did not exist during Pollock's lifetime. Did this mean the end of the trumpeting of chaotic mathematics as a means to naturalize abstract art?

Not in the least. If we find similar fractal patterns in Pollock's drips and supposedly chaotic natural scenes of trees in the forests, rivulets in the sand, or snow melting on the grass, then this might help explain why such abstraction on the wall lures us in, makes us feel like we are inside a whole environment. Even the belief that "I could do that," that you could drip your own drips to fool some of the people some of the time, may be beside the point. Here's an artist who developed an extreme technique, something even the connoisseurs of art

initially laughed at, and then showed at the end that he too was able to represent aspects of nature that no one previously had thought could be represented. Pollock's images had fractal qualities before such qualities were officially named. These qualities are found in nature, and the paintings seem somehow natural. The fact that his works change the way we see nature may not be the greatest thing about them, but it is one way they alter the meaning of human perception. When after a few decades we come to accept some expressionism as art, we have a new way to make sense of the natural world. Art changes the way we see the world that makes us possible.

Are more orthodox fractal images art? How can we tell if they are beautiful? A group of creative mathematicians, Ralph Abraham, Julien Sprott, and the aforementioned Richard Taylor, have been doing empirical aesthetics with the many fractal-generated images that are becoming ever more complex and familiar through screen savers, computer images, and computer graphics in the workplace and the world of entertainment. This group is scientific enough to make aesthetics simple: get a sample of people to look at a bunch of images and judge which ones they like the best. The results seem to suggest that the most-preferred fractal-based images are the ones that have a fractal ratio of 1.5 to 2, a similar relationship to those fractals found in the natural world of trees, branches, clouds, snow melting on the grass, and so on, supposedly suggesting that our aesthetics is rooted in the natural world around us, the same world that Pollock hooked into with his own intuitively fractal method. We come from nature, so we prefer nature.

Aesthetics as a matter of preference that can be easily measured is one way to try to quantify all this brash creativity that may mark a true difference between art and science. Science is bold enough to believe that something as wary as beauty can be caught and frozen as a number, something objective that can't be argued with—the golden ratio, the perfect circle, a perfect balance of symmetry and asymmetry. "Of course we do this," remarked my friend Sonja Lobo, a Brazilian biomaterials researcher. "We have to struggle so hard, each of us working on one tiny piece of the problem. Science is cumulative, a vast storehouse of knowledge growing in explanatory power. But art doesn't have to

think this way. It has always been perfect. It leaps from whatever objective knowledge the artist might have come across and dares to dream a new world into existence. This new world is not judged on whether it is right or wrong, but how its image moves us, how it stays with us, how it inspires us to think about order and beauty in a new way."

Does the art we prefer secretly hide some basic principles of nature? Richard Prum would say that's rubbish—what we like starts out as being arbitrary until a culture evolves to praise it. Yet we should not forget that art can also be useful. Jackson Pollock hides actual objects inside his wild abstractions, a technique that comes right out of the tradition of camouflage, a human art derived from the helpful coloration that keeps an animal out of view, making it harder for predators to find their prey.

But successful camouflage is not only about fitting in, chameleonlike, to the background you hope will disguise you. It is also about visual disruption, presenting patterns that will confuse the viewer, such as zebra stripes, mottled spots, and other patterns that make the boundary of an animal in its habitat or a soldier on the battlefield far less clear—images that dizzy the eye so that foreground melds into background, confounding our perception until we can no longer tell what it is that we see. It appears that nature has evolved through a combination of efficiency and artistry, which reveals a whole different way in which art and science may be intertwined.

Hiding Ingenuity,
or Think Like a Squid
Camouflage Between Art and Nature

IN a corner of the Smithsonian American Art Museum in Washington, around a bend and through a series of clean, elegant rooms, lies one of the most remarkable paintings of a peacock you will ever come across. What is unique about this large oil painting is that you can barely see the bird at all. On a quick glance this picture looks just like an ordinary woodland, leaves green and yellow glinting in the sun, a fragment of blue sky peeking through. Only if you gaze at the painting a bit carefully will you soon see that there is a peacock in this forest, nearly totally camouflaged in the morning sun.

This is the work of Abbott Handerson Thayer, and over time it has become his most well-known painting. In its implied abstraction, "Peacock in the Woods" seems to prefigure the wild splashes of color that would culminate in the intense wildness of Jackson Pollock fifty years later, and there is no doubt Pollock himself knew of this painting through his study with Thomas Hart Benton. Second, Thayer is known as the father of military camouflage, the art of disguising articles of war, from uniforms to battleships, which began in earnest during World War I. It was Abbott Thayer, with the help of his son the writer Gerald Thayer, who formulated the visual principles of camouflage that made the artifacts of war difficult for the enemy to see. From observation of nature and the introduction of the latest aesthetic styles and techniques, art contributed to the military needs of society, a legacy that excites some while it troubles others.

Yet for Thayer, the stakes were much higher, concerning the very

Fig. 22. Abbott Thayer, "Peacock in the Woods" (1907).

aesthetics of nature itself. Heavily impressed by Darwin, he was swept up in the idea that every animal had evolved to perfectly live in its surroundings. But that, as you remember, is only half of Darwin's theory. The other half enraged him—Thayer was quite troubled by Darwin's whole notion of sexual selection to explain the evolution of taste and beauty. Such a frivolous explanation, he felt, was unnecessary, since every pattern and every coloration found in the animal world serves in fact to conceal animals, not to make them stand out and call attention to themselves. On the contrary, *all* animal patterning can be explained by the need to remain as hidden as possible at all times. Even what appears garish, including the tail of the peacock, is in fact a sophisticated form of camouflage that can dupe even such a great scientist as Charles Darwin.

Hence the invisible peacock in the temperate forest (a habitat,

incidentally, far removed from the appearance of the woods in the bird's native India). Or consider the beautifully abstract painting of a wood duck, which does live and nest in the temperate forest, in figure 23.

The very beautiful distinctive patterns of this, our most garishly colored duck, are yet another sophisticated coloration that has evolved to keep these animals elusive, especially hard to see. Previous observers of such colors in nature had missed the concealing qualities of the bird's plumage because they were not trained as artists, say the Thayers, and missed the truth of the bird, "liquidly alive with sober iridescence . . . from chestnut red glossed over with purple, through all degrees of blue to golden green . . . softly blended with clean-cut, sharp-edged markings." Then the black and white patches and stripes are "ripple pictures depicting motion and reflections in the water," all ingeniously evolved to hide the bird not by inconspicuousness but by "disruptive conspicuousness," coloration that confuses us into not even realizing the bird is there.

Listen to how much Thayer junior has to say about the single vertical black and white decoration that separates the male wood duck's breast from its wings in his father's painting. As this decoration seems to vertically cut the features of the bird right in half, it then reflects two specific kinds of detail in the duck's environment: "a narrow sky vista reflected side by side with a dark stem or tree trunk, and a sky reflection glancing from the side of a sharp, single ripple." This is just one observation in four pages of detailed discussion of the specific coloration of the wood duck, which he concludes has this effect: "Thus the ripple-marks he leaves in his wake and those that roll out from his further side are continued and repeated on his obliteratively-colored body, and this gives the final touch of perfection to his 'vanishment'" as he glides across the dappled surface of a lake. This, the most strikingly colored and bright of American ducks, has evolved all this glitter and frill to become truly invisible. Can this be true?

"The world has had enough," wrote Gerald Thayer, "of pictures of birds and beasts with their light-and-shade falsified to make them show." Real animals in their environment are nearly invisible, and we should realize that this is the crux of natural aesthetics. "Nature has

Fig. 23. Abbott Thayer, "Male Wood Duck in a Forest Pool" (1909).

evolved actual Art on the bodies of animals. . . . The forest vistas painted on animals' coats have been compounded and epitomized and clarified until only pure, essential typicality remains . . . just as in great human art, but far more essentially and surely." Thus art in nature, because it has evolved so rigorously for the purposes of concealment, is perfect, useful, but also beautiful. Concealment is thus the guiding principle of animal aesthetics—defining each species, but also based on a single aesthetic principle common to all species.

For the Thayers it was important that camouflage alone be enough to explain all the dramatic appearance of nature's creatures. Why did

Fig. 24. Flamingos in disguise at dawn? Abbott Thayer (1909).

they want only one principle to be enough? Because Darwin's two-part theory of selection was too messy. You have to hand it to the Thayers to work so hard to explain everything with camouflage—even pink flamingos. Flamingos are so hued not because they eat shrimp and other foods with carotenoids, but because at sunrise and sunset they should be invisible. Red sky at night, flamingo's delight.

In six hundred oversized pages, Gerald Thayer makes the case for the disruptive camouflage principle with the visual support of his father's paintings and diagrams. But is their theory true? Because of their artistic acumen, the Thayers were able to look at the beauties of nature and come up with aesthetic rules of color and shading that they then set down. These rules came to change the way we understood how to paint and design those things we wanted to make invisible.

If nature is full of conflict where its actors need to be secretive and hidden, so is the human world of war. See or be seen, the motto of nature, leads to survival of the most invisible, right out there on the battlefield. In terms of practical application, it did not so much matter whether all animal coloration had evolved for invisibility; more important was the idea that patterns that seem bright and overtly visible can in fact be used to hide an object. Cloaking doesn't mean simply blending in. Instead it can work by confusing the eye so that it cannot tell

where figure ends and background begins, be it a bird in the bush or a warship on the open sea. It's all about the practical sense of optical illusion that makes painting itself possible:

> It takes the eye of an artist . . . to recognize the wonderful truthfulness of all these pictures which Nature paints. . . . Is it any wonder that artists should feel keen delight in looking at the disguising-patterns worn by animals? They are, in the best sense of the word, triumphs of *art*; and in a sense they are *absolute*, as human art can never be. . . . Color and pattern, line and shading,—all are *true* beyond the power of man to imitate, or even fully to discern.

The Thayers truly love nature and sense the rightness of the form that is found there. Without the single Occam's Razor–like explanation of camouflage, they would be left in a state of suspicious unease, beauty without explanation. Sexual selection is clearly too frivolous for them, but their striking visual examples tell only the story they want to tell. Sometimes the wood ducks, peacocks, and flamingos are staring us in the face with their raw and spectacular coloration. The camouflage theory doesn't account for that, while Fisher and Prum's runaway sexual selection theory does. Prum suggests we assume the beautiful coloration that evolves is arbitrary, and work from there. Thayer and son take the opposite tack. And yet, with their deep attention to chronicling the specific nature of the beauty they see, the Thayers delve into natural beauty with an intensity few writers can achieve.

One person who found Abbott Thayer's clever illustrations laughable was President Teddy Roosevelt, who had just returned from an African safari full to the brim with enthusiasm for the spectacular appearances of zebras, giraffes, and a blue-rumped baboon. "Africa borders the Mediterranean Sea," Roosevelt wrote. "You could claim that if the baboon stood on its head by the sea you could confuse the animal and the sea, and that might tell you something about optics, but nothing about the real animal." So why are the Thayers so sure of themselves? "Ah," said the president, "these are the excesses of a certain kind of artistic temperament."

But Roosevelt wasn't laughing when he heard about some of the Thayers' experiments with boats. They took one sailboat on Lake Winnipesaukee in New Hampshire and painted everything on it entirely gray, and took another and painted the top of all objects on the boat gray, and the bottom portions of every box, table, rigging, mast, and so on bright white, just like all those wild animals with white underbellies and dark tops and sides. This is the principle of countershading, which the Thayers were the first to recognize. The results from a distance were astonishing—the plain gray boat was always visible, but the countershaded boat vanished into the background, becoming impossible to see. Now they knew that the concealing colorations they observed in nature could have practical military application. All that remained was for a war to come up that would require their services.

When the *Titanic* sank in 1912, Abbott Thayer wrote in despair of the grave error in imagining that icebergs are visible in the dark because they are white. It is precisely when they are the purest white that they are most impossible to see. A few months into World War I, Thayer urged the Allied forces to paint all vertical surfaces on their ships white and all horizontal surfaces gray, like the back of a seagull. This is the lesson they could have learned from the *Titanic*. Instead, wider influence from the world of art caused World War I ships to be painted in far wilder patterns, raw blocks of black and white and improbable angular patches of color that would really confuse the eye.

What is the role of aesthetics in camouflage? Evolution refines its creatures over eons of time, so it can claim a kind of certainty and expertise that human whim can only dream of. We appraise nature in awe and wonder, and it's always more than we'll ever figure out—an idea that is great, total, sublime, and still somehow *dull*. Nature is amazing, but it's not going to change as fast as humanity wants, with our drive to constantly revolutionize everything. We know the biosphere is more than we can ever be, and will as a whole outlast anything any one species wants to do. That's its total aesthetic power, and we are helpless in the face of it.

Camouflage, with its adaptive clarity, seems then to be the opposite of frivolous, whatever-we-like aesthetics evolved through genera-

tions of sexual selection. It's certainly too easy to say concealment explains every animal's color, but it is a valuable military strategy. The Thayers were certainly not the only ones on to it. At the same time, artists with other influences were realizing they could directly aid their respective countries by using their particular talents to disguise the articles of battle. French painter Lucien Guirand de Scevola, working as a telephone operator in an artillery regiment in late 1914, realized that he could make a cannon harder to see by painting it with abstract, angular black and white shapes, a technique later named *zébrage*. Modern camouflage may have begun with Thayer's wood duck, but it moved on to wild cubist abstraction, an amalgamation of all the artistic movements going on at the time.

When Pablo Picasso saw one of these fantastic cannons being wheeled through the streets of Paris in 1915, he said, "It is we who have created that!" Famous cubists such as Picasso and Braque were never directly involved in any of the *camoufleur* regiments that both the French and the Americans were setting up in the later years of the war, but lesser-known artists influenced by the legends were clearly applying these principles out there in the trenches. Meanwhile, the Germans stuck with more traditional impressionist tones of uniform camouflage, though they did produce a curiously Mondrian-like helmet. Coincidence? The direct influence of art on warfare? Such imagery and ideas were in the air, flowing from aesthetics to praxis and back. Figure 25 shows André Mare's sketch from within a *camoufleur* team on the Western Front.

There is debate over just how much specific influence cubism had on camouflage development, since as art cubism was rather unpopular at the time, especially in France. Looking back a hundred years later, it seems obvious that the art influenced the warriors. Or were they simply happening at the same time, a kind of convergent cultural evolution? Ideas circulate in the air, individuals at any one moment have all the same roots and antecedents, so artists and science catch the same whiffs of the new. When I look at dazzle battleships today, they seem more radical and arresting than the angles of the cubists or the wham-bang words of the futurists. People actually painted battleships to look like this and thought they'd be invisible. (See figure 26.)

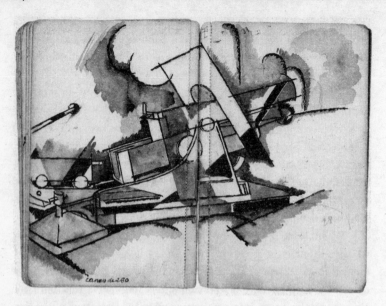

Fig. 25. André Mare's cubist cannon.

How did such wild abstraction come to be practiced by an organization as staid as the Royal British Navy? It took a visionary a bit more levelheaded than Thayer. In 1914 Glasgow professor of zoology John Graham Kerr wrote a letter to Winston Churchill, then First Lord of the Admiralty, reiterating Thayer's principles of disruptive coloration, found throughout the animal world to cloak all kinds of creatures. According to countershading, ships should be dark above and light below, following Thayer's suggestions. But learn also, says Kerr, from the zebra, and consider irregularly breaking up the coloration of ships vertically with angular areas of black and white, to "destroy completely the continuity of outlines by splashes of white." Here humanity would not simply be copying nature but expanding upon nature, improving nature's colorations to hide big boats that are nothing like the animals that nature had evolved. Churchill was not yet interested; such ideas suggested frivolity, excess, waste, and weren't going to improve upon the traditional seriousness of naval coloration: solid, serious, imposing gray.

Fig. 26. A World War I dazzle-painted ship.

"Such proposals," said Captain Thomas Crease, assistant to the Admiralty, "are of academic interest but not of practical advantage." While Thayer the theory-mad artist was considered too full of himself to be taken seriously, Kerr was perhaps also too theory-bound to realize that out on the water, light conditions are constantly changing, so any fixed patterning is going to be visible at some times, invisible at others.

In actuality, there is no way to hide a giant warship on the open sea. But it can be painted to deceive an observer nonetheless. The idea is that if you paint broad swaths of black and white patterns on big boats that run counter to the actual features on the ship—size, number of guns, direction of movement—a distant viewer will be confused by the sight and be unable to tell how big the ship is or which way it's moving.

British artist Norman Wilkinson is the man who claims to have invented dazzle painting and named it as such. Under his direction, the Royal Navy painted fifty ships, each with a different pattern, and when tests were done, most observers were successfully perplexed and could hardly tell which way the ships were going. By June 1918 more than two thousand British ships had been painted in the dazzle style. The American navy then requested to borrow Wilkinson for a few months, and one high-ranking admiral screamed, "How the hell do you expect me to estimate the course of a goddamn thing all painted up like that!"

which of course proved the advantage of dazzling the fleet. By the end of the war, twelve hundred American ships were similarly decorated, adding the further innovation of breaking up the patterning into separate blocks of patterned areas, further confusing the viewer. This version of the style was nicknamed "jazz painting" or "razzle-dazzle," echoing the hippest music of the day.

Wilkinson didn't like this, because it made it seem like the camouflage scheme, like the music, was some kind of American invention. It hardly mattered, since dazzle painting was everywhere, a great artistic innovation that blended cubism and animal camouflage into something new, hip, and exciting. By 1920 there were dazzle-painted women's bathing suits that made it nearly impossible to assess the figure of whoever was swimming in it.

When I first came across pictures of dazzle boats, I couldn't imagine they came all the way from World War I. They looked so contemporary, even futuristic. Why were World War II ships all clad in gray, and why don't we see battleships painted so dazzly today? At the very end of 1918 doubts about the system's real value began to creep in.

Captains in the Mediterranean thought that the use of white paint was dangerous, making ships unusually visible on moonlit nights in their warmer waters. The British navy conducted a study and determined that dazzle painting was not particularly effective. Sixty percent of attacks on dazzled ships resulted in damage, compared to 68 percent of attacks or nondazzled ships. And 40 percent *more* dazzled ships were initially attacked than the nondazzled ones (1.47 percent dazzled, 1.12 percent nondazzled, so not a huge percentage in any case). The statistics were inconclusive and used as fodder for both sides of the argument. It may be that the most valuable aspect of dazzle painting was to increase the morale of men at sea. Cruising in the middle of a dazzled convoy was like traveling through a floating art museum. The exciting appearance of these great ships was met with great acclaim by the public whenever they sailed by. The naval war was not cold, merciless, and gray but beautiful and spectacular—a heightened aesthetic experience in which artists and scientists had together exploded principles of nature into a grand experiment of perception and illusion. Who wouldn't con-

sider these grand paintings part of the history of human art inspired by
ideas about nature and revolution both?

THE art world for the most part has ignored such amazing works as
these, because it could not really contain them in its arenas of muse-
ums, galleries, or any other temples of purely aesthetic enjoyment. In
fact, most people are as surprised as I was to discover that thousands
of World War I ships were painted in unique patterns like the one in
figure 26 and that people cheered them and loved them, perhaps not
recognizing that these were the most contemporary principles of avant-
garde art put to practical use. The aesthetics here is a mix of the prag-
matics of Thayer's one-sided naturalism with the exuberance of cubism,
or maybe it's all some kind of convergence in a culture that was confront-
ing the tragedy of a great war with the experimental mood of the age.

It may have been the shocking beauty of dazzle-painted battle-
ships that made this camouflage technique so popular in World War
I. Statistical doubts about its value did push the technique under-
ground in the years following the war, but dazzle painting was con-
tinued by the American navy on all Tennessee-class battleships in
World War II.

Whether or not it works, dazzle camouflage remains an exciting
aesthetic derived from nature, a form of biomimicry, a word used when
humans imitate living nature to make something useful. Do we like
camouflage because it works or because it looks cool? Because it proves
nature is efficient or because it reveals nature to be flamboyant? Sci-
ence never believed Thayer to be correct, because animal coloration
and evolved aesthetics sometimes want an animal to stand out and be
noticed, never only to hide. But if hiding turns out to be enhanced with
bold, garish colors, the distinction between visibility and invisibility
gets much more woolly. Beauty in itself can have contrary purposes,
work in mysterious ways. Adaptive coloration may not be something so
separate from sexually selected gaudiness. We had learned the nuances
of camouflage through trial and error, but we still lacked a comprehen-
sive, rational theory of how it really functions.

The British naturalist Hugh Cott was the next innovator in the attempt to push humans to learn camouflage principles from the way nature really worked, not just what our intuition tells us. In 1940 he was distressed that London double-decker buses were being hastily painted on top with the standard fuzzy oval shapes of tan, brown, green, and gray, while the front, back, and sides were still red, making them even more conspicuous from the air and possible bombing by the Germans. Had nothing been learned from the forms of cloaking that work in nature—had they forgotten the whole countershading debate of the previous world war? Cott's grand volume *Adaptive Coloration in Animals*, a five-hundred-page copiously illustrated tome, does not push a single extreme vision, as Thayer did, but instead presents the following distinct cloaking strategies used in nature: merging (rabbit, grouse, polar bear); disruption (plovers, zebras, moths); disguise (stick insects, leafy sea dragon); misdirection (butterflies, tropical fish); dazzle (grasshoppers, wood ducks, peacocks); decoy (angler fish, spiders); smokescreen (cuttlefish, squid); the dummy (flies, ants); false display of strength (toads, lizards, birds). Seventy years later it is still the best book on camouflage ever written.

Infantrymen packed this heavy book in their kit bags so that they could study out on the front Cott's unique blend of evolutionary science and artful descriptions of the veiled beauty of nature, all cast in contemporary wartime language:

> The fact is that in the primeval struggle of the jungle, as in the refinements of civilized warfare, we see in progress a great evolutionary armaments race. . . . The perfection of concealing devices has evolved in response to increasing powers of perception, which in many predatory animals, and especially in birds, are of such an order that there is no reason to believe that even the most elaborate cryptic uniforms of tropical insects . . . have been developed beyond the degree of usefulness.

Cott thus becomes the first writer to introduce the metaphor of the arms race into biology, and he nearly swallows it whole, with no ap-

FIG. 12.—*Cardioglossa gracilis* FIG. 13.—*Eques lanceolatus*

Fig. 27. Disruptive camouflage in frog and fish. From Cott's Adaptive Coloration in Animals.

pearance evolving in nature beyond usefulness. But study his writing, and you'll see that beauty is tremendously motivating to him; what Cott added to the study of camouflage is more concern for how animals see each other, not just how we see them.

When I heard that this volume was popular wartime reading for soldiers, I found it hard to believe until I got my hands on an old, dusty copy and found I couldn't put it down. Already by 1940, Cott felt a nostalgic yearning for an age when people studied nature more seriously because they were not yet saturated with imagery. "So dull and dead have we become as a result of visual experience, that to appreciate the wonder and wealth of colour around us we must be shown our surroundings in some novel or unusual manner—in a picture for instance." Artists, with their patient striving, work hard to recover the gift of seeing—what Ruskin called the "innocent eye"—to scrutinize the world and reveal the wonder that is actually there. Visual form can be grasped when we sense the differences in nature of color, shade, and form. Cott calls the ways animals influence other animals by sound, sight, and scent "allaesthetic character," and he organizes these into three main categories: concealment, disguise, and advertisement, the three offering up features elusive, deceptive, or attractive.

Cott is quick to mention that concealing coloration is only one part of the story. He pays close attention to the difference between coincident disruption and differential blending. Disruptive coloration is nature's answer to dazzle painting. With the examples of East African tree frogs and the jackknife or horseman fish, we see how garish pattern-

Fig. 28. The selective disguise of moths. From Cott's Adaptive Coloration in Animals.

ing on creatures makes it hard to judge where their outlines end and their habitat begins.

On the other hand, differential blending offers up more fuzzy patterns that blur into the surroundings, as on many moths and birds.

Cott is also impressed that cryptically hidden creatures sometimes flash into brilliance when they move: the bright black and white in the hoopoe lark as it flies, or the flashes of color in flying lizards and grasshoppers, who surprise us with brightness as they move. So in a single species, there may be color conflict between the need to stay hidden and the desire to attract. In fact, the great puzzle in nature is how the very same processes of color balance and relationship lead to both standing out and slipping in, as advertisement and concealment are in a way one and the same.

Countershading, Thayer's great discovery, is, in the real animal world, not so simple as dark above grading into light below. A wide va-

Fig. 29. Basic camouflage patterns, according to Cott.

riety of complex patterns blend to create this important disguising effect. (See figure 29.)

These beautiful patterns all serve the same function, but the variety shows how many distinct ways the countershading effect can be created by patterns that nature has evolved based on the underlying chemistry and physics of life.

Pattern, notes Cott, can transcend anatomy, suggesting that the visual aesthetics of living forms independently from organismic development. Think of the coincident patterns on the backs of snakes, toads, and birds that "cut right across different organs or parts of the body, so that underlying anatomical features become entirely subordinate to the illusionary appearance superimposed upon them." These patterns evolve for ecological reasons, as they define the creature along with its place, just as flowers evolve colors and forms to attract those destined to pollinate them. Why certain colors? Why certain forms? With his compendium of ingenuity, beauty, and archetype, Cott wants to present a rigorous functional explanation for everything lovely he finds, but at the same time it is clear that wonder at the marvelous diversity of pattern in animals and plants is what has lured him into the whole subject. It is, though, wartime, and he does hope that the military will learn

from the power of imagery: "In nature visual concealment and deception have proved one of the main means of obtaining those two life essentials—security and sustenance. In everyday matters, opposite devices making for conspicuousness possess also a power—whether in the form of street signs or lip-stick—which is universally recognized."

Animal disguise has evolved, human disguise is invented. Human camouflage, argues Cott, is suffering from arrested development, still stuck in its infancy from World War I. Both have parallel needs, "the capture of prey or the capture of markets; the frustration of a predatory animal or of an aggressive Power." We need all the help we can get to fight the axis of evil! Close attention to the cloaked beauties of nature will help us win the new war.

Camouflage did become much more scientific in World War II, and in the decades afterward it has even become chic. What we think of as the standard camouflage pattern of green, brown, and gray blotches was based on the more impressionistic pattern used by the Germans in World War II, then refined at a U.S. Army research lab in 1948, but not introduced in combat until the Vietnam War in 1967. It was tweaked in 1981 and became officially known as the woodland pattern. Since then, though, it has become a fashion statement and appears on all kinds of clothing. Is this ironic? Surprising? No. In fact, the popularity of camouflage is a key to my story—people like the patterns that seem to abstract from the full possibilities of nature designs with that special ability to make us stand out just exactly at the same time as we blend in. The same patterns might have simultaneously different functions; perhaps the fact of the pattern comes before its purpose in the great hierarchy of things. This may easily sound like heresy in a world evolved through fitness and adaptation, but fitness and adaptation alone are *boring*. The beauty of fitness and adaptation are central to their success.

Camo spandex pants, camo hats, camo undies, pink and yellow camo backpacks—we've seen them all as we try our best to act and dress as flexibly as squid. Standard camo patterns were ubiquitous all over the world's military uniforms until the army started doing more

Fig. 30. Razzacam, an as-yet-unsold camouflage pattern from the HyperStealth Corporation.

advanced psychological research into visual perception in the 1970s and realized, with the help of the latest mathematics, that natural coloration and texture have a fractal element, a certain random micro detail that presents multiple levels of visible pattern at vastly different scales, but all built on related principles.

Put this idea into camouflage and you can dither it into overlapping scales, like adding the leaves to trees, the crenellations into the rock, so even what we think of as the familiar camo pattern becomes confused through levels of disruptive coloration at macro and micro scales together. This is how we get the latest advance in military camouflage, with pixelated and dithered patterns that are dizzying to look at, confounding our ability to parse their organizational structure. Many of the latest patterns were developed by Guy Cramer and Lt. Col. Timothy O'Neill of the aptly named HyperStealth Corporation. Some of their patterns are functional works of abstract expressionism, and I could well imagine them becoming fashion statements in a decade or two. Figure 30 shows their experimental pattern, Razzacam, based on the dazzle camouflage of World War I ships. Would it work with people? You

MACRO PATTERN MICRO PATTERN

Fig. 31. The theory behind Optifade, the first camouflage designed from the animal's perspective.

can hardly tell where the human ends and the world begins. Where will these disguises be most effective? Or is that really the point? Maybe what's better is that they just look so cool.

So far no military organization has yet taken on any of these razza patterns, but I'm sure they have a future in the world of fashion. There is, though, an even wilder pattern that has proved useful. W. L. Gore, the ever-innovative makers of Gore-Tex, the first waterproof fabric that breathes, hired HyperStealth in 2008 to develop a pattern for them called Optifade, based upon a theory they strangely call "the science of nothing." After detailed research into what deer can actually see, together with the latest application of fractal mathematics to Cott's principles of disruptive coloration, they claim to have created a camouflage pattern that makes hunters nearly invisible to their most common prey, the ungulates who are basically red/green color-blind and in general possess 20/40 vision rather than 20/20. So much for the great visual acuity of wild beasts! There is a micro pattern of tiny squares

Fig. 32. An Optifade jacket.

fractally calculated to match the spatial frequency of the basic land-scape, and superimposed on this is a macro pattern of disruptive color-ation so the animal can't tell where the hunter ends and the forest begins.

This is the first camo pattern designed to fool the deer, not the hunter, so it doesn't look like any photorealistic copy of a bunch of au-tumn leaves! The clothes themselves retain some of the confounding quality of those flapper dazzle bathing suits.

Hunters report that it works amazingly well, that they're aston-ished how closely they are able to approach a deer without the animal having any idea that they are there. (A few critics wonder if humans need this kind of advantage in the contest.) Science helps with conceal-ment once again, with the rather obvious revolution of us looking at the world from their perspective. And it presents a new kind of futuristic cool, something I'm tempted to wear around an urban jungle, if only for the theory of it. Camouflage is still at the cutting edge of human aesthetic sense.

So the latest camouflage research has its phenomenological side, em-phasizing what it is like to see the world as an animal might see it, not how we see it. Here the most exciting work is being done with

cephalopods—the squid, the octopus, and their relatives, who have bodies covered in cells called chromatophores that allow them to adjust their appearance at will. They can decide when and how to be visible or invisible. Here is a class of animals that make camouflage a matter not of evolution but of free choice.

Nowhere is this behavior more amazing than in the antics of the giant cuttlefish, a remarkable squid about the size of a large flounder. This is an animal most unusual in its camouflaging prowess, because it seems to have total control over its visual appearance. Charles Darwin already realized, a century and a half ago, that they were extraordinary:

> These animals also escape detection by a very extraordinary, chameleon-like power of changing their colour. They appear to vary their tints according to the nature of the ground over which they pass: when in deep water, their general shade was brownish purple, but when placed on the land, or in shallow water, this dark tint changed into one of a yellowish green. The colour, examined more carefully, was a French grey, with numerous minute spots of bright yellow: the former of these varied in intensity; the latter entirely disappeared and appeared again by turns. These changes were effected in such a manner, that clouds, varying in tint between a hyacinth red and a chestnut-brown, were continually passing over the body. . . . These clouds, or blushes as they may be called, are said to be produced by the alternate expansion and contraction of minute vesicles containing variously coloured fluids.

The squid or octopus can blend into almost any underwater background it naturally finds itself swimming in. But if it doesn't want to blend in, it can place upon its body a series of pulsating, moving, dazzle-like stripes. It can even mix and match, making one side of its body appear invisible and the other side pulsating and patterning. They can communicate with each other by setting off moving patterns all over their skin, all the while being basically color-blind. They can disguise themselves to hide upon colors that they can't even see. Males

Plate 1. Abbott Thayer believed even the peacock's plumage was a form of camouflage.

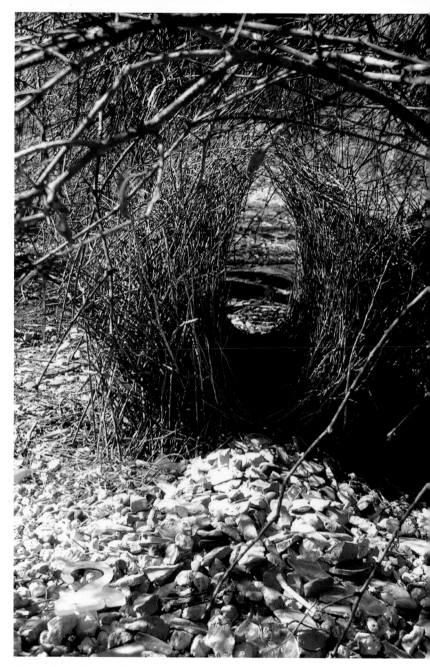

Plate 2. A satin bowerbird's bower.

Plate 3. A sculpture by Patrick Dougherty, "Na Hale 'o waiawi" (2003).

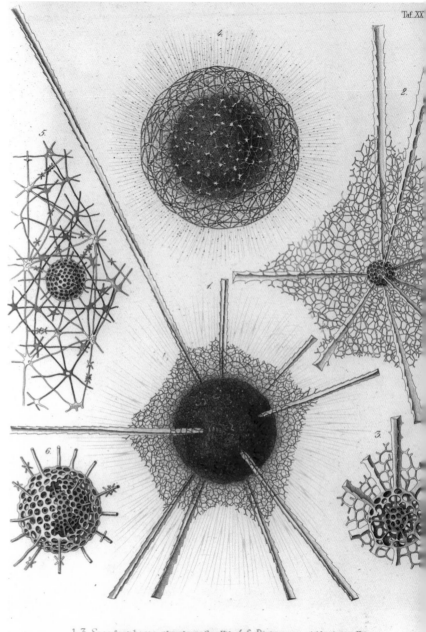

1-3. Spongosphaera streptacantha, Hkl. 4-6. Dictyosoma trigonizon, Hkl.

Plate 4. Haeckel's art.

Plate 6. Abbott Thayer's wood duck, invisible upon a pond.

e 7. Three WWI dazzle-painted ships, inspired by Thayer's duck.

Plate 8. Hugh Cott's camouflaged potoo.

Plate 9. A giant cuttlefish invisible in shallow Australian waters.

Plate 10. Ad Reinhardt, "How to Look at Modern Art in America" (1946).

Plate 11. A detail from Brad Paley's conceptual map of the sciences.

Plate 12. Jane Richardson's pastel of a folded protein, the most famous example of how art has aided science (1981).

te 13. A detail from Evelina Domnitch and Dmitry Gelfand's "Camera Lucida," a chemical artwork.

Plate 14. Alexander Ross, "Untitled" (2009).
(Courtesy of David Nolan Gallery, New York)

e 15. Thomas Nozkowski, "Untitled 7-61" (1995).
tesy of Pace Wildenstein Gallery, New York)

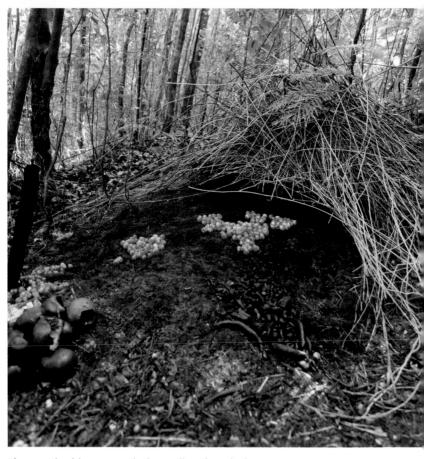

Plate 16. The elaborate artwork of a Vogelkop's bowerbird.

can suddenly change their appearance to look like females for the purpose of distracting other males.

How are they able to assess their situation in the environment and decide whether to stand out or blend in? We have no idea how this animal is able to turn its chromatophores on and off. These creatures are like virtual-reality avatars, changing their physical shape and appearance in forms of interaction we can barely grasp. Cuttlefish and related cephalopods, such as the mimic octopus, suggest a possible future direction for dazzle camouflage: how about confusing patterns that move all over the bodies of our soldiers and ships? The enemy would sure be confused then.

You might call cephalopods the bowerbirds of the underwater realm, not because they make art in the form of sculpture but because they are another wildly extreme order of animals. In elucidating the beauty and complexity of forms of life in nature, extremes make the most interesting examples. Just as bowerbirds shifted the notion of art in birds beyond dramatic experience and performance into the making of astounding artworks, squid turn the range of animal patterning into something dynamic, not static, so in a single kind of animal we may find the full range of natural patterning, some kind of universal pattern engine in one single beast. Thus they might be the ideal model species with which to examine the idea that natural patterning on an animal might follow some kind of basic, fundamental laws, which can help us in our mad quest for some evidence of aesthetic ideas in the very way nature is put together.

Roger Hanlon is the dean of squid researchers, and he's done careful work on cephalopods at the Woods Hole Marine Biological Laboratory for many years. In his 1996 book *Cephalopod Behavior*, coauthored with John Messenger, he notes twenty-one chromatic signals that many species of cephalopod are able to turn on and off at will all over their bodies: general paling, intense whitening, general darkening, pulsating flashing, a passing cloud formation of dark moving waves, the conflict mottle, dark longitudinal stripes or streaks, dark bars, bands of rings, dark spots (large or small), dark eye rings, dilated pupils, the sudden appearance of false eye spots, dark waving arms, white- or dark-edged

suckers, zebra bands (or flame markings), lateral mantle blush, dark or light fin lines, accentuated white gonads, accessory red nidamental glands, and, last but not least, blue iridescent rings.

These creatures are living, underwater-breathing examples of fluid organisms that express themselves with something akin to dynamic tattoos, which can be combined with a stretching and pulling of their own body forms to morph themselves into all manner of contortions for a startling or bluffing effect on their potential prey. The computer scientist Jaron Lanier has written that people would be far more excited about cephalopods if we hadn't seen so many animated characters do the kind of things onscreen that squid actually do under the water. They are another anomaly, a curiosity of the animal world that may hold the key to a natural aesthetics of pattern and form, of the relationship between camouflage and revelation. A single animal intelligence possesses the unique ability to change its appearance at will, taking all the tricks of disguise and startle and melding them into unique combinations. Once again it brings up the question whether blending in and standing out may not be so different at all.

In the "passing cloud" displays, cuttlefish and octopi turn their chromatophores on and off in a synchronized manner so that dark cloud-like shapes appear to flow along the body of the animal. In the "flamboyant display" they flail and distort their arms, suddenly turning on disruptive coloration. Either they suddenly sink into a background of floating weeds with this technique or they show a threatening posture. Sometimes they use blinking bioluminescence to either startle or bluff, and then there is a class of activities named "protean behaviors" that are just too complex to explain—for example, performance of a whole series of distinct body patterns one after another: pulsing bands, longitudinal bands, sudden eyespots, passing clouds, glowing fins.

As with the mad sonic displays of mockingbirds or lyrebirds or the dances of cranes, we know not why an animal should have evolved such astounding abilities. Some even say that to ask for a reason for the precise nature of such complex animal abilities is not really a scientific question. Evolution has given us a realm of possibilities, from the usual adaptive to the extremely sexually selected and (in the case of squid) the

extremely adaptive. Did squid *need* to evolve in this particular way, with this level of craziness? The possibility was there, and chance won out—this family of animals became blessed with nearly magical abilities, abilities whose neuronal origin we can so far only imagine.

Cephalopods have this repertoire of skin color signals they can turn on and off for a whole range of purposes. Way back in the beginning of the twentieth century, Wilhelm Bölsche already knew about their wildness. For him the cuttlefish was yet another example of the vast sexual possibilities nature offers:

> In the sand it is a drab brown, like a hare. A sudden start, and the cuttlefish in the water becomes a black-striped zebra. . . . The drab brown at the bottom was protection. The zebra gear is threatening rage, spectacular color. . . . Do you see another cuttlefish placidly rocking itself in the water high above? Is it a "she," the one whom the little he-zebra loves and over whom he has kept jealous watch from his concealment in the sand? Now another male cuttle exhumes himself from his hiding place and . . . like a dreamy boy, has begun to rise upward toward the region of the female. Quick as lightning the legitimate suitor dashes after him, turning into a furious zebra. "Come on, look at me, I dare you," glittering daggers pulsing from every stripe! The rival, seeing himself caught, loses his keenness for the love adventure, and drops down as quietly as he has come up.

What no one quite knew back then was just how expert and nuanced cuttlefish camouflage could be. One side of the animal can be camouflaged, while the other side might put on a dazzling display of color, perhaps to remain hidden on one side while psyching out his prey or a predator on the other side or trying to impress a possible mate. Probably the most complex practical example of the intelligent use of selective color change is seen in a remarkable film made by Hanlon, where during mating season, when male cuttlefish are competing for the attention of females, a big male is getting ready to mate with a female, and suddenly a smaller male tries to muscle his way in. The

little guy suddenly changes his body color to resemble a female, with her more brownish coloration. All of a sudden the big male is distracted and tries to mate with the smaller male, who then suddenly changes his appearance back into that of a male and quickly slinks in and mates with the female. "Huh?" the big guy might be thinking. "What was that?"

Such are the practical uses of advanced control of the color of one's body. Hanlon and Messenger present a table that summarizes the function of these different colorations a squid's skin can take, presenting the standard range of Darwinian encounters. A female presents the pattern of vertical bar, bright white, arms drooped, meaning "court me." Males present an ipsilateral color of bright white, contralateral dark, meaning "males keep away, females stay near." Between males appear great contests of sudden zebra displays going against lateral flame markings and sudden eyespots, each competing as if to say, "I am stronger, fitter." So the standard story of sexual struggle goes, with the unique chromatophore tools only squid and octopi have.

When feeding, they put on the passing cloud display of dark moving waves. This sends the signal "stop and watch me," mesmerizing their prey. Then *thloomp*—the tongue goes out and the watcher is quickly eaten. The related flamboyant display of dark mottle, arms splayed up like a kung fu master, is a thick, heavy texture, saying, "You, predator, see my weapons. I am large and fierce. I *dare* you to attack me," and usually they're left alone. Such are the parallel uses of the same techniques.

Some scientists have pointed out how much in common these squid repertoire have with the complex behavior of birds, with their visual signals having directional transmission and reception, rapid fading, interchangeability, specialization, arbitrariness, discreteness, and some kind of semantic qualities, where different gestures mean distinct things in distinct contexts. But squid display seems to be innate, not learned, so it would be inaccurate to say these animals have a kind of culture the way whales and birds do. The babies can do much of the same chromatic stuff as the adults, leading Jaron Lanier to conclude that the main thing missing from the cephalopod life cycle is childhood: if squid had childhood, they might have evolved the kind of

learning that leads to whole civilizations and deep reflective thought—mostly a metaphor, in his writings, for how to assess these creatures, which are the real-world examples of virtual reality in their ability to form and re-form themselves to send messages to each other about aspects of underwater life we can hardly fathom or imagine.

What are we able to most learn from these masters of disguise and body art? Most pointedly, a nuanced approach to the whole question of camouflage, the study of which has so far been based more on arbitrary human categories than anything learned directly from nature. Martin Stevens wrote in 2007 that we need more research on how animals perceive camouflage, rather than what we humans see and are amazed by in the animal world. We must get beyond our natural human prejudice, which wants to see things our way. Since so much interest in camouflage has been generated by attempts to improve human military camouflage, we may have missed the most important aspects of it, how animals see each other. How, for example, are dazzle and disruptive patterns really related? Both seem to shock the visual system through apparent confusion. Are they in fact distinct mechanisms or approaches? One emphasizes high contrast to disguise things in motion, such as zebras or World War I battleships. But the other uses visual confusion to hide objects in their surroundings. How different are these processes, especially from the animals' perspective?

This is what Roger Hanlon, having worked for so many years with cephalopods, has to say about the question:

> In our work with cephalopods and fishes (having access to video and thousands of images of camouflaged animals under natural conditions), it seems that there may not be a compelling reason to separate background matching and disruptive coloration too distinctively. These two mechanisms are, after all, to some extent human conveniences to help understand the complexities, the compromises and the continuum of camouflage. It may be beneficial to . . . define quantitatively those examples of animal patterns that may be designed to achieve specific versus general background matching . . . "in the eyes of the predator." . . .

Fig. 33. Roger Hanlon's basic cuttlefish camo types.

A future step might be to determine what aspects of the visual background lead to divergences between the pattern deployed by the animal and the statistical properties of the background. Moreover, if a certain background evokes a body pattern that has background matching as well as disruptive features in it, then we can (hypothetically) begin to sort out which visual background features cause this intermediate, or hybrid, pattern. Perhaps these approaches can begin to bridge the continuum between the seemingly interrelated tactics of background matching and disruptive coloration.

Previously Hanlon and his team had summarily organized all the seemingly vast possibilities of squid camouflage (never mind all those other wild transformations for the moment) into uniform, mottle, and disruptive patterns.

These three basic strategies seem to be all that is needed for cephalopods to cloak themselves in whatever background they find themselves in. It is quite mysterious how they are able to perfectly match background colors even though they themselves are color-blind, but this fact seems to show that a sensitivity to luminosity is enough to deal with the natural environments the squid find themselves confronted with. Laboratory studies done with cuttlefish on checkerboard

Size class
(mantle length)

6
(17.47 cm)

4
(6.87 cm)

1
(0.86 cm)

Check area 12% 40% 120% 400%

Fig. 34. Cuttlefish trying to blend in upon checkerboards.

backgrounds of various sizes (see figure 34) have revealed at exactly what scale they turn from uniform through mottle to disruptive approaches to blending into this artificial environment, of the kind they would never naturally encounter.

These cuttlefish have only eleven color areas on their backside that can be independently turned on and off for cloaking purposes, but you can see that this number is enough for a range of possible disguises and reactions to this unfamiliar high-contrast world.

And it seems that in the wild, these distinct categories may seem to blur. With an Australian cuttlefish traveling over a busy sea floor, it can be hard to tell what is disruptive camouflage and what is background matching. Armed with a mélange of camouflage techniques (see figure 35), the cuttlefish can decide whether to blend in or stand out, as its brain proves that it is a master of basic natural pattern principles.

Figure 36 is the one cuttlefish picture that really does it for me. This nearly invisible creature is incredibly beautiful, not only because he can hide so expertly but also because he is an artist who is able to slide so easily between the visible and the invisible. I was going to write that he *knows* what the difference is between blending in and standing out, but of course we can say nothing of what cuttlefish know or don't know. Cuttlefish, squid, octopus, cephalopod—all these names are strange

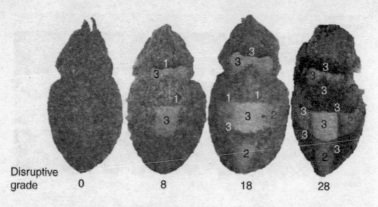

Disruptive grade 0 8 18 28

Fig. 35. Cuttlefish camo strategies.

and remote for such astounding creatures. We don't even know how to talk about them! Jaron Lanier writes that as he watches cuttlefish morph into all manner of strange colors and shapes, he is filled with one emotion: jealousy. "In order to morph in virtual reality, humans must design morph-ready avatars in laborious detail in advance. . . . [We cannot] improvise ourselves into different forms." He is not impressed by those who are trying to demonstrate that with their on-and-off, left-side-one-pattern/right-side-another behavior with and to each other, that cephalopods have something akin to a language. No, says Lanier, these squid and their kin are way beyond language, because they communicate by changing their whole being, shape, form, and color into wildly different things.

They operate, he thinks, in the world of postsymbolic communication, where if you want to think "zebra pattern," you just cover yourself with the zebra pattern. If you want to think "passing clouds," you become the passing clouds. It's the old Zen idea of dissolving into the moment, sinking into the background so precisely that at that instant—*ah!*—you reveal that you suddenly stand out. Camouflage is advertisement, invisibility is the shock of surprise. Our hunt for reason and strategy may deny the raw beauty of an animal's pure control of instantaneous pattern. What would it be like to feel this? "This is an extraordi-

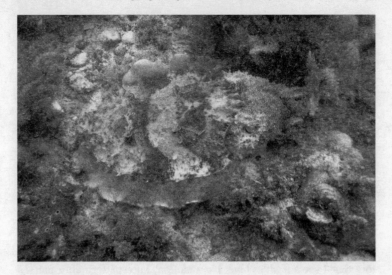

Fig. 36. Cuttlefish camo in the wild, from Australia.

nary transformation that people might someday experience," writes Lanier. "We'd then have the option of cutting out the 'middleman' of symbols and directly creating shared experience. A fluid kind of concreteness might turn out to be more expressive than abstraction."

So let's not imagine that the squid might have a kind of communication a little like ours; let's realize instead how they achieve something amazing we can only dream of and invent complex software to emulate. They communicate by directly changing their form into something new. They are beyond symbol. Their message is their bodies themselves.

Sure, it's easy to get carried away. Of course we really know nothing about them. We gawk at them and delight in what we see. Who knows what it's actually like to be a squid?

As the mockingbird plays fancy and free with all the bird sounds in its realm, mixing and matching them according to precise codes and rules, the cephalopod plays with our very notions of pattern organization. Background matching or disruptive dazzle—what do such human categories really have to do with what the cuttlefish can do? They play

with natural color like it is putty in their hands, color in their brains, chromatophores turning on and off at will. They are the masters of the full range of natural pattern, all its possibilities to be used in any situation of encounter, with members of its own species to mate with or fight with, other species to eat or be eaten by. In a way they are prime examples of the adaptive-struggle vision of how evolution works. Or are they?

The more I read about these amazing underwater beasts, the more I think that since we have so much imagery and data about them, we can try harder to actually think like a squid. As I wandered in the forest yesterday—a hot spring morning, the dappled sunlight shining on the green leaves, the brown forest floor—I saw a landscape all awash with patterns, then with sudden movements. A brown butterfly flits by, but look, the edges of its wings are bright blue. Why? To hide, to advertise? Sure, the flitting of the insect does those things. But before that I see a flash of blue, I see motion, I see pattern after pattern overlaid on each other. I know this is Earth, not another planet. We have a way of organizing life, color, shape, and design here. I move not to be visible or invisible, but just to move. There is a way things grow, a shape that they take. I imagine how it would be to suddenly blend in or to stand out without having to change any clothes.

The deeper one goes into the aesthetics of camouflage, the more often one comes across this perplexing conclusion: blending in and standing out can be accomplished with the very same pattern. Disruptive coloration, like back in the days of dazzle-painted warships, can make one invisible by being astonishingly visible. The pattern aesthetics of nature are a wash of confusion? Not really, but there are roots of a system here. The cephalopods are the masters of pattern recognition and pattern painting. Not only do they know instinctively the best reasons for changing one's appearance at will or on the fly, but they have encapsulated the basic principles needed to understand pattern.

Ruth Byrne, at the Konrad Lorenz Institute of Evolution in Austria, has completed the most systematic work on the notion that the visual behavior of squid could be looked at as a language—let's call it "squiddish" (not a bad word at all, somewhere between "itchy" and

"squeamish")—and she has schematically analyzed the components that make up the wide range of display and body patterns of one particular easy-to-observe species often seen by scuba divers, the Caribbean reef squid. For example, the most complex of patterns on this animal is a double-signaling arrangement, where a male presents an aggressive zebra pattern on one side of its body to a rival male swimming beside him, while the other side of the body offers up the stripe display to a female, indicating sexual arousal. If the other male and female switch positions, the patterns spontaneously switch, revealing that the reef squid, among many other cephalopod species, can send one message with one side of their bodies and a completely different one with the other. Or perhaps they are schizophrenic enough to fight and love at the same time. So the double signal display can be broken down into all the following components: brown mantle, head, and fins; mid-dorsal line; zebra left mantle; stripe right mantle; fin dots both sides; zebra left fin; white right fin edge line; teardrop head; blue-green eyebrows; pale arms both sides; zebra left arm; brown tip right arm only.

It's all described on a most understandable Web page, a clear and simple description of the way just one species of cephalopod is expertly in control of the full range of possibilities of its own visual appearance. Figure 38 shows this one most complex display in the context of three other reef squid patterns.

Can such displays be said to possess a grammar? Martin Moynihan was pushing toward it in his 1982 summary of research with this reef species as the model. "Many patterns are designed to be overlooked or misread by some, not all, potential readers. They are designedly tricky." He goes further out on a limb: "There must be some sensible logic behind or beneath the most glittering or opaque surfaces. Bullshit baffles brains, but perhaps not indefinitely. Truth may out." You see what studying squid does to the minds of biologists? Start to look at these components of ceph displays as standards, positionals, modifiers, signifiers, basic terms of linguistics. Their messages are distinct and unescapable. "Most of their signals are concerned with attack, escape,

Fig. 37. A model of the Caribbean reef squid's most complex display.

and sex, and perhaps feeding and gregariousness." These essential facts of life are encoded into basic visual information. Is this the fundamental aesthetics of life, solving these basic problems? Should we all have such schematic organization as a basic illustration of how these facts are combined at the root of all of our lives? Wait a minute—does the squid implicitly diagram basic life functions into colored stripes and waving movements, a kind of abstract art based on life's fundamental needs that each member of its species can and must understand? They are the visual masters who can make abstract art most concrete.

Descriptive natural science is full of wild, improbable details. Concluding, rhapsodic statements such as Moynihan's might trouble more careful scientists such as Roger Hanlon, but Hanlon too is searching for the largest general lessons that can be gleaned from studying the specifics of the visual grammar and live patterning behavior of the squid. As we can learn from those birds who imitate other bird songs a philosophy of how sound can be assembled and categorized, we may be able to learn from the cephalopod the basis of how patterns can be formed and re-formed to express all possible meanings. Of course we can identify purpose, function, behavior, how all this patterning is used. But our astonishment at the improbable beauty of this unusual solution to life's challenges will still remain and should not be quelled once we claim to be able to explain. It's still beautiful, possibly unique. And how, precisely, is one species meant to learn from another?

Fig. 38. Acute examples of the reef squid's double-signal display in context. (a) Plaid is a display used mostly by juvenile squid for camouflage purposes. It is made up of brown stripes and bars on the mantle and is accompanied by a posture called Full-V. (b) Zebra is used in male-male agonistic interactions. The arm posture spread intensifies the message of this display. (c) Stripe is a male courtship signal toward the female. (d) Double Signaling is the amazing ability of squid to send two different messages to different receivers at the same time. Here a combination of Zebra (toward a male) and Stripe (toward a female) is shown.

Soon we will be able to get one step closer to learning what it's like to be a squid with a whole movement toward dynamic, interactive chromatophoric clothing that changes its appearance as we wear it. There are MIT researcher Diana Eng's Twinkle dresses, laced with glowing strands of LED lights that flicker on and off like those longitudinal cuttlefish stripes that let the world know that you're ready for mating (though no doubt the dress's message is not meant to be quite so direct). The dress includes microphones that can be tuned to pick up the wearer's voice, so it might only light up when she speaks, or perhaps when specific observers speak. Might one side light up and the other remain mute? All a question of programming, and the more we learn about cephalopod color control, the more we might want such

Fig. 39. Cott's invisible potoo.

a feature in the clothes we wear. Thus there is Joanna Berzowska's Intimate Memory dress, with pressure sensors in the fabric linked to LEDs that indicate where on the cloth the wearer has been touched. You can adjust the lights to fade as time passes. Are such garments practical, or are they wild abstractions? Or, like camouflage in nature, are they a little bit of both?

And of course it should be no surprise that our friends at Hyper-Stealth are working on camouflage clothing that changes color depending on where its wearer wants to hide. Have they really figured it out? That information *might* be classified.

Functional and arbitrary beauty compete for ours and nature's attention. Advertisement and concealment blur in the swirl of fantastic patterns that nature has evolved—once again the thrum of function can't explain the precise magic that is there. The squid somehow knows, the wood duck knows, the unstated fractal rules out in nature know; there are consistencies, parallels, in the way patterns form, and ever more human attention is needed for us to grasp them. What patterns appear are those that seem to work and those that species like. We like them too. As Richard Prum puts it, "If art is coevolved between trait and appreciation, then there are lots of ways in which there is a coevolved relationship between signaler and receiver." It starts as a private world only those who are part of a species can truly appreciate. But humans have the privilege of looking beyond our species bounds. There are practical advantages to this. "If there is an ecological, economic, or sexual exchange, then there is an opportunity for gaming the system, interfering and gaining an advantage." So we create camouflage of our own. But in the end we admire what we've done even more than what we hide. We may nod with Picasso and Gertrude Stein and look at all the visible invisibilities of nature with ever wider eyes: "*Mon Dieu,* it is *art* that has taught us to see *that.*"

Back to Hugh Cott's marvelous engraving of a potoo hidden in a black and white Costa Rican forest, frozen vertically like the tree trunk on which it hides. (See figure 39.) In nature the visible and invisible dance back and forth with each other, depending on how much we have learned to see. The science and art of this magic merge into one at the moment we grasp it.

CHAPTER 6

Creative Experiments

When Science Learns from Art

POLLOCK'S fractals work because they have the same chaotic proportions as nature. Go back to camouflage and you will find that nature evolves art to be bold and invisible, even at the same time. What guidance does the wild world give? We might as well skip art and just wander through the trees. We are supposed to need art because it perfects what we are unable to easily see. Its pictures abstract from the melee of raw sound, light, form, and feel. Before we even had the idea of evolution to explain how it all came to be, there were centuries of classification, illustration, and organization—the taking down of all the diversity of nature to make it seem sensible to us.

The artist, wrote Sir Joshua Reynolds in an address to his students at the Royal Academy in 1770, "acquires a just idea of beautiful forms; he corrects nature by herself, her imperfect state by her more perfect." Science and artist are then both after the truest form, beautiful and right. They combine the quest of Plato, for the pure forms hidden behind the imperfections we see, and the dream of Aristotle, for the whole of human creativity and technology designed to improve upon the possibilities nature left unfinished.

This idea goes way back, but it is in the eighteenth century, with the rise of the Enlightenment and the goal that knowledge should be published, depicted, and available to all, that the great task of creating scientific atlases of visual information was first taken seriously. Legions of artists were employed to render the magnificence of nature exactly,

with rigorous detail. These illustrations—beautiful, symmetrical, more realistic than any moving, real creature one might ever come across—sit gathering dust deep in our august libraries, offering a precision that even prophets of wild digital visualization of data such as Brad Paley think offer more exact information than more recent technologies including photographs and digital analysis. Why is this? How come Hugh Cott's black and white example of an invisible rainforest potoo is more graphic than any color plate picturing the same thing?

Lorraine Daston and Peter Galison, in their monumental and elegant study *Objectivity*, say that in the eighteenth century, artists trusted their own abilities more. They tended to say that objects in nature were unrepentantly variable, so their pure and exact forms had to be generalized by the artist from the irregularity of the evidence into ideal forms only a keen human observer could elucidate. Art could be exact, while nature was unclear. We only had to standardize our techniques—our etching, our cross-hatching, our standards of proportion—to figure out how to represent nature more accurately than it could ever be seen with the glancing eye.

By the mid-nineteenth century, photography had reared its head and introduced a new term to the debate, something we might imagine has always been around: objectivity—of the camera, the machine, the reality. By contrast, the individual's gaze on phenomena was multifarious and never likely to agree—the subjective, the untrustworthy, the woolly. The naturalists, who had now become scientists, wanted to remove themselves from the absorption of data. Now nature should be revealed as it is, without our simplifying and bending it, our tendency to interpret, to idealize, to wish it were so.

But that never really happens. All those photographs of snowflakes, like the earlier engravings, end up exact, perfect, symmetrical, even though the real flakes are full of unevenness and irregularity. When a strobe photograph is finally taken of a drop of milk splashing onto a flat plane, Arthur Worthington first draws a picture of the process so it is perfect, mathematical, and symmetrical. Later he publishes the actual photographs, which are messy, uneven, and blurry. Which is

the truer portrayal of this simple natural phenomenon? Principles of pure form are at work, but the reality of nature is inexact, always imperfect. How shall we handle that imperfection?

Art can choose to abstract toward the pure and the perfect, like mathematics, or it can celebrate the messiness and court the importance of unevenness, realizing that form isn't everything, that you must have that swing if you want to mean a thing. So modern art is different from the mathematics that tries to analyze it or present itself as raw beauty. There is always something more. No method of visualizing is ever really objective. Does calling it all subjective reinforce this view or serve to discipline it?

Science wants to describe the world as it really is. Certainly it's too simplistic to give in to the conceit that every generation comes up with its own criteria for what is true, making science nothing more than cultural fashion. Sure, we're happy to believe that this is the appropriate view for art, since we don't want to take responsibility for calling something good or bad. And though others want to call science a similarly cultural construction, scientists have ample evidence that their discipline shows progress, that it's getting better, that we are learning ever more of how nature works and are ever able to put this knowledge to constructive use, in the way Aristotle and Joshua Reynolds want us to.

In revealing the secrets of the natural world, we want to believe we know more now than we did a hundred years ago, or ten years ago, or even last year. Science as a towering edifice built on the tiny specific contributions of each scientist seems to suggest this. But art? Hardly anyone would say we have better art than we did before. As always, there is some good, some bad, very little that will last long enough to stand the test of time. Still we go on making it, abstracting from nature, or trying to comment on it in a way that might change the manner in which some people see. Its discipline is of a different sort than that of science.

Into this conflict Ernst Haeckel returns. Now we can see exactly why his influence on science and scientists is considered a bit suspect. He fully believed that the clearest ideas of the principles of evolution could be found in images, as much so or more as within words and de-

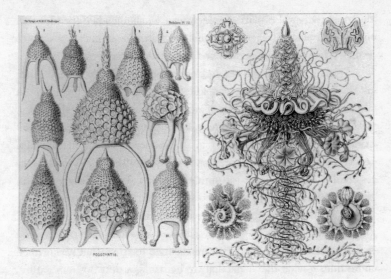

Fig. 40. Is the left Haeckel science, the right one art?

tailed explanations. Haeckel deeply loved the beauty in natural forms and presented them incessantly with boundless artistic and prolific energy. But Daston and Galison point out a clear difference between, for example, Haeckel's illustrations of the science of underwater medusas and the art, comparing one illustration from Haeckel's scientific *Challenger* report and another from his book *Art Forms in Nature*. The scientific illustrations are labeled, rougher, diagrammatic, only slightly imperfect and asymmetrical, while the art forms are beautifully ornate designs.

Should such forms be more accurately called "out from" nature or "inspired by" nature? For Haeckel, they are most decidedly within nature, but does it then require an artist, not a scientist, to see them? There is no denying their beauty, and no denying their influence on the decorative styles of the turn into the twentieth century. Do they need to be correct to have such an influence?

Unfortunately, Haeckel made one serious blunder that damaged his reputation as a scientist. A keen hunter for immediate evidence of

the great theory of evolution everywhere, he championed the idea that the development of each individual organism, from cell to zygote to embryo growing up into adulthood, somehow retraces the path of evolution that led to this species and its correct form. In technical terms, he claimed that "ontogeny recapitulates phylogeny," which is almost a phrase of precision poetry, but in any orthodox sense it is totally wrong. Yet Haeckel wanted to illustrate it, so he prepared a masterly illustration of the embryos of a cow, a pig, a rabbit, and a human to show how at a certain point they were all nearly indistinguishable. However, critics soon pointed out that the similarities were heavily exaggerated in the scientific image to prove his point, using the picture as a stronger argument than mere words could ever produce.

Because the picture of embryos looked scientific and was presented as scientific evidence, readers were inclined to trust what was printed more than if what they looked at were art forms derived from nature, creative explorations of scientific ideas. In a scientific climate where objectivity was a kind of sacred principle, Haeckel soon found himself ostracized from the mainstream. He tried to defend himself by announcing that his versions of these embryos were engraved so as to only show the essential features, those necessary for the proving of his point. He simplified and homogenized so as to make his theory clear. Too clear, in fact. Pictures are worth a thousand words also in science, and if we are to believe they are more objective than the wiles of argument and the reams of numbers that constitute data, then they must be treated as something nearly sacred.

Yet we hear what we want to hear, we see what we want to see. Consider Percival Lowell, who believed there were canals on Mars. Straining his eyes through a tiny telescope, Lowell saw faint lines crisscrossing the red planet. With the improvement of photography he was able to get round, fuzzy images of this distant world, which he said confirmed the appearance of these magic lines, possible confirmation of the ruins of some ancient civilization. The pictures were published and discussed far and wide, so powerful and suggestive was the possibility that something might be up there. Only thing was . . . no one else could see them, as much as we all wanted to see something up there.

Who *wouldn't* want to find evidence of civilization on Mars? Our stories and dreams have always guided us. Look back at the tragedy of the discredited Lowell and you could see either a fabulous hoax or a magnificently conceptual art project. But if it isn't really there, it isn't really science.

Art tests us, inspires us, allows us to see all sorts of things that might not really be there. This expands our consciousness, lets us think in all kinds of new, imaginary ways that cannot be explained. So what can art really offer science, which has such different criteria for charting what matters? Perhaps an alternative way of knowing the world.

Being more artist than scientist, I do feel what I do is much easier than science. Using music to make sense of nature requires some sort of talent that has been disciplined, and then daring to go out on a limb with it to try something new. Science does that, but then must do and redo, test and retest, collect ever more data before making even the most tentative of conclusions. Art can just go right out there and say it. But all the practice and training in the world won't create greatness, in either field.

Most scientists I asked about whether art had truly influenced science said in general no, because they recognize the fundamental difference between the enterprises more than most artists, and the rest of us, do. We are entranced by parallel images from subatomic particles and Zen brush painting, but we don't think through the fundamental oppositions of such activities. Science is a cumulative quest for the objective description of the way the world really is, with each stab toward the truth subject to rigorous scrutiny, logic, and possible repeatability. Art is a stab in the dark, a quest to make a strong statement, to feel "true" in the gut by doing something polished and complete enough to cause an instant stir in the heart. You can analyze it, you can test it, you can try to explain it, but the greatness will be more than the sum of its parts. It may be an easy gesture or a labored effort, be done with the turn of the hand or with a sudden glance. As much as one may speak of similar gestures in science, they represent an aesthetic part of the scientific work, not the main gist of it.

Science and art have different criteria for truth. They present

their conclusions with a different sort of stance, a different weight. An artist can convince by the splendor of his work or just by the conviction of his presentation, even the image of a whole that doesn't quite make sense and cannot exist apart from its presentation. Like a fine bird song, which has no message or meaning outside its performance, it is what it is, and if it touches enough who experience it, it will endure. But not science. Every conclusion is subject to the intense scrutiny of the whole field and will most likely be superseded by new discoveries over time. In science there is most definitely progress. In art we recognize changes in taste over time but not aesthetic advancement.

Most of us would not say today's art is better than that made in the Renaissance or Enlightenment periods. It is certainly different, and we may or may not prefer different things today. Art is primarily expressive and evocative, not needing to be useful and informative. But I would like it to help us, to improve our lot, in a way to progress. I want to imagine it can change the way we see the world and improve our understanding. So should it then at least sometimes positively influence science? Taylor and his colleagues believe Pollock anticipated the discoveries of fractal mathematics, though maybe he is instead saying that what is great in Pollock's wild imagery is the fractal naturalness of it, which is more like an accidental secret code than a real insight. In the end he too is showing how mathematics might explain art, giving science the upper hand, a kind of solid, exact power that comes with science's ability to do things, to make things, to physically improve the world. Compared to the changes in our world that science has wrought, art can seem downright frivolous, but it does make us laugh and cry.

I got very few suggestions from scientists of cases where art had clearly propelled science along. Some pointed to the artworks of sculptor Kenneth Snelson, with rigid objects held in place by taut flexible wires, which his teacher Buckminster Fuller saw in class at Black Mountain College in 1948 and later named "tensegrity." This gave rise to a whole new way of looking at the relationship between tension and rigidity, having all kinds of applications in biomechanics and architecture, most famously in the large-scale projects of architect Norman Foster. The reality of the sculpture gave a three-dimensional image of

Fig. 41. Kenneth Snelson's "Needle Tower," the inspiration for tensegrity.

the theory, and engineers and scientists now saw the movement of living things in a new way, inspired by an artist who found a particular way of putting objects together, linking them, and finding it beautiful.

One scientist who has thought quite deeply on this is the Nobel Prize–winning chemist Roald Hoffmann, who has also published several books of poetry and is famous for organizing the monthly "Entertaining Science" events at New York's Cornelia Street Café, one of the longest-running series of informal gatherings to present science and downtown culture together, the forerunner of the great science festivals now popping up in major cities all over the world. Chemistry, he says, surprisingly, is often all about *drawing*. The vocabulary of chemistry can get so technical that even its practitioners cannot understand all the words in a typical journal article in the field. But when they see molecules drawn, with their elements and their interconnections, in the standard and universally understood way, then it all makes sense. Chemists are trained connoisseurs of a particular kind of illustration, which, in its universality, has more currency in explaining its concepts

than the confusing gobbledygook of words, which outsiders like to call jargon. Even within the field it is jargon, and there are too many terms to ever know. The image is the key, the drawing tells all. Writes Hoffmann in a special issue of the journal *Hyle* on aesthetics in chemistry:

> The communication of molecules' architectonic essence by little iconic drawings (rather than photographs or etchings), and by ball and stick models, is of proven value—remember this year [2003] marks half a century since the Watson and Crick paper. They didn't synthesize DNA, they reasoned out its structure, almost willing a model into being.
>
> It never ceases to amaze me how a community of people who are not talented at drawing, nor trained to do so, manages to communicate faultlessly so much three-dimensional information.

He is amazed but also shocked by his colleagues' resistance to a more aesthetic approach to the world. Why is it, he wonders, "that people who have learned to communicate visually in such a variety of artistic styles—chemists—are not more tolerant of expressionist and abstract artistic ways of communicating knowledge and emotion"? I would say it is the classic sense that in science the march of knowledge is rigorous and cumulative, while an artist can just get up there and say something, make a gesture, do something different or out of whack and demand to be taken seriously, and his culture sometimes will take him seriously without needing to ask all these questions that situate the work in its context. Art does not work the same way as science, so if you talk about their relationship or how to combine them, you will want to tell your audience if what you present is to be taken as science or as art, and in each case it will need to be enjoyed or assessed differently. This is not to favor one or the other way of knowing, just to recognize that they will always be different, and if something is to be both art and science, then it will have to allow these two different ways of interpretation.

So as a musician, I can sail off the coast of Hawaii and try to play music live with humpback whales, and sometimes I get those whales to

sing along with me, and the interspecies results might once in a while be interesting to listen to as a kind of music that crosses many aesthetic lines. All I have to do is get one beautiful recording, show that it really is a live interaction between human and whale, and present the work as such. Is the whale really responding to my clarinet? How is he adjusting his song in response to mine? To say something scientific about this, I'm going to have to go out on hundreds of trips and collect a lot of data of whale-human interactions that can be statistically analyzed. To turn this into a scientific experiment, such data are essential. Only then could I make more objective conclusions about what I hear as beautiful. As an art experiment, one beautiful human-whale duet is enough. It is easier in that it takes less time, but you have to be musically prepared to take such a thing seriously. That's the harder part.

Hoffmann has thought much more deeply on this. He has considered how science might learn far more subtlety from art. After being amazed by how much chemists can express to each other using drawing, a fundamentally artistic technique, he thinks more daringly about how art might inform science. What of abstraction? We have spoken of abstract art for more than a century; can there also be something called abstract science? For one, we cannot be sure any art is really abstract; if it doesn't represent the appearance of nature, does it not idealize nature by seeking to exalt pure form one way or another?

Abstraction, when it was introduced, seemed to be put forth in opposition to something, a more naïve notion that art could basically represent the world. So let's try for an abstract science. Is there any sense in which chemistry could be seen as being in opposition to something? It too is sometimes opposed to nature. Hoffmann says:

> Chemists in the laboratory are torn between emulating nature and doing things their own way. A protein, through its own curling and its tool kit of sidechain options, shapes a pocket where, say, a molecule with only right-handed symmetry fits. But it not only fits, it has something done to it—a specific bond in that molecule is cleaved, or an atom is delivered to it. The chemist's fun, much like abstract art, is in achieving the same (why not better?) degree of

shape control that nature does, but doing it differently, perchance better, in the laboratory.

With greater abstraction may come greater fun.

Greater attention to form and simplification is the basis of science's tendency to break things down into their simplest parts. Yet it is not the elegance of the rules that most impresses Hoffmann but the sense that the playing of the game can trump the results, like Hermann Hesse's vision of the mysterious spiritual/technical activity he introduced in *The Glass Bead Game*, an activity never quite defined but consuming its players like a whole sci/art culture—a vision that impressed me for years as a college student, especially the fact that it could never quite be described because its totality was so immense. So it's either a metaphor for life itself or a call to generate the great games of today, intricate structures playing in cyberspace or on total digital machines. But that's still probably not it; it's more likely that great sense you feel when, against all odds, all the processes you think through at any given moment suddenly seem to make sense and all fit together like some great "aha" moment that finally really works.

Hoffmann gazes at the cool geometrical forms of Rothko, amazed by their exactness and fuzziness at once. Art has evolved to depict tendencies, hazy eminences like the unclear parts of the brain that may light up when one or another thought process happens. In this science of the mind, the brain is not like a device, with gears and cogs churning the machinations of thought; no, in this model hazy areas on the screen light up, and we have a glimmer of idea we might begin to chart. Data? A diagram? Proof, some clear result? Not really. But art can be blurry and with this blurriness offer a new kind of precise meaning that inspires many disciplines of science where inexactness does not stop us.

Chemistry can work against nature as well as revealing nature. Hoffmann, along with Charles Wilcox and Roger Alder, tried to stabilize square planar carbon atoms flattened away from their usual tetrahedral shape, a process he said really had an

abstract feel to it. That molecule's geometry is about as far as possible from that of a normal carbon atom with four atoms bonded to it at the corners of a tetrahedron. Our transgressive whim could be seen as playing games with high-energy structures. However we, and others, immediately had therapeutic designs—for the molecules, not humans—to ameliorate the energetic suffering of such preposterous bonding configurations.

Abstract art sometimes celebrates the aleatory as a principle in making good work. This doesn't mean music made of random noise, art made by filling a canvas with out-of-control paint splatters, or poems shouted entirely out of nonsense words. It means freeing oneself from common constraints to let loose new ideas, which then surprise with what comes out. It's possible to make good work this way only if one's aesthetic sensibilities are honed to choose the best out of what results. That's how John Cage got the most out of what he called "chance operations." He set up situations where he didn't know what sound would come out, or what word would be chosen for a text, then he would carefully choose from among the results, making him a special kind of control freak. His work does have a precise style to it, not always evidenced in what it sounds like but visible in the grammar of its presentation.

A wild bunch of possibilities can lead to unexpected results. Even in chemistry this approach can get somewhere:

The idea is to come up with a set of facile reactions that generate not one, but millions of diverse molecules within one beaker. In part, but only in part, this work has a biomimetic motivation. For at some stages nature introduces steps that are dispersed, to populate niche-seeking molecules. Most do nothing, but a few succeed. The workings of the immune system and the diverse structures resulting out of terpene synthesis are examples. But the laboratory generation of vast "libraries" of potential enzyme inhibitors or fuel-cell catalysts has a feeling of seeing the aesthetic value in chance.

As our main subject here is biology, and life itself, we clearly see the aesthetic value of chance as an aleatory process that produces the whole tangled bank of the vast beauty of nature. To embrace it, to love it, and ultimately to value it is not to throw caution totally to the winds, but to recognize that it is very difficult to exactly pinpoint the source of a creative vision. Ideas come from all over the place, but we must attune our aesthetic enough to recognize their value when we happen to confront them.

Hoffmann concludes with a more challenging notion, to try to shake up both disciplines:

> Abstract art is cold. And so is science. I put it this provocatively so as ultimately to work against this caricature, a prevalent one, I am afraid, of both abstract art and science. How can they both be "cold"? The way into emotion in abstraction (and the appreciation of science) is not direct. It has to be learned.

Abstract art and science both take effort to understand. Abstract art is far from what we are usually taught to see, and the language of science uses words that readers have often never seen before. It takes training to make sense of both.

Scientific language is difficult because it must refine our usual ways of using words to become extremely precise. The official jargon of each field is necessary to avoid ambiguity and incrementally advance the vast storehouse of scientific knowledge, but to Hoffmann, it doesn't reflect what it really means to do science. "What violence that dull language, that rigid format, does to the scientific imagination! How it dissipates in jargon the underlying thrill of feeling, say, the reactivity of a molecule turned upside down by clever substitution!" The language game of science doesn't want to know how the researcher feels or whether he loves the molecules he synthesizes or not. We don't even want his diagrams of his results to convey any emotion of discovery; we only ask that they be accurate, conclusive, and right. Hoffmann thinks abstract art has a tendency to do the same—to cut out the figurative, the easily human, and to avoid the representation of

emotion, which is most easily seen with images we know and can identify with.

Artists might disagree with this last idea. Sure, the most extreme or mathematical abstract art is famous for its erasure of emotion, but in its bold strokes it can cut through culture to evoke great feeling in some universal appreciation for those basic forms. Or maybe, as Hoffmann suggests, we get more out of images we are taught are of greatest significance. I'm suspicious of that, as it seems to ask for less attention to the visual rather than more. Give people the chance to explore new forms of beauty, treat your audience with love and respect, and they are more likely to get what you're after than if you assault them with arrogance, shock, or threat.

When the figurative is pushed away in art, the cognitive comes to the fore. "Oh, beauty comes back, no way of keeping its subversive pleasures out of the soul," our poet-scientist writes. He doesn't really agree with his own caricature of coldness, but does lament that coldness is much harder to counteract in science than in art. Having praised the pancultural simplicity of chemical diagram, he knows that improvements in the visualization of the most important entities in his own dear science have come right from the experiments made by artists in the twentieth century. "So we focus in a cubist way on one part of a molecule, distorting it, and we indicate forces with Klee arrows. And when we need to represent essences, to focus in on what matters, we simplify, often in the way artists did in the beginning of abstract art in the 20th century." Hoffmann has always been a little suspicious of elegance as a way to bring aesthetics into science, writing elsewhere that with that "inbred love of the simple comes . . . prejudice and a falling for demagoguery, and for advertising."

> These cater to that love for the simple and pure in us. The beeline that cubane [a synthetic carbon molecule in the form of a cube] and a simple melody have into our soul, compared to the struggle that ribonuclease and a composition of György Ligeti has to be admired, are connected . . . to reductionist fantasies of physicists that beautiful (read "simple") equations must be true.

Fig. 42. *Jane Richardson's pastel drawing of the ribbon protein triosephosphate isomerase.*

He's done enough science to realize the simplest explanation is not always the true one.

And Hoffmann does offer many examples where art has directly aided science. Biopolymers, the backbones of proteins, appear sometimes helical and sometimes stretched out with a pleated appearance. In the 1980s Jane Richardson invented a way to visualize these proteins that clearly learned from the constructivist attempts to play around with the rhythm and bounce of familiar forms. In the early days she drew these chemical entities by hand, and over the decades this has evolved into a whole series of computer programs for the dynamic visualization of all kinds of data. In a way, though, the earliest hand-drawn images are the most exciting, and the most beautiful, such as the drawing of triosephosphate isomerase in figure 42.

This appears at the end of Hoffmann's article, really his pièce de

résistance, a scientific picture that clearly has some of the dance and exuberance of Klee or Kandinsky, a drawing truly beautiful and exciting. Chemistry has relied on schematic drawings for so long, but Richardson realized that many important proteins needed to be described in a dynamic, visual way. Her initial round of ribbon drawings in the 1980s conveyed this sense of motion with swirls, strands, and arrows. By the twenty-first century she developed several generations of computer software that present kinetic, 3-D renderings of these basic building blocks of nature. Her latest is called KiNG, and can be downloaded free from her Web site.

The latest example of art aiding our understanding of proteins is even more interactive. Beginning in 2005, biochemist David Baker created an online game called FoldIt to allow Internet users all over the world to try to figure out how complex proteins might be folded and visualized. Starting out as a kind of scientific puzzle, it has evolved into a multiplayer collaborative competition where the more you play, the better you can get at understanding how proteins with many interconnected strands may fold upon one another in the actual microscopic world. In 2010 Eric Hand published a paper demonstrating that expert players of FoldIt can do a better job figuring out how proteins fold than computer algorithms can, paving the way for a new era of citizen science as video game, making use of an art form so avant-garde that there is hardly any established place for it in aesthetics. Figure 43 shows an example of a protein being folded in FoldIt in midplay.

This trajectory of visual and creative scientific innovation would have been impossible without Richardson's creative leaps in protein visualization and the advances in computer graphics software since the 1980s. It is art that enabled us to learn to read such images, to see information within them. And it is a new sense of participatory art, the playing of computer games, that gets the mind of the crowd involved. Now there is a successor to FoldIt called EteRNA, which uses a different graphic model and adds one new prize: the winning proteins will be synthesized at Stanford University. So the most beautiful designs invented by players will be turned from fantasy into fact—that's almost

Fig. 43. The FoldIt game in action.

like having your video game avatars leap from virtual reality into your living room.

The same is true of the immensely chaotic images of how information flows today, as in maps of the Internet or computer-made complex visualizations of how the world fits together, such as Brad Paley's diagram of the interrelationship among the sciences. (See figure 44.)

Compare this to Ad Reinhardt's cartoon of how to look at modern art in America from 1946. (See figure 45.)

You need computers to make an image like Paley's, and you need a world that has lived through a twentieth century of abstract art to have even the possibility of *reading* such a thing, though in a way reading it is not the main point, because surely it would be easier to read all those descriptions of branches of science if they appeared straight on a page. On the other hand, maybe it has specifically learned from Reinhardt's whimsical picture of all the categories, divisions, styles, and minute demarcations that people like to make.

This is an exercise of creative visualization, an artwork more than anything else, an image that helps make sense of a world of knowledge so involved no one could ever hope to keep track of it—a different situation,

Relationships Among Scientific Paradigms

Fig. 44. Brad Paley's visual representation of the relationship between the sciences.

Fig. 45. Ad Reinhardt, "How to Look at Modern Art in America."

perhaps, from the end of the nineteenth century, when Haeckel still imagined he could paint all of life, its symmetries, and the range of common patterns and forms that document the great tangled bank itself. But today far too much is going on, with the swirl of information ever about us in the world, now more instantly accessible than ever.

Lewis Mumford wrote things like this about the frenzied pace of

modern life already in the 1930s; I suppose at any point in the rush of progress we can comment on the impossible blur of it all or study closely how our ways of thinking evolve, and try to do the most possible with all the tools available to us at the moment. We want to believe there is steady advancement in science, so for science the past doesn't look all that interesting, though art and culture easily show the opposite. Even Brad Paley wonders how it is that so much more information can be contained in old engravings than in the latest computer-generated precise imagery. There may be more in Richardson's hand-painted ribbon proteins than in the endlessly flexible computer pictures. Haeckel's engraved radiolarians show more gravity and detail than any recent photographs I have seen, for they are full of the interpretive power of an artist wanting to explain, not limited by exactly what the machine can capture. Field guides to nature use paintings and diagrams far more than photographs, because they show more possible marks of identification than one could ever actually see when confronting an actual, real bird, though I'm sure computer-animated video field guides are just around the corner.

Hoffmann still doesn't want science to become as art. If aesthetics drives the quest for knowledge, it could become too puffed up on its own mastery and elegance. He is afraid of "talking down utility and ethical concerns. It seems to me that modern science, and chemistry in particular, has lost a little of the romantic but ultimately necessary idea that one goal of science is ameliorative—as Peter Medawar has said: to leave the world a little, just a little better place than the way we found it." When artists talk about improving the world they are either laughed at or seen as propagandists, yet there is no doubt that art is one of the best uses of human time and effort, showing that we can make our little efforts at beauty in a world where beauty has evolved only over millions of years of arbitrary refinement, or so the story goes. The chronicle of bowerbirds proves that we're not the only ones who have evolved such a need, but they and we are but few species among millions. We need to celebrate our specialness by doing something that does not destroy the planet. It is both easy and impossible.

Yes, there is a side of the arts that is specifically about expressing

the creative urge, rather than constructing new knowledge or solving the practical issues of humankind. That is their luxury and their freedom, and it has always been part of humanity to want such things. Another view of the situation makes the arts especially useful to science: as the statistical analyses of Robert Root-Bernstein show, that the most accomplished scientists, such as those who win Nobel Prizes, including our friend Dr. Hoffmann, are twice as likely as more "normal" scientists to have taken artistic pursuits seriously, to the point of publishing fiction or poetry, performing and composing music, or exhibiting their own visual artworks. Since science separated itself from natural history in the nineteenth century, its pundits have been recommending that the best students are not the most single-minded but instead those with the widest interests. Santiago Ramon y Cajal, the discoverer of neurons, advised professors to pay attention to any student with "an abundance of restless imagination . . . and an artistic temperament which impels him to search for, and have the admiration of, the number, beauty, and harmony of things." Cajal also believed that discoveries that had not been *drawn* had not been *seen*. It was not enough to describe scientific results in words; one had to creatively visualize them as well.

Root-Bernstein points out that it is most common for scientists to find the appraisal of a scientific theory or result to be best when it is a thing of beauty. Physicist Robert R. Wilson, also a sculptor of shiny, smooth organic-type metal forms, feels that these practical tools of physics should also be regarded aesthetically. "The lines should be graceful, the volumes balanced. I hoped that the chain of accelerators, the experiments, too, and the utilities would all be strongly but simply expressed as objects of intrinsic beauty." This is probably the most common way scientists have expressed the value of art to their work, as providing a vision of how beauty can pervade experience and give comfort to the idea that the rigors of discovery can also make us swoon. Hoffmann warns us against taking elegant simplicity too seriously, when the world is full of messy confusion. This poetic chemist also cautions us against thinking that art is easy, impulsive, free, and creative, and reminds us of some statistics on what it takes to be welcomed as artist or

scientist, pointing out that in the best chemistry journal in the world, 65 percent of full articles submitted are accepted, whereas in a routine literary journal, less than 5 percent of poems are let onto the page. Hoffmann has to his credit published plenty of both, as have many of the artist-scientists Root-Bernstein celebrates.

Art for its own sake, or to teach us something? Biologist C. H. Waddington, also an artist, dancer, and poet, wrote that an "art object is always an instruction to act or experience, not a piece of information, as living things are organized instructions, not organized information." They are dynamic, not static—art affects us, that's how it works. Life contains the rules that make the regeneration of life possible. This is where its creativity, beauty, and wonderful inexactness lies. Waddington's work in the arts got him that idea.

Physicist Wilhelm Ostwald, who won the 1909 Nobel Prize in Chemistry for his work on equilibria, went on to propose an influential color theory that influenced many modern artists, especially Mondrian. C. T. R. Wilson invented the cloud chamber to reproduce the beautiful coronas and glories he witnessed while mountain climbing. It was a device that became essential for the investigation of radioactivity and cosmic rays. Organic chemist Robert Woodward found chemistry deeply sensual: "I love crystals, the beauty of their form—and their formation; liquids, dormant, distilling, sloshing!; swirling, the fumes; the odors—good and bad; the rainbow of colors, the gleaming vessels of every size, shape, and purpose. Much as I might *think* about chemistry, it would not exist for me without these physical, visual, tangible, sensuous things."

Root-Bernstein piles example upon example in his study, which is remarkable for its moving verbal arguments as well as its statistical weight. He concludes that science and art should each recognize their mutual accomplishments, not to superficially blend them, but to recognize the difference and power of each, something not valued enough in our usual approach to these topics.

Root-Bernstein is also a booster for the collective value of people doing art and science together. Hoffmann is more cautious, careful about making too easy a link by championing elegance in theory and

solution, reminding us to remember the specific differences between art and science. Neither man has much patience for the "two cultures" of writer C. P. Snow, who argued in the 1960s that the scientific and artistic sides of society were diverging so much that they could barely talk to each other anymore. We no longer think that way, and I am trying to show that we never really did. Art has been at the heart of science, and science at the heart of art, for centuries.

Since Snow's day we have worked hard to bring it all back together, because of technology's increasing fluidity and ease of use, and because we no longer trust the earlier dream of being able to engineer and plan all of society. Because of the great tragedies of our time, and our great triumphs, we know that art is a form of knowledge and science a thing of beauty; neither should claim precedence over the other.

Still, one should be careful in bringing art and science together. E. O. Wilson, an outstanding biologist as well as a great nature writer, wrote his famous book *Consilience* specifically to explain how art and science might be better assimilated. It's a noble and enthusiastic effort, but in the end he does say the kind of thing that angers artists, making all art and human culture a subset of biology. Artists don't like this because it makes science encompass all that they do, and fosters the tendency for biology to reduce art to an evolutionary adaptation. Wilson means well, but he has no trouble calling all human cultural behavior a simple biological strategy.

Of course, at a basic level he is right: when we consider humanity as a species, anything one or another individual does is of little or no consequence in the grand scheme of our species' appearance and disappearance on this Earth. Our whole species might be a mere evolutionary footnote, highly unlikely to evolve again, and very unlikely to appear once more if by some means we were able to roll back the clock of evolution to the point before which we branched off from our ancestors. Another time round, we wouldn't have evolved at all.

Wilson writes quite lyrically of science's need to reduce complexity down to its simplest parts in order to make sense of it. Reductionism remains science's most mundane and dominant tool, yet Wilson describes it poetically:

Let your mind travel around the system. Pose an interesting question about it. . . . Become thoroughly familiar—no, better, become obsessed—with the system. Love the details, the feel of all of them, for their own sake. Design the experiment so that no matter what the result, the answer to the question will be convincing.

Wilson defends reductionism as something beautiful, not a confining vision that sucks the life out of glorious reality.

He does believe that science will soon be able to explain why we find art so compelling. Science may not touch us emotionally, but only its rigorous method will be able to find the reasons for our deepest feelings. The human brain

constantly searches for meaning, for connections between objects and qualities that cross-cut the senses and provide information about eternal existence. . . . In order to grasp the human condition, both the genes and culture must be understood, not separately in the traditional manner of science and the humanities, but together, in recognition of the realities of human evolution.

Art is the way to present and evoke feeling, but science dares to explain it. The best art, Wilson presumes, is that which is truest to our biological origins. Wilson guesses that art evolved to enable our sense of self-reflection, unique in the animal world, to bring us back into joyous contact with where we came from. Art's quality should be measured by its fidelity to human nature, its ability to reveal our essence and our species' place in nature. Necessity is the goal of invention, and the beauty in art should also be its truth. Here Wilson nods in the direction of Denis Dutton, suggesting that because we are animals, the product of adaptive evolution, our best stories, poems, melodies, and rhythms are those that reflect facts about our biological roots.

There is something circular about such an argument. Few artists or art lovers would agree with it. Only after there is agreement that an artwork is good do we look for reasons for its goodness. Not all humanists are comfortable with Wilson's wish that science will be able to

prove the value of our aesthetics and culture. Poet and farmer Wendell Berry wrote *Life Is a Miracle* to specifically challenge what he saw as Wilson's elevation of reduction and explanation over wonder and experience. "We know," writes Berry, "more than we can say. . . . There is no reason whatever to assume that the languages of science are less limited than other languages." He would welcome Roald Hoffmann's concern that scientists don't celebrate their own sense of joy and beauty enough. They leave too much out of their hypotheses and conclusions, favoring a language that hides too much of what they know. Even Wilson, a great nature writer himself, still may be hiding something from us. Once after a lecture, I asked him if he really thought nature was a machine. "Oh no," he responded. "We have much better metaphors than that. But they are too complicated for the general public."

The scale of such thinking is so vast as to make anyone who values her own individual creative vision to feel beyond small, more than that, tiny, crushed by what Kant called the dynamic sublime—the awesome scale of nature itself. Science with its daring to investigate the totality, the huge scale of evolutionary time, humiliates us to insignificance. You imagine you can create something of beauty, of value, of originality? You are acting deep within the grand march of biology, in which no individual matters all that much. We are trapped by our destiny to reproduce and further the strategy of the species, which, in the case of humanity, means technology, arts, culture. A curious path to take, a little like bowerbirds and peacocks, but even more extreme, and likely to die out before long.

I'm sure Wilson wouldn't put it this way. His intentions are honorable, and he is an artist as a writer, and of course he may be right that the individual achievements of art can hardly matter in the grandest scheme of things. Of course biology could also be rendered insignificant, a subset of chemistry, itself a subset of physics, where the raw patterns of nature are mystically articulated in ideas that can barely be tested by the most arcane technologies we dream up. But then philosophers will tell you the whole idea of science is just a subset of philosophy, the field that decides what entities are, what logic is, where is movement and where is rest. There is a tendency in every field to be-

lieve it is better than the rest. It is a silly, unnecessarily exclusive tendency.

"Consilience" is a nice, unfamiliar word that Wilson could have brought into general currency. But science cannot be the ruler in this new harmony; no, each approach to nature must recognize its uniqueness and independent value, which I have tried to summarize here. Wilson is right to point out that science is not just another competing way of looking at the world. In science we do find real progress, knowledge increasing, data building upon data. It is a system that has improved our lives, while the greatest art remains firmly relevant even as time goes on. Science has a right to be confused about this, and in a way to be jealous of the resonating power of great art to touch us equally over the centuries. Art's power is immediate, not historically bounded, as science by its nature must be. Science may want to be beautiful, but its effort is cumulative, total; no individual discovery can ever be complete the way an artwork can be. Neither science nor art will ever include the other.

Wilson does make some intriguing blanket statements about the arts. "Imitate, make it geometrical, intensify: That is not a bad three-part formula for the driving pulse of the arts as a whole. Somehow innovators know how it all is to be done." Wilson is intrigued by Mondrian's earlier work, from 1905, where in "The Geinrust Farm in a Watery Landscape" the young Piet drew a row of very thin trees in front of a dark shadowy house in charcoal, all in an arrangement of spacing and proportion that Wilson says follows a pattern that modern brain imaging would conclude is the most arousing to the human mind.

Later, Mondrian abstracts this technique to weaving, flowing branches, still intuitively coming up with an arrangement that science today can conclude is the most pleasing, and then abstracting toward a cubist direction, and then to bold rectilinear colors and patterns in the style we most expect from him. And yet in all his work we can find those proportions that science can calculate as being the most amenable to human perception and enjoyment. He figured out on his own the best possible ratios and appearances.

Can science really calculate such things? Wilson is impressed that

in the 1970s Belgian psychologist Gerda Smets had already concluded that when it comes to evaluating abstract designs, people prefer 20 percent redundancy, or repetition. She concluded this was something innate, not something culturally learned. We always knew we need a balance between sameness and difference—now a scientist has quantified it. Wilson is impressed he found the same thing in Mondrian. Why don't artists like this method, or the simplicity of its conclusion?

We feel it robs our thunder, applying numbers to our hunt for genius. We know advertisers think this way, and that there are computer programs out there trying to create the next hit song. We want to believe movies are created by auteurs, that writers create their novels alone, and that focus groups don't lead to movies with better endings: if there's one thing you can't steal, it's that feel. Here the tensions come out between art and science; here is where I want scientists to admit they too can learn from art, rather than believe they can explain it. Otherwise it's still the case of one approach to the world claiming it's better than another.

Russian artists Vitaly Komar and Aleksandr Melamid satirized this statistical approach by doing statistical surveys in several countries to find out what people liked best in painting and what they liked least. True to Wilson's and Smets's belief, most people wanted the same thing, whether in Kenya, Ukraine, or the United States. Most popular were scenic landscapes with a river and some mountains, and the color blue was up there. Children, animals, families, ordinary people, maybe some famous people. Komar and Melamid then painted "ideal pictures" that put the results of their survey into practice.

Their ersatz Hudson River landscape features children wading, George Washington, and a couple of deer. The Finnish version swaps the deer for a large moose. In France they prefer naked people. In Denmark, a Danish flag and a few ballerinas. Everywhere, the least popular paintings featured the colors yellow, orange, and brown, with rigid geometric shapes—those same shapes I praised in my chapter on modernism! Turns out nobody really likes them. All the paintings, best and worst, are hideous constructions without that real balance Wilson

praises, but that is their point, to show that statistics are never going to help you make art, good or bad.

It is significant that when Wilson wants to get poetic he switches to italics, as if saying this is not the usual Wilson, but a parallel artistic Wilson. He's not quite comfortable with this sort of language: *"Poet in my heart, walk with me across the mysterious land. We can still be hunters in the million-year dreamtime. Our minds are filled with calculation and emotion. We are aesthetes tense with anxiety. . . . How can we be sure that eagles never speak, that everything can be known about this land? . . . in expanded space-time the fiery circle of science and the arts can be closed."* To have a poet in your heart is not the same as taking poetry seriously enough to work to become a poet. (I for one have a scientist in my heart but often feel I lack the diligence to really figure out those bird and whale songs that puzzle me so. I am happier being spontaneous, jamming along, making music that some people like but that I cannot explain. I am afraid that if I learn to explain it, I will no longer be able to play it.)

One of Wilson's most provocative exclamations comes right near the end of his book, a book that I have to admit really made me angry when I first read it, but which more than a decade later I have come to appreciate much more: "If history and science have taught us anything, it is that passion and desire are not the same as truth. The human mind evolved to believe in the gods. It did not evolve to believe in biology." We know that science never satisfies our hunger for a simple answer to guide us, to buoy us above the chaos of all possible contingency and the flood of information. Sure, science progresses, but it does not reassure us there is a real reason for beauty in the way things have turned out. It does not produce a rational aesthetic that leads us to make better art. (Though some of its practitioners still believe we can get there. Rick Prum still believes he's going to progress in aesthetics where all others have failed. Is this mere hubris?)

Wilson's thinking has evolved after *Consilience*: he has since written eloquently on what must be done to save our shrinking biodiversity, and now has even written a novel called *Anthill* that alternates

between the story of a conservationist and the life cycle of a colony of ants. This is definitely a Renaissance man. Who's to say what his greatest achievements will be over time—his description of new insect species or his efforts to mobilize the rest of us to care and to save the vast storehouse of nature? What motivates people most to act—information, description, beauty, or tragedy? Reductionism cannot encompass the greatness of a life. Where are the artistic investigations that are also informative in the path of cutting-edge science? Where are the research conclusions that are truly beautiful?

I think of the work of the Russian artistic team Evelina Domnitch and Dmitry Gelfand, who "create sensory immersion environments that merge physics, chemistry and computer science with uncanny philosophical practices," as they describe it. Current findings, particularly regarding wave phenomena, are employed by the artists to investigate questions of perception and ephemerality. Such investigations are salient because the scientific picture of the world, which serves as the basis for contemporary thought, still "cannot encompass the unrecordable workings of consciousness."

Having dismissed the use of recording and fixative media, Domnitch and Gelfand's installations exist as ever-transforming phenomena offered for observation. Because these rarely seen phenomena take place directly in front of the observer without being mediated, they often serve to vastly extend the observer's sensory envelope. The immediacy of this experience allows the observer to transcend the illusory distinction between scientific discovery and perceptual expansion. In order to engage such ephemeral processes, the artists have collaborated with numerous scientific research facilities in Europe, Russia, and Japan.

I have written elsewhere of how much art there is responding to science, but it is much harder to find science that learns directly from art, since the goals of the two enterprises remain quite different. Or if they both have a similar goal of revealing deeper truths about nature, one does so with amazing insight, the other with rigorously documented investigation. But Domnitch and Gelfand's work crosses the line sometimes because it reveals natural phenomena scientists thought

were impossible to see or even to create. Their best-known work, "Camera Lucida," investigates the mysterious phenomenon of sonoluminescence, a physical oddity discovered in 1929, whereby tiny oxygen bubbles bombarded with sound can be compressed enough to faintly glow. Could the process be intensified into an artistic experience?

Working from this footnote in chemistry that explained how the gas inside a bubble could be compressed intensely enough to glow with light if stimulated by a powerful enough sound, they refined the process in collaboration with Japanese chemists to produce a three-dimensional gaseous response to music that can be seen in a darkened room with the naked eye. It took a whole series of unsuccessful experiments, some with highly toxic sulfuric acid, before they produced a result easily visible and also visually interesting in a mysterious, cloud-like way. The paper in which they describe the project, appearing in the hybrid journal of science in the arts, *Leonardo*, has a bit of a mix of hard scientific and creative language:

> The unidirectional jets of luminescing bubbles started to swirl and rip apart into trembling, gelatinous vortices, simultaneously forming periodically exteriorized rings. The entire chamber was permeated by colliding and interweaving spirals of light, the quantity of which no longer corresponded to the number of transducers. Although we could distinguish certain recurring patterns of luminescence, the overall environment was tremendously varied both in form and light intensity. The correspondence of these variations to the audible sound composition was inexplicable yet starkly apparent. We realized afterward that we had inadvertently ignored the amplifier's bleeding voltage meters used to indicate threshold amplitude levels, and that we had triggered a high-pressure thermo-acoustic breeze. We named this phenomenon "xenon wind."

With the phenomenon of xenon wind unleashed and possible to control, Gelfand and Domnitch were able to build glass aquarium-like enclosures full of liquid, into which the xenon gas is projected and then stimulated with sound to produce the mysterious glowing figures.

There have been plenty of ways to visualize sound in two dimensions, like Hans Jenny's Chladni figures, updated by Alexander Lauterwasser to produce the visually beautiful sound wave in liquid images called cymatics, which are undeniably beautiful and clearly reveal some of the basic wave patterns at the physical heart of the universe, one of those roots of a special kind of beauty that some claim has universal, spiritual overtones. But "Camera Lucida" is unique in that it reveals a chemical phenomenon that had been previously noticed but was not possible to reliably produce until these two Russian artists decided to make it more visible for aesthetic reasons. Who knows what scientific conclusions on the rules guiding flow can be determined out of their artistic experiment. I saw the work inside a spherical glass ball at an arts festival in Riga a few years back, and it was dark, mysterious, enveloping, and didn't quite work so well that day! But the rich layer of story and methodology underlying the project impressed me as being far more scientifically guided than much other work of this kind. Gelfand and Domnitch had to do a lot of scientific investigation and collaboration with engineers before they could get the whole process better understood. Turned out chemists hadn't thought it would be possible to make sonoluminescence bright enough to be photographed until art came calling, desperate to see such fluid, moving, irregular, and lifelike sound structures. The artistic instigation made the scientific revelation possible, and the result is mysterious swirling images no one had ever quite seen before, like imaginary creatures, strange science fiction sea dragons curlicueing their way from gas in liquid, from sound, into magical light.

This is an exciting, dynamic picture, a mixture of blur and precision that once again seems to have the qualities that mark life, even though it is an unforeseen chemical reaction where the chemicals themselves glow when placed in unusual, never-before-tried circumstances. This is not a picture of anything of clear scientific meaning, but instead the thrum of intense sound against an artificial chamber, where once again simple mathematics at work in the physical and chemical world enable complex patterns to appear, sound working upon substance toward the revelation of light. This is about five seconds of glowing xenon

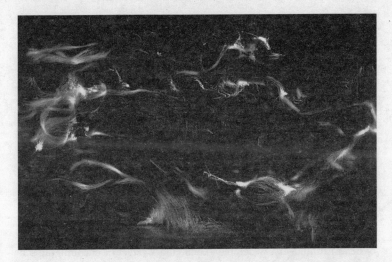

Fig. 46. Evelina Domnitch and Dmitry Gelfand, "Camera Lucida" (detail).

inside a touchy solution of sulfuric acid, taken at the Physikalisches Institut III of Goettingen University.

> This caustic mixture allows one to observe the brightest possible multibubble sonoluminescence. Three ultrasonic transducers were glued to the glass resonator, which were driven by 3 separate amplifiers and function generators at frequencies between 22 kH and 60 kH. A hydrophone encased in a water-filled beaker was submerged in the acid to record, along with 2 video cameras, over 3 hours of "xenon wind."

As photographs, these images show yet another example of this fractal order, which is also found in the growth of natural plants, and is what some mathematicians believe separates Pollock drip paintings from their less-than-genius competition. What would make this work art, as opposed to scientific imagery revealing some specific new discovery? The simple Arthur Danto answer would be to say that if the image is beautiful when put aside for pure aesthetic contemplation, say, on the

wall of a gallery, then what we have here is art. That's the way it has been since Duchamp: put it on display out of its original context and in the new context of the art world, and then it is art; if the audience finds it beautiful, or just revelatory, then it works.

The more complex answer involves the whole story of the scientific research that leads to these images, the role of high-intensity sound in making the shapes visible, and the role of these artists in pushing scientists to refine an investigation of some poorly understood physical phenomenon toward the goal of making this glimmering mystery more available and more visible. This is a work whose presentation must include its whole story, which makes a more complete tale than simply presenting some shapely glowing specters swirling inside a ball of clear, toxic liquid. Here you have a couple of artists doing science in pursuit of beautiful imagery, which has the ancillary effect of encouraging scientists in several countries to further their investigation of a phenomenon that is first of all aesthetically interesting before it is of practical value. Sonoluminescence is intriguing, but ultimately it is beautiful only after Domnitch and Gelfand have created the technology to make it so. And at the same time they have pushed science a bit further along. Potentially there could be many applications for reasonably managed gases that glow when stimulated by sound—the possibilities are actually endless. Two artists have showed the way; now it remains for scientists or engineers to be practical with the results.

These artists have aesthetic goals in mind, rather than aiding science or pushing their careers along in immediately practical ways. Science wants to investigate and reveal how the world is objectively laid out, and art is to creatively present instances of illumination and beauty that might learn from science, inspire science, or have nothing overtly to do with science. Art celebrates, science explains. Or science reveals, art comments. They have always taught each other and learned from each other. The more we admit their true differences, the more they can work together, whether in the same individual or in the collaboration of individuals.

I have tried to make an unpopular case: that art influences science much more than we usually admit. Now how might this case continue

if the very notion of art changes to include the whole story, the situation, the relationship between the artist and his inspirations and the specialties of his audience? The abstraction that changes our way of seeing is already old-school, so last century. What does the conceptual and more process-oriented art of our new century change about how nature is understood?

CHAPTER 7

The Human, the Elephant, and Art Out of Relationship

YOU could say I've been pushing an old-fashioned, long-dead notion of art this whole book, praising work that plays with vision, delights our minds and hearts, and makes us see the world a whole new way. We might learn what is right by studying nature, but what we decide to love, is it arbitrary in the end? We toy with it through the centuries, further and further from the need to represent what is objectively out there, since now we have technology that can do that seamlessly, easily. And with all our tools we strive to learn ever more about the world. Art dares to imagine, to play. It does suggest new ways to measure or be exact, and thus it can aid science.

Seeing the world a new way? Aiding science? These can only be ancillary functions to the true joy that is art. I'm still after the beautiful, because so much of information and experience is so ugly. But am I behind the times? Many would say art has moved way beyond me by now. Everyone's been drugged by Duchamp and knows well that anything can be put forth as art if someone decides to accept it. Prum tells us that's how it happens with sexual selection in nature anyway.

We human seekers of art, now freed from the conceit that the object itself might actually matter, have tended to go with Danto's flow that art has become philosophy: it must ask questions, shuffle ideas, confuse us, make us think. Even if most people still think art is something pretty to stick on the wall, the cutting edge hones its blade ever sharper, slicing our preconceptions into bits. Will the boundaries between art and science in their tandem exploration of what nature is

dissolve further or build up higher as we deal with the most contemporary kinds of art, art that can be hard to tell whether it is there at all? From the stronghold of the concept comes the idea that includes *you*, as the audience becomes wholly part of the show.

So let's assume for a moment this position I don't really agree with, that the object itself no longer matters as much to the meaning of art, since our world is overstuffed with objects and it is harder than ever for any one of them to impress us. And follow for a moment Prum's idea, which he trumps up from Darwin, that any feature at all can turn out to be sexually selected for its beauty, so arbitrariness is the name of the game. Evolution, in nature, maybe even for culture, determines what is preferred, what is good. It could be anything, anything at all.

So what place is there for aesthetics, the assessment of what is good and bad, beautiful or ugly, interesting or dull? The answer is in relationships, from the artwork to the spectator, from the performer to the audience. This is the latest stage in how our understanding of art has moved beyond Danto's celebration of the situating of art in the midst of philosophical questioning. Remember he says that the more questions an artwork raises, the more it slinks into the territory of philosophy and becomes beautiful as it increases our sense of wonder and contemplation of what, if anything, it might mean. But nowadays there is a twist beyond that: the development of artworks that involve their public in more direct ways, where the borders between creator and contemplator begin to break down. This is called relational aesthetics, and we need to figure out if it has a place in our increasing appreciation of the natural world.

The French curator Nicolas Bourriaud coined the term "relational aesthetics" in 1995 to help figure out how we could make sense of art that didn't seem to have physical presence, where the object and its beauty or lack thereof couldn't define the totality of the art experience. "Art," he tells us, "is a state of encounter." Artworks tend to have a shape and a form, but so does everything else in nature and culture. Things come together after encounters between other things, like Lucretius's ancient Greek vision of atoms and how they crash against each other to make the birth of the world. Forms come into being from the

random encounter between previously detached elements, arbitrary moments of link and interaction, but never arise alone, enclosed in themselves.

Abstract, maybe empty, but also refreshing. Thus a great artwork is not the triumph of a master but the master creating plus viewers taking it all in. The "Mona Lisa" is only completely itself in the process of apprehending it, that beautiful small thing, hidden behind glass, observed by a steady stream of pilgrims shuffling toward and away from it in the Louvre. The whole situation is part of the artwork, plus the generations of history and commentary about the painting, forming a world of meaning where the work itself is only the point around which all the interest is focused. It become its greatest only when the world of possible understanding of the painting is included in our grasp of its importance.

I know, this is starting to sound like the kind of circular talk in philosophy that makes me run from the room and regret my Ph.D. But we do advance ourselves by figuring out how to better articulate our questions. The best art "stirs up new possibilities of life. . . . Each particular artwork is a proposal to live in a shared world." You want to know if a work is any good? Ask only this question of it: "Does this work permit me to enter into dialogue? Could I exist, and how, in the space it defines?"

The same might be asked of all the minutiae of information I have offered you in this book right in your hands. Think for yourself: how do all these interesting tidbits about nature and art matter to you, in the here and now, as you relate to the information on beauty and truth you are taking in? And it's not really a collection of interesting tidbits I want you to remember; no, that's too much like the knowledge we get out of a world of instantly accessible Internet facts. Assuming you've actually read this far, that you relate to the enveloping task of reading a whole book up to this point, taking the time for it, taking pleasure in it, using the whole string of words and sentences to affect the way you think, then when you put it down and go back to your usual life, you are meant to see the world and the connection between art, evolution, and science in a whole new way. I want your relation with this book to

change the way you see and conceive the world of natural evolution and the world of human cultural evolution, with art and science, beauty and use, now much closer and intertwined.

I know, no one wants to analyze an activity right while you're in the midst of it. But it's important so we can understand why it is that artists and curators today are so enamored of the idea of relational aesthetics. It helps to explain the hope not only that an audience can relate to an art exhibit or style of challenging, unclassifiable art but also that there might be a new way to evaluate art beyond the sense of weightlessness, or lack of gravity, that the Danto perspective seems to too easily offer us—once anything can be paraded as art, if the best it can do is to turn itself into philosophy and make us think, then how do we evaluate the beauty of said philosophy, since philosophy is too often turgid and only rarely elegant or scintillating, not to mention beautiful, touching, suddenly grasping us at the heart? Instead take Bourriaud's question seriously: does this work bring you into a new space where you can engage with it, or does it leave you cold, mystifying you and leading you to turn away?

Art should now be first and foremost an experience that lures us into a period of engagement with a new experience (of beauty? of truth? of questioning?). Never mind our likes and dislikes—before needing to judge, we first must want to engage, and take time for the work in the midst of so much else competing for our attention.

Does this relational idea make any sense in our dealings with the natural world? Relational aesthetics means the viewer has got to be involved. Science preaches objectivity, keeping the biases of the researcher out of the way into the realm of pure data, pure calculation. Humanist critiques of science have often preached that being human is itself a bias, so we only find things humans are able to measure and see, differences and details that are only visible to us. This way we've missed the ultrasonic songs of hummingbirds and mice, and this is why we didn't do the research to create the camouflage least visible to elk and moose until quite recently.

Human perceiver bias might run way deeper than that. We think calculating and measuring are objective, but they may just be an oddly

human way of making sense of a world that might actually be put together in a whole different way—maybe a rush of continuous flows and tendencies, not really objects, but flickering colors, overlapping sounds, motions, processes. We·know each animal sees the world in strange and different ways, why should not our vision of the whole be peculiar to us? In fact, it's the exception, not the rule, that one species steps back to reflect on everything not directly relevant to its survival. This whole human project of seeking knowledge in science and celebrating the world with art could be considered one very unusual life strategy. Looking at it that way is one aspect of how scientific objectivity does not help us feel the value and beauty of the world. It does not teach us to compare and to feel.

But you don't have to think about it that way. Instead, take a relational aesthetic approach. Everything we learn about nature makes it matter for us, because it is ceaselessly amazing, ever greater than the vast amount about it we can know. This may be a bit of a platitude, but it is one of celebration, wonder, joy. The more we know, the lower our jaw drops, the more we are inclined to just say, "Wow!"

The art that favors the relational admits that the object is not as important as the level of experience the audience hopes to get from their encounter. In the extreme this leads to a kind of art that is entirely composed of the encounter, with no object beyond this to remember or to hold on to. This kind of conceptual art is not just philosophy, not content with being only an idea, but rather involves the forming of a *situation*, a kind of ritual that takes place as an artwork only when the viewer is there.

I knew very little about this kind of artwork until I received a mysterious phone call in October 2007 from a person I did not know, Tino Sehgal. He told me he was organizing an event at the Marian Goodman Gallery, a prestigious address in midtown New York, which would consist of a group of philosophers and theorists discussing the state of our society, technology, relationships, and the future. "It is difficult to explain," he wrote me, "except in person, but for now I will say the closest thing to what I have in mind is a formalized version of the nineteenth-century *salon*, where people would gather to have serious conversations

in their homes, making rigorous intellectual discussion a part of social life."

Now, I'm the sort of person who's always a bit bored, always looking for the next challenging thing to do that I haven't done before. So immediately I said I was interested. Then, as technology today so easily allows us to do, I looked up this unusual name and discovered Sehgal was a hot young artist, of Swedish and Indian heritage, now living in Berlin, who, among other accolades, was chosen to represent Germany at the Venice Biennale in 2004. He is an artist who does not believe in making tangible objects. "We have too much stuff," Tino has said. "I don't want to make any more."

How to reconcile such a position with an artistic path? Sehgal sets up situations. Performances? No, Tino insists these are not performances. There is no script, no photographs are allowed, no films or videos are permitted. There can be no record whatsoever of the work once it is done. Why not? "Well," as characters in his Venice piece famously intoned, "it would no longer be contemporary."

There is an environmental concern to Sehgal's work that informs this taboo. Invited all over the world to the latest and most contemporary temples of art of now and the future, he refuses to fly there in a plane. If they want him, they've got to let him travel by train or boat. He is an artist who is relevant precisely because the public and the art world can't quite define what it is he is up to. At a time when it seems like everything has been tried, when some artists take refuge in abstruse philosophy to attach to their work ideas that often aren't really there and others are returning to basics and traditional senses of technique and craft, it is hard to claim that the borders of what art can be are still being pushed. But that's what Tino believes he can do.

Or so I read, in the many online articles written on Sehgal. But now I had agreed to be part of a Tino Sehgal work, something called "This Situation." What was I getting myself into?

It began with a dinner, a vast salon around a huge table in a downtown Chelsea restaurant, with the whole cast of thirty. There were dance critics and arts consultants, a philosopher who once acted in Hollywood films, professors who specialized in eighteenth-century

literature, graduate students mired in the funk of dissertation comple-
tion, a comic book scholar who champions the value of graphic novels,
a New York City judge who is working on a doctorate in theater. "I've
done this piece previously in Berlin and Frankfurt," says Tino, "but
never have I found as many disaffected academics as here in America."
He smiles.

All of us, I guess, are a little bored with our regular lives, ready to do
what we usually do—talk, posture, defend, and argue—but in a struc-
tured ritual, on display at a famous art gallery, triggered by the arrival of
visitors to the exhibition. Is it philosophy as spectator sport? Art where no
art can be seen? Welcome to the situation—art that corporeally has be-
come philosophy.

I can't show it to you unless you were there, but I can tell you al-
most everything you need to know to do it yourself. There are thirty
people in the cast, but only six perform at any one time, for four hours
at a stretch, half the length of a full day the gallery is open. As long as
people are observing, there are no breaks. But if the room is empty,
then we can break character and relax.

We learn six different positions to arrange ourselves in the room,
most based on postures people take in famous artworks by the likes of
Seurat and Manet. We memorize up to a hundred quotes from through-
out history, identified only by date, not by who said them, to detach our
understanding from what we think we know. "In 1957, someone said:
'Until now situations have only been interpreted. Our task today is to
create new ones,'" which is the defining manifesto of the situationist
movement. I suppose this whole piece is one of those new situations.
Or maybe it's just a Victorian salon on display. Other quotes deal with
poise and conduct: "In 1647 somebody said, 'It is in the art of conversa-
tion where the true personality shows itself. No act in life requires
more attention, though it be the commonest thing in life. One will ei-
ther succeed or fail completely with it.'" Or cryptic dreams of a new
way to live: "In 1896 somebody said, 'We should unite stoicism, asceti-
cism, and ecstasy. Two of them have often come together, but the three
never.'"

And then we are supposed to have an ordinary conversation about

these quotes. Sometimes we will ask each other what they mean. Sometimes we will wonder why they matter. Sometimes we will drift off on totally unrelated tangents. As we speak normally, we are supposed to move as if in a slow-motion dance. Our movements should have no accents, even if our speech might. This is a tough combination to learn— speaking normally but moving unusually. At a certain point we are allowed to turn to someone in the audience and say, "Or what do you think?" At other moments we are meant to compliment them obliquely: "Wow, that line makes me feel that you would be the perfect person to be trapped on a desert island with. I know you could figure out how to get us home."

If a new person walks into the room, then we turn to them and say in unison, "Welcome . . . to 'This Situation.'" Then we all breathe in, "Aaaaaaaah," and walk backward to our next position. Then a new quote comes up, as if out of thin air: "In 1993 somebody said, 'We cannot conceive of solutions to global warming without a change of mentality. The only acceptable end to human activity is a sense of subjectivity that continuously self-enriches its relation to the world.'"

"This particular piece," Tino told me, "works best among people who are trained in their working lives to hold long conversations about very abstract topics. That is why I have tended to pick academics, or at least trained intellectuals. I want people who believe these kinds of topics are meaningful and important to discuss."

We rehearse for several weeks, memorizing quotes, learning the moves. We try to figure out how normal our conversation should be. Shall we be relaxed, or admit we are on display? At the end of every rehearsal Tino gives us notes. "You are like a psychological European theater director, trying to get us to think like you," I tell him.

"This is not theater," he corrects me. "There is no script. There is no stage. I'm asking you to be yourself."

"But there are rules," I remind him. "So is this a philosophical game?"

"To play it well does not mean to win," he teaches me. "It means to contribute to an interesting situation."

Did we succeed? The critics all praised this piece, saying it was a

true breath of fresh air in the New York art world, a work genuinely engaged with the problems of the moment, with a tone searching, optimistic, and speculative, not cynical or absurd. Very strange to be praised in the *New York Times*, the *Village Voice*, and *Time Out* not for making art but for *being* art. "This Situation" was a work composed out of philosophy, not using philosophy to justify itself. It was only as good as our conversation, which was sometimes genuine, other times glib.

In the midst of it, sometimes I wanted to laugh, feeling like I was performing a staged cocktail party with an unlikely audience. But the more I did it, the more I felt I was not good enough, needing more rehearsal, more practice—practice at turning an abstract quotation into something relevant and open that could engage an audience, practice in listening well enough and knowing what to say that was real, genuine, and not too much like a professor lecturing to a blank slate of students.

Being in "This Situation" changed me, forcing me to examine how I situate myself in the world. And that is somehow the point of situationism, whose founder, Guy Debord, defined a situation in 1957 as "a moment of life concretely and deliberately constructed by the collective organization of a unitary ambiance and a game of events." Sehgal has taken the typical activity of intellectual discussion and added only the slightest twist: the ideas and our dance through them are put on display.

There is enough surprise so that just when a visitor thinks she has the whole thing figured out, something unexpected may happen. And this keeps the public there. Some of them stayed in the gallery for hours, which is certainly much longer than the average art installation holds the public's attention.

Being a hit artwork is a lot different from being the artist behind the work. It's rather a strange experience, being an object to be looked at and listened to, not even a performer who has learned his lines well. "I'm not an actor," I tell myself. "I'm just being myself, but I'm being praised for following Tino's rules." It was Balthasar Gracian who said once, way back in 1647, that conversation is the thing that matters. Who? I don't know. I don't care. I don't even know if I'm any good at holding a conversation, though sometimes I think that I've had so few really good ones that I can count them on the fingers of one hand. I

learned something, though, by turning conversation into a ritual, with rules to follow like a life-size game. Upset the familiar, behave just a little bit differently, and there's no telling what will happen and what people will think of you. Set up even a slightly different situation and you might even create art or, more selflessly, be the art that everyone together, all around you and in your world, is creating together and no single person can take the credit for. We are all needed to make it work.

In 1967 somebody said: Never has a technical invention changed the face of science without having had a philosophical outlook at its side.

In 1981 somebody said: We live in a legal, social, and institutional world where the only relations possible are extremely few, extremely simplified, and extremely poor. There is, of course, the relation of marriage, and the relations of family, but how many other relations should exist, should be able to find their codes, which is not at all the case.

In 1983 somebody said: Well, it was never very clear what the situationists meant with "the construction of new situations." When we talked about it, I always gave as an example love, but they would not want to have anything to do with my example.

Step into any art museum today and it is easy to be overwhelmed by the sheer cacophony of images. There is just so much to see. And remember we're already coming from a home saturated with images, where we're spending more than four hours a day online, imbibing the visual as much as the literal, with words falling by the wayside as we think in pictures, still and moving, counting as knowledge what we find there. What image on a wall could be as powerful today as those great paintings of the past in the day when there was nothing to compete with them? Rembrandt's "Night Watch," Géricault's "Raft of the Medusa"? It used to be long ago that paintings were the main repository of visual information and history we had. Now look at us.

No wonder that art has to compete with so much for our attention. Especially the more recent, more pure, resonant kinds of abstract work that want us to change the way we see, those arrangements of pattern, line, and color that I've been claiming can change the way we understand nature, science, and the course of evolutionary events. Still, all of it takes work, and it's easy to let one's attention wander. The art that requires this much discipline from us can be too much for us and not easily welcome us out of our shells of pictures swirling one after another in our heads. Remember, this is why Jaron Lanier said no one cares much for the marvelous abilities of squids—we've seen all that morphing ability already, in cartoons on TV. How nice that it's also real.

So all this is not to get depressed about the difficulty of getting a visual message through. It's a call to arms for a kind of art that is based on stylized engagement with its audience. This is how Tino Sehgal has been able to make work that has been noticed and praised by critics and viewers alike. You do not forget your experience of a Sehgal work, because it is created to directly engage you.

Two years after his triumphant arrival in New York with "This Situation," Sehgal returned to a venue more extraordinary—the totally empty rotunda of the Guggenheim Museum. The building is so beautiful, so unique, and so specific in the way it implicitly guides visitors to spiral onward and upward that many have commented on how difficult it is to see the art in such a place—one's attention is glued to the structure itself. I'm sure there is some species of bowerbird that would go crazy for it.

But Sehgal's art has no corporeal form, so it perfectly complements the space. And this work, commissioned by the museum with only an oral agreement, no paperwork, no documentation, no images, no videos, no films, takes advantage of the upwardly spiraling narrative offered by the continuous floor of the building itself. I hope I'm not transgressing the artwork's rules by describing it to you.

As you enter the museum at the base of the rotunda, you are motioned to begin walking up the inclined spiral. A child, between the ages of eight and ten, comes up to you and says, "May I ask you a ques-

tion?" and if you agree, your participation in "This Progress" begins. "What is progress?" the child asks, and then you decide how to answer. Either I am the best or worst sort of person to play this game, because I teach classes on this subject and have tried to write books about it for years. "Progress," I say on my first time through the work, "happens definitely in science and technology, which get better and better over time. But I'm not sure our appreciation for art, science, or each other improves with time. It would be nice if it did, but often it does not." The child leads me by the hand further up the helix, where I am introduced to an older teenager, maybe one who has already started college. "This is David," she says. "He thinks there's progress in science and technology, but maybe nowhere else."

The teenager says he had heard that new studies had concluded that learning happens best in small-group social situations, when teacher and student can both speak together as equals. I nod, knowing, as a professor myself, that this is the best kind of class to be in front of. We walk slowly up the museum's round incline, talking all the way. All of a sudden the conversation ends, far too soon. I want to give this kid advice, talk more, realize immediately that I do not have enough serious conversations in my life. Too much of all that I say is gossip, banter, jokes, odd little stories. I hope this whole book isn't all odd little stories, though I also hope within its serious claims you find wonder and joy. I may be hoping for too much. Left alone, I'm relating too much to myself. Walking up the museum, this work is making me think about conversation, too much about conversation, how we relate to one another following all kinds of implicit rules.

The youth moves away into the shadows of the crowd. A youngish adult comes by, late twenties or early thirties, armed with a quote, as in "This Situation": "This morning I read an article in the newspaper announcing that dinosaurs, long envisioned as drab gray and green, might have been brightly colored, even gaudily striped. All my childhood memories need to be revised into something more like Maurice Sendak's *Where the Wild Things Are*. Is this a case where art had already progressed in advance of science?"

"Well . . ." I pause to think how much to reveal. "Actually, scientists have thought dinosaurs had colored feathers for some time now. Only just now Richard Prum has found out what colors precisely for one species using modeling and DNA analysis. . . ." But my interlocutor has already disappeared into the museum's hidden stairs, as he's hit upon a topic that I think I know too much about. I circle upward, suddenly alone, hoping to soon touch the ceiling.

An older man comes and walks beside me, starting with stories that seem personal, not out of any script. Easier thus to remember these several months later. "I remember as a kid out on Rockaway Beach there were all these little shacks on the beach. We called them bungalows. I wonder what happened to them? Do you think we've lost something now that they're gone?" And here near the summit the whole notion of progress is called into question, the longing for the past that comes up whenever improvement toward the future comes up.

Now it was time to walk quickly down to the bottom of the helix and start walking up again. People have often said how overpowering this building is, how beautiful it would be to see it without paintings on the walls. Now we could all experience that. But I am touched by how unusual it is to immediately engage in the discussion of serious issues while spiraling up the floor of this iconic art museum.

Sehgal does not encourage documentation of his works: there are no catalogs, no Tino Sehgal action figures, coffee mugs, or books on how to set up your own situationist works or games at home. That might all be too crass. Yet he does not shun the marketplace: these works of his are bought and sold, only by verbal agreement, all over the world. This is pure art of human encounter, as Sehgal told Arthur Lubow in the *New York Times Magazine*:

> For the last two or three hundred years in human society, we have been very focused on the earth. We have been transforming the materials of the earth, and the museum has developed also over the last two or three hundred years as a temple of objects made from the earth. I'm the guy who comes in and says: "I'm bored with that.

I don't think it's that interesting, and it's not sustainable." Inside this
temple of objects, I refocus attention to human relations.

"This Progress" is not a happening, it is not a performance. Some
visitors saw it as a giant schmoozefest, a monthlong party in the most
beautiful of all art museums. It may seem too thin and empty to be
great art to some, but many who experienced it were genuinely touched
in a way art today often fails to reach us, and I think this is because it is
an artwork that genuinely works to engage you, to lure you in, through
conversation on something of deep seriousness, taking your participa-
tion seriously but not offering up a deluge of information. And there is
a real moment of pathos when the conversations suddenly stop. Just as
we start to really engage, we are left alone as the speakers—child, teen-
ager, young adult, middle-aged adult, older and wiser adult—quickly
fade into the background and we are left with our own thoughts.

Tino didn't invite me to be in this piece, though many of my col-
leagues from the first show were invited back. I wondered why. Did I
not make the grade? I probably don't talk fluidly enough; I'd rather play
music or write than chatter. Or maybe he just worried that I lived too
far away from the center of town to be as available as his "actors" ought
to be. Maybe next time. Soon I start a new exercise in the investigation
of "This Progress." Has art progressed when it moves beyond the need
for the making of things in a world that has too much of everything?
Makes me think that I need more serious conversations in my life. Why
don't I have them? Life makes me jump from fact to fact, sound bite to
picture bite. Who has time for depth? The work is taking hold of me,
and I am touched. What more can we ask from art? It should not ex-
plain as much as reveal.

Did critics praise this piece simply because it was something dif-
ferent? Jerry Saltz in *New York* magazine said:

> I was suspended in some weird nonspace. I felt variously shook up,
> spaced out, turned on, told off, intimidated, ashamed, thrilled, and
> shocked. Yes, it's artsy artifice; yes, it sometimes feels like you've

stepped into a Monty Python sketch. Doesn't matter. This show is wondrous-strange, and can produce waves of uncanny self-revelation, surprise, and delight.

But he was more surprised that for the first time in his years of reviewing the art scene, he actually made an artwork cry:

I had been so slow taking notes and asking questions to the perfect little girl who greeted me and started the conversation that, after passing me to the next person, she had broken down in tears. It was a lesson in how vulnerable art can be.

Howard Halle in *Time Out* was not excited to be assaulted by people in a museum: "It reminded me of those trips to Bloomingdale's during which salespeople run up to you and spray perfume in your face." And he thought Sehgal's prohibition against photography and documentation was just "a sales gimmick, making you want to see his work all the more." Art was never meant to please everyone. Half of the people who walked into the museum said no when the child came up to them to ask if they were ready to hear a question. And among that group were a few who demanded their $18 ticket price back. This is all part of what art is meant to do at the cutting edge, and here Sehgal has been successful at something that was only suggested in the 1960s: really forming an art that is beyond the material, even beyond the concept, in that it genuinely engages the public by making their conversations not an afterthought to the performance but the center of the game.

Is this all we really want from art? One erstwhile blogger comments that it is rare enough for an artwork to give us something to immediately relate to:

It's hard to feel anything when you're standing in front of a Jackson Pollock painting, you here and it there, wondering what the big deal is. But, if you engage with the artist's intoxicated dance, lock in on a line with your eye and follow it, walking back and forth, your eyes

zooming up and down, swinging with the paint and letting it lead your tempo, not only do you instantly "get it," you are elated.

But even Pollock is a pretty elitist artist. If no one tells you to engage with the work this way (and trust me—no one will) the painting will continue to hang on its wall, totally separate from you and your life. This is why Tino Sehgal may be my new favorite contemporary artist.

You can change what "This Progress" says; you can easily make it your own. It may laugh, it may cry, but it will certainly engage you if you let it ask you questions. Sehgal says he has been able to dematerialize art in a way the radical innovators of the sixties were unable to achieve because they could not eschew documentation: they immediately tried to augment their happenings with films, papers, notes, photographs. Perhaps that was too early an age to take the removal of the object from art at all seriously. Now that everyone can document everything incessantly at any moment, with millions of images and videos and recordings being snapped and captured all over the world at any instant, the idea of art being beyond its own representation may finally have come to the time that wants it. You have to be there to get a Sehgal piece—how much of contemporary experience cannot be replaced by its avatars anymore?

Much as most everyone seemed to enjoy the Sehgal pieces in the Goodman Gallery and in the Guggenheim rotunda, these overwhelmingly positive reviews and reports are still pooh-poohed by the art establishment of art lovers, critics, collectors, and artists, because such work has the mark of sleight of hand to it. Plenty of experiences are loved by all who are part of them, but we don't call them significant art—you still ought to have a *there* there, something tangible, real, beautiful, inestimable, a work that shows human genius, something that changes your life forever because you have witnessed it, or let it forever alter the way you grasp the world. Shouldn't that be the mark of a masterpiece? Isn't all this relational aesthetics stuff just the clamoring of a tentative generation that wants everything to matter *just for them*? Jackson Pollock elitist? Come on, take a risk—use *your* effort to

inhabit the splatter, don't expect it to reach out and touch you, art is not an instant message beamed in only for you. Become part of something bigger than yourself, that *doesn't* care for you until you have the patience to care for it.

Okay, I know it's easy to get carried away here. Art that is about relationships is simply a different kind of art, which will never be for everyone. But how does it fit into our theme? Can it change the way we understand nature? Or has it too learned from nature? I have said time and again that the art of abstraction and pattern makes nature seem ever more incessantly and essentially beautiful if it is to be necessary. Evolution has brought us this beauty, and it has a sense of rightness that will always be more than our human flights of fancy and experiment can possess. But relatedness—well, that's the only way we are to imagine that nature needs us, that we might possibly fit in. We are a greater species the more we understand how we are connected to the natural forces that have made us possible: that is the main lesson of ecology as a science, the approach to nature that shows how no entity makes sense without the web of connections that sustains it. It's a science whose aesthetic is profoundly relational—the more connections we identify, the better we know who we are and where we stand. The more the world means and works for us, the less it is random, terrible, dangerous, or frightening. And if we know our place, we will be able to maintain our place. We will not persist in imagining that humans are independent, better, separate, smarter, more important than anything else in the world.

Does art help us do this? It does if we use art to relate more widely to the intelligent possibilities of creativity around us. The widespread acceptance of abstraction as beauty in our human world means we will find more artistic moments in the raw natural world, and it also leads us to realize how evolution does produce the need for some creatures to make art as much as, and probably even more essentially than, we do. When human artists are making work like Patrick Dougherty's and we appreciate it, the bowerbird's species-level creativity seems all the more impressive and important. But what about animals that have learned to make art only through human relationship, in encounter

with our training to encourage them to express themselves? Is there any reason at all for us to take this seriously? Because of the art we now value, I believe we have to. And perhaps the theory of relational aesthetics makes it all even more important.

so let us turn now to the elephant.

The loosening toward abstraction that characterizes much of the mainstream of twentieth-century art is one of the great achievements of our era. Previous to modernity, art seemed ever pushing forward, always claiming to encompass and supersede all that came before, standing on the shoulders of giants just to do them one better. With this century's explosiveness, this no longer seems possible. Rules have been cast aside, through layers and layers of further letting go.

The freeing may leave us with little guidance, but it has liberated us; we have learned how to see so much more. Nature now looks like art, instead of the other way around. The drip patterns made by water on a desert cliff can resemble a painting. The songs of larks over the rustle of a meadow can at last be accepted as music. The darting of herons after fish in the river can be seen as a dance. Abstraction has drawn us closer to the art that has always been out there in nature. The result of this is that we all should feel more alive. Art that raises the right questions may have great importance for a culture in dire need of self-questioning, such as our own at this precise moment in time.

We may not know how to tell what is good or accomplished, but we find art everywhere around. Even in the zoo. In the early 1980s, trainer David Gucwa noticed that one of his charges, an elephant named Siri, was playing with a stick, doodling in the dirt in her cage at the Syracuse Zoo. Many elephants have been seen playing in this way, but Gucwa had the insight to encourage his elephant to move from dirt to paper. Over the next two years, he engaged in a remarkable experiment that tests the boundaries of transspecies communication. He supplied Siri with pencil and paper, later paint, and the elephant commenced to produce works that many humans have marveled at and easily been able to call art.

The drawings seem right out of the minimalist canon of twentieth-century art, and there is clearly something special about them. Gucwa did not teach Siri to draw and did not pull the paper away from her when he thought enough was enough. Most important, he offered her no rewards of food or anything else once the works were complete. He did consider this expansion of his training work into artistic encouragement as a kind of collaboration, but the important thing was that he decided to take Siri's creative explorations seriously, to give them a place in her daily routine. That was the extent of this relational project between him and her. The elephant decided when to start and when to stop. The works look at first glance like an Asian calligraphy—not dashed off, but the sudden release of a spirit that has been pent up for a long time, an animal in a cage.

The book David Gucwa put together with journalist James Ehmann, *To Whom It May Concern*, is so successful because it does not presume any conclusions about the validity of elephant art, but just presents the works for us to consider, juxtaposed with written reflections on elephants throughout history. "The proper study of mankind is man," wrote Alexander Pope in 1733, "but when one regards the elephant, one wonders." Gucwa and Ehmann then engaged on a most relational project, which led to very interesting results. They mailed copies of Siri's drawings to all kinds of experts to get their reactions, without at first telling them who or what had made the works.

Joel Witkin, professor of art at Syracuse University, was one of the first to see Siri's works. "This drawing indicates a grasp of the essential mark that makes emotion," he beamed. "I can't get most of my students to fill a page like this." When he later learned it was by an elephant, he was not angry. "I am even more impressed. Our egos as human beings have prevented us for too long from watching for the possibilities of artistic expression in other beings. . . . These drawings are wonderful," said Witkin, an artist whose own work is patiently realistic. Art education professor Hope Irvine said, "They are certainly not drawn by a child. They almost look like an adult trying to draw like a child," which reminds one of Picasso's famous line, "Once I drew like Raphael. It has taken me a whole lifetime to learn to draw like a child." That's what

Fig. 47. A drawing by Siri the elephant.

minimalist abstraction may be about, a difficult striving to recover some lost innocence. Like being naïve enough to imagine we can once again find a way into nature after all our species has been through.

Onondaga chief Oren Lyons said, "You can't speak for the animal. All you can do is appreciate what she has done—if you dare." Animal psychologist Donald Griffin, the man who discovered sonar in bats, wrote back, "They are complicated pictures, but I don't know what they tell us about what the animal was thinking. Of course, I have the same feeling about all modern art." Stephen Jay Gould was fascinated, though he did caution against too much anthropomorphizing. "I have a hard enough time assessing my own motivations. Lord only knows what goes on inside the brain of an elephant."

They then sent the drawings to Willem de Kooning, who responded, "That's a damn talented elephant. I look forward to following his career." The great artist was inclined to trust the elephant, to want

to appreciate her work, not to imagine she is trying to tell us something that can be easily explained. De Kooning knew that art is more than psychology, and that abstraction must lead to an openness to seeing artistry where previously it was invisible. He had the guts to realize that to appreciate the creativity of an elephant implied an advancement of the human character, not a belittling.

The more interest that came to Siri's works, the more people urged Gucwa to arrange that they be put on display, perhaps auctioned off to raise money for the cash-strapped zoo. He was vehemently opposed to this idea, seeing himself more as an experimenter, investigator, or facilitator. He wanted these works available in one place for viewing and study, not "hanging on the playroom walls of rich folks out in the affluent suburbs." Gucwa was a pure believer in the art of his elephant as a beautiful and nearly sacred thing. He wanted no part of the marketplace, even if it was for a good cause.

Sehgal would disagree with him on this score. He'd probably applaud the relational aspect of what Gucwa did with these elephant drawings, using them as touchstones to start genuinely interesting conversations. But for them to be taken seriously as art, even conceptual interspecies art, Gucwa should not have been afraid to have them bought and sold, thrust into the international exchange that puts numbers and worth upon culture. It works for him, for it was necessary for him to have the kind of art world success he has achieved with his radically ineffable works. Sehgal has had as much influence as he has because he is smart, careful, exploratory, and good: his works are better than any sweeping generalizations of the situationist genre would allow.

The same could be said of Siri's drawings: there is something undeniably beautiful about them, whoever is behind them. They can be loved by anyone. Perhaps the title of the book should have been *From Whom It May Concern*, since we know so little about what the artist had in mind, what she wanted, why she made what she did. There is no artist statement, there is no story from behind the scenes. We add on afterward because we are unable to ask this elephant artist direct questions.

It is no accident, I think, that Siri's work tends in the minimalist,

Fig. 48. A painting by Siri the elephant.

expressionist direction. Maybe I just happen to like that kind of art, or maybe it just fits my thesis that if we take art such as this seriously, as the twentieth century has encouraged us to do, then there is so much more of it to see all around us, and the world is an ever more beautiful place. Some would take this to be one of art's greatest con games, but I really believe it is more about the expansion of our ability to find beauty in the world around us. And it seems like many who have been touched by Siri's drawings would heartily agree.

Siri's story and Gucwa and Ehmann's book about it remain the purest example of art made by a captive animal that I know of, because of the beauty of the work itself and the relational story they tell upon it. For all his work promoting his elephant's creative side, Gucwa was hardly rewarded; he was fired from his job just as his art project became more widely known. Today he has moved on to other things. Siri the

elephant is still at the Syracuse Zoo, now a kind of matriarch among their elephants. She even has her own Facebook page. Her long-ago interest in art is not even mentioned.

Siri's story is not the final chapter in humans' passing interest in elephant art, not by a long shot. A different breed of facilitators of pachyderm painting has come along, two artists who are more interested in expanding the discourse on who or what can be an artist, and who also see the potential financial benefit for raising money for these animals, who are so threatened in their native lands. Komar and Melamid, the team of Russian émigrés who previously asked the world what the best painting should look like, have now decided that they are the best candidates to really teach elephants how to paint. To make the best painting for themselves, or for us? I think even they ought to be surprised with the results.

Their elephant project is kinder and gentler than the earlier Most Wanted Paintings project. Start with the fact that elephants in Thailand were an essential part of the logging industry in Thailand, since they were better able than trucks to navigate the complex terrain. Each elephant was carefully domesticated by a single trainer, called a mahout, and if the relationship between human and animal proceeded properly, the elephants were a lot easier to maintain than machines.

Now that the country is mostly deforested, logging has been illegal in Thailand since 1990. There is little left for these commercial elephants to do but roam the streets neglected or else live in camps to amuse tourists. The plight of these large, incredible animals who have lived so close to people for so long touched Komar and Melamid, and they decided art might be a way to get people to appreciate them again once more.

For the first time these provocateur artists combined their antics with conservation, with a plan to bring awareness and support to the elephants' plight through art. They are going to teach the elephants of Thailand to paint, and flood the world with elephant art. "It is either the greatest idea in the world or the most stupid," says Melamid to a group of assembled bigwigs from the World Wildlife Fund. Money is promised. They're off to Siam.

Keep in mind how different this project is from David Gucwa's. Komar and Melamid are desperate for publicity—for the elephants first, not really for themselves, though they are not shy about attention. They are going to teach the elephants to paint, through their mahouts, holding a special brush modified into a tomahawk shape to make it easier for the elephants to hold. Every mark made by the animal is only after the mahout has trained the animal to get used to certain particular motions. It's definitely a collaborative process. At the end, as in most animal training exercises, the pachyderm is specifically rewarded with a meal. This is how art making is taught at the Thai Elephant Art and Conservation Center. The mahout crouches on the ground at the elephant's feet and dips the brush into whatever color nontoxic paint he sees fit. Then he hands the brush to the elephant, who curls it in his trunk. The mahout guides the trunk toward the canvas and turns the trunk in slow circular movements so a mark is made, hoping that the animal will get the hang of it and start to *want* to paint. At the end, it's lunchtime.

Classic animal training literature would call such activity "enrichment," something designed to relieve captive animals' boredom by engaging their creative and curious urges, which often have nowhere to go when they are in the service of man. Komar and Melamid, though, have larger aims. On one hand they want the public to be impressed by and to care more about elephants, so we will be more mindful of their plight and treat them with ever more respect. Then at the same time they are happy to raise questions about the way humans both idealize and criticize art.

I confess I am a bit enraged when I see their elephants are neither painting of their own volition nor exercising their creativity when they want to, without expectation of reward. The story of Siri and David Gucwa seems more pure, the art more delicate and beautiful. But Komar and Melamid got the art world to notice their activities. They did all the schmoozing necessary to get the message out. And it got viral, became bigger than they ever imagined. Still, some people considered it all a hoax, since these paintings were really a collaboration between human mahout and trained elephant. So what? says Melamid. "Of course

it is all a hoax! All art is a hoax, like the idea of three-dimensionality in paintings. Is it a window? Or a painting of a window? My god, what a master!"

But at least we know that there is intention behind the work of human artists, that they want us to contemplate their expressions as detached objects of beauty. Oh? "It is not the intention of the artist that matters," continues Melamid. "It's the later interpretation of their intention that does. . . . This is about the fact that elephants are painting. Who's to say these animals are not artists?"

How will we know whether these elephants' work is any good? "We will tell you, because we are famous artists from New York. We will determine for everyone what is good and what is bad."

It can be hard to tell whether they are joking or not. Komar says, "Of course it is hard to tell. Look at whole Soviet Union. Was it serious country or biggest joke of all time? Still historians not sure." The problem of elephant art seems a whole lot lighter compared to that. Or is it? The fact is, people can be more willing to appreciate a piece of abstract art if they hear it is made by an animal; you might think it is because people like to joke about modern art being a crock of shit, all too easy, like child's play, but it may be something deeper. We *want* to be connected to the animal world, and love finding examples where animals show surprisingly creative abilities. It may make humans' relentless need to express and to create seem all the more natural, all the more explicable or justifiable. This may be why I want to convince you that it is important that life is itself beautiful, that evolution is partly about natural and sexual selection exploring odd possibilities simply because they can be explored.

Still, does nature care that it is beautiful? What say the elephants to their creations? Melamid, the only one of the pair who seems to talk, praises their elephants for knowing exactly what art means to them: something that will get them their next meal, classic training. Siri in Syracuse seemed more content to make art for its own sake, or to alleviate her boredom. Thierry Lenain brings up the issue in his most excellent book on the related history of monkey painting, noting that those works become art only once taken away from the artist-

chimpanzee: "Our fascination begins where the monkey's interest leaves off. The effect of our game of artistic contemplation on his work leaves the monkey cold, just as the monkey's indifference to the finished work remains incomprehensible to us." That's because what really does separate humans from animals is not any aesthetic sense or artistic ability but the need to obsess over it, to worry about it, to endlessly examine ourselves instead of just living the life we have to live.

"Certainly my IQ is higher than an elephant." Back to Melamid. "But how much of my IQ do I use when I paint? It's not like Jackson Pollock was a mathematician or something, so maybe it's not so crazy to see that elephants and humans can compete in this arena." So have their charges got any talent? Is there a five-ton artist in the room? I confess that when I first saw Komar and Melamid's book *When Elephants Paint* I was quick to judge it a clever response to *Why Cats Paint*, which, although subtitled *A Theory of Feline Aesthetics*, is more of a send-up of the art world than anything else. The paintings, minus the whole adventure story, never did much for me. But now it's more than a decade later, and I'm inclined to study the whole journey and Melamid's remarks far more closely. I like the careful way in which he uses irony.

Still, most of the paintings look like the nonpareil abstract painting that one sees in galleries all over the chi-chi world. As my teacher Roger Shattuck once advised me, "Ninety-nine percent of art has always been trash." A few of the elephant paintings, though, do strike a chord. A more minimalist work by a ten-year-old elephant named Bird in Ayutthaya, Thailand, has dark purple and green, strong, rough strokes that seem to illustrate something of the feel of that heavy, rough trunk holding the hammer-gripped brush. I am touched by its weighty abstraction.

The pinnacle of the story for Komar and Melamid may be the benefit auction at Christie's New York headquarters, when an elephant painting sells to Stuart Pivar, a noted collector and founder of the New York Academy of Art, a small downtown school that promotes traditional, realist painting. Pivar hangs his acquisition in his very traditionally decorated Manhattan apartment, right near a priceless masterpiece by the

Renaissance painter Pontormo. Here is a collector who favors realistic art by humans and might only be impressed by the abstract if it shows creativity from another species. "I never dreamed it would come to this," says Melamid. "In a way this proves the idea that great art is always tied to the miraculous." Consider the fact of an elephant painting—no one can say it is not a painting. Thus art expands, and becomes a bit larger than our own single, specialized, curious species.

It is the public side of the Elephant Art and Conservation Project that grabbed hold of Komar and Melamid and then the whole world. "A traditional painter organizes lines and colors on a canvas," Melamid quotes Alexander Bogdanov of Russia's constructivist era. "The real art of the future will be organizing people, making things happen in the world." And so we return to the situation and the world of Tino Sehgal and the aesthetics of relation. The whole story of where elephants and humans can go once admitting this creative connection is the greatest benefit this project can reveal.

And the tale of elephant artists does not end here, even though Komar and Melamid dissolved their artistic partnership a few years ago. Nearly six million people have seen a video on YouTube of an elephant painting a portrait of an elephant, a painting you can order for yourself online. What has happened to the animals' innate abilities at abstract expressionism? The irony of elephant art is greater than we might have first imagined: if these works are the result of collaborative training between animal and mahout, then with enough training they can reproduce all kinds of movements with their trunks. So why not teach elephants to paint more realistic, universally likable pictures? These look less like what the art world might be offering up to its most discerning clientele, but the wider world is more impressed by these kind of pictures.

These days on the Web site of the Asian Elephant Art Conservation Project, the elephants' pictures of flowers in pots and outline paintings of other elephants command the highest prices (still under $1,000, pretty reasonable as fine art goes, and all the money goes to help the artists and their plight). The project's current director, David Ferris, describes the situation thusly: "The AEACP was originally created as

an alternative to illegal logging, to begging on city streets, or having to perform circus tricks. The very core concept of the project is to provide a way for an elephant to earn a living as an artist. Painting an hour a day after bathing, eating, and relaxing doesn't sound like a bad life to any of us I'm sure."

So today's elephant-concerned tourist or art buyer has a choice: abstract elephant art or realistic elephant art. Depending on your own aesthetic, one may seem more serious than the other. All are good, though, because all represent a way to help these animals while respecting their creative ability, which is still basically astonishing. Though I still hark back to the more innocent and beautiful story of Siri in Syracuse, the elephant who wanted to make art for the sheer joy of it, without being trained to do any one thing or another. And I'm not the only one.

There is a rival source of elephant artworks in Thailand that tells us that elephants do make art without training and that one should look for this authentic art, not the carefully trained and conditioned lines. The Elephant Art Gallery in Chiang Mai takes a decidedly confrontational approach:

On other elephant art websites you are likely to see something completely different, such as endless identical so called "self portraits" with a few carefully controlled lines that depict an elephant outline often holding a flower in its trunk, or perhaps a painting of a vase of flowers, or a landscape, geometric shapes, or "pointillist" patterns in neat rows. Do you think any of these paintings were created from within the artist of its own volition? Of course not!

Those elephants have been highly trained for long periods to repeat patterns of brushstrokes on commands and physical prompts from the trainer. They have no idea whatever what we humans "see" and there is nothing remotely natural or original in what they produce. By our definition this is NOT real elephant art.

Figure 49 shows the standard "self-portrait" elephants have been taught to paint, the image quite beloved on YouTube.

Fig. 49. A Thai elephant trained to paint its own self-portrait.

Now, elephant art, like so many human genres, has its critical champions of authenticity: "What an elephant produces naturally is abstract art and like all abstract art, it is open to interpretation. . . . Paintings that are executed by sentient beings will always elicit a response because I believe that we recognise in them something fundamental. When I study a painting by an elephant I see something awesome and primeval. . . . Art by elephants has an immediate visual, aesthetic appeal."

This remains the first and final lesson—we cannot shake our amazement, as much as we want to explain it away. It is so hard to think of an abstract painting by an elephant as anything but an artwork, and that is a tribute to the success of abstraction in changing the way we see the world. Once we admit this, the world with its creative urges becomes a far more beautiful and accessible place.

It is time to stand up for the achievements of the twentieth century in the arts, not to shoot them down. Art's modern battle to free itself

from all constraints mirrored blind leaps to liberation in our recent past: music that is four minutes of silence, paintings that are completely red, performances deliberately unfocused or untrained. We had to go through these steps to cleanse our culture of excess, drive, and even the will to progress, to imagine that the great march of our Western way was going any one fantastic place in particular. It is not. We are en route to many places, and there are many ways to distinguish good from bad, many ways to be aware of art's creative responsibility.

It is sometimes hard to find artists who will call their work abstract, and too easy to find philosophers who admit their thinking is too abstract. The conscience of the quest to evoke or explain remains the immediate glow of reality. Each endeavor must illuminate these concrete experiences, the living causes of wonder.

We of the culture who do not know just what to believe in have been blessed by the openness brought by our recent history. It is no accident that we are finally able to look at the art of elephants with some seriousness, or to be forced to admit that art teaches us not so much about the artist but more about ourselves and how much explanation we demand before we can really see.

A shadow, a light, a melody that triggers a memory, the cry of a crow, the moving warble of a group of flying cranes—all contain possibilities of song, chances for communication, someone trying to speak. Never forget the elephant. Or the dinosaur, the vulture, the plunging waterfall, or the oldest living tree on Earth. They all contain infinite stories and must never leave our memories empty.

Art does not belong to us. It abounds everywhere. When it works, it goes somewhere we were not aware of when we began. We are responsible for how little we know; it's no one's fault but our own. And yet the more we learn, the less sure anything seems to be. That's the danger of education. That's the fault of the information society. Too many images, too much trust in our ability to classify it. Throw away as much as you can of what you know, and you might at last be able to see.

CHAPTER 8

The Brain in the Cave

Art at the Edge of Human Certainty

So should elephants be allowed to express themselves, or shall we teach them to paint their own likenesses so as to make their work more appealing to the general tourist? After all, art is money; if you're a Thai elephant in art school, it keeps you off the streets. Perhaps you think such treatment of animals is cruel or unusual, or that to talk about it as art is rather frivolous, but take a look at what you find if you go back to the earliest examples of prehistoric human art. (See figure 50.)

These are all isolated fragments of complex, multilayered cave paintings, all done by firelight in totally dark caves. Back in the early Pleistocene, the images humans were most wrapped up in recounting were those of the greatest animals in our midst. Before any sense of abstraction or symbol or pattern or rule, the earliest human artworks were of the quarries of the hunt, especially the biggest ones: mammoths, elephants. No wonder we are still in awe of animals and trying to figure them out.

In this chapter we will reach out toward two opposite frontiers in trying to figure out what humans are thinking about when we make art. Prehistoric art is as fascinating as it is hazy and remote—we have only shadows of its exactness, outlines or fragments of the great stories painted in caves or etched in rock. We can only speculate to what extent such works were made for practical or sheerly aesthetic means. Ancient imagery is even more vague than the abstractions of the present when we imagine what it can do to frame the place for our species in the world. Did we need art way back then for any different reason

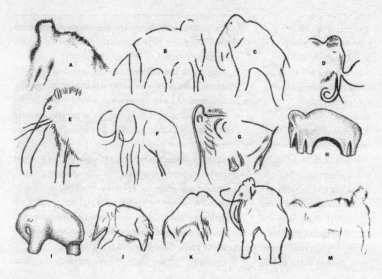

Fig. 50. Montage of various prehistoric human drawings of elephants.

than we do now? Are there unique clues in prehistoric art for the ultimate reasons why humans may have always needed art? Does this need separate us from or tie us more closely to the bowerbirds and elephants of this world?

Individual elephants may be separated from the fray for our study and comparison, but more often than not the shape and form of ancient art looks more like figure 51.

With this sketch from the inside of the Cave of the Three Brothers in France we have a magnificent overlay of animals upon one another, like the piles of images catalogued in our memories or a child's story-drawing upon which he can easily recount the history of actions, layer upon layer, leading up to the end of the battle or the hunt. Or you can just marvel at the energy and the way the real animals so depicted swirl swiftly into abstraction. But is that only what the eye of a more contemporary viewer might see? The image must grab us before any story that tries to tell us what it means. Don't read too much about any work of art before you look hard enough that you might actually see.

Fig. 51. Paintings on the wall of the Cave of the Three Brothers.

What do we see when we see the image of an animal? Is it different from any other shape? Do we see tonight's dinner, or a creature in the midst of the vast web of evolution on which we also appear in our own precise place? Does education or instinct define what such an image does to us? I tend to see the swirl of memory in an image like that, as when I close my eyes and think of the myriad things that have happened to me over the past days, trying to hold on to all of this in a single image. I see the real happenings merge into a complex abstraction as I

imagine a drawing of it, like the child's layered storytelling, like the camouflage hidden in a splattered Pollock.

I wonder if it is a century of abstraction seeping into our culture that has enabled me to see like that; or perhaps these images are so many thousands of years old that we will never know. We will have to hypothesize, going for coherent explanations at the far limits of data. The ancient, venerable quality of such imagery makes us stand in awe of it. How have they lasted? Why were they made in the dark? Were they any more ritualistic and specifically meaningful than any individually expressive art made today?

There is that old truism that primal cultures are far more pragmatic than we are. When I returned from a trip in wild Labrador to the Inuit town of Kujjuaq, I talked to an old man about my two-week journey. "See any animals?" he asked, a common question.

"Not much," I told him. "But there was one rabbit who walked right up to my boots and sniffed them, like he had never seen a human before."

"And?" he replied.

"And what? He just walked away."

"What?" said the native. "You didn't *shoot* it?"

And I laughed, having learned the lesson that any Arctic animal story ought to end with a roast bunny in a pot, or at least a satisfying meal. No innocent admiration for creatures when you're living close to them. Eat or be eaten—the simple, practical life.

I don't know how much this story relates to layers of ancient animal imagery, but it does back up the standard notion that ancient art was meant to recount important practical stories rather than abstract imagery common to the root forces of life. It suggests that ancient humans are closer to the world of animals, to those aesthetic universals that may or may not exist along the evolutionary pathways of life.

If the beauty in the animal world is either evolved through sexual selection or the result of basic patterning possible in the workings of life, then what lessons can we humans glean from this? We evolved with all these forms appearing all around us, so we may have formed our preferences there? Or did we always want to distinguish ourselves

from the animals, by asking questions about them, naming them, drawing them so we could control them?

I do not want the purpose behind anyone's art to detract attention from its beauty. It is more important to marvel at the bowerbirds' works than to check them off as just the most outlandish way evolution has figured out to display male quality. The attempt to understand prehistoric art may be as much a history of how we in contemporary times have strived to make sense of those human artifacts at the very limits of our ability to preserve our past.

So what are our root images, the visual thoughts at the earliest memories in our brains, those pictures that precede even language or any attempts to organize thought? This is why I am interested in the earliest glimmers of human art—not so much to explain why our species needs art but to ask what are the most basic things our brains can see. We have to go far back beyond the idea of representing tasty animals that we would like to kill and eat, into the very imagery the brain makes for itself even without any outside stimuli.

Picture yourself inside one of these dark prehistoric caves. It is so dark you can see nothing. Or is it nothing that you see? Paleolithic art has elements beyond the outlines of beautiful beasts, drawn with rare and honest energy. There is also the kind of patterns one sees even when the eyes are closed, known as phosphenes. Scholars looking for a biophysical origin to the forms of human art go back to such images of waves, dots, zigzags, grids, and nested curves. We may see them without knowing where the images come from, either the eye or the brain. Close your eyes after staring at the sun and they appear; they show up in the middle of the night, in the heart of dreams. If you've seen enough abstract art, you may be more inclined to take such images seriously.

David Lewis-Williams, probably the most psychologically minded of theorists of Paleolithic art, describes the origins of art in terms not of what it does for us but of how it might emerge out of attending to these swirling brain visions. They reveal a geometry inherent in the structure of our visual system, which comes to the fore when the system is cast into sudden darkness or stressed, as in migraine headaches,

when people hallucinate while taking psychotropic substances, or when people are led into a trance through ritual methods. Human societies throughout history have valued visions and trances, but of course you don't need drugs to see these things. The same kinds of images crop up in recent scientific studies of the neurobiology of sleep. (See figure 52.)

Depending on your context, you might see these as a sampling of imagery from indigenous tribal art, prehistoric patterns seen in ancient caves, or the kind of hallucinations one gets while either having migraines or taking drugs. Oliver Sacks recognized that such patterns are fundamental to the physical workings of nature, and he realized that anyone who suffers migraines would open up the pages of Haeckel's *Art Forms in Nature* and see not only the myriad shapes of nature's microscopic creatures but also the visions that swirl around in his or her own head. That's Sacks's explanation for the famous visions of Hildegard of Bingen; he says they are well-known to all who suffer from or study migraine headaches. The pulsing stars in the sky, the mandala-like omnipresent circle diagrams that incorporate Christian imagery with the phosphenes that pulse in our own heads—these too are based on the fundamental patterns nature makes possible, the circle, the spiral, the star, the burst. These patterns have a fundamental gravity because they are the shapes at the conceptual root of nature. Evolution makes use of them because physics, mathematics, and chemistry make them possible. They are deeper in the world than anything specifically human, and they glimmer forth in the most ancient of human art, side by side with the practical documentation of the results of the hunt and the animals of power.

Hildegard describes it like this: "I saw a great star most splendid and beautiful, and with it an exceeding multitude of falling stars which with the star followed southwards." Then they went away. "Suddenly they were all annihilated, being turned into black coals . . . and cast into the abyss so that I could see them no more." Sacks describes it thus: "She experienced a shower of phosphenes in transit across the visual field, their passage being succeeded by a negative scotoma." In one of his earlier books, before he became the great medical essayist he is today, Sacks presents paintings done by some of his migraine

Fig. 52. Phosphenes recorded in sleep.

patients, illustrating the visual delirium that they experience. These pictures are full of luminous, repeating, tessellated, kaleidoscopic, regular patterns like those that make up the very root fabric of existence, streaming right from within the normal visual field, like dazzle camouflage coming from within our own mind.

Today they look like images familiar from a visit to any art museum, but what did they look like to Hildegard? Glimmers of the divine, she says, but all successful art has always had a tinge of that. Dostoyevsky also suffered from migraines and saw in the moments when they overtook him an eternal harmony, something deeply all-consuming: "During those five seconds I live a whole human existence." Each artist demands the greatest meaning from such experiences that totally consume us. It has probably been like that since humans began to reflect upon and creatively respond to the world they live in and through. The late contemporary artist Louise Bourgeois may have been thinking the same when she said, "Once I was beset by anxiety. . . . I could have cried out with terror at being lost. But I pushed the fear away—by studying the sky. . . . I saw myself in relationship to the stars. I began weeping, and I knew that I was all right. That is the way I make use of geometry today. The miracle is that I am able to do it, by geometry."

The brain that experiences such visions, be it a Paleolithic artist inside a totally dark cave or a migraine sufferer today, first apprehends

Fig. 53. Painting by a migraine patient.

the visions as an initial stage of understanding, in Lewis-Williams's explanation. Then the brain tries to elaborate the patterns into iconic, familiar forms in the actual world: waves, lines, patterns on animals, evolved natural forms. In a third stage, shamans, visionaries, and hallucinators talk about being lured into a tunnel or a vortex, where they themselves enter the patterns and forms. They become the animals graced in spots, lines, and camouflage. The whole vision takes us in.

Nancy Aiken, in *The Biological Origins of Art*, collects impressive visual evidence showing how phosphenes take the same form as abstract imagery found in cultures from all over the world, and also in the doodles of children.

They are thus imagery that humans have always had the capacity to understand. How much we value them depends on what external significance they are given, or how much our appreciation of art leans toward the abstract.

This again is one reason I think we possess a heightened sense of aesthetic possibility today—we take doodles and hallucinations more significantly as art, so a larger, richer portion of experience is now

Fig. 54. Phosphenes between cultures.

available to us as being aesthetically interesting. And it gives support
for the joy in finding intricacy and symmetry that so touched Ernst
Haeckel, who spread the gospel of Darwin's evolution far and wide
with his revelations of intricate, swirling, symmetrical forms, showing
just how much beautiful diversity life did contain. Something about
symmetry has touched us for thousands of years, and it's probably not
just that we see such swirls and patterns in the most intense kinds of
headaches we may get. There are deeper parallels of form in all the
beauties that we most wish to see, either real or imagined.

This is certainly the coolest vision of primitive art, a picture
melded purely out of experience, not out of history or explanation. It's
worth holding on to because it makes abstract art the most ancient
kind of human artistic seeing, something that comes already from
within our own brains. Ellen Dissanayake is famous for defining the
earliest and widest form of human art as the "making special" of expe-
rience, going back three hundred thousand years to the times proto-
humans were known to decorate themselves with red ochre in a
celebratory fashion. But even she is puzzled why humans have always
spontaneously and excessively made geometric shapes, even though
little in nature is purely or exactly geometrical. Why have we always
understood and craved exactness? Plato said we are always searching
for the perfect forms at the root of an imperfectly experienced world.
Even the most ancient human artists realized such forms were real

enough to incorporate into their designs. Did they take them more or less seriously than the animals they decorated and drew? Our brains have evolved to seek abstraction as well as the practical; we have always been awash in the search for pure idea. We divide the world into pure shapes in order to make sense of it, and we play along with those shapes when deciding to make art.

Dissanayake says, in her excellent book *Homo Aestheticus*, that although humans discovered fire and invented tools to gain advantage over a sometimes hostile environment, they still needed to conquer the fear of a threatening environment with rituals, music, and beautiful works that could emotionally soothe and satisfy us. The need to make art comes from a natural ability to shape and elaborate, but she sees this tendency as different from the dances of whooping cranes and the art of bowerbirds only in degree, not in kind. The human uniqueness is to make a decision to add art to moments of importance in life and society: the arts are good not only because they make us feel good individually, as bowerbirds and cranes probably also feel, but because they unite us in collective belief and action.

She believes that we reinforce the practical with the beautiful, enhancing celebration with art that taps into our basic sensitivity to the evolved patterns of nature, which evolution has wrought out of the possibilities of symmetry and form that are the pure fabric of the universe. The most enduring art taps into cognitive universals that all humans are able to apprehend: circles, diagrams, regular routes from center to periphery, the satisfying balance of mandalas and the unity of Navajo sand painting. We have always wanted to enhance experience through the creative life. A world infused with art is a better world to live in; we celebrate ourselves and the greatest way to connect with what surrounds us. We smile, we cry, we embrace and fall into beauty.

Making sense of prehistoric art may always be an exercise in far-off speculation. Those who seek to explain these ancient markings may always be following their prejudices and hunches. Some of our awe in the face of such images has to do with the fact that they viscerally speak to us of a time from which so little that is human factually remains. We smile when we realize how beautiful these images seem to

us, recognizing some commonality of aesthetic with these far-off ancestors: the beauty of the line forming that horse, the firmness of that painted arrow, the sexiness of the curved hip, the familiarity of those swirls and stars. Abstract pattern has been with us as long as the need to celebrate the hunt or the battle and the need for love. Enough art today covers this same ground.

But there are some mysteries that make these prehistoric galleries ever mysterious. These works were painted in caves, worlds of nearly total darkness. They could only be painted or viewed by flickering candlelight, perhaps only in special rituals where few would be welcome in at any one time. Maybe the flicker made the paintings seem strangely alive, like the visual buzz of old televisions or the glittering uneasiness of 3-D television. Then as now, we know it's not really alive, but only pretending to move.

Always intrigued by mysteries it will be impossible to resolve for sure, people have taken all manner of approaches to assimilating and cataloging such visual mysteries. The time is so remote from the present and the images so sketchy that they are open to so many possible interpretations. Dale Guthrie, whose magnificent book *The Nature of Paleolithic Art* provided that initial collection of elephant images at the beginning of this chapter, believes that this world of art is not so different from our own today, that it is about individual artists responding to everyday activities and trying to document them with beauty: hunting, fighting, sex, birth, death. He is more suspicious of the legions of shamanistic, mystical interpretations of the sacred quality of this art that give it a sense of remote, integrated awe far from our present world of multiplicity and expression.

Iegor Reznikoff has even been intrigued by the multisensory possibility of these underground exhibition situations. What if they were something closer to multimedia installations, or stage sets for song? He claims that the paintings are found in only the most resonant spots inside the caves, exactly where one might sing or chant and have the greatest echo or sense of space in a performance. It's impossible to know whether such an observation is cause or effect, but it does sug-

gest an intriguing possibility: that down in the dark, where vast scenes and layers of story were painted like the story-pictures of a young child, stories and music could also be sung in the perfect natural locations marked for deep artistic experience. Was it all shamanistic, magical, or simply a matter-of-fact part of documenting lives? Perhaps both, as it all seems too long ago to really know.

Would not an artist today paint with the best possible light? Not necessarily. We bend experience to greatest possible aesthetic effect, disorienting the audience so that they are captivated. Imagine these grand subterranean images offered to the public in flickering firelight, perhaps accompanied with sound and story. Before anything else, it was a situation, a performance to witness. With moving light passing over the pictures, the walls of the cave might have appeared to come alive the way movies appear alive to us today. And will we ever know? Searching for ever more evidence, we will always keep trying to make sense of ancient beauties we can never be sure of, details we will endlessly enjoying guessing at. We keep the past alive by endlessly reinterpreting it.

With different media, back in a world far removed from our technologically infused surroundings, we still wanted the same things from art back then: a way to make the invisible visible, to push for the truth of things by experiences that would amaze us before we could explain them. And we still can't explain them, and they remain astonishing. What we painted back in caves touches us now as much as it did then. As little as we may be sure of the real context or correct way to take in these images, beautiful they remain.

Yearning for meaning in the ancient and barely visible, we search for resonances in what we see with what we like to see today. There are the lines of animals, forms of nature that we know well and which mean more to us now than we can say, as probably then. We know we are related to these creatures: we chase them, hunt them, eat them to survive. They are alive and we know we will never know them, never know how much they know and what they don't know. They are endlessly in our gaze.

Then there are the abstract forms and shapes, rules of nature that have always been there—generated by simple mathematics, evolved by a process where no one is in charge. Beauty happens because it can.

These pictures are old, barely visible, made in the dark. We will never be sure how to see them, whatever evidence of their creation we find. But they have to have survived for a reason. They stay beautiful however more we learn. Approach them with questions and respect. Be not afraid of speculation.

JUMP ahead and dare to look inside the brain to wonder what the mind is thinking, what happens when it confronts art it likes or dislikes. And can we deal with uncertainty in what we can hardly see? The British neuroscientist Semir Zeki is the one professor in the world in neuroaesthetics, a field of his own invention. For twenty years now he has been the strongest proponent of the task of observing what happens in our brains when we look at art, hoping to learn something about how our minds make sense of art based on where activity appears in the deep gnarled hollows of our brains, as observed in PET and fMRI scans. The mind is the most mysterious of human faculties—so mysterious, in fact, that we're not even sure whether it exists. At least we know the brain exists, and we assume that what we count as the mind comes somehow out of the firing of neurons that we see in the gray matter inside our heads. But what exactly is going on there? It is amazing, in fact, how primitive our understanding of the brain is even after decades of work prodding, cutting, now more passively being able to observe it. Neuroscience is just extremely difficult. The different parts of the brain are not distinct gears in a machine with clearly defined parts; no, it is even more remarkable that they are just areas where activity can be observed, soft, organic, living sections that light up with activity when certain things seem to be going on.

Neuroaesthetics is the attempt to combine observation of brain activity with conclusions about what the mind is judging about the art that it sees. It is a very radical, tentative discipline. Artists and critics may laugh and say, "Ha! You're never going to figure out what separates

good art from bad by watching colors in a brain scan light up—culture is much deeper than that."

"All right," say the neuroscientists. "Show me where it is, then. Where is this human mind that supposedly appraises the whole of history and art? Where is it except in these slight electrical motions inside our heads?" This is truly science pushing against its inherent limits, which is either its most exciting edge or its most ridiculous.

In any case, it is right at the hazy edge of investigation, where we can barely see anything at all. Like trying to make sense of the meaning of the few ancient artworks that remain deep inside dark, lightless caves, the attempt to watch brains at the moment they apprehend works of art involves creative speculation as much as observation. Perhaps it's better understood as an artistic process itself, a science not afraid of trying to frame the impossible, like a leap to conquer the sublime.

Semir Zeki has specifically stated how much he has learned from the experimental tendencies of twentieth-century art. Artists, he believes, "are neurologists who actually study the brain" when they push the possibilities of expression to their limits. It is when art is at its most abstract that artists do what scientists do: find a pure and extreme stimulus and investigate how the brains of viewers respond to it. When it works and they discover something perceptually interesting, they are discovering things of interest to science, often long in advance of the science that is able to explain what is going on.

Zeki likes modern art for his experiments because these artists want to reduce the complex of forms to their essentials, or to try to find out what the essence of form as represented in the brain may be. The straight lines of cubism, for example, are the basis of all human visual perception; they "will be found, in effect, in all plastic works of art once the preoccupation with imitation has disappeared." So abstract art helps us actually see how the brain is simplifying the visual field to make sense of things. In the midst of searching for the constant truth of forms, a somewhat Platonic goal, Piet Mondrian focused on regular grids and lines, building a robust visual language that changed our sense of aesthetics nearly a hundred years ago.

Why was this approach so effective? Only in the 1960s did David Hubel and Torsten Weisel discover orientation-selective cells in the brain that respond especially to straight lines, giving physical justification for the human interest in such regularity. "I cannot cease to be fascinated," Zeki writes, "when I watch a single cell, among billions in the cortex, respond with such precision, regularity and predictability to a line of a given orientation, and also watch its responsiveness diminish progressively as one changes the orientation from the optimal one until, at the orthogonal orientation, there is no response at all."

Kinetic artists such as Alexander Calder emphasized movement in their works instead of color or form, and these too found a wide audience. Why would we be interested in movement for movement's sake? Only a half century later was the V5 motion center of the brain identified, an area full of motion-selective cells that light up in response to movement rather than other aspects of the visual field. In its particular investigation of narrowed-down aspects of visual possibility in the name of pure aesthetic contemplation, twentieth-century art becomes a laboratory of possible experiments to reveal the inner workings of our mysterious brains. Paul Klee said that "art makes things visible," and it is one of the claims of this book that art, as it expands our perception, expands our ability to make sense of nature. Zeki takes this claim in one very specific scientific way, reminding us that "art also obeys the laws of the visual brain, and thus reveals these laws to us."

The most important law of the brain for Zeki is a particular understanding of the word "abstract." He means it not in the sense of not representing anything clear and recognizable but in the sense of starting with a specific experience and making something general and lasting out of it: "By abstraction I mean the process in which the particular is subordinated to the general." Zeki expands on this:

> I would like to propose not only that all brain systems, however they differ in their functions, are engaged in abstraction and concept formation, because they are all somehow involved in the acquisition of knowledge, but also that a basically similar neural process governs the generation of different ideals by the brain. Art is basically a

by-product of this abstracting, concept-forming, knowledge-acquiring system of the brain and can only be understood biologically in that context.

But how does the brain form such abstractions? This is a tough problem for neuroscience to solve. It may require a lot of tough work for the brain to take the particular and generalize effectively from it. Art may be a refuge for our brains in the midst of such hard work, making us smile as we toil so hard. Aesthetic theorists have always said things that resonate with such an approach. Constable said in the eighteenth century that the grandeur of art consists in "getting above all singular forms and local customs, with the Artist making an abstract idea superior to any individual tree, landscape, Madonna, child, or portrait." The greatest work is more universal than the singularity of its subject. It is pure, perfect, what Plato might call an ultimate form but Zeki calls an ultimate abstraction.

Is this the same as Hoffmann's abstract science? Not really. Remember, Hoffmann tries to learn more specifically from art to grasp the elusive feel of chemical structures as he struggles to find ways to combine elements and then figure out how to represent them—his is a very specific scientific quest in which art can be helpful. Zeki is still on the hunt for great generalities in a brain where he sees activity heat up and cool down. What a shame it is no machine, but a living, breathing mass of pulsing tissue, in which all our thoughts are somehow formed. He hopes to see the most important of concepts form right before our eyes on the readout of an MRI. Yet despite our highly advanced technology, we hardly know what it is we are seeing. Look deep into the brain with the latest machines, just as we gaze back thousands of years to the remnants of the earliest human art, and we see only glimmers of the depths we know must be there at the foundations of human intelligence and artistic vision.

Some humanists may laugh at Zeki's quest to gaze at exactly what art does to us as our brains take it in. Do not dismiss him because his MRI readouts look so fuzzy and tentative. He may so far be seeing very little, but he is putting forth an idea that makes art even more important to

science than my previous examples, where artistic innovation suggests new ideas and approaches to scientists. Here Zeki is saying artists are themselves neuroscientists because they elevate the specific into the general, the grand, and the abstract. And in delving deep into pure fields of color, shape, and motion, to the very heart of human aesthetic experience at its most bold and basic, twentieth-century art has made it possible for science to ask pure foundational questions at the root of our biological thought processes, and to be able to understand the most basic, thrumming responses.

So parts of the brain light up in luminous, fuzzy patterns where and when art is contemplated by a receptive individual. Previous generations might have seen nothing but a tiny light or spot of color, but today we see how significant this tiny glimmer can be. All around us are the bright shimmering visualizations of new sources of data and knowledge, and aesthetically we must be ready to take in the tentative suggestions of order and plan. There is almost nothing there that we can see. But that nothing might mean more than the definite and the exact. The brain is full of active cells always in motion, and the constancy of a fixed idea is more the exception than the norm. Art can never be simply quantified or explained, and neither can the brain. Start to make sense of the rapidly firing neurons in the brain, and fixed states are notoriously hard to catch. It is impossible to pin down the motion one sees, and so Zeki says that ambiguity is neurologically a most precise concept:

> It is not uncertainty, but certainty—the certainty of many, equally plausible interpretations, each one of which is sovereign when it occupies the conscious stage. . . . The information reaching the brain is constant from moment to moment . . . while the percept shifts and is inconstant.

Is this a simplistic picture of what makes the uncertain valuable in art? This is why art in its highest function does not prove useful or clearly solve problems; that is not what it's for. Art worthy of the name

Fig. 55. A human brain contemplates Mondrian.

will continue to offer myriad interpretations and inspire as many parallel quests for explanation as the most vexing scientific questions. But which form of human knowledge is happier to admit ambiguity? Is that the one most in line with the actual way our brains work?

The brain is most exercised and titillated when it has too much to think about, when it cannot quite decide what it is taking in, when the swirl of perceptual possibilities echoes through the firings of thousands of neurons. If it does not rest, it keeps contemplating, and the greatest works of art must then be visited again and again. "Great art," Zeki writes,

> is that which corresponds to as many different concepts in as many different brains over as long a period of time as possible. Ambiguity is such a prized characteristic of all great art because it can correspond to many different concepts. Its close affinity with the unfinished is easy to understand, for they both offer the spectator the luxury of choosing from many alternatives, and even picking the alternative that best fits brain concepts at any given time.

We will not let Zeki get away with saying that what makes art great is that it is simply ambiguous. It ought to at least be *wonderfully*

ambiguous, and probably the ambiguous workings of the brain are equally wonderful. The aesthetic moment is always emotional as well as many-sided. Zeki knows this too, so in his recent work it is not surprising he has been peering inside the brain to find a particular kind of ambiguous abstraction, the "neural correlates of beauty." Rather than trying to consider whether our brains can objectively know if something is beautiful or not, in this experiment he decides to trust his subjects. He presented ten people with three hundred different paintings—landscapes, abstractions, still lifes, and portraits—and asked them to categorize the works they saw as beautiful, neutral, or ugly, a simple decision with regard to preference, nothing more ambiguous than that. Then they viewed the paintings a second time, this time while undergoing MRI scans so the scientists could observe exactly what was lighting up inside their brains.

What did Zeki discover? Not surprisingly, when a painting is viewed that the subject previously decided was beautiful, activity occurred in the orbitofrontal cortex, a part of the brain previously associated with reward stimuli. Perhaps more surprisingly, a whole different area of the brain was engaged when a painting judged ugly was viewed: the motor cortex, associated with movement rather than reward.

> The activation of motor cortex is of special interest. It is not unique to our study. . . . The area is activated, for example, in studies of transgressions of social norms, of fear inducing visual stimuli, of congruent fearful voices and faces, and of anger. . . . It would therefore seem that activation of motor cortex may be a common correlate not only of the perception of emotionally charged stimuli but also of stimuli of which we become conscious. Why this should be so is conjectural, but it suggests that perception of visual stimuli in general and of emotionally charged stimuli in particular mobilizes the motor system, either to take some action to avoid the ugly or aversive stimulus or, in the case of beautiful stimuli, to make a response toward them. We are puzzled that perception of the beautiful does not mobilize the motor system to the same extent as the perception of the ugly.

Repulsion thus evokes a greater desire to turn and flee than attraction encourages us to approach—is that all beautiful versus ugly comes down to? Well, that's all they could see inside the brains of those who decided. The researchers do not claim to have discovered what beauty means to the living mechanics of the brain. In the end they too want to retreat to philosophy and ask, What kind of world is it we live in that allows beauty to exist? And what must we assume in order to give our aesthetic judgments of beautiful versus ugly any validity whatsoever? Both questions must depend on the "activation of the brain's reward system with a certain intensity."

Zeki wants to explain deep human creative struggles through the basic ways the brain works. In his most ambitious essay on art he tries to examine the expression of romantic love in the works of Michelangelo, Wagner, and Dante, emphasizing how these great artists were unable to truly experience love in their actual lives, and so only in their art were they able to realize this high and essential sentiment. Zeki makes clear that to explain what these artists are up to, he is resorting not to psychology but to something more foundational, "the organizing principles that dictate the functioning of the brain."

It's one thing to identify elements of abstract art that directly appeal to our basic units of perception and interest in visual illusions. Such shapes and lines clearly generate notable activity in very specific, consistent areas of the brain. But what of deeper, more complex aspects of art? How does an artist go so deep into such matters of representation and revelation that he is able brilliantly to evoke feelings that he himself has never adequately felt in real life? We are back to abstraction and ambiguity, which art can reveal (or revel in?) far more precisely than science.

Zeki is a welcome champion of complexity in a world where we have melodic expectancy theorists trying to show that all over the world, in whatever culture you go to, people think a major chord is happy and a minor one is sad, or that all people know how to tell a consonance from a dissonance no matter what language they speak. Zeki is not interested in such possibilities of agreement, because that is commonplace, not artistic. Art is found when one pushes ambiguity forward

into the arena of perception. He admires Wagner because the com-
poser pushes unresolving chords out onto the operatic stage and lets
them resound onward without resolution. That's how the famous
Tristan chord of E, G#, D, and A# is held out on and on to produce a
cloud of sonic longing. In the overtures between epic scenes in his gar-
gantuan cycle of operas, Wagner has been said by some to have in-
vented movie music long before there were movies, by putting sustained
harmonic uncertainty out to underscore the rough complexity of seri-
ous emotions.

I'll have to say that this chord, held out on an unending organ-
type sustained sound, still sounds alluring and uncertain, even to
someone as used to outer-edge harmonies as myself. Something am-
biguous does go on in my brain when I hear this chord. It's deep. I'm
not sure I want Zeki to tell me exactly where in my brain the neurons
are firing, and I'm not sure I want to know exactly what these firings
mean. Then again, he doesn't really know, but he does imagine that
neuroscience will one day know. As the map of the brain becomes
more certain and clear, our scans of its activity will be like GPS screens
of the future—they may enable us to finally get precise when speaking
of ambiguity and abstraction, those terms of uncertainty that are pow-
erfully alive inside the greatest experiences of art, whether visual, au-
ral, or tactile. Science wants to be precise about the indefinite, but for
now, and for always, we have art to celebrate such matters for us.

Still, the striving toward what we cannot quite be precise about is
of the essence of the great edges of science and the most daring leaps
in art. Wagner remains in the realm of tonality as he extends a chord
that makes little harmonic sense underneath the most dramatic of ac-
tions. He makes us realize that such indeterminate sounds are the
perfect accompaniment to the most tense moments in a dramatic tale.
Similarly, the patterns of a brain enlightening as it experiences some-
thing beautiful are the traces of the mind's attentiveness at the moments
it is surely lured into the works most worthy of intense contemplation.
We puzzle and linger over the beauties of the world, natural and hu-
man, that attract us most at the very point where they cannot be ex-
plained. All attempts to be decisive about why such things involve us so

are woefully incomplete. We do not know where this chord is going to go; we can't list the defining qualities of genius.

We don't know why ancient artists preferred to paint in caves shrouded in darkness, as the greatness of such sealed-up galleries is their obvious audacity. It may be folly to believe there is any kind of progression in art, going from the simple to the complex, the tentative to the confident, the worse to the better. We have always been open to opportunities to experience beauty, only now we have so many centuries of imagery swirling endlessly on top of itself, folding over and over in our brains like some impossible protein that we would need legions of video game players all over the globe working together to find out. There is no easy map to all that we know today, and we still find experiences at the edge of our possible knowledge to be the most interesting. So let's celebrate some artists who work at the edges of art and science in their transformation of ideas gleaned from nature.

One Culture of Beauty, Between Art and Science

So art can be seen to outlast science, as the images inside prehistoric caves are as mysterious now as ever, and we cannot explain away or supersede them, whereas ancient knowledge of the practicalities of nature is usually seen as scientifically way out of date. Science progresses, while art remains. Meanwhile, the current exploration of the workings of the brain is inspired by artists who first dared to experiment with our perception to present strange images betwixt and between what is real, offering them to us with the following test: can you see these things as beautiful? I have already presented the idea that art may aid science in more ways than is first apparent. Art, as we know, can take inspiration from everywhere. And what art these days has learned from the aesthetic possibilities in the workings of evolution itself can be seen in the wonders that Haeckel first illustrated for us and in the latest promise of genetic manipulation and the digital imagery of how life in its complexity actually works. Since Zeki says art can be so experimentally suggestive, let's explore how artists are exploring the themes of beauty and praxis so central to this book.

You might ask me if I take any kind of stand on what art to include here and what to ignore. Sure I do—I have my own aesthetic preferences as much as anyone else. Do my own choices matter? Only if you believe my argument that evolution produces results that are beautiful, not only practical. Survival of the beautiful, survival of the interesting, not only survival of the ingenious and the useful; aesthetic selection, not

only natural selection—I have suggested this is an important part of what happens in nature and something that art in its many forms has helped us understand over the last two centuries, ever since the rise of evolutionary theory in biology and in culture. But where is art going today? Still trying to shock, confound, and enrage? Not only. It still wants to be beautiful. It still must grab us aesthetically before any questions it wants to raise. Engagement with art is fundamentally an engagement with beauty, even if it is strange or unfamiliar beauty.

So I will introduce some artists whose work engages the approach I have encouraged here, the questions I have found interesting, only if I find their projects able to touch the desire for beauty that still matters for me when it comes to art. Some might find this view old-fashioned, but I still need to find the art in the midst of inventiveness and innovation. It was wonder that got me into all this, and at the end of all the investigation the sense of wonder must still remain.

One of the major themes in this book has been the celebration of the way in which the vast beauty of the diversity of life has emerged without any design being behind it, but merely by the unfolding of very simple rules upon time and possibility. This is the sense of organization called "emergent order," and it has been invoked to explain the beautiful evolved complexity of all kinds of patterns, systems, and behavior without anyone guiding it.

Many artists have been equally inspired by this principle, and one who has produced a series of beautiful, stirring works using computer programs that simulate emergent order is C.E.B., or Casey Reas, who emphasizes that he uses such software because it makes works that have a certain organic quality that looks like living things, or, in the case of the work "TI" from 2004, appears to grow as the viewers take it in.

Figure 56 is a series of large white discs on the floor of the gallery, onto which images produced by emergent order software algorithms are projected from above. The viewer sees each disc as a kind of giant digital petri dish, with constantly changing pictures that look like growing bacteria or living plants appearing upon them. As Reas describes

Fig. 56. Casey Reas, "Process 10, Installation 1" (2004).

these works, they sound like a veritable ontology of how the world is put together, a description of a kind of D'Arcy Thompson vision of the universe, where form guides all and process makes the work happen:

An Element is a simple machine that is comprised of a Form and one or more Behaviors. A Process defines an environment for Elements and determines how the relationships between the Elements are visualized. For instance, Element 1 takes the form of a circle and one of its behaviors moves it along a straight line at a constant speed. Process 4 fills a surface with Element 1 and draws a line between elements while they overlap. Each Process is a short text that defines a space to explore through multiple interpretations. A Process interpretation in software is a kinetic drawing machine with a beginning but no defined end. It proceeds one step at a time,

and at each discrete step, every Element modifies itself according to its behaviors. The corresponding visual forms emerge as the Elements change; each adjustment adds to the previously drawn shapes. During the last seven years, I have continuously refined the system of Forms, Behaviors, Elements, and Processes. The phenomenon of emergence is the core of the exploration and each artwork builds on previous works and informs the next. The system is idiosyncratic and pseudo-scientific, containing references ranging from the history of mathematics to the generation of artificial life.

The honesty of an artist calling his work "pseudo-scientific" is important. This is a series of works that looks like some scientific imagery, that resembles the forms that living evolution creates by the unfolding of simple mathematical rules. But it is neither of those things at all, but more clearly the appropriation of basic ideas of how nature works, put into service in the creative context, to show how beauty can be made out of simple rules.

This is an idea that twentieth-century art has exploited vigorously, but before the advent of computer software the process was much more labor-intensive. Reas describes how he got into it: "In 2003, I became obsessed with the work of Sol LeWitt and exploring his works had a clear impact on my recent software." LeWitt has written a series of precise instructions for drawing on the walls of art galleries and museums. His assistants follow these instructions to a T and produce the elegant, exact pencil drawings of lines and circle on the gallery walls, where the work can be seen. It stays until it is painted over or erased. Reas started with a simple question: "Is the history of conceptual art relevant to the idea of software as art?" He then tackled the question by implementing three of LeWitt's drawings in software and then making modifications.

After working with the LeWitt plans, I created three new structures unique to software. These software structures are text descriptions outlining dynamic relations between elements. They develop in the

Fig. 57. Casey Reas, "Process 13" (2010).

vague domain of image and then mature in the more defined structures of natural language before any consideration is given to a specific machine implementation. Twenty-six pieces of software derived from these structures were written to isolate different components of software structures including interpretation, material, and process.

Only after watching his software draw and create did he realize he had made something that seemed alive, which is the highest compliment to an artist hoping to be influenced by nature. Science, as we have seen, can reveal beauty but is often uncomfortable with it. Art can take the scientific method and use it to create the beautiful, then explore the beautiful further, and ever further, presenting the results for us to admire and be astonished by. They do not need to explain or reveal anything real at all.

Remember the slight differences between Haeckel's images presented as scientific documentation and those presented as art forms from nature. The diatoms as cataloged strive to be unambiguous, graphic, and clear, with their beauty presented as documented fact, something new and amazing in nature that his attractive illustrations can reveal to us. When he later turns these into art, he mixes and matches, assembles designs on the page in as alluring a way as possible, showing tentacles of jellyfish oozing among sponges and plants, all decorating the page with the multifarious evolution of spectacular life-forms, emphasizing form and pattern over individual exactness and type. Are such artworks also pseudo-scientific? Haeckel presents them as art, not science. When drawing as a scientist, he puts the images forward as science, not art. He knew the difference, and so should we.

Acting as artists, acting as scientists—each is a different way people can try to know and express the world. Know the difference, and you will know how both aspects of understanding can complement each other and how they are needed to present a greater picture of what we can figure out and what can best be enjoyed as mystery.

Reas offers the emergent side of evolution-inspired contemporary art, the form and transformation of D'Arcy Thompson. For something approaching Haeckel's ooziness we can consider the animations of Jonathan McCabe, who has capitalized on the fact that for Haeckel, form and symmetry are essentially dynamic, not fixed. If Haeckel could easily have made films of how creatures developed and evolved, he surely would have; today such expression is within the reach of a wider range of artists.

McCabe demonstrates, more beautifully than any other artist I know, how you really can take the equations of simple mathematics and use them to produce uncountable results of patterned beauty. The same algorithms that explain how a leopard got its spots and how a dinosaur got its feathers can be used to generate, automatically, perhaps way too much art.

These endeavors are inspired by the famous work of Alan Turing in the early 1950s on a theory of biological pattern formation, now

often referred to as Turing patterns or reaction-diffusion patterns. . . . An example is the formation of spots or stripes on an animal's coat. . . . The activator promotes cells to become coloured, and the inhibitor discourages them. The activator is short range, because it diffuses slowly and/or is destroyed quickly, while the inhibitor is longer range because it diffuses more quickly or is more stable. A coloured spot is stable as the coloured cells encourage their neighbours to be coloured whilst telling the surrounding area to stay colourless.

This is the commonality behind images that Haeckel worked so hard to represent, and which Philip Ball has explained so lucidly as the fundamental physical law of pattern in nature. Who are we to say they are beautiful? Is it so just because we have evolved in this same world of physical law? McCabe wonders too what they look like, and he proposes certain analogies: They look like electron microscope images. They look like diatoms and radiolarians. When they start to get uneven, with different layers of reaction-diffusion systems at work, they get more artistic and less like diagrams proving symmetrical points. He says, "This may be an example of a 'frustrated system' where each Turing instability is 'trying' to form a pattern at a certain length scale which is incompatible with the other Turing instabilities. Animations of the process show that the system doesn't settle into a stable state, unlike simple Turing patterns, but continuously moves between states of high entropy." Like the ancient programmers' game of Life, the results may be unexpected and attract us because they look curiously alive.

For McCabe, all of this is the result of mathematical theory being applied in a model, with different parameters inserted into the equation for purely aesthetic delight, as Prum might say. He just wants to see what kind of images might result from the application of modeling software toward aesthetic creation. On his Web site McCabe presents hundreds, even thousands of visual experiments produced with variations of the reaction-diffusion model, showing convincingly how simple mathematics can result in all kinds of emerging complexity or, more interestingly, emergent beauty.

Fig. 58. Jonathan McCabe, "Multi-Scale Radially Symmetric Turing Patterns" (2009).

It's still up to people to choose which images are worth preserving. As I sift through all these wild images looking for the one or two I can insert into this text, I wonder what my criteria are in selecting them. No surprise, really—I am looking for the ones that will make you go "Wow!" just as they do to me. Immediate aesthetic impact is the goal.

Then I start to examine my selections, and I see that the choices that grab me most are those that are not exactly symmetrical, those a bit further away from the Haeckelian radiolarians that McCabe is intrigued to see that his artworks resemble. Life lives out the model, but the model must be tweaked a bit to produce something more like art and less like decoration. And this leads to a whole question involving the relevance of Haeckel to the making of art, not only ornament. Is not ornament the most practical kind of art, since it is used on the practical things that we use? No, art is supposed to be something higher, more pure, and maybe more ambiguous than craft—the core of how the brain works, but not simple symmetry, pattern, or design. Art from nature cannot be that. So which of the McCabe pictures grabs you the most?

I guess in both it is still symmetry that one really sees. I do wonder why I find the symmetrical one on the left, which looks more like a microscopic living thing, to be *less* artistic. It is certainly more like

Fig. 59. Jonathan McCabe, "Bone Music 3" (2010).

cosmic, visionary, or ancient migraine-inspired abstract imagery, while the one on the right is more like the oozing flow of capillaries, veins, or growing branches. There is more unevenness still in McCabe's etch-like "Bone Music" series (figure 59), more like high-tech imaginary scrimshaw.

With its unevenness, to me it looks a little more like art and less like scientific illustration. But am I just biased toward abstraction? These images seem more like art when they seem less obviously like diagrams of rules—when the results are surprising, uneven, hard to catch; when they look more human, less the creation of a machine, even if they are actually the creation of a machine. The human must sift through all the machinations and decide which ones shine and should be remembered. We pick from the stream of mechanical results based on the whims of what we like. I like to be surprised the moment I thought I had things figured out. But that's only my preference—not everyone would go that way.

Or would they? Pronouncements in aesthetics are notoriously un-

reliable even as it is incredibly important to take a stand on what art is good and what is bad. You must never be afraid to judge, even if you don't think you know enough ever to be sure. No one ever is, but we still have to make choices, and they are guided as much by individuality as they are by the majority—even in the world of life, certainly at the species level, where we see unpredictable beauty and diversity fighting against the common shapes of adaptation. There will not be many species like peacocks, but there will be a few. One peacock and a handful of birds of paradise and bowerbirds. Many species of grayish whales but only one that is radically black and white, like a dazzle-painted warship. Nature offers many possibilities for beauty, but only a few get chosen. Roll the choices back some millions of years and different creatures would emerge. See a different tree against a different sky and you will end up making different art.

Why do these few sometimes get chosen? Neuroscientist V. S. Ramachandran has one possible answer. He points out that in addition to the sense of aesthetic measure that many have suggested—a sense of balance and evenness, or a particular ratio like the golden section, which is something that is preferred in natural and human aesthetics—there is also a principle of "peak shift," where we can come to prefer extreme forms of the things we like. The tails of peacocks and the overall plumage of birds of paradise are extremes in gaudiness and glitz in art and ornamentation. A baby gull prefers a long stick with three red stripes painted on one end to an actual mother gull's beak that looks like an imperfect version of this ideal. Cardinals prefer synthesized pure versions of their songs to the real thing. Thus there is a longing for pure Platonic forms, extreme and ideal possibilities of beauty, rather than the imperfect real thing. For Ramachandran this is only one of many artistic principles—like Dutton and Zeki, he makes a comprehensive list showing that no one answer to the aesthetic question will be enough. (Sometimes he lists eight laws of art, sometimes nine, sometimes ten, because, like most of us, he can't quite make up his mind.)

When people try to rate the value of computer-generated imagery in a quantifiable way, what results come to the top? Scott Draves's

famous Electric Sheep project has generated fractal-based images through the distributed processing of thousands of computers working together running screen-saver programs, and it has allowed users to vote for them online. Whenever tests like this are rigorously done, a particular fractal dimension near 1.5 proves to be the most popular, similar to Richard Taylor's math analysis of what makes Jackson Pollock's drip paintings better than everyone else's. Does it all come down to one number, a ratio that picks the right balance between complexity and simplicity, symmetry and asymmetry? Is there one kind of beauty we want in art, something deriving from nature, and something else in our mates, the engine of sexual selection and creature diversity? Surely evolution of art and of species is not one and the same.

The number is what it is—just a number. It cannot substitute for an aesthetic experience. But it is a number suggesting that what we find beautiful out of natural form's simple emergent equations is not the most easily symmetrical, not the regular forms that make Haeckel's aesthetic ideas more inspirational to decorative art than to fine art. Reas, McCabe, and Draves show that artists today may have better tools for the exploitation of formal beauty from nature into art than Haeckel's illustrative skill and love for the ornate shapes of individually symmetrical creatures. Haeckel's work inspired scores of chandeliers and cornices, but today we have the swirling, shimmering branches of artificial life that never look the same way twice. Does Haeckel's influence on aesthetics from today's standpoint seem a bit limiting?

David Brody wrote an interesting appraisal of Haeckel's relevance for artists today in the journal *Cabinet*. Is the "microbial baroque" enjoying a renewed popularity? Brody finds numerous artists today who are as seduced by the beauty of Haeckel's omnibus as they were a century ago. "Once entranced, however, many also register an ambivalent attraction/repulsion to *Art Forms*'s romantically totalizing worldview, to the heavy, structuralizing hand that renders medusae as swimming chandeliers, and echinidea as hovering spacecraft." Most artists Brody spoke with knew nothing of Haeckel's racist leanings and his later importance for the Nazis, but most were not surprised to hear that something like that was going on beneath his grand vision of the beauty of life.

Fig. 60. Alexander Ross, "Untitled" (2009). Courtesy of David Nolan Gallery, New York.

"Indeed, if one sees Haeckel's lust for unification as suspect—leading to overdetermined (though fascinating) art, and bad (though compelling) science—then the very characteristics which attract an artist to his images—their integrated, harmonious, 'monistic' design—would be their most dangerous and dishonest features."

Brody speaks with painter Alexander Ross, whose work in water-color and drawing is full of allusions to Haeckel. Ross called *Art Forms in Nature* "a revelation . . . a prime mover in the germination of my thinking." Haeckel's biological encyclopedia was "a potent dream-world," which "seemed to scream, 'If nature can play reality designer, you can too.'" And it is interesting to look at Ross's work and see clearly how it is definitely art and not design, with its hand-drawn forms inspired by life but doggedly abstract, with a fattened sense of whimsy.

In a way the art must try to prove less, explain less, and grab us

obliquely with its odd twists of form that look like tubes and trunks that nature wrought but are not quite the same. The aesthetic cannot quite be the same as the real, at least in work that is classically abstract. Yet Haeckel continues to challenge and attract us because of the sheer magnitude of his vision of the symmetries of organic life. As Brody describes it, "The totalizing confidence of his project—its implication that nature *is* art *is* design *is* science—is what compels, in spite of the implied denial of humanistic values like idiosyncrasy or accident or freedom."

Artists whose work aspires to a nature-like rightness can also be suspicious of this side of Haeckel. Thomas Nozkowski, whose work is not built on tendril or crystalline forms, calls himself anti-Haeckelian.

> The more I looked, the more pissed off I got about him. His ordering processes are very 19th-century, very Germanic, and I think they lie. . . . He finds what he expects to find. For all the work's ostensible beauty, it does seem a period piece, inherently nostalgic. I don't question the seriousness of how he plays the game, I just think that intellectually he fails. . . . I think that can always lead to evil—aesthetic evil first, then maybe evil in the real world.

While looking at this work, which is pure, alluring, able to change how I might look at nature without itself trying to look too much like the myriad possibility of evolved forms, I can see Nozkowski's worry that life should be more than a multifarious list of symmetries. Nature is also a source of amassed, moving, simple forms, and these too are at the root of our aesthetic experience, which, as I have pointed out above, has always had a place for abstract swirl, edge, circle, and pattern. I'm not sure I'd go with Oliver Sacks and say so simply that such understanding comes from the fact that humans have always been susceptible to migraine headache visions, but whatever happens to us can inspire aesthetic choices. I would be happier saying that the visions produced by migraines tap into basic senses of line, edge, and form that are at the root of how nature and ourselves have been formed. Calling attention to them will continue to alter the way we see the world.

Fig. 61. Thomas Nozkowski, "Untitled 7-61" (1995). Courtesy of Pace Wildenstein Gallery, New York.

There are many other artists who have let Haeckel's sense of the ordered organic seep into their thinking and work. Karen Margolis, an artist who is inspired by the "imperfect perfection" of circles in Zen calligraphy, makes painted paper cutout installations that clearly resemble Haeckelian forms. I asked her if he was an influence, and she was surprised to hear others were paying attention to him. "Having used the microscope as a source of imagery in my own art, I have often found my way to Haeckel's *Art Forms from the Ocean* for inspiration; I am influenced more by his determined rigor in crafting his structures and not concerned whether his creatures are authentic or not. I rather like the idea that he did not get caught up in the facts, but used artistic license—but I guess that's why I'm an artist and not a scientist." Her work "Too Close To," hand-cut out of a single sheet of paper, illustrates the hunt for order in the midst of living uncertainty.

Fig. 62. Karen Margolis, "Too Close To" (2009).

Brody wants to cut off any easy dismissal of Haeckel by reminding us that he was a scientist blessed with artistic talent, a rare and important combination. He reminds us that we praise the genius of Leonardo da Vinci even though one of his main sources of income was designing clever and cruel machines of war, and we don't hold that part of his career against him.

Haeckel's lithographs encompass an otherworldly formal clarity, teased out from messy reality by the delicate emphases of the

trained hand; they evince a kindred delight in draftsmanship in service to science, a devotion to a truth higher than mere optical objectivity. Both Haeckel and da Vinci maintained a boyish fascination for spiky armored creatures, for the gracefully fantastic and grotesque. Of course, one is the greater scientist and the other the greater artist. But the megalomaniacal determinism that tints the edges of Haeckel's vision signals, perhaps, the last shudder of a dying da Vincian ideal, a union of curiosity and craftsmanship, poetry and industry, science and art.

Are we less innocent today, no longer able to dream of total theories, easy visions of where the universe and creativity are progressing so that our understanding improves clearly toward some great and explicable goal? Life evolves but is said to be going nowhere, far from Henri Bergson and Teilhard de Chardin's notion of *l'evolution créatrice* that was leading humanity toward some guiding goal of unity and understanding with all creation. Haeckel wanted something like that too, and the sense that science melded with art would help him get there was driving his and much of the society's visions forward, until the twentieth century's horrors filled us all with terror and doubt. We no longer trust this great humanity anywhere near that much.

Knowledge today seems to progress incrementally, in fits and starts, where great problems such as sequencing genomes are solved and then we wonder how they can affect our continuous searches for grand meaning, purpose, and solutions to life's woes. Art out of nature and science and back into nature and science is the spark that lights our creativity on its way. Today's ways of seeing are specific, full of image and chance, yet still wanting hope and aiming for the astonished smile.

These ideas have a place in commercial art and design as well. A graphic design company called the Barbarian Group put together a collective art project at the McLeod Residence Gallery in Seattle in 2007 called "Biomimetic Butterflies," based on the reaction-diffusion patterns that give rise to real butterfly spots and patterns over millions of

Fig. 63. The Barbarian Group, "Voronoi Butterflies" (2007).

years of evolution. They plugged their simple equations into abstract butterfly wing shapes and cut out the results with a laser paper cutter.

After laser cutting, and some clean-up with an X-Acto knife, the wings are glued to a small piece of cotton to form a simple and delicate hinge. Using lightweight fabric keeps the overall look clean and creates a hinge with much less resistance than a more standard mechanical hinge. Each wing is fitted with two pairs of neodymium magnets by sandwiching the wing paper between each pair, making sure that the polarity on all magnets is consistent.

To keep the butterfly mechanisms fixed in place, they pinned them to the backing board with the actual pins used to mount real butterflies. An invisible motor kept these stylized patterned wings in motion, slowly flapping on the gallery walls.

"The result is a bit creepy," one gallery visitor felt.

It's plainly obvious that they are not real butterflies. The body, head and legs are nowhere to be seen. You can even see the texture of the paper. And yet, they stir some strange emotion that makes one think these paper butterflies want to be free and are struggling against the black metal pins which hold them in place. The silence of the mechanisms assists in this illusion because no mechanical noise can be heard.

The first family of butterflies was based on the Voronoi tiling algorithm, an equation commonly used to explain how spaces in nature are divided into equidistant shapes. (See figure 63.)

Fig. 64. The Barbarian Group, "Flow Butterflies" (2007).

This algorithm is quite similar to the way real-world leaf and butterfly wing patterns are formed. Other approaches Barbarian used were more fanciful, such as a design based on the geometry of flow. (See figure 64.)

Curves like these would never appear on real butterflies, but they are based on mathematical models that could apply to real-world water flows and drifting sand. On paper they seem striking and almost possible, in some alternate imagined but convincing world. Cut them out in paper and make then move; then you have something that will lead viewers to gasp with delight.

so these days there are many artists impressed by the advances science is starting to make in the direct investigation of how raw beauty itself evolves in nature. All it takes is a few simple mathematical rules, or the simple fact of a complex evo-devo discovery, to offer enough inspiration for an artist to make a striking series of images or an installation that stems from a single "wow" moment of scientific insight. It doesn't take much more than a single scientific result that offers a beautiful image or a sublime idea to give an artist enough to go on.

But there is another, perhaps deeper direction in art-science integration that is appearing more and more frequently: artists who are deeply steeped in the science that inspires them. Some have advanced degrees in science as well as in the arts, and some are in the midst of studying both. The best of these realize that the mix of art and science is not an easy synthesis, and also know that each is so important that they cannot ignore the other.

Anna Lindemann studied biology with Richard Prum at Yale

before heading to Rensselaer Polytechnic Institute to get a master's degree in music and media art, which she has just completed.

Her piece "Winged One" is a direct hybrid of science lecture and performance. It begins with Lindemann as lecturer standing in front of a magical blackboard, the surface of which soon morphs into a series of stop-motion images, with bird embryos, gene diagrams, and a chalk-drawn ballerina who evolves more-than-human appendages. Lindemann is not afraid of presenting the exact details of science in this work.

> This fanciful lecture format alternates with DNA transcription and protein folding illustrated with stop-motion animations using yarn, beads, and lace. Papery silhouette animations and dance evoke the possibility of genetically engineered human wing growth and flight. . . . In the first section, selector genes are introduced and attention is focused on Ultrabithorax (Ubx), a selector gene important in defining wing identity in insects. The chalkboard lecture animation is paralleled by the abstracted microscopic world of . . . avian Tbx5, and its avian downstream target gene that gives rise to wings, merges into a macroscopic abstracted world of a flying bird. In the final section, the microscopic abstracted world of human Tbx5, and its human downstream target gene that gives rise to arms, merges into the macroscopic abstracted world of a silhouetted human. In the final section of *Winged One*, a gene splice in the microscopic world gives rise to the winged one, a silhouetted human with wings.

How is it that a human develops arms and a bird develops wings? By tweaking our genes a bit, humans might grow wings too? Fantasy takes off from here. "Is this a science lecture, or art? It is about what the listener is able to understand, or not understand," says Lindemann. The animated chalkboard lecture alternates with the weaving and the beads, the yarn unfurls, the searching modernist music plays, and we've mixed the old-fashioned avant-garde with a presentation of weird science.

Her earlier piece "Bird Brain" is a stop-action animated film,

Fig. 65. Anna Lindemann, still from "Theory of Flight" (2011).

made in her kitchen, that presents a whole narrative not depicting but inspired by the courtship stories of the bowerbird that she heard in Richard Prum's class. She works with rice and pasta. The bird is cardboard and torn-up newspaper and it looks handmade, while the music is very precise and rigorously composed. Either it's cognitive disconnect or it lures us in with its homemade, craft-like quality. In a rice forest, a male bowerbird builds an impressive bower of butterflies to attract a mate, while a female bird tends to her nest atop a kitchen stove. We see glimpses into the biology of these creatures as butterfly wings develop and pasta mitosis animates the growth of the incubating egg. Animation, stop motion, and live action tell the tale of these birds, and live musicians and electronic music unite in simple melodies and angular jungle rhythms.

Lindemann's works ruminate upon all the kinds of ideas I have brought forth here, combined with a handmade, low-fi, folksy side. They are warm and welcoming, not alienating, formidable, or scary. There is something anarchically cute about it all, whimsical like Satie.

I asked Lindemann why, with her music being so precisely composed and expertly performed, she chooses visual elements that are handmade, craft-like, old-fashioned-looking, and cute while making

Fig. 66. Anna Lindemann, still from "Bird Brain" (2010).

art based on cutting-edge science about the role of beauty in nature. She says, "My hand-crafted visual aesthetic comes from my enjoyment of making things with what is at hand and a genuine naïveté when it comes to painting, drawing, and animating. I find there is something magical about familiar, common objects (cardboard, buttons, rice, lace) coming to life and becoming something else. This makes the biological themes of molecular processes somehow more friendly and accessible."

Lindemann calls her genre of work "Evo Devo Art," referring to that field of science that combines evolution and development, the approach that can explain how butterflies got their spots and how dinosaurs got their feathers. This emerging area of biology brings together the creation of new forms upon principle and beauty, building upon Haeckel and Thompson, combined with today's sophisticated genetics that were unavailable to artist-scientists in the nineteenth century. Influenced by her professor Richard Prum's love of beauty and aesthetics, Lindemann shows one way in which art can emphasize that the beautiful and the delightful are an essential part of the evo-devo story.

With her works that incorporate a lecture element, Lindemann

had in mind Evo Devo Just-So Stories. The questions that the field of Evo Devo investigates—how butterflies got eyespots, how animals got legs, how feathers first came to be—are similar to those questions of Rudyard Kipling—How the Camel Got His Hump, How the Leopard Got His Spots. But the answers of Evo Devo involve the wondrous co-option of genetic networks and cell signaling that defines when and where specific kinds of cells develop rather than the decrees of a Djinn punishing the camel who refused to work by giving him a store of water so he could work without ceasing.

At the work's premiere in April 2009, Lindemann invited Richard Prum to precede the performance with a lecture on the reality of bowerbird sculpture, competitive performance, and the role of parasites in sexual selection.

He gave an animated lecture describing bird mating and breeding systems, and many people in the audience commented on how wonderful it was to have an introductory context to some of *Bird Brain*'s avian inspirations, allowing them to detect the male bird's butterfly bower and courtship dance as well as the more abstracted brood parasite that takes on the form of human hands in *Bird Brain*. While a biology lecture is not an integral part of *Bird Brain* as a work, it was an important part of the initial presentation of this piece and in retrospect set a precedent for incorporating lectures on biological subjects in my work.

I asked Anna if she thought, as Richard Prum does, that the just-so story is more an allegory for modern biology's attempt to explain all evolved beauty as a form of adaptation than an admission either that evolution pursues arbitrary aims or that it follows basic laws of pattern and form dictated by chemistry and physics. She said, "To me these things don't seem incompatible. An evo-devo just-so story may have elements of environmental forces shaping natural selection, developmental

constraints, and some level of arbitrariness (perhaps like runaway sexual selection) or even the arbitrariness of developmental mechanisms as part of an explanation of how something came to be. Arbitrariness and uncertainty/probabilistic explanations seem like important parts of the modern just-so story."

And so the bowerbird is back, collecting his ragtag assembly of the shiny and the scarce. He must decorate the world, make it special, bring pleasure to the mate who decides she is impressed. You can look at this sexual selection story and think mating is the goal, the ultimate prize, but maybe that is the most mundane way to make sense of what is going on. Mating is not unusual; enough of it happens in the end. Biologists like to say that in nature everyone does *not* get the girl, with only the strongest and best males getting the choicest matings, but I don't know if the evidence generally makes that true. The fact that bowerbirds mate is not all that interesting. The fact that they have evolved to make beautiful, wild, and crazy art is what is truly astonishing about them. This behavior endures over millions of years of reproduction, struggle, birth, and death. This species never would have survived if its art was not created. Only those birds able to make something grand and remarkable are the ones that endure, passing their genes on to the next generation. The ability to make beauty is the trait that survives. Survival of the beautiful is one important lesson to learn from evolution, since survival of the fittest has never been enough to explain everything that nature is.

Bowerbirds too may edge toward the abstract. Figure 67 depicts no mess in the forest, but a spotted bowerbird's careful creation, labored upon for months, hoping for the female critic's earnest approval. Is such a mess necessary by virtue of nature's essential ways, or is it some random, silly whim of evolution? Remember Philip Ball's worry that biology's quest to find an adaptive purpose for every beautiful evolved and developed feature might be hunting and pecking for a just-so reason, rather than simply admitting that evolution has always had a sense of whim and caprice, where random mutation taps into basic laws of form in nature that tend toward certain patterns and processes that we, as part of the great march of evolution as well, tend to find beautiful.

Fig. 67. Bowerbird artwork or trash in the woods? You decide.

All of the works of art I have mentioned in this chapter (of course, just a small selection of the many wonderful and creative things being tried by artists inspired by beautiful survival today) could be considered evo-devo art because they all make their own kind of reference to the wonderful forms nature has created through evolutionary processes where no individual artist is in charge. The human artist transfixed by this amazing fact puts forth his or her own situation that celebrates how simple processes may lead to complex, formal, designerless natural beauty.

One thing all my examples here share is that they are not afraid to celebrate beauty, even in an age where we have been jaded by the ease of seeing so much of it. Another writer might have focused on the excellent art that toys directly with genetics, creating glowing, bioluminescent bunnies or campaigning for the Earth by remediating climate change. I am still more attracted to things that are beautiful rather than those that only realize concepts or solve problems. Aesthetic

delight at what people can do when inspired by new things discovered about nature still touches me more, and I have tried to show how beauty matters both to the force and rules of natural evolution and to the potential of human art to change the way science delves into and reframes the world. I hope that after reading this far you will consider the possibility that in a world where we have learned and destroyed so much, there is still a place to dance, draw, sing, play, and love.

DO you think I'm going to tell you at the end how to tell good art from bad? This is such an unpopular question in the world of the arts today. In art school students learn they must shock, circumvent, create new genres, enrage the audience, dodge the bullet, make things that no one has any idea how to tell whether they are better or worse than anything else. Is it all just supposed to make us think? Philosophy is bad enough on that score, as it is so much better at offering questions than at providing answers.

But art is different, so immediate, so direct, so clear. It must encourage wonder, make us sigh, cry, smile, make us love it or else hate it. It must matter, drawing us in or sending us packing. If it provokes no strong reaction, then it has got nowhere. It must be beautiful and engage us first aesthetically before grabbing us any other way.

So art can learn much from studying that one aspect of life and its evolution that has celebrated beauty over millions of years. What Darwin called sexual selection I would like to call aesthetic selection, or maybe artistic selection, or beauty selection, not because I don't think sex is important but because the phrase "sexual selection" deflects our attention away from its beautiful results and back to the necessity of desire. Perhaps the important thing about desire is that it generates beauty, something that lasts longer than any want.

Perhaps the study of aesthetic selection does not seem as significant to science as the elucidation of real, practical adaptations that nature has evolved. Why explain what is magnificent and mysterious? Is this only the metaphoric pulling off of angel's wings that so upset John

Keats? The more we learn about the mystery, the more we will admire it. Mystery and magic never really go away.

Sure, you can love art while knowing nothing about it, and when you learn more you may lose interest in the things you once loved. Some believe that what is clearly the most popular has a right claim to being the best, but those who pay deeper attention to any of the arts know that popularity goes only so far toward explaining what matters. It really is the most primitive way to decide what is good. It is not popular in nature to have extreme beauty in plumage, song, or shape. But in certain species these strategies find their way to fruition, and the rest of life does benefit by seeing what is possible and rarely done. Do sparrows care about peacock tails? They may admire them in a uniquely sparrow-like way. Or they may have no interest at all.

But we are certainly interested in all strategies in life and culture, from the adaptive problem-solving path to the wildly daring. Humans followed our own peculiar evolutionary path to become the one omnivorous species interested in everything. We are destined to try to learn as much of the natural world as possible, and will keep asking thorny questions that we prefer more than their answers.

Still, how can we tell what is beautiful? Believe in what lasts, knowing that evolution has kept these beautiful forms alive because they started out being possible and ended up being actual—not because they had to be, but because they ended up surviving through a mix of randomness and opportunity that likely would not be repeated if we were to roll time back a few million years and start again. So is there nothing especially good about what life strategies and results we have got? They are important because they are there. And we are there too.

Human culture evolves, but not so simply as nature does. We can learn to take in all that is around us, make decisions, and choose trends and opportunities. Or maybe we can't learn as much as we think; perhaps what people like depends, as does aesthetic evolution, on the whims of the possible that arbitrarily catch on.

It makes me think of a real problem of aesthetics that has always

vexed me. I am motivated by my preferences to like certain kinds of music, art, literature, and film. As I learn more about these things, when I learn what is possible and what greater depths of meaning and expression can come with more mastery and complexity, what I like will change. Yet I will only go so far. I don't want to learn so much as to destroy my love for the arts that have nourished me for decades. But often as I drive for hours on the highway listening to the same songs that have touched me for many years, I think about how bad so much of this music that I like really is. Nothing much is happening, it's all so simple, and if it gets too complicated, I just don't like it all that much. Even as a composer and musician, I know there is better music out there, music I could listen to and play and even write, but sometimes I'm just afraid to do it. It will destroy my sense of taste, and make me question everything I believe about aesthetics, that the beautiful must touch you initially and will stay with you forever if the work is really good.

The beautiful things we make aspire to be as necessary as the rules of nature and the forms of life that time has massaged into being through the evolution of beauty, which is such an important part of the complete development of life. We will never be as sure of ourselves as the aesthetic of any single species is. Without thinking or wondering, the peacock knows he is nothing without his tail. Life is beautiful as it lives and endures, not needing to question whether it could have taken another path.

Only humanity is plunged into such doubt, and only we have the choice whether to take the beautiful seriously, or not. Call me an aesthete and say I'm deadening myself to the need for the right or wrong, or at least the better and the worse. I don't want to tell you how to behave, this is true. But I want to tell you how to look and listen, and to follow your innate intent toward the beautiful, rather than repressing it. Biology is not here to explain away all that we love in terms of the practical and rational. That is not how nature works. Nor should we shrink from our natural astonishment at the magnificence evolution has produced. It may all be a vast artwork in the manner of John Cage's "chance operations," but it is not really arbitrary, in Richard Prum's

sense, and certainly not random in any absolute sense. Parallels in order and form exist through nature from mathematics into physics, through chemistry, and on up into life and ideas. I almost want to just sing out the praises of these patterns rather than explain them to you. In the end I am a bad explainer, a mediocre storyteller, but an enthusiastic reveler—just pay attention, open your mouth in astonishment, and let the beautiful touch you, if not consume you.

I have always remembered this famous Navajo song, ever since I first read it in a Sierra Club picture book as a teenager many years ago:

Beauty before me, there I walk
Beauty behind me, there I walk
Beauty above me, there I walk
Beauty below me, there I walk
On the trail of beauty, there I walk
Forever with beauty, all around me.

When I get old, there I walk
Still on the move, there I walk
I'll wander still on beauty's trail
And live again—there I walk
My words still aim for beauty.

This has always stayed with me, a call not to arms but toward the best way to live. The world we live in is so beautiful it brings us to tears; we should not be afraid of it nor be content to blithely celebrate it. I've quoted them before, but I cannot stray far from these guiding words. We have to investigate, to delve deep into beauty; rather than pick it apart in such a way that it dies, we must inhabit the wonder that is the world, recognize it, love it in moments both of bliss and of investigation. The beautiful is the root of science and the goal of art, the highest possibility that humanity can ever hope to see.

Acknowledgments

Thanks so much to all who helped me research a project where I tread outside my usual sonic and environmental territory into the world of visual art and the theory of biology. Scientists and artists who gave graciously of their time and ideas include Roald Hoffmann, Patrick Dougherty, Anna Lindemann, Tyler Volk, Sonja Lobo, Mark Changizi, Tino Sehgal, Christine de Lignieres, and especially Richard Prum, whom I only vaguely remembered from college. Thanks especially to our research group on complex bird song at CUNY, including Ofer Tchernichovski, Christina Roeske, Eathan Janney, and Gary Marcus. And thanks to research assistant Tanya Merrill, who transcribed some long and hard-to-decipher interviews conducted in noisy locales.

Thanks to Rob Friedman, Burt Kimmelman, Fadi Deek, and Don Sebastian at the New Jersey Institute of Technology for encouraging me to research topics ever farther afield from my expertise.

Other readers and colleagues with helpful suggestions included David Ross, John Horgan, Lily Zand, Oliver Schaper, Lara Vapnyar, Barbara Rothenberg, Daniel Rothenberg, Jaanika Peerna, Umru Rothenberg, Lawrence Weschler, Amelia Amon, Heie Treier, Richard Kroehling, Philip Ball, Peter Koepke, Johannes Goebel, Amy Lipton, Patricia Watts, Raphaele Shirley, Charles Lindsay, Catherine Chalmers, Scott Diel, Tom Bissell, Alison Deming, Simmons Buntin, David Abram, Eva Bakkeslett, and Daniel Opitz.

Warm thanks to Syd Curtis for telling me not to step onto that bower with the blue plastic decorations I found in the Queensland rain forest

in 2004. Thanks to Hollis Taylor and Jon Rose for introducing me to the bowerbirds outside their house in Springwood, Australia. To John Hughes and John Vallance of the Sydney Grammar School for inviting me back down under. To *Island* magazine in Tasmania for publishing an article that begat the bowerbird chapter, and to *Parabola* for publishing a related piece in their Beauty issue.

Thanks to my agent Michele Rubin, editor Peter Ginna, and assistant Pete Beatty at Bloomsbury, who made this book a reality. Thanks again to my family for putting up with all those piles of obscure books on every possible surface in our house, to my son, Umru, for his endless outpourings of creativity, and to my wife, Jaanika, for her ever-beautiful way of seeing the world.

I dedicate this book to my mother, Barbara Rothenberg, a great artist and teacher, who first taught me why modern art matters. Sorry, I know I was often a reluctant and cranky student, but maybe this book proves I remember something.

For Further Reading

In writing *Survival of the Beautiful* I had to canvass very different kinds of literature from the perspectives of both art and science. All of Darwin's writings are online, even his correspondence, and one can search through them with an instant concordance the way people used to only do with religious texts. Perhaps he is now the prime religious source for all students of life! See www.darwin-online.org.uk. Beyond *The Descent of Man* there are a handful of excellent books on the history of sexual selection theory, most notably Helena Cronin's *The Ant and the Peacock: Altruism and Sexual Selection from Darwin to Today* (Cambridge: Cambridge University Press, 1993). Another fine introduction is Matt Ridley, *The Red Queen: Sex and the Evolution of Human Nature* (New York: Macmillan, 1994). More recently there is Marlene Zuk's *Sexual Selections: What We Can and Cannot Learn About Sex from Animals* (Berkeley: University of California Press, 2003), and a more radical take comes from Joan Roughgarden, *The Genial Gene: Deconstructing Darwinian Selfishness* (Berkeley: University of California Press, 2010) and of course *Dr. Tatiana's Sex Advice to All Creation* by Olivia Judson (New York: Holt, 2003).

Even Dr. Tatiana can't hold a candle to Wilhelm Bölsche for making sexual selection luscious and alluring. Look for your two-volume copy of his *Love-Life in Nature* (New York: Albert and Charles Boni, 1926, and many other editions); you will not be disappointed, but don't believe everything he says, especially the last hundred pages.

On Darwin and art, there is the fabulous exhibition catalog

Endless Forms: Charles Darwin, Natural Science, and the Visual Arts
(New Haven: Yale Center for British Art, 2009), and a related academic
volume edited by Barbara Larson, *The Art of Evolution: Darwin, Dar-
winisms, and Visual Culture* (Hanover: Dartmouth University Press,
2009). Ernst Haeckel's *Art Forms in Nature* (New York: Prestel, 1998)
is available in many editions, and a beautiful compendium of his work
was recently published, edited by Olaf Breidbach of the Haeckel Haus
in Jena: *Visions of Nature: The Art and Science of Ernst Haeckel* (New
York: Prestel, 2006). Robert Richards's new biography of Haeckel is
simply wonderful; *The Tragic Sense of Life: Ernst Haeckel and the
Struggle over Evolutionary Thought* (Chicago: University of Chicago
Press, 2008)—it all comes down to the untimely death of Haeckel's
first love.

There are a handful of books on how evolutionary science has
changed the way art is made. The most intriguing is Juan Romero and
Penousal Machado, eds., *The Art of Artificial Evolution: A Handbook
of Evolutionary Art and Music* (Berlin: Springer, 2009). On the con-
vergence of art and science in general, there is Stephen Wilson's
Art + Science Now (New York: Thames & Hudson, 2010), an excellent
compendium. A similar book from the sixties is still timely, written by
the great biologist C. H. Waddington, *Behind Appearance: A Study of
the Relations Between Painting and the Natural Sciences in This Cen-
tury* (Cambridge, MA: MIT Press, 1970). There is also the masterly
study by Lorraine Daston and Peter Galison on the role of creative
imagery in science, *Objectivity* (New York: Zone Books, 2007).

See also Roald Hoffmann's special issue on aesthetics in chemis-
try of the online journal *Hyle*, http://www.hyle.org/journal/issues/9-1.
E. O. Wilson's rousing *Consilience: The Unity of Knowledge* (New
York: Knopf, 1998) could be seen as the twentieth century's answer to
Ernst Haeckel's *Riddle of the Universe* (New York: Harper and Bros.,
1899). They are both audacious and controversial. Another can-do
attempt to merge the two cultures is David Edwards, *Artscience: Cre-
ativity in the Post-Google Generation* (Cambridge, MA: Harvard Uni-
versity Press, 2008). Neuroscientists who want to figure out art include
Semir Zeki, *Inner Vision: An Exploration of Art and the Brain* (New

York: Oxford University Press, 2000) and V. S. Ramachandran, *The Tell-Tale Brain: A Neuroscientist's Quest for What Makes Us Human* (New York: Norton, 2011). Visually this material is beautifully explored in Margaret Livingstone, *Vision and Art: The Biology of Seeing* (New York: Abrams, 2008).

On the important question of arbitrariness in evolution versus natural laws of form, there is no better science writer than Philip Ball. His first volume on the subject was *The Self-Made Tapestry: Pattern Formation in Nature* (New York: Oxford University Press, 1999), recently updated into three separate shorter volumes, *Shapes, Flow, and Branches* (New York: Oxford University Press, 2009). It's worth having all of them around for inspiration and history. See also Tyler Volk's expansive *Metapatterns: Across Space, Time, and Mind* (New York: Columbia University Press, 1995).

On art in evolution, Denis Dutton's *The Art Instinct: Beauty, Pleasure, and Evolution* (New York: Bloomsbury Press, 2008) is the clearest presentation of an adaptationist view—I only wish Professor Dutton were still around so I could have a good argument with him. An evolutionary approach to the study of literature is found in Brian Boyd's *On the Origin of Stories: Evolution, Cognition, and Fiction* (Cambridge, MA: Harvard University Press, 2009). On an evolutionary approach to the cutthroat world of the sky-high art market, see Don Thompson, *The \$12 Million Stuffed Shark: The Curious Economics of Contemporary Art* (New York: Palgrave, 2008).

Never mind the market; what of the content of modern and contemporary art? A few recent works of art criticism do try to bring beauty back into the debate, from Arthur Danto's *The Abuse of Beauty* (Berkeley: University of California Press; Chicago: Open Court, 2003), and Dave Hickey's very readable books *Air Guitar: Essays on Art and Democracy* (Seattle: Art Issues Press, 1997) and *The Invisible Dragon: Essays on Beauty* (Chicago: University of Chicago Press, 2009). There is no critic of art criticism more provocative than historian James Elkins, in *What Happened to Art Criticism* (Chicago: Prickly Paradigm Press, 2003) and the fabulous *Six Stories from the End of Representation: Images in Painting, Photography, Astronomy, Microscopy,*

Particle Physics, and Quantum Mechanics, 1980–2000 (Palo Alto, CA: Stanford University Press, 2008).

There are wonderful books written by twentieth-century artists on their aesthetic process, the best of which is certainly Paul Klee's two volumes of lecture notes from the Bauhaus, *The Thinking Eye* and *The Nature of Nature* (New York: Overlook Press, 1992). Piet Mondrian's little-known *Natural Reality and Artificial Reality: An Essay in Trialogue Form* (New York: Braziller, 1995) is also one of my favorites. Wide-ranging and triumphant is Amédée Ozenfant's *Foundations of Modern Art* (New York: Dover, 1952).

On how abstract expressionism builds on the art movements that came before it, there is no better book than Henry Adams, *Tom and Jack: The Intertwined Lives of Thomas Hart Benton and Jackson Pollock* (New York: Bloomsbury Press, 2009). If you want to know how these artists learned from the practice of camouflage, you must go back to the source and read Gerald Thayer's *Concealing-Coloration in the Animal Kingdom* (New York: Macmillan, 1909), which you may download freely from Google Books. The one great advance upon this mad, obsessive text is the volume soldiers carried in their kit bags in World War II, Hugh Cott, *Adaptive Coloration in Animals* (London: Methuen, 1940). If you manage to find a copy, you will see why it was so popular. The best recent book on the history of camouflage is Peter Forbes, *Dazzled and Deceived: Mimicry and Camouflage* (New Haven: Yale University Press, 2009).

What about these fabulous creatures so close to being real artists? On bowerbirds there is Clifford Frith and company's massive *The Bowerbirds* (New York: Oxford University Press, 2004) and the classic A. J. Marshall, *Bower-Birds: A Preliminary Statement* (Oxford: Clarendon Press, 1954). On cuttlefish and squid there are two books, Martin Moynihan, *Communication and Noncommunication by Cephalopods* (Bloomington: Indiana University Press, 1985) and Roger Hanlon and John Messenger, *Cephalopod Behaviour* (Cambridge: Cambridge University Press, 1998), though if you get a chance to take a look at the wonderful hand-drawn *Catalogue of Body Pattens of Cephalodopa* by Luciana Borrelli et al. (Firenze: Firenza University Press, 2006), you

will see that art is truly necessary to do squid science. On the art of elephants, David Gucwa and James Ehmann's *To Whom It May Concern: An Investigation of the Art of Elephants* (New York: Norton, 1985) is a truly beautiful work, a much more reverent take than the humorous *When Elephants Paint* (New York: Harper Perennial, 2000) by Russian artist-provocateurs Komar and Melamid.

On the evolution of human art, there are a handful of fine books harking back to our earliest creativity. Ellen Dissanayake's *Homo Aestheticus: Where Art Comes from and Why* (New York: Free Press, 1992) is among the most thoughtful. Nancy Aiken's *The Biological Origins of Art* (New York: Praeger, 1998) seeks to put all in context. On cave painting in particular there is the most philosophical David Lewis-Williams, *The Mind in the Cave: Consciousness and the Origins of Art* (London: Thames and Hudson, 2004) and the compendious Dale Guthrie, *The Nature of Paleolithic Art* (Chicago: University of Chicago Press, 2006), full of interesting theories and images.

It is easier than ever for anyone to access specialized scientific papers and to investigate unusual artistic movements through the vast web of information we're all seemingly attached to all the time these days. But it's just as easy to get lost. I urge you to go further and search for the beautiful in all its forms, in the most unexpected places, as the former chasms between science, nature, and art are now some kind of navigable cloudy bridges or paths. Enjoy all the possibilities. Dig deeper, and keep asking more and better questions in order to make better work that is ever harder to pigeonhole.

Notes

For sources with a doi number, visit http://dx.doi.org.

CHAPTER 1: COME UP AND SEE MY BOWER

4 **"The sight of a feather"** Letter from Charles Darwin to Asa Gray, April 3, 1860, Darwin Correspondence Project, no. 2743, http://www.darwinproject.ac.uk/entry-2743.

12 **"This sense has been declared"** Charles Darwin, *The Descent of Man, and Selection in Relation to Sex*, 2nd ed. (London: John Murray, 1874), 92.

12 **"The best evidence"** Ibid., 413–14.

13 **"My aviary is now tenanted"** Charles Darwin, "Notes," in G. J. Romanes, *Animal Intelligence* (London: Kegan Paul, 1882), 279.

14 **"portrays females as principally constrained"** Gerald Borgia, "Sexual Selection in Bowerbirds," *Scientific American* 254 (June 1986): 98.

15 **Madden found that mating success** Joah Madden, "Bower Decorations Attract Females but Provoke Spotted Bowerbirds," *Proceedings of the Royal Society* B 269 (2002): 1347–52.

15 **But Borgia found that in a different population** Gerald Borgia and U. Mueller, "Bower Destruction, Decoration Stealing and Female Choice in the Spotted Bowerbird *Chlamydera maculata*," *Emu* 92 (1992): 11–18.

17 **A recent study by Burgia's student Gail Patricelli** Gail Patricelli, Seth Coleman, and Gerald Borgia, "Male Satin Bowerbirds, *Ptilonorhynchus violaceus*, Adjust Their Display Intensity in Response to Female Startling: An Experiment with Robotic Females," *Animal Behaviour* 71 (2006): 49–59. The fembot bowerbird can be seen in action here: http://www.youtube.com/watch?v=dV2P3CqfM04.

18 **"The ancestor to the lineage"** Gerald Borgia, "Comparative Behavioral and Biochemical Studies of Bowerbirds and the Evolution of Bower-Building," in *Biodiversity II*, ed. Marjorie L Reaka-Kudla, Don E. Wilson, and Edward O. Wilson (Washington, D.C.: Joseph Henry Press, 1997), 273–74.

22 **"I am not a bird"** Goldsworthy quoted talking to Attenborough on "Flying Casanovas," *Nova*, PBS, December 25, 2001, http://www.pbs.org/wgbh/nova/transcripts/2818bowerbirds.html.

23 **"I was drawn to sticks"** E-mail from Patrick Dougherty, February 3, 2010.

24 **"As to beauty, I often say"** Ibid.

26 **"The pointlessness of art"** Iris Murdoch, *The Sovereignty of Good* (New York: Routledge, 2001), 84.

CHAPTER 2: ONLY THE MOST FASCINATING SURVIVE

29 **Dietmar Todt and his students have shown** Silke Kipper, Roger Mundry, Henrike
 Hultsche, and Dietmar Todt, "Long-Term Persistence of Song Performance Rules in
 Nightingales," *Behaviour* 141 (2004): 371–90.

32 **the famous narwhal's tusk** Martin Nweeia et al., "Hydrodynamic Sensor Capabilities and
 Structural Resilience of the Male Narwhal Tusk," 2005, http://narwhal.org/news2.html.

34 **"For neo-Darwinists, randomness"** Philip Ball, *Shapes* (London: Oxford University
 Press, 2009), 284.

35 **"What with standing half in the shade"** Ibid., 151.

37 **"The flower . . . exists for its own sake"** John Ruskin, *Proserpina: Studies of Wayside
 Flowers* (Sunnyside, Kent: George Allen, 1879), 73–74.

37 **"I observe, among the speculations"** Ibid., 93–94.

38 **"incapable of so much"** Ibid., 94–95.

38 **"If I had him here in Oxford"** Ibid., 94.

39 **"He who thinks that the male was created"** Charles Darwin, *The Descent of Man,
 and Selection in Relation to Sex*, 2nd ed. (London: John Murray, 1871), 616.

39 **"Everyone who admits the principle of evolution"** Ibid., 616–17.

41 **"were the most magnificent works"** Robert Richards, *The Tragic Sense of Life: Ernst
 Haeckel and the Struggle over Evolutionary Thought* (Chicago: University of Chicago
 Press, 2008), 1–2.

42 **"The interest which we take"** Ernst Haeckel, *The Wonders of Life* (New York:
 Harper, 1905), 184–85.

45 **"If we are to speak of love"** Wilhelm Bölsche, *Love-Life in Nature*, trans. Cyril
 Brown (New York: Albert and Charles Boni, 1926 [1902]), 1:7.

46 **"Think of the vast region"** Ibid., 2:55.

46 **"Now take the case of an amorous male frog"** Ibid., 2:247.

47 **"aesthetic work, having absolutely nothing to do"** Ibid., 2:285.

48 **"Our brain feels the blue bird"** Ibid., 2:286.

48 **"An animal is as if bewitched"** Ibid., 2: 300.

49 **"Think of the rhythm"** Ibid., 2: 314.

50 **"You clearly have occurrences"** Ibid., 2: 315.

52 **"To treat the living body as a mechanism"** D'Arcy Thompson, *On Growth and
 Form* (Cambridge: Cambridge University Press, 1992 [1917]), 2–3.

53 **"We seem to know less and less"** Ibid., 166.

53 **"The harmony of the world"** Ibid., 326–27.

59 **"Whenever I get the chance"** Dave Hickey, "Revision No. 5: Quality," *Art in
 America*, February 2009, 33.

CHAPTER 3: IT COULD BE ANYTHING

61 Author conversations with Richard Prum and Ofer Tchernichovski took place at Yale
 University in May 2009.

65 **Amotz Zahavi, the Israeli biologist** Amotz Zahavi et al., *The Handicap Principle: A
 Missing Piece of Darwin's Puzzle* (New York: Oxford University Press, 1999).

66 **The Victorian era was threatened by this** See Joan Roughgarden, *The Genial Gene:
 Deconstructing Darwinian Selfishness* (Berkeley: University of California Press, 2009),
 and Marlene Zuk, *Sexual Selections: What We Can and Can't Learn About Sex from
 Animals* (Berkeley: University of California Press, 2003).

67 **the European marsh warbler** See David Rothenberg, *Why Birds Sing* (New York:
 Basic Books, 2005), 96.

68 **the work of R. A. Fisher** R. A. Fisher, *The Genetical Theory of Natural Selection*
 (Oxford: Clarendon Press, 1930), and M. Kirkpatrick, "Sexual Selection by Female
 Choice in Polygynous Animals," *Annual Review of Ecological Systems* 18 (1987): 43–70.

69 **Take a male bird who is bright red** G. E. Hill, "Female Mate Choice for Ornamental Coloration," in *Bird Coloration: Function and Evolution*, ed. Geoffrey E. Hill and Kevin J. McGraw (Cambridge: Harvard University Press, 1006), 2: 137–200.

70 **"People choose sexual selection"** Telephone conversation with Martin Nweeia, December 2006.

71 **"To me, the expansively arbitrary diversity"** Richard Prum, "The Lande-Kirpatrick Mechanism Is the Null Model of Evolution by Intersexual Selection: Implications for Meaning, Honesty, and Design in Intersexual Signals," *Evolution* 64 (2010): 3085–100, doi:10.1111/j.1558-5646.2010.01054.x.

73 **"And why need Warhol *make*"** Arthur Danto, "The Artworld," *Journal of Aesthetics and Art Criticism*, 1964, 580–81.

74 **"It is the role of artistic theories"** Ibid., 584.

75 **From Arthur Danto's recent book** Arthur Danto, *The Abuse of Beauty* (Chicago: Open Court, 2003).

76 **Certain things about Duchamp's "Fountain" trouble Dutton** Denis Dutton, *The Art Instinct* (New York: Bloomsbury Press, 2009), 193–202.

77 **"Please note that I didn't"** Ibid., 200–201. Dutton cites John Brough on taking Duchamp at his word.

77 **"Erich Jarvis has shown"** See Erich Jarvis, "Learned Birdsong and the Neurobiology of Human Language," *Annals of the New York Academy of Sciences* 1016 (2004): 749–77; Aya Sasaki, Tatyana D. Sotnikova, Raul R. Gainetdinov, and Erich D. Jarvis, "Social Context-Dependent Singing-Regulated Dopamine," *Journal of Neuroscience* 26 (2006): 9010–14.

80 **"Is that really true? What about that study"** Mariko Takahashi et al., "Peahens Do Not Prefer Peacocks with More Elaborate Trains," *Animal Behaviour* 75 (2008): 1209–19, doi:10.1016/j.anbehav.2007.10.004.

82 **Tchernichovski is one of my favorite** Ofer Tchernichovski et al., "Studying the Song Development Process: Rationale and Methods," *Annals of the New York Academy of Sciences* 1016 (2004): 348–63. See also Ofer Tchernichovski, Partha Mitra, et al., "Dynamics of the Vocal Imitation Process: How a Zebra Finch Learns Its Song," *Science* 291 (2001): 2564–69.

87 **"the pygmies in the Ituri Forest sang 'Clementine'"** David Rothenberg and Marta Ulvaeus, eds., *The Book of Music and Nature* (Middletown, CT: Wesleyan University Press, 2001), 240.

88 **Damien Hirst can put a shark in formaldehyde** Don Thompson, *The $12 Million Stuffed Shark: The Curious Economics of Contemporary Art* (New York: Palgrave, 2008).

92 **He called this a reaction-diffusion system** Alan Turing, "The Chemical Basis of Morphogenesis," *Philosophical Transactions of the Royal Society B*, 237 (1952): 37. See also Hans Meinhardt, *Models of Biological Pattern Formation* (London: Academic Press, 1982).

93 **he and Williamson were able to tweak** Richard Prum and Scott Williamson, "Reaction-Diffusion Models of Within-Feather Pigmentation Patterning," *Proceedings of the Royal Society of London* B 269 (2002): 781–92, doi: 10.1098/rspb.2001.1896.

96 **"One thing that people"** Gary Marcus, personal communication, March 2011.

97 **which came first, the feather** Quanguo Li, Richard Prum, et al., "Plumage Color Patterns of an Extinct Dinosaur," *Science* 327 (2010): 1369.

99 **"The functional morphology"** Patricia Brennan, Christopher Clark, and Richard Prum, "Explosive Eversion and Functional Morphology of the Duck Penis Supports Sexual Conflict in Waterfowl Genitalia," *Proceedings of the Royal Society* B, December 2, 2009, doi:10.1098/rspb.2009.2139.

CHAPTER 4: POLLOCK IN THE FOREST

102 **"The urinal is there"** Philip Hensher, "The Loo That Shook the World," *The Independent*, February 20, 2008, http://www.independent.co.uk/arts-entertainment/art/features/the-loo-that-shook-the-world-duchamp-man-ray-picabi-784384.html.

105 **"The artist," he writes, "sacrifices"** Willard Huntington Wright, *The Creative Will* (New York: John Lane, 1916), 12.

105 **"Even in the most abstract"** Ibid., 15.

106 **"has posed problems which mere collections"** Ibid., 85–87.

106 **"primitive demand for symmetry"** Ibid., 110–11.

106 **"It is a complete cycle"** Ibid., 121.

108 **Biologist Geoffrey Miller even says** Geoffrey Miller, *The Mating Mind* (New York: Random House, 2000), 272.

110 **"With the function of the flower"** Paul Klee, *Notebooks, Volume 1: The Thinking Eye* (New York: Overlook Press, 1992 [1961]), 351–54.

111 **"Monday, March 13"** Ibid., 367.

111 **Brian Eno's *Oblique Strategies*** Brian Eno, *Oblique Strategies*, http://www.rtqe.net/ObliqueStrategies.

112 **"Nature is perfect"** Piet Mondrian, *Natural Reality and Abstract Reality*, trans. Martin James (New York: George Braziller, 1995 [1919]), 39.

113 **"Everything that appears geometrically"** Ibid., 38.

113 **"The new man will learn to see"** Ibid., 110.

114 **"Bees construct their cells"** Amédée Ozenfant, *Foundations of Modern Art*, trans. John Rodker (New York: Dover, 1952 [1931]), 284.

114 **Pure art is a "maximum efficiency"** Ibid., 300.

116 **"should have the sharpness"** Max Bill, "Concrete Art," reprinted in *Max Bill* (Buffalo: Albright-Knox Art Gallery, 1974), 47.

117 **"In the search for new formal idioms"** Max Bill, "The Mathematical Approach in Contemporary Art," *Werk* 3 (1949), reprinted in *Max Bill*, (1974), 94. Also at: http://www.math.neu.edu/~eigen/122oDIR/MaxBillArticle.html.

117 **"The building up of significant patterns"** Ibid., 96.

118 **"radical attempt to dispense"** Max Bill, "Structure as Art? Art as Structure?" reprinted in *Max Bill* (New York: Rizzoli, 1978 [1947]), 155.

119 **"Look to that complementary part"** George Birkhoff, *Aesthetic Measure* (Cambridge: Harvard University Press, 1933), 6.

120 **Music psychologists** David Huron, *Sweet Anticipation: Music and the Psychology of Expectation* (Cambridge, MA: MIT Press, 2008).

120 **"The 'complexity' of paintings"** Birkhoff, *Aesthetic Measure*, 212.

122 **"Dynamic balance is asymmetrical"** Thomas Hart Benton, "Mechanics of Form Organization in Painting," part 1, *Arts* 10, no. 5 (1926): 286.

123 **"an affair of groping nebulosity"** Thomas Hart Benton, "Mechanics of Form Organization in Painting," part 3, *Arts* 11, no. 1 (1927): 44.

123 **"We should be able to get at the logic"** Thomas Hart Benton, "Mechanics of Form Organization in Painting," part 5, *Arts* 11, no. 3 (1927): 146.

124 **"I taught Jack that"** Henry Adams, *Tom and Jack: The Intertwined Lives of Thomas Hart Benton and Jackson Pollock* (New York: Bloomsbury Press, 2009), 308.

124 **"Jack never made a painting"** Ibid., 362.

124 **"That's not painting, is it?"** Ibid., 263.

124 **"I'm very representational"** Ibid., 313.

125 **Russian psychologist A. I. Yarbus** Alfred Yarbus, *Eye Movements and Vision*, trans. Basil Haigh (New York: Plenum Press, 1967), 178. Also in Margaret Livingstone, *Vision and Art: The Biology of Seeing* (New York: Harry Abrams, 2008).

126 **"The concreteness of a painting"** Quoted in Adams, *Tom and Jack*, 325.

127 **"It seems to me that"** Quoted in Richard Taylor et al., "Fractal Analysis of Pollock's Drip Painting," *Nature* 399 (1999): 422.

127 **Taylor and his colleagues** Ibid. See also Richard Taylor, "Personal Reflections on Jackson Pollock's Fractal Paintings," *História, Ciências, Saúde—Manguinhos* 13, supplement (October 2006): 108–23. These and others may be downloaded here: http://pages.uoregon.edu/msiuo/taylor/art/info.html.

128 **"The quantitative and exact nature"** Henrik Jeldtoft Jensen, "Mathematics and Painting," *Interdisciplinary Science Reviews* 27, no. 1 (2002): 49.

130 **the most-preferred fractal-based images** Scott Draves, Rulph Abraham, et al. "The Aesthetics and Fractal Dimension of Electric Sheep," *International Journal of Bifurcation and Chaos* 18, no. 4 (2008): 1743–48.

CHAPTER 5: HIDING INGENUITY, OR THINK LIKE A SQUID

134 **"liquidly alive with sober iridescence"** Gerald Thayer, *Concealing-Coloration in the Animal Kingdom* (New York: Macmillan, 1909), 66–70.

134 **"The world has had enough"** Ibid., 128.

137 **"It takes the eye of an artist"** Ibid., 239–40.

137 **"Africa borders the Mediterranean Sea"** Peter Forbes, *Dazzled and Deceived: Mimicry and Camouflage* (New Haven: Yale University Press, 2009), 80.

139 **French painter Lucien Guirand de Scevola** Ibid., 104.

139 **"It is we who have created that!"** "Camouflage at IWM," *Sunday Times* (London), March 21, 2007.

140 **John Graham Kerr** Forbes, *Dazzled and Deceived*, 86.

141 **British artist Norman Wilkinson** Ibid., 93.

144 **"The fact is that in the primeval struggle"** Hugh Cott, *Adaptive Coloration in Animals* (London: Methuen, 1940), 2.

147 **These beautiful patterns all serve** See Philip Ball's most excellent book *Shapes* (New York: Oxford University Press, 2009) for the best recent discussion on the role of underlying natural pattern law behind the images that nature evolves.

147 **"cut right across different organs"** Cott, *Adaptive Coloration*, 430.

148 **"In nature visual concealment and deception"** Ibid., 438.

148 **woodland pattern** Forbes, *Dazzled and Deceived*, 253.

149 **HyperStealth Corporation** www.hyperstealth.com.

150 **"the science of nothing"** http://www.optifade.com/hunting-gear/content/how-science-of-nothing.html.

152 **"These animals also escape detection"** Charles Darwin, *Voyage of the Beagle* (London: John Murray, 1845), 7.

155 **"In the sand it is a drab brown"** Wilhelm Bölsche, *Love-Life in Nature*, trans. Cyril Brown (New York: Albert and Charles Boni, 1926), 1:206.

155 **a remarkable film made by Hanlon** Roger Hanlon's film of a male squid masquerading as a female: http://www.youtube.com/watch?v=OEqsgwyvtqc&feature=related.

156 **So the standard story of sexual struggle** Roger Hanlon and John Messenger, *Cephalopod Behaviour* (Cambridge: Cambridge University Press, 1998), 127.

156 **Some scientists have pointed out** Roger Hanlon et al., "Cephalopod Dynamic Camouflage," *Philosophical Transactions of the Royal Society* B 364 (2009): 429–37.

156 **Jaron Lanier** Jaron Lanier, *You Are Not a Gadget* (New York: Knopf, 2010), 189.

157 **Martin Stevens** Martin Stevens, "Predator Perception and the Interrelation Between Different Forms of Protective Coloration," *Proceedings of the Royal Society* B 364 (2007): 1457–64, doi:10.1098/rspb.2007.0220.

157 **"In our work with cephalopods"** Hanlon et al., "Cephalopod Dynamic Camouflage."

160 **"In order to morph in virtual reality"** Lanier, *You Are Not a Gadget*, 190.

162 **Ruth Byrne** Ruth Byrne's visual squid model can be found here: http://www.byrne.at/squidmodel/index.html.

163 **"Many patterns are designed to be overlooked"** Martin Moynihan, *Communication and Noncommunication by Cephalopods* (Bloomington: Indiana University Press, 1985), 108.

163 **"Most of their signals are concerned with attack"** Ibid., 94.

165 **Diana Eng's Twinkle dresses** Diana Eng's Twinkle dresses and other luminescent tech clothing, based on technology developed at the MIT Media Lab, can be seen at www.fairytalefashion.org.

166 **Joanna Berzowska's Intimate Memory dress** Stephen Wilson, *Art + Science: How Scientific Research and Technological Innovation Are Becoming Key to 21st Century Aesthetics* (New York: Thames and Hudson, 2010), 155.

166 **camouflage clothing that changes color** http://www.hyperstealth.com/Brussels/ index.html. See also http://kitup.military.com/2011/01/chameleon-camo-is-here-maybe .html?wh=wh_lead.

CHAPTER 6: CREATIVE EXPERIMENTS

168 **The artist, wrote Sir Joshua Reynolds** Joshua Reynolds, *Seven Discourses on Art* (London: Cassell 1901 [1790]), http://www.gutenberg.org/ebooks/2176.

169 **Lorraine Daston and Peter Galison** Lorraine Daston and Peter Galison, *Objectivity* (New York: Zone Books, 2007).

171 **But Daston and Galison point out** Ibid., 247.

174 **sculptor Kenneth Snelson** http://www.grunch.net/snelson/index.html.

176 **"The communication of molecules' architectonic essence"** Roald Hoffmann, "Thoughts on Aesthetics and Visualization in Chemistry," *Hyle* 9, no. 1 (2003): 7, http:// www.hyle.org/journal/issues/9-1/hoffmann.htm.

177 **"Chemists in the laboratory"** Roald Hoffmann, "Abstract Science?" *American Scientist* 97, (2009): 450.

179 **"abstract feel to it"** Ibid., 451.

179 **John Cage** See John Cage, *Silence* (Middletown, CT: Wesleyan University Press, 1962).

179 **"The idea is to come up with a set of facile reactions"** Hoffmann, "Abstract Science," 451.

180 **"Abstract art is cold"** Ibid., 452.

180 **"What violence that dull language"** Ibid.

181 **"Oh, beauty comes back"** Ibid., 453.

181 **"inbred love of the simple"** Hoffmann, "Thoughts on Aesthetics and Visualization in Chemistry."

182 **Jane Richardson** Jane Richardson's lab page is http://kinemage.biochem.duke.edu.

183 **an online game called FoldIt** www.fold.it; Eric Hand, "Citizen Science: People Power," *Nature* 466 (2010): 685–87.

183 **EteRNA** http://eterna.cmu.edu/content/EteRNA.

187 **"talking down utility"** Hoffmann, "Thoughts on Aesthetics and Visualization in Chemistry."

188 **"an abundance of restless imagination"** Quoted in Robert Root-Bernstein et al., "Arts Foster Scientific Success," *Journal of Psychology of Science and Technology* 1, no. 2 (2008): 57.

188 **"The lines should be graceful"** Ibid., 58.

189 **"art object is always"** C. H. Waddington, *Biology and the History of the Future* (Edinburgh: Edinburgh University Press, 1972), 37.

189 **"I love crystals"** Bernstein et. al., "Arts Foster Scientific Success," 59.

191 **"Let your mind travel"** E. O. Wilson, *Consilience* (New York: Knopf, 1998), 54.

191 **"constantly searches for meaning"** Ibid., 163.

192 **"We know," writes Berry** Wendell Berry, *Life Is a Miracle* (Washington: Counterpoint, 2193), 45.

193 **"Imitate, make it geometrical, intensify"** Wilson, *Consilience*, 220.

194 **Gerda Smets** Gerda Smets, *Aesthetic Judgment and Arousal* (Leuven: Leuven University Press, 1973).

194 **Vitaly Komar and Aleksandr Melamid** *Painting by Numbers: Komar and Melamid's Scientific Guide to Art* ed. JoAnn Wypijewski (Berkeley: University of California Press, 1998).

195 **"Poet in my heart"** Wilson, *Consilience*, 237.

195 **"If history and science have taught us anything"** Ibid., 262.

196 **"create sensory immersion environments"** Evelina Domnitch and Dmitry Gelfand, "Artist Statement," http://portablepalace.com/ed.html.

197 **"The unidirectional jets"** Evelina Domnitch and Dmitry Gelfand, "Camera Lucida: A Three-Dimensional Sonochemical Observatory," *Leonardo* 37, no. 5 (2004): 393.

198 **Hans Jenny's Chladni figures, updated by Alexander Lauterwasser** Alexander Lauterwasser, *Water Sound Images: The Creative Music of the Universe* (Newmarket, NH: Macromedia, 2007).

199 **"This caustic mixture"** http://portablepalace.com/lucida/index.html.

CHAPTER 7: THE HUMAN, THE ELEPHANT,
AND ART OUT OF RELATIONSHIP

203 **"Art," he tells us, "is a state of encounter"** Nicolas Bourriaud, *Relational Aesthetics* (Paris: Les Presses du Réel, 1998), 18.

204 **"stirs up new possibilities"** Ibid., 20.

204 **"Does this work permit me to enter"** Ibid., 109.

210 **"a moment of life"** Tom McDonough, ed., *Guy Debord and the Situationist International* (Cambridge, MA: MIT Press, 2004).

214 **"For the last two or three hundred years"** Arthur Lubow, "Making Art Out of an Encounter," *New York Times Magazine*, January 17, 2010.

215 **"I was suspended in some weird nonspace"** Jerry Saltz, "How I Made an Artwork Cry," *New York*, February 10, 2010.

216 **"It reminded me of those trips to Bloomingdale's"** Howard Halle, "Tino Sehgal's Work Proves That Talk Is Cheap," *Time Out New York*, Feb. 8–17, 2010, http://newyork.timeout.com/arts-culture/art/63345/tino-sehgal.

216 **"It's hard to feel anything"** Dahl, "Art: Tino Sehgal's 'This Progress' at the Guggenheim," February 20, 2010, http://dahlhaus.blogspot.com/2010/02/art-tino-sehgals-this-progress-at.html.

220 **The book David Gucwa put together** David Gucwa and James Ehmann, *To Whom It May Concern: An Investigation of the Art of Elephants* (New York: W. W. Norton, 1985).

222 **"hanging on the playroom walls"** Ibid., 54.

225 **"Of course it is all a hoax!"** Komar and Melamid, *When Elephants Paint* (New York: Harper Perennial, 2000), 47.

226 **"We will tell you, because we are famous artists"** Ibid., 74.

227 **"Our fascination begins"** Thierry Lenain, *Monkey Painting*, trans. Caroline Beamish (London: Reaktion Books 1997 [1990]), 185.

227 **"Certainly my IQ is higher than an elephant"** Komar and Melamid, *Why Elephants Paint*, 94.

227 ***Why Cats Paint*** Heather Busch and Burton Silver, *Why Cats Paint: A Theory of Feline Aesthetics* (Berkeley: Ten Speed Press, 1994).

227 **"Ninety-nine percent of art"** A conversation with Roger Shattuck, circa 1995.

228 **"I never dreamed it would come to this"** Komar and Melamid, *Why Elephants Paint*, 99.

228 **"The AEACP was originally created"** David Ferris, http://www.elephantart.com/catalog/plight.php.

229 **"On other elephant art websites"** Henry Quick and Issaraporn Kaew-ee, http://www.elephantartgallery.com/learn/authentic/are-elephant-paintings-art.php.

CHAPTER 8: THE BRAIN IN THE CAVE

236 **David Lewis-Williams** David Lewis-Williams, *The Mind in the Cave: Consciousness and the Origins of Art* (London: Thames and Hudson, 2004), 127. See also James Kent, *Psychedelic Information Theory: Shamanism in the Age of Reason* (Seattle: CreateSpace, 2010), http://psychedelic-information-theory.com/ebook/index.htm, and

Philip Nicholson and Paul Firnhaber, "Autohypnotic Induction of Sleep Rhythms Generates Visions of Light with Form-Constant Patterns," 56–83 in *Shamanism in the Interdisciplinary Context*, ed. Art Leete and Paul Firnhaber (Boca Raton: Brown Walker Press, 2004).

237 **Oliver Sacks** Oliver Sacks, *The Man Who Mistook His Wife for a Hat* (New York: Summit Books, 1985), 161.

237 **"I saw a great star"** Quoted in Ibid.

237 **"She experienced a shower"** Ibid.

238 **"Once I was beset by anxiety"** Ellen Dissanayake, *Homo Aestheticus: Where Art Comes From and Why* (New York: Free Press, 1992), 84.

239 **Nancy Aiken** Nancy Aiken, *The Biological Origins of Art* (New York: Praeger, 1998), 158.

240 **But even she is puzzled** Dissanayake, *Homo Aestheticus*, 81.

242 **Dale Guthrie** Dale Guthrie, *The Nature of Paleolithic Art* (Chicago: University of Chicago Press, 2006).

242 **paintings are found in only the most resonant spots** Iegor Reznikoff, "The Evidence of the Use of Sound Resonance from Paleolithic to Medieval Times," in *Archaeoacoustics*, ed. Graeme Lawson and Chris Scarpe (Cambridge: Cambridge University Press, 2006), 77–84.

245 **"are neurologists who actually study the brain"** Semir Zeki, *Inner Vision: An Exploration of Art and the Brain* (New York: Oxford University Press, 1999), 113.

246 **"art also obeys the laws of the visual brain"** Semir Zeki, "Artistic Creativity and the Brain," *Science* 293 (July 6, 2001): 51.

246 **"By abstraction I mean"** Zeki, "Artistic Creativity," 52.

246 **"I would like to propose not only"** Semir Zeki, "Neural Concept Formation & Art: Dante, Michelangelo, Wagner," *Journal of Consciousness Studies* 9, no. 3 (2002): 56.

247 **"getting above all singular forms"** John Constable, cited in Zeki, "Artistic Creativity," 51.

248 **"It is not uncertainty, but certainty"** Semir Zeki, "The Neurology of Ambiguity," *Consciousness and Cognition* 13 (2004): 175.

249 **"Great art," Zeki writes** Zeki, "Neural Concept Formation & Art," 67.

250 **"The activation of motor cortex"** Hideaki Kawabata and Semir Zeki, "Neural Correlates of Beauty," *Journal of Neurophysiology* 91 (2004):1704.

251 **"the organizing principles that dictate"** Zeki, "Neural Concept Formation and Art."

CHAPTER 9: ONE CULTURE OF BEAUTY, BETWEEN ART AND SCIENCE

256 **"An Element is a simple machine"** Casey Reas, "Process Compendium," original written for the Programming Cultures issue of *Architectural Design* (2007), http://reas.com/texts/processcompendium.html.

257 **"In 2003, I became obsessed"** Casey Reas, "Process/Drawing," original written for the Programming Cultures issue of *Architectural Design* (2007), http://reas.com/texts/processdrawing-ad.html.

259 **"These endeavors are inspired"** Jonathan McCabe, "Multi-Scale Radially Symmetric Turing Patterns" (2009), http://vagueterrain.net/journal14/jonathan-mccabe/01.

263 **V. S. Ramachandran** V. S. Ramachandran, in his latest book, *The Tell-Tale Brain: A Neuroscientist's Quest for What Makes Us Human* (New York: Norton, 2011), seems to have settled on nine laws of art, 200.

263 **Scott Draves** http://electricsheep.org; also http://scottdraves.com/sheep.html.

264 **"Once entranced, however, many also register"** David Brody, "Ernst Haeckel and the Microbial Baroque," *Cabinet* 7 (2002), http://www.cabinetmagazine.org/issues/7/ernsthaeckel.php.

265 **"a revelation . . . a prime mover"** Ibid.

266 **"The more I looked, the more pissed off I got"** Ibid.

268 **"Haeckel's lithographs"** Ibid.

269 **Henri Bergson and Teilhard de Chardin's notion** Henri Bergson, *Creative Evolution* (1910), http://www.archive.org/details/creativeevolutiooberguoft.

270 **"After laser cutting"** Barbarian Group, "Biomimetic Butterflies" (2007), http://mcleodbutterflies.com/installation.

272 **"This fanciful lecture format"** Anna Lindemann, personal communication.

274 **"My hand-crafted visual aesthetic"** Ibid.

275 **"To me these things don't seem incompatible"** Ibid.

Illustration Credits

Figures 1 and 3 courtesy of Gerald Borgia.

Figures 2, 4, and 67; plates 2 and 16 courtesy of Alexis Wright.

Figures 5 and 6 courtesy of Gail Patricelli.

Figures 7 and 8; plate 3 courtesy of Patrick Dougherty.

Figures 9 and 12 courtesy of the author.

Figures 13–15, 17 courtesy of Richard Prum.

Figure 16 courtesy of Michael di Giorgio.

Figure 19 courtesy of Overlook Press.

Figure 21 courtesy of Springer Verlag.

Figure 30 courtesy of HyperStealth, Inc.

Figures 31 and 32 courtesy of W. L. Gore, Inc.

Figures 33–36; plate 9 courtesy of Roger Hanlon.

Figures 37 and 38 courtesy of Ruth Byrne.

Figure 41 courtesy of Kenneth Snelson.

Figure 42; plate 12 courtesy of the Richardson Lab.

Figure 43 courtesy of David Baker.

Figure 44; plate 11 courtesy of Brad Paley.

Figure 45; plate 10 courtesy of the Smithsonian Museum of American Art.

Figure 46; plate 13 courtesy of Evelina Domnitch and Dmitry Gelfand.

Figures 47 and 48 courtesy of Siri the elephant.

Figure 49 courtesy of Komar and Melamid.

Figure 50 courtesy of R. Dale Guthrie.

Figure 52 courtesy of Philip Nicholson.

Figure 53 courtesy of Oliver Sacks.

Figure 54 courtesy of Nancy Aiken.

Figure 55 courtesy of Semir Zeki.

Figures 56 and 57 courtesy of Casey Reas.

Figures 58 and 59 courtesy of Jonathan McCabe.

Figure 60; plate 14 courtesy of David Nolan Gallery, New York.

Figure 61; plate 15 courtesy of Pace Wildenstein Gallery, New York.

Figure 62 courtesy of Karen Margolis.

Figures 63 and 64 courtesy of the Barbarian Group.

Figures 65 and 66 courtesy of Anna Lindemann.

Index